CINEMA ANN ARBOR

CINEMA ANN ARBOR

HOW CAMPUS REBELS FORGED A SINGULAR FILM CULTURE

FRANK UHLE

UNIVERSITY OF MICHIGAN PRESS
ANN ARBOR

Copyright © 2023 by Frank Uhle
All rights reserved

For questions or permissions, please contact um.press.perms@umich.edu

Published in the United States of America by the
University of Michigan Press
Printed on acid-free paper
First published March 2023

Manufactured in China

Design and editing: Ann Arbor District Library, Fifth Avenue Press
aadl.org/fifthavenuepress

A CIP catalog record for this book is available from the British Library.

Library of Congress Cataloging-in-Publication data has been applied for.

ISBN 978-0-472-13347-5 (hardcover : alk. paper)
ISBN 978-0-472-22138-7 (e-book)

DEDICATED TO MY FRIEND, MENTOR, AND TEACHER HUGH COHEN; AND TO THE MEMORY OF AMY LOOMIS, MARVIN FELHEIM, ED WEBER, GEORGE MANUPELLI, PETER WILDE, AND ART STEPHAN

CONTENTS

INTRODUCTION		**VIII**
CHAPTER 1	PIONEERING PRESENTERS	**2**
CHAPTER 2	POST-WAR EVOLUTION	**18**
CHAPTER 3	CINEMA GUILD BREAKS OUT	**34**
CHAPTER 4	THE ANN ARBOR FILM FESTIVAL	**50**
CHAPTER 5	DOUBTFUL MOVIES	**78**
CHAPTER 6	BEYOND BUTTERFIELD	**92**
CHAPTER 7	IF THEY'RE DOING IT, WHY CAN'T WE?	**110**
CHAPTER 8	REVOLUTIONARIES AND RIPOFFS	**134**
CHAPTER 9	NEW PERSPECTIVES	**158**
CHAPTER 10	PERFECTION, NOT PROJECTION	**178**
CHAPTER 11	CULT MOVIES AND CAMPUS VISITORS	**192**
CHAPTER 12	A LIBERATING EFFECT	**208**
CHAPTER 13	THE RENEGADES RUNNING THE ASYLUM	**234**
CHAPTER 14	BENDING TO THREATS	**268**
CHAPTER 15	A DESCENT INTO DISAPPOINTMENT	**284**
ACKNOWLEDGMENTS		**305**
BIBLIOGRAPHY		**311**
PHOTO CREDITS		**317**
INDEX		**321**

INTRODUCTION
MOVING PICTURES

IN PREPARATION FOR the University of Michigan's 2017 bicentennial, no expense was spared to celebrate every aspect of student and academic life. Books were published, apps were created, exhibits were curated, and dozens of historical markers were stenciled onto sidewalks. The splashiest event of all was scheduled for homecoming weekend. "HAILStorm" featured a stunning, high-definition 3D video summarizing the school's 200-year history, which was projected onto the facade of the iconic Rackham Building. Free polarized glasses, glow sticks, and slices of cake were given out to all who came. I took my eight-year-old daughter, and as we watched it unfold through the evening's drizzle, I couldn't help thinking about someone I used to know named Peter Wilde. Peter had been the chief projectionist for the university's now-defunct student film societies, and delighted in melding derelict components into systems capable of showing movies in Dolby Stereo and 3D. Had he not died too young, thirty years before, it struck me that Peter might well have been overseeing the complex HAILStorm presentation.

At the time, I was working for the audiovisual support unit of the College of Literature, Science, and the Arts, and, as part of the bicentennial effort, had been charged with putting together a history of our department, which was the direct descendant of Wilde's Film Projection Service. While conducting my research at the Bentley Historical Library, I began finding interesting documents from the film societies themselves (one of which—Cinema II—I had been a member of), but when I opened a folder of yellowed clippings marked "Moving Pictures," I was genuinely shocked to discover that their history stretched back further than I ever imagined. The collected newspaper articles, ads, and bits of ephemera were from a group called the Art Cinema League, which had been launched in 1932. Quite possibly the first student film society in the nation, it had been Ann Arbor's only source for art and foreign language films through the late '40s, and occasionally hosted guests like Dutch documentary filmmaker Joris Ivens and poet Carl Sandburg. In an era when the university kept a tight rein on campus activism—and even expelled communist-sympathizing undergraduates—the group had also courted controversy by showing numerous Russian-made and anti-war titles, sometimes in the same building that HAILStorm had been projected on.

I set aside my departmental research for a moment and began to consider tackling a new subject—the history of the campus film societies. Barely any trace of their existence remains today, but before digital streaming, DVDs, and VHS tapes made esoteric content easily available, a half-dozen such groups brought Ann Arbor thoughtfully curated thematic series, regional and even national premieres, and visitors who ranged from Frank Capra and Jean-Luc Godard to Andy Warhol and the Velvet Underground. Independently run by students and community members, they became one of Ann Arbor's signature cultural offerings, helping build a strong local film culture while drawing movie lovers from around southeast Michigan. As they sought out cutting-edge

fare, their efforts also sometimes led to university crackdowns and even the arrests of four members of the most prominent film society, Cinema Guild.

I took the idea to bicentennial theme semester chairman and history professor Howard Brick, who himself fondly remembered attending Cinema Guild shows in the early 1970s. With his support, I started mapping out a 5–8,000-word narrative based on the Bentley's clippings, my own experiences, and interviews with key people like professor Hugh Cohen, who had been a member of Cinema Guild from 1960 until its final days, was arrested in 1967 for showing Jack Smith's "obscene" *Flaming Creatures*, and was still energetically teaching film classes in his late 80s.

But as I began talking to Hugh and other friends who'd been in groups like the Ann Arbor Film Cooperative and Alternative Action, I kept uncovering more stories that I'd never heard before. Maybe it was my perfectionist nature, but it began to look like I couldn't do the university's film societies justice with a breezy highlights piece. There were also major tangents that deserved attention, like the Ann Arbor Film Festival, founded with support from Cinema Guild in 1963 and still perhaps the most prestigious experimental film showcase in North America. I would want to cover the prolific underground filmmaking scene it inspired as well, plus valiant off-campus presenters like Eyemediae and the Ann Arbor Silent Film Society. As the circle kept widening, I realized that the story was not going to be ready in time to publish during the university's bicentennial year.

Though the archives surprisingly held only scattered pieces of film group material beyond the Art Cinema League clippings, my interviewees had begun to give me amazing documents and photos, and I hit the mother lode when my high school classmate Reed Lenz, who had inspired me to join a film society in the first place, showed up at my door with six bankers boxes containing the final office files of Cinema Guild. Then, the bicentennial team unveiled a searchable digitization of the student-run *Michigan Daily* newspaper, which revealed 4,689 hits on the phrase "Cinema Guild" alone. Suddenly I had a tool that could guide me to articles about film societies that nobody had any memory of, which revealed names of participants that I began to track down for further, sometimes surprising additions to the story. My own father even got into the act—he had enrolled at the University of Michigan in 1945 and was the only person of the more than 75 I interviewed who had attended, or had any recollection of, the Art Cinema League.

As my research continued, one thread in particular kept growing stronger and began to drive my quest to learn the full story of the societies' rise, heyday, and painful demise. Though the theme seemed at first to be one of college students showing subtitled movies and occasionally hosting a VIP guest, with periodic controversies thrown in for texture, the subversive nature of unregulated groups screening films on campus began to take a central role. Launched to present artistic movies in the Hollywood-dominated Great Depression, by the 1960s the University of Michigan's film societies had become a critical channel to the counterculture by presenting content that was excluded from all other media outlets, and was even illegal, as Hugh Cohen learned. They might have gone too far in the 1970s by showing hardcore pornography in the same auditoriums where students attended classes by day, but while porn was unquestionably a vital source of income that helped underwrite the obscure titles members wanted to offer, in the wake of their

INTRODUCTION

battles against censorship it was also a way to remind the university that freedom of speech meant tolerating all kinds of content, even when it was blatantly offensive.

During these years, the film societies became a crucial haven and creative outlet for people who didn't fit in elsewhere. Gay students, budding filmmakers, and campus rebels of all types were drawn to the groups. Opposition to "the man" got the best of a few, and several film societies took advantage of the university's weak oversight to launch money-making hustles that ended up stiffing distributors and the U itself of thousands of dollars.

For much of the film groups' existence there were no or few university courses on movies as an artform, and Cinema Guild in particular took on an educational mission that served people both on and off campus. Before either made a film, Ken Burns and Michael Moore were regular attendees, and a significant number of film society members themselves entered the industry as filmmakers, critics, and academics, including writer/director Lawrence Kasdan (*The Big Chill, Star Wars, Raiders of the Lost Ark*); producer John Sloss (*The Fog of War, Boyhood, Green Book*); *Sneak Previews* co-host and author Neal Gabler (*An Empire of Their Own, Walt Disney*); and curator Philip Hallman, charged with overseeing the University of Michigan's growing archive of filmmakers, like Orson Welles, John Sayles, and Robert Altman. The fact that the latter's papers wound up at Michigan at all can perhaps be traced to film group members welcoming the avid marijuana smoker with "the best pot in town" on his first visit to Ann Arbor.

Three years too late for the University of Michigan's bicentennial, the Ann Arbor District Library agreed to publish my story under its Fifth Avenue Press imprint, and their own archives began supplying me with even more material, including unpublished pictures taken by *Ann Arbor News* photographers. I think it was worth the extra wait, and I hope you will enjoy reading it.

Frank Uhle
Ann Arbor
June, 2022

Frank Uhle

is a member of

cinema II
the university of michigan

fall _79_ to fall _80_

Cheryl Weather
president

CHAPTER 1
PIONEERING PRESENTERS

ANN ARBOR'S reputation as an oasis for art and underground movies, and the University of Michigan film societies that gave it life, was still decades away when the industry began. Evolving out of "magic lantern" slide shows and the photographic studies of Eadweard Muybridge, motion pictures were introduced commercially in 1894 by Thomas Edison as an amusement parlor novelty called the Kinetoscope. Two years later, his company's Vitascope became the first movie projector marketed in the US, and it was quickly franchised to traveling operators who brought the primitive short films Edison was also making to audiences around the country. The Vitascope debuted in Detroit on July 1, 1896, and likely appeared in Ann Arbor later that same year.

Along with short excerpts from plays and footage of scantily clad dancing girls, a popular subject of early motion pictures was the restaging of boxing matches. In 1897, an Edison competitor called the Veriscope Company took the bold step of filming an entire heavyweight title bout between champion "Gentleman Jim" Corbett and Bob Fitzsimmons, in the process creating the world's first feature-length film. Using three hand-cranked cameras and widescreen 63 mm stock, Veriscope captured the event in real time, through challenger Fitzsimmons's winning solar plexus punch and the crowd swarming the ring. *The Corbett-Fitzsimmons Fight* premiered in New York in late May, then began a tour of the country that was scheduled to stop at Ann Arbor's Athens Theatre on October 16, 1897. Opened as Hill's Opera House in 1871, this downtown venue had recently been renamed due to Ann Arbor's reputation as "the Athens of the West," with a makeover that included a painting of Niagara Falls on the drop curtain. With nearly 1,200 seats, it was the city's largest entertainment facility.

TOP: *U of M Daily* ad, 1897
RIGHT: The *Ann Arbor Argus*

Motion pictures were barely three years old, but there were already concerns that exposing viewers to forbidden activities onscreen would corrupt or otherwise harm them. Boxing was illegal in much of the country, including Michigan, and with 3,200 mostly male students enrolled at the University of Michigan, local clergymen and college administrators grew worried that seeing *The Corbett-Fitzsimmons Fight* might inspire some to acts of violence. Before it reached town, a letter signed by U-M president Harry Hutchins, five deans, a regent, a faculty member, local business leaders, and all of the town's pastors was sent to Athens manager L. J. Lisemer. Published on the front page of the *U of M Daily*, it decried the "scarcely less brutalizing effect than that of the fight itself" seeing

OPPOSITE: Rackham Lecture Hall, 1938. Bentley Historical Library (BHL)

PIONEERING PRESENTERS 3

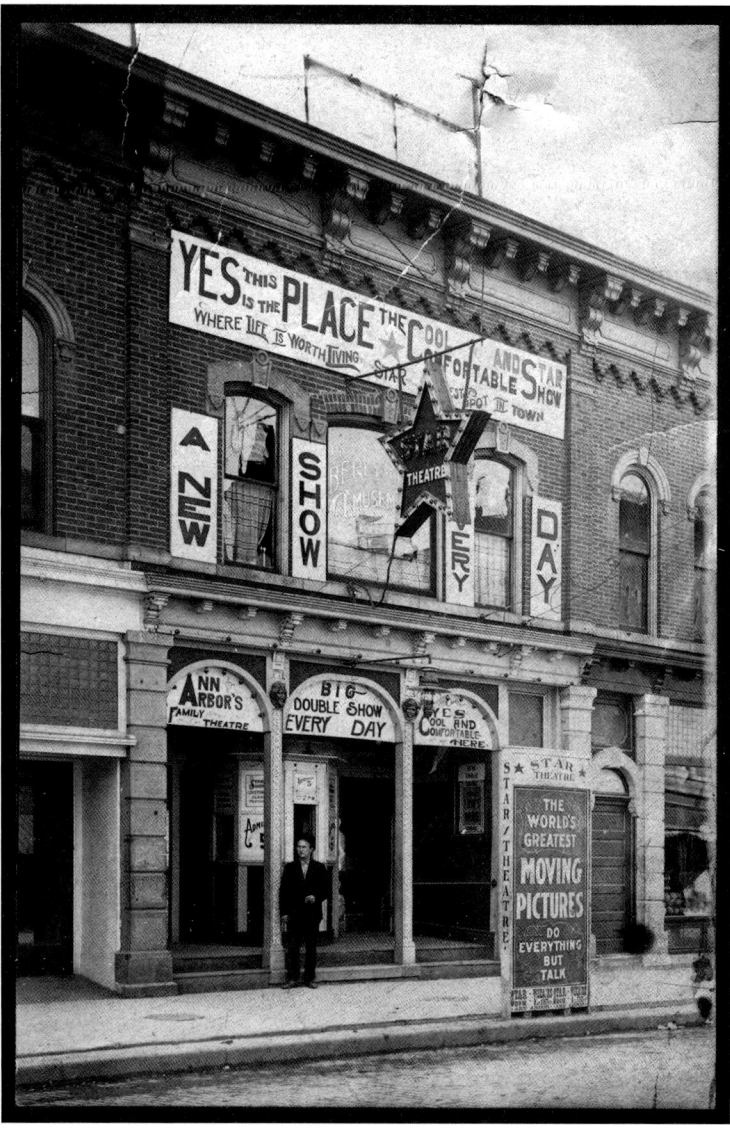

The Star Theatre.
Washtenaw County
Historical Society

the film might have on its viewers: "In view of the inevitably evil effects of the exhibition upon those who attend, and indeed, directly or indirectly upon the whole body of young people gathered in this great educational center, we respectfully suggest to the management the propriety of withdrawing the same." But the Athens's Lisemer held his ground, according to the *Ann Arbor Argus*, both because of an expensive cancellation clause in his contract and the fact that he had seen the film and "did not consider it demoralizing."

While a wave of violence does not appear to have followed the Athens's screening of *The Corbett-Fitzsimmons Fight*, just over a decade later an incident at a local theater did spark a riot by University of Michigan students. By that time, movie exhibition had evolved from use as a novelty on vaudeville bills, at the Athens and similar venues, to continuous daily showings at a half-dozen storefront nickelodeons that opened starting in 1906. One, the Vaudette, was close to campus at the corner of State and Liberty streets, but most were a half-mile away downtown and offered a family-oriented mix of short silent films, singalongs, and live performances. These included the Star Theatre, which opened on West Washington Street in August 1907 and whose management seemed to have a particular antipathy toward university students.

Several different versions of the events of Monday, March 16, 1908, have been written, but what appears the most credible witness-based account was published the next day in the *Michigan Daily*. It reported that on the preceding Saturday, a group of four U-M students had been watching a film at the Star when its house officer asked one to stop whistling and scuffling his feet before ordering him to leave. "As he was passing out, it is alleged that Manager Reynolds said, 'That's right, officer, put the hound out.' The three companions admit that their friend slapped the manager. It is then alleged that the officer jumped onto the student and cut his head open with a heavy blow of his club." House officer Jacob Schlimmer was an ex-boxer who had once served time for assault and battery.

That night a protest was held outside the theater by about 200 people, who dispersed peacefully. But two days later,

A Student of the U. of M. "Riot Course" returning from a recitation.

"I DON'T WANT STUDENTS IN MY PLACE."

Star manager Albert Reynolds

Star manager Albert Reynolds was heard giving a curtain speech in which he declared, "I don't want students in my place," and when word of his remarks reached campus, a much larger crowd began to gather. Estimated by the *Daily* at 800 to 900 and by other sources at up to 2,000, they started off singing, "We're here because we're here, because we're here" in response to Reynolds's comments, but things quickly got out of hand. First there was shouting, then eggs were thrown, then harder projectiles were discovered at a construction site across the street: "Urged by curbstone harangues, irresponsible individuals began hurling bricks at the illuminated front of the show place. One by one the lights were extinguished. One by one the windows were crushed in and a two-by-four battering ram soon punctured the flimsy woodwork of the front. A few students went inside and soon pushed the electric piano out. A final chord was struck and the piano was in the hands of a hundred students each claiming a souvenir. A few chairs were demolished and some of the decorations on the walls were torn down."

Alerted to the situation, U-M president James B. Angell and several deans raced to the scene, which briefly caused the crowd to grow quiet and respectfully take off their hats. But his declaration, "Gentlemen, this is deplorable," and pledge that "if any injustice has been done to you, we will help you" had little effect. The riot swiftly resumed, and Ann Arbor's 12-man police department was able to make only scattered arrests as members of the crowd moved on to attack the jail and steal a hose that members of the fire department had been attaching to a hydrant to disperse them. The chaos finally ended late in the evening when word was received that the mayor had telephoned the governor to mobilize the National Guard.

Fifteen of the arrested students were subsequently charged with rioting, but they received strong support on campus and from prominent locals, and the case was settled with a collective payment of $1,000 to repair the theater and the policemen's uniforms. The story was covered widely, with sensational accounts appearing in newspapers around the country, including the *New York Times*. The event caused significant embarrassment to both administrators and alumni, but it would not be the last time that University of Michigan student filmgoers would make headlines.

By the 1910s, movies were starting to be shown on campus, often as part of a special lecture, and high-profile events began to incorporate the new technology.

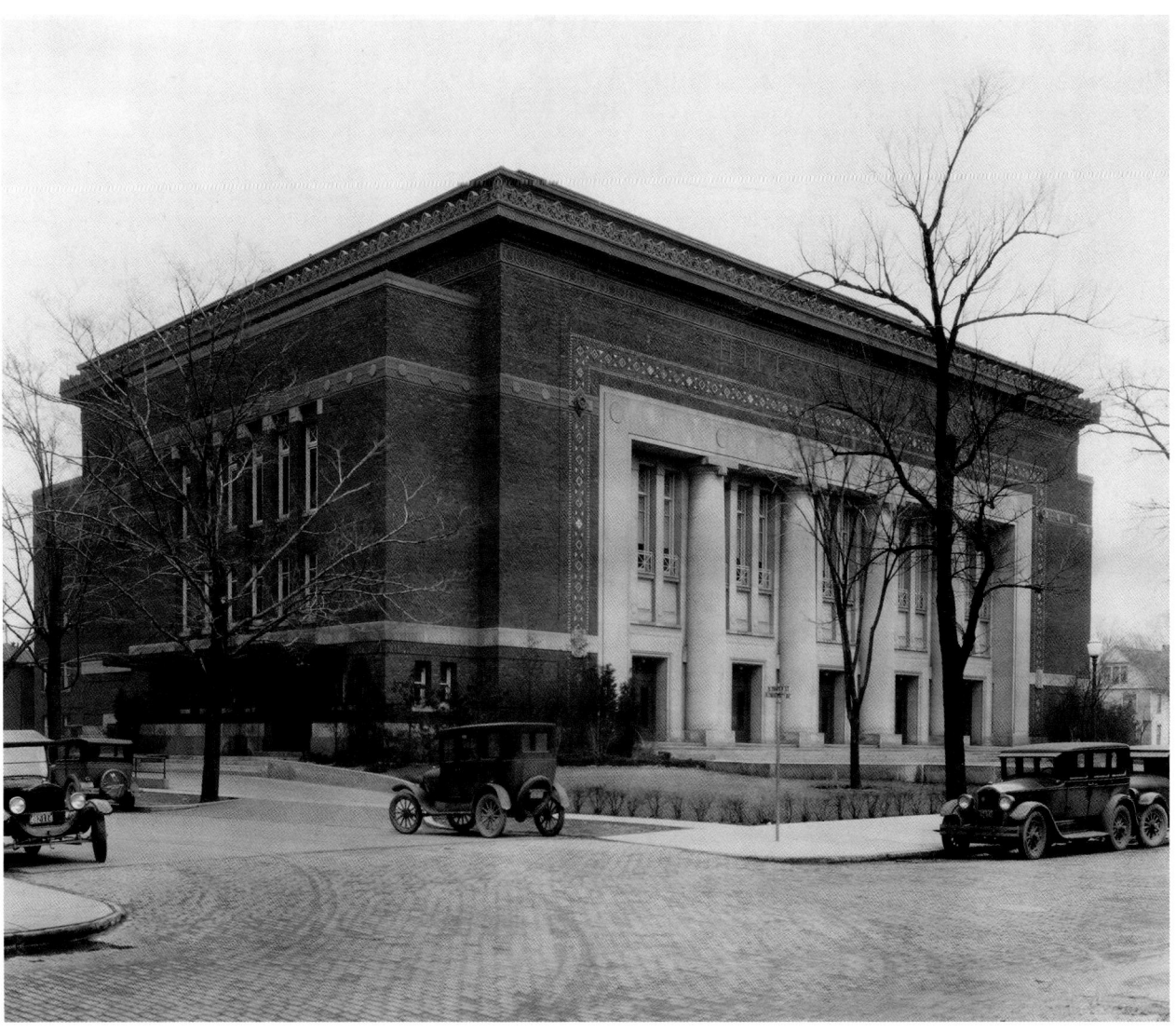

Hill Auditorium. Washtenaw County Historical Society

Films were advertised as part of the program at personal appearances, like the June 1913 talk by Antarctic explorer Roald Amundsen at University Hall and the May 1919 lecture by World War I fighter pilot Eddie Rickenbacker at Hill Auditorium. At the latter, according to the *Daily*, footage of "an actual air duel between a Hun and a Yankee" was shown. Opened in 1913, the 4,300-seat Hill soon fell into regular use as the city's largest motion picture theater, hosting special screenings of movies shot at U-M athletic events and even Hollywood features shown in conjunction with campus gatherings like Cap Night.

As new university buildings were constructed, their large auditoriums began to incorporate projection booths. The 400-seat lecture hall in the Natural Science building, completed in 1915, was outfitted to show films, leading the *Daily* to note: "So far as is known, Michigan will be the first university to employ moving picture apparatus in the regular teaching of scientific subjects." Films for study and for teaching were shot by researchers in different disciplines, at the hospital, and even through the telescope at the U-M Observatory, which reputedly captured the earliest moving images of

the moon. Outreach to alumni was also accomplished through the new medium, with films shot on campus becoming a popular feature of their gatherings around the country.

Movies became a way to attract students to organizations near campus as well. For a time, Lane Hall, which opened in 1917 as a YMCA, offered films with popular stars like Mabel Normand and Charlie Chaplin in a second-floor auditorium two nights per week, while both the First Methodist and Congregational churches began to feature movies to draw students to services. The latter came with the added attraction of a massive pipe organ to provide the silent pictures' musical accompaniment. Film programming by religious groups would remain a standard campus offering for many years to come.

Art Films at Mendelssohn

During the movies' first two decades, the quickly made shorts of Edison and others gave way to films with scripted stories, star performers like Chaplin and Lillian Gish, and sprawling, big-budget productions by directors like D. W. Griffith and Cecil B. DeMille. By the 1920s, the motion picture had advanced to tentative recognition as a new art form, and Ann Arbor's crude nickelodeons had been replaced by fully realized movie theaters, including the campus-proximate Arcade and Majestic and the downtown Wuerth, Orpheum, Rae, and Whitney. The latter, called the Athens Theatre when *The Corbett-Fitzsimmons Fight* was shown, had by this time increasingly shifted from live events to movies.

With sophisticated, artistic films now beginning to emerge from places like Russia, Germany, France, and occasionally even Hollywood, Ann Arbor movie fans found there was no easy way to view the vast majority of them. Despite an unusually well-educated populace due to the presence of the University of Michigan, which then had about 10,000 students in a town of only 20,000, the local theaters seldom took a chance on anything that wasn't geared to mainstream tastes. Art films could only be found in cities where so-called "Little Cinema" theaters had begun operating, and in 1928 one opened in Detroit, an hour to the east. The 600-seat Little Theatre sometimes advertised its offerings in the Ann Arbor papers, and, until members of the University of Michigan community began to attempt similar programming, became the closest place for Ann Arbor residents to experience such films.

While the campus had seen occasional one-off screenings of films like German director F. W. Murnau's *The Last Laugh*, shown at Hill by the American Association of University Women, the first opportunity to create a regular showcase

TOP: *Michigan Daily* ad for December 1918 church film screening. BOTTOM: 1928 *Daily* ad for Detroit's first art house

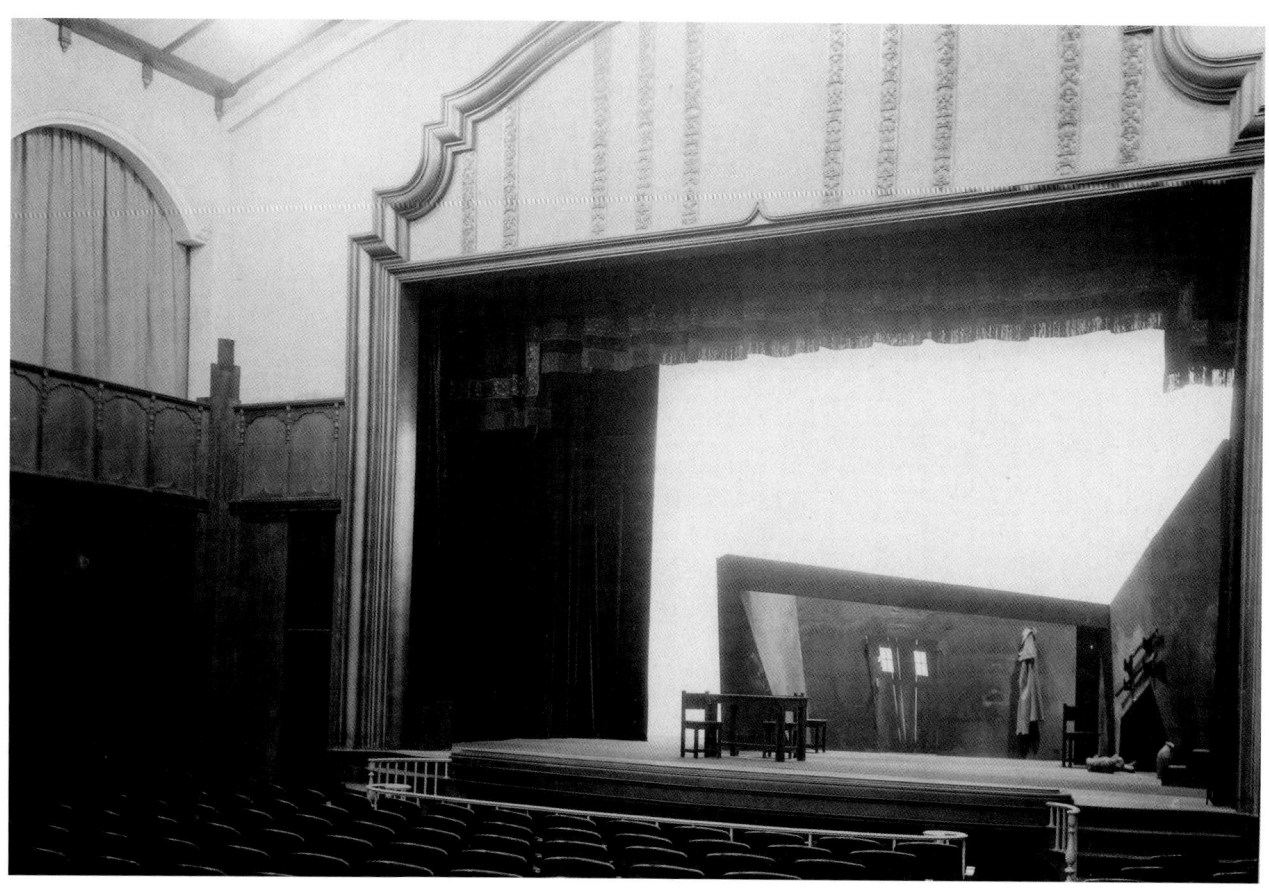

ABOVE: Lydia Mendelssohn Theatre, 1930s. BHL

Amy Loomis. *Michiganensian*

for art movies came with the 1929 opening of the Women's League building. Constructed as a social center for female students, who were not allowed unescorted into the Michigan Union (built a decade earlier to serve men), the new facility incorporated the 700-seat Lydia Mendelssohn Theatre, which was designed to accommodate theatrical performances and included an orchestra pit and projection booth. Though the movie industry had just begun the conversion to sound, Mendelssohn's planning came on the cusp of this evolution and it could only show silent films.

The Mendelssohn Theatre's first manager was Amy Loomis, a 1922 U-M graduate who had acted on regional stages and in New York before returning to Ann Arbor. Charged with coordinating theatrical and musical events at the new performance space, she decided to add film screenings during weeks when no live events were scheduled. Her explicit goal here was to expand Ann Arbor's cultural horizons, as she told the *Daily*: "The purpose is not a commercial one, as we are interested in giving the new art movie a place in the theater work of this university." Loomis's series began with the Michigan premiere of the 1921 Norwegian feature *Markens*

Grode (Growth of the Soil), which was just seeing its first release in the US. She described it as "a work of art, in all the highest meaning of the term."

Anticipating the programming of future U-M film societies, Loomis preceded the feature with a pair of recent experimental shorts, *The Life and Death of 9413, a Hollywood Extra* and an expressionistic adaptation of Edgar Allan Poe's *The Tell-Tale Heart*. All were accompanied by undergraduate Jack Conklin on piano, with the 50-cent ticket price comparable to what an evening screening at a commercial theater cost. *Markens Grode*'s week-long run began on Monday, October 21, 1929, just three days before Wall Street's Black Thursday meltdown, which marked the start of the Great Depression.

Daily music and drama editor William J. Gorman gave the new film exhibition concept his qualified approval: "Miss Loomis's announcement that the Mendelssohn Theatre is going to attempt a policy of serious, high-class silent pictures is more or less welcome. It is essentially an experiment. Foreign pictures employing the particular advantages of camera technique carefully and intelligently for artistic effect will be absolutely new to Ann Arbor, which doesn't even get to see the better American pictures. There will be no attempt at competition with local movie-houses, which have the glamour of garish architecture and the noise of expensive organs and do not object to moderate whistling

Daily ads for Mendelssohn Theatre films

or sibilation." Gorman was apparently referring to the newly opened Michigan Theatre just three blocks away, whose Barton pipe organ was capable of a wide range of sound effects to accompany silent films.

Amy Loomis's movie series proved popular, and for more than two years she continued to present art films when the opportunity arose between live events and theatrical productions. Her programming included acclaimed features like Carl Theodor Dreyer's *The Passion of Joan of Arc*, F. W. Murnau's *Nosferatu*, and Sergei Eisenstein's *Old and New*, as well as the first US showings outside New York of British comedy *Widecombe Fair*.

The Art Cinema League

In 1932 Amy Loomis left town to join the Copley Players in Boston, leaving her film series in limbo. Seeking to continue

PIONEERING PRESENTERS 9

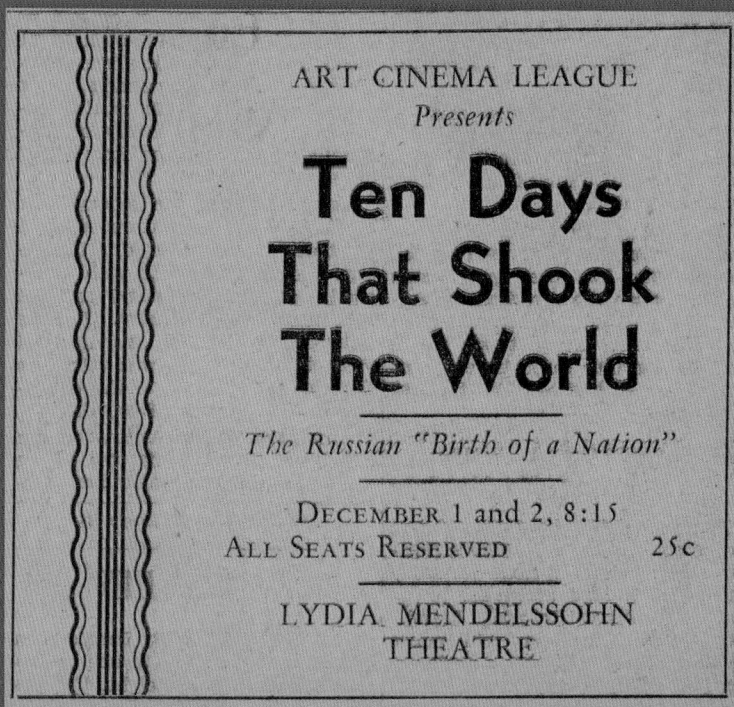

TOP LEFT AND BOTTOM: Program note for an Art Cinema League screening, January, 1933. BHL

PARTY CANDIES NOVELTIES	GIFTS for all occasions
MacDiarmid's Candies	The Kress Art and Gift Shop
719 North University	312 So. State Ann Arbor

THE ART CINEMA LEAGUE—an earnest movement by members of both the faculty and student body of the University of Michigan to fulfill the demands of intelligent theatergoers for intelligent forms of dramatic expression.

We plan to bring films of the calibre of "Kameradshaft," "Maedchen in Uniform," and "Storm Over Asia." We plan to bring to you King Vidor, the great American director, and Max Eastman, the brilliant poet.

Join with us in our endeavor to educate ourselves to a finer appreciation of the arts. Become an associate member.

If you write, we have it	DRUGS KODAKS
Typewriters Fountain Pens Correspondence Stationery Student & Office Supplies Greeting Cards	Calkins-Fletcher Drug Co. 4 Dependable Stores
O. D. MORRILL 314 South State Street The Typewriter & Stationery Store	We have served Michigan and her students for forty-seven years
Since 1908 Phone 6615	CANDY SODAS

Play Production

"HEDDA GABLER"

February Offering

PROGRAM
January 18, 19, 20

Charlie Chaplin Comedy
 The past generation's conception of comedy
The Cabinet of Dr. Caligari
 Direction Robt. Wiene
 Camera Willy Hamiester
 Design { Walther Reiman
 Herman Warm
 Walther Rohrig }
 CHARACTERS
 Cesare Conrad Veidt
 Jane Lil Dagover
 Caligari Werner Krauss
 Francis Hans von Tvaradovski
 Alan Friedrich Feher
 Music by J. W. Conklin

Latest Fiction Jig-Saw Puzzles	Lingere Gifts Gloves
The Printed Page	*She's hard on Stockings* but she's a Holeproof Hosiery Fan! chiffon and service 69c and up
RENTAL LIBRARY	CAMPUS SHOPPE
14 Nickels Arcade	229 So. State Ann Arbor

"THERE WILL BE NO ATTEMPT AT COMPETITION WITH LOCAL MOVIE-HOUSES, WHICH HAVE THE GLAMOUR OF GARISH ARCHITECTURE AND THE NOISE OF EXPENSIVE ORGANS."

William J. Gorman, *Daily* music and drama editor

this popular new facet of campus life, a group of students and professors banded together to form an organization they called the Art Cinema League. Secretary-treasurer and graduate student Philip Seidel explained their mission to the *Daily*: "We feel that there is a definite need for films of cultural value, for outstanding films which are not presented at the popular theaters." The paper ran a supportive editorial which concluded: "There is no doubt that the Art Cinema League should and will receive substantial support from the faculty and student body. Probably no other art has so huge a following as the silver screen, and the league has taken upon itself the task of bringing the finest films produced in other countries than our own within reach—entertainment hitherto inaccessible to most of us."

The Art Cinema League was one of the earliest campus film societies in the United States, and possibly the very first, though this is difficult to establish with certainty. Film clubs had become popular in Europe beginning in the 1920s, with the first American organization dedicated to showing art films founded in New York in 1925, according to Haidee Wasson's book *Museum Movies*. It had quickly become a for-profit theater, however, and while Little Cinemas sprang up in a number of cities, the growth of film societies was much slower, with only about two dozen estimated nationwide by 1940.

Following the pattern established by Loomis, Art Cinema League screenings were held at Lydia Mendelssohn Theatre, though now for shorter, weekend-long runs. The ACL's inaugural program on December 1–2, 1932, featured Eisenstein's *Ten Days That Shook the World* and several Russian shorts, and when the screenings sold out, a third night was added. A U-M film society tradition of sorts was also established when the feature's glorification of the Russian Revolution inspired a letter to the *Daily* accusing the ACL of being an arm of the Communist-allied National Student League. Group spokesman Philip Seidel vehemently denied the charge.

Limited at first to silent titles like *The Cabinet of Dr. Caligari* and Vsevolod Pudovkin's *Mother*, the ACL earned enough from the 25 cents it was now charging for tickets to pay for

OPPOSITE TOP RIGHT AND ABOVE: Early Art Cinema League advertisements

PIONEERING PRESENTERS 11

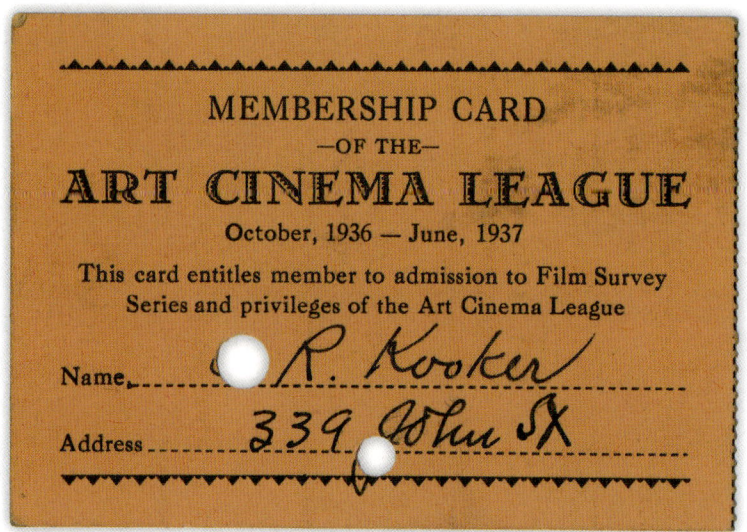

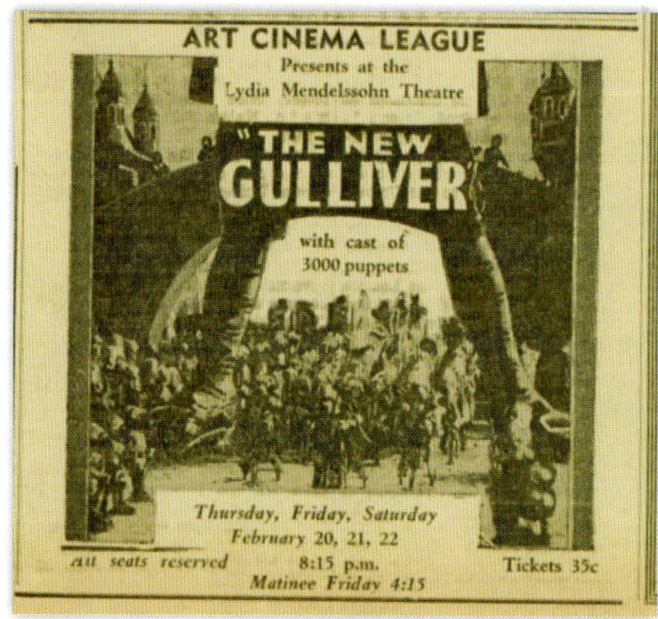

the installation of sound projection equipment and give $200 to the Good Will Fund for needy students. In April 1933, the film society presented its first "talkie," G. W. Pabst's *Kameradschaft*, while announcing an ambitious plan to sponsor guest speakers and other events on campus. Oscar-nominated *The Crowd* director King Vidor politely declined the group's invitation, writing, "I am more interested at the moment in doing a picture than talking about them," but that spring the ACL brought both poet Carl Sandburg and composer Roy Harris to campus.

As the Art Cinema League hit its stride, it presented Ann Arbor and sometimes regional premieres of important new films like John Ford's *The Informer*, the until recently banned German *Maedchen in Uniform,* and Aleksandr Ptushko's stop-motion *The New Gulliver*, advertised as the film's first US screening outside New York. Ticket prices had risen to 35 cents to help fund improved sound equipment and a new screen, but were still the same that local commercial theaters charged. Because the film society consistently attracted audiences for its specialized titles, distributors sometimes also provided prints for members-only preview screenings.

In a February 1935 letter to the *Daily*, the group's board noted with pride: "The purpose of the Art Cinema League is to show the best available from each of the major film countries of the world. We were pioneers in this endeavor, but now there are many similar organizations at International House of the University of Chicago, Michigan State, University of Pennsylvania, Columbia, Harvard, and University of California, as well as in many of the larger cities throughout the nation. Because of our early start

we have been confronted with many difficulties. It has been difficult to obtain films. We have been accused of having the most diverse of ulterior motives. We have had difficulties with sound equipment and even met with NRA interference temporarily. We are simply trying to render a cinema service to Ann Arbor such as will not be undertaken except by some such group. We believe that there are values other than mere entertainment to be had from the cinema." (The NRA, or National Recovery Administration, was a Depression-era federal agency created to help get people back to work.)

The ACL's programming was also putting Ann Arbor on the map for film fans from around the state. While the Detroit Institute of Arts' recently launched Detroit Cinema Guild had screened several of the same titles at a much higher one-dollar non-member rate, according to the ACL's letter a number of Detroiters were planning to drive to Ann Arbor to see the Russian-made *Chapayev*, which the museum had been unable to obtain.

MOMA Series Expands Scope

In 1935, New York's Museum of Modern Art launched its Circulating Film Library, and the Art Cinema League quickly took advantage of this low-cost resource for important older titles. In the fall of 1936, the group presented MOMA's "Survey of the Film in America," whose selections ranged from an 1893 Edison short to the 1930 Oscar-winning feature *All Quiet on the Western Front*. The museum required that tickets to the five-evening series be sold in advance, and passes were available for a dollar at the Michigan League, Union, and local bookstores. The screening of

"WE HAVE BEEN ACCUSED OF HAVING THE MOST DIVERSE OF ULTERIOR MOTIVES."

An ACL Letter to the *Michigan Daily*

historic films was then quite unusual, and the series quickly sold out.

As the Depression dragged on and millions of Americans remained unemployed, political activism was on the rise. In the mid-1930s the University of Michigan's National Student League chapter brought speakers to campus, published a newspaper, and protested against militarism, tuition hikes, and racist acts like the football team's sidelining African American star player Willis Ward to appease opponent Georgia Tech. The university administration took a harsh position against participants, however, and in 1935 president Alexander Ruthven forced four members to withdraw from the university. Though the Art Cinema League generally sought to appear apolitical, in October 1936 it brought to campus Dutch documentary filmmaker Joris Ivens, who spent two nights presenting films like his acclaimed portrait of striking Belgian miners, *Borinage*. In November 1937 the group also screened Ivens's new Ernest Hemingway–narrated *Spanish Earth* in conjunction with a week of events focusing on Spain's civil war.

While Ann Arbor's commercial theaters had sometimes programmed

OPPOSITE TOP AND MIDDLE: Art Cinema League membership card. BHL

PIONEERING PRESENTERS

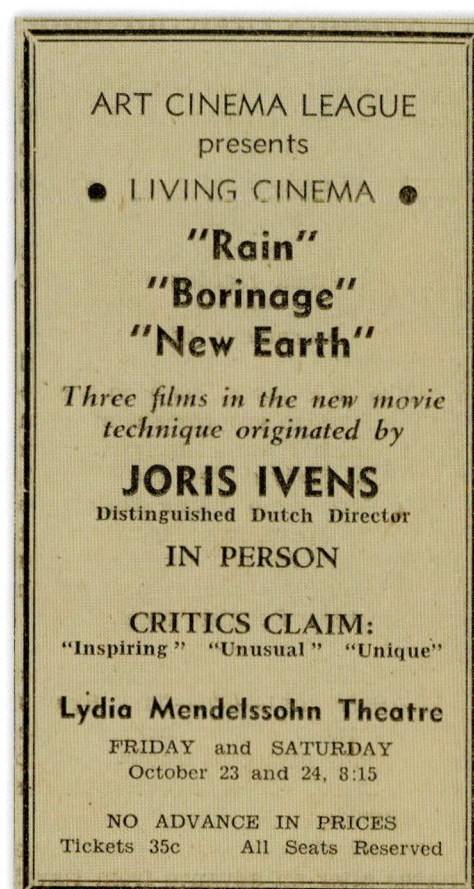

A 1938 Art Cinema League flyer. BHL

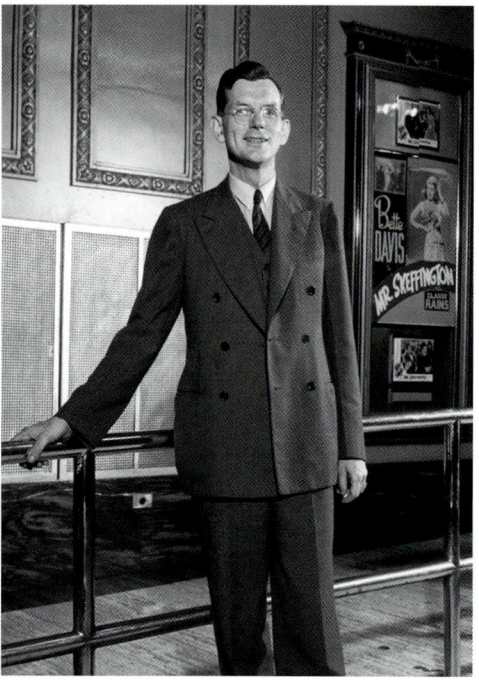

Gerald Hoag in the lobby of the Michigan Theatre. © 1944 MLive Media Group. All rights reserved. Used with permission

foreign films, including a 1932 series of German talkies that the Whitney pitched to the city's sizable immigrant population, the ACL was apparently not seen as a threat. In a 1938 letter to the *Daily*, Michigan Theatre manager Gerald Hoag noted that of such titles he had shown, only the 1931 Russian *Road to Life* had turned a profit. He credited the Art Cinema League with "completely fulfilling all requirements in this direction," while adding that an Ann Arbor filmgoer, "can, during the course of a year, get a pretty good bargain for his 35 cents spent in seeing films made in Hollywood." Hoag's employer was the Michigan-based W. S. Butterfield Theaters chain, which had entered the local market in 1908 by taking over the then-vaudeville-

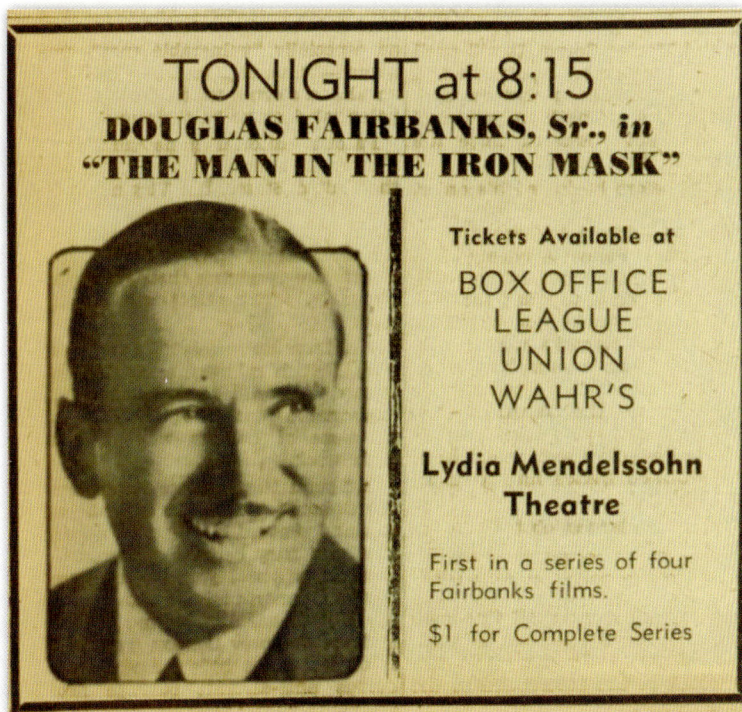
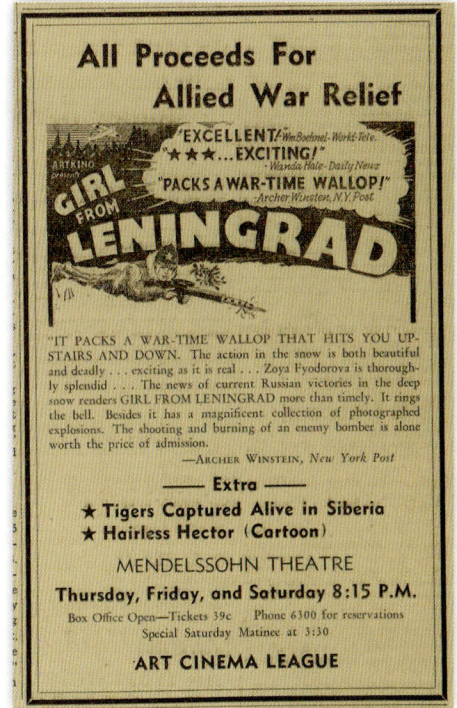

focused Majestic before gaining control of all of Ann Arbor's commercial cinema screens. Subsequently put in charge of Butterfield's local operations, Hoag would preside over his empire for nearly four decades from the lobby of the Michigan, winning a reputation for handing out passes to U-M athletes as well as for his conservative views.

By now a few colleges had tentatively begun offering classes that treated movies as an art form, but University of Michigan administrators judged film unworthy of academic study and the library rarely purchased books on the subject. The Art Cinema League's adventurous programming highlighted this deficit, and in 1938 the *Daily* published a series of op-eds by Edward C. Jurist on the topic. Noting the "packed houses" ACL screenings attracted, he observed that "the films brought to the Lydia Mendelssohn Theatre are the very films that would be necessary for a cinema course." He also presciently suggested that "regular and private showings of the league would eliminate an important expense item." But despite such encouragement, it would be three decades before the university took the art of film seriously enough to add to the curriculum, leaving the ACL and its successors to explore the topic on their own. In addition to providing screenings of art films, the organization also began giving money to the university library for the purchase of film books.

As the 1930s drew to a close, the Art Cinema League's schedule continued to feature weekend runs of new-to-Ann

ABOVE: 1941 handbill. BHL

PIONEERING PRESENTERS

Rackham Lecture Hall, 1938. BHL

Arbor foreign films like Jean Renoir's *Grand Illusion*, Eisenstein's *Alexander Nevsky*, Alfred Hitchcock's *The Lady Vanishes*, and Chano Urueta's *La Noche de los Mayas*, as well as MOMA-curated retrospective series and occasional special programs. Following the death of silent-screen icon Douglas Fairbanks Sr. in December 1939, the group organized a retrospective of four of his films with live accompaniment arranged by music student Caroline Rosenthal. By this time screenings were taking place in both the 700-seat Lydia Mendelssohn and the new, fan-shaped, 1,100-seat Rackham Lecture Hall, whose spacious projection booth featured state-of-the-art 35 mm equipment.

Following US entry into World War II, the ACL began booking more topical features, like the 1941 Russian war film *The Girl from Leningrad*, as well as adding newsreels of the latest developments abroad. But with the university increasingly focused on preparing students for military service, the film society's operations were suspended at the end of 1943.

Paul Robeson as EMPEROR JONES

THE
ART CINEMA LEAGUE
announces its

New Spring Series

Lydia Mendelssohn Theatre
Series Price $1.10 (including tax)
Single Admission 39c (including tax)
Series Tickets on Sale at Wahrs and League

February 22—Eugene O'Neill's
"**EMPEROR JONES.**"
with Paul Robeson

March 8—"**LA MATERNELLE.**"
(One of the Finest French Films Ever Produced, with English Titles.)

March 15—"**THE THIRTEEN.**"
"A Triumph! * * * ½." New York Daily News

April 5—"**THE LADY VANISHES.**"
Easily One of the Best Hitchcock Films Ever Made.

ALL SUNDAY NIGHT PERFORMANCES
Two Series Tickets Available
6:30 P. M. and 8:30 P. M.

☞ DON'T MISS John Steinbeck's "THE FORGOTTEN VILLAGE." Thursday, Friday, and Saturday nights, February 19-20-21, at 8:15 p.m. Lydia Mendelssohn Theatre. Box office opens Wednesday, February 18, at 10:00 a.m. Phone 6300 for reservations.

La Maternelle

1942 Art Cinema League flyer. BHL

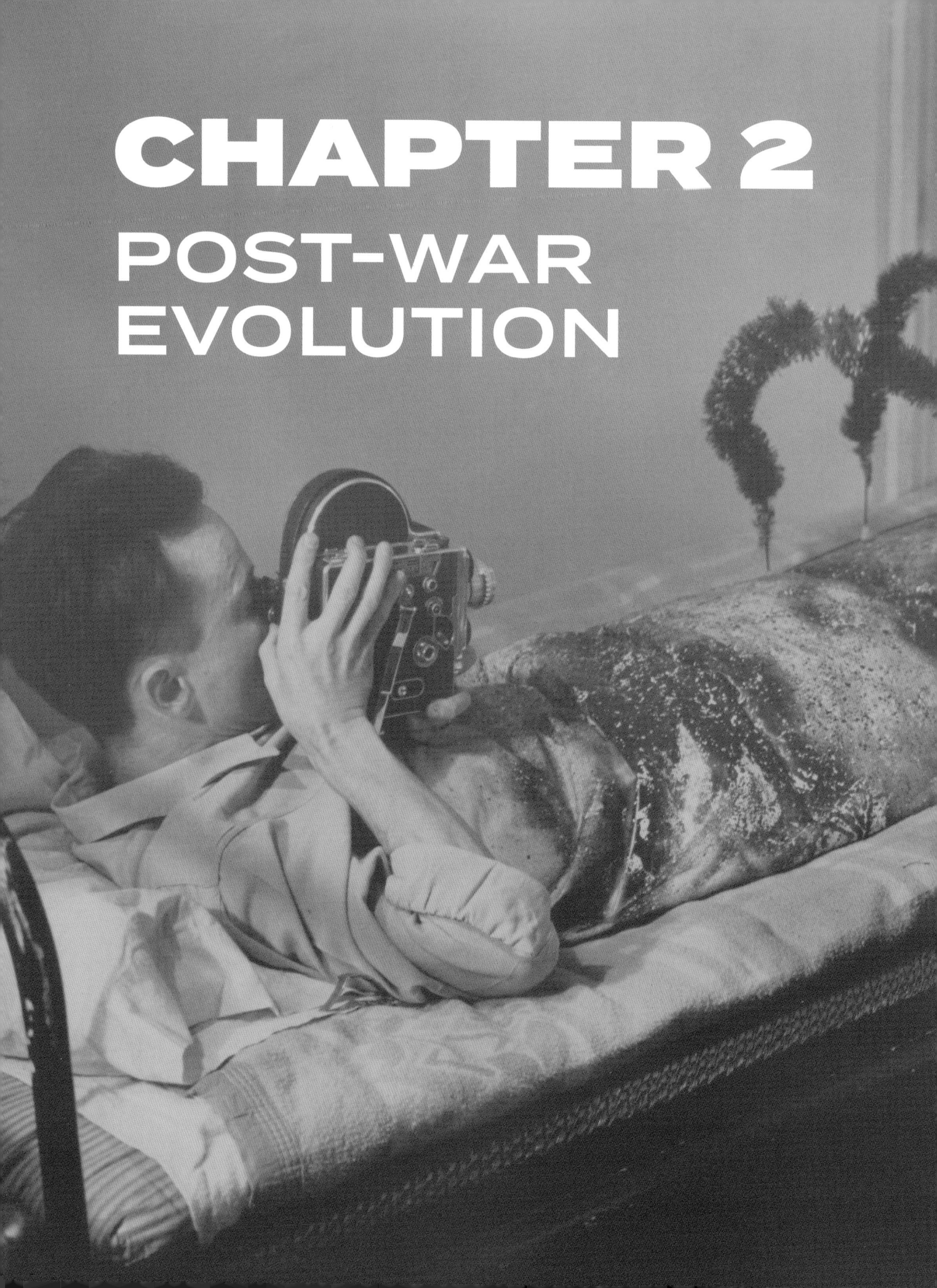

CHAPTER 2
POST-WAR EVOLUTION

THE WAR EFFORT HAD heightened the university's promotion of language instruction, and when the Art Cinema League was reconstituted in the conflict's waning months, its board was recast to largely consist of faculty drawn from the school's five language departments. Along with professors from the architecture and engineering schools, the ACL would now have just two student members, who were charged with handling day-to-day operations of coordinating advertising and booking films. The group's mission would initially remain unchanged: "When the war came, people wanted popular films, so the organization folded up," board member and English professor Hereward T. Price explained to the *Daily*. "It is now clear that the art of film is one of the great arts, and it is important that students become acquainted with the best that is being done." The revived ACL's first screening in March of 1945 was Marcel Carne's 1939 *Le Jour se Lève (Daybreak)*, which was followed by Renoir's anti-war *Grand Illusion* and Orson Welles's *Citizen Kane*.

With the end of hostilities, a new wave of socially conscious films like Vittorio De Sica's *The Bicycle Thief* and Roberto Rossellini's *Open City* began to emerge from Europe. Discovering this artistic, intellectually stimulating cinema that was so different from Hollywood became an important rite of passage for many college students. My father, Alvan Uhle, had never seen a foreign film while growing up in relatively cosmopolitan Columbus, Ohio, but after enrolling at the University of Michigan in 1945, began seeing films like the French period drama *Children of Paradise* at the Art Cinema League. "It made a tremendous impression," he recalled. "It opened a door." The

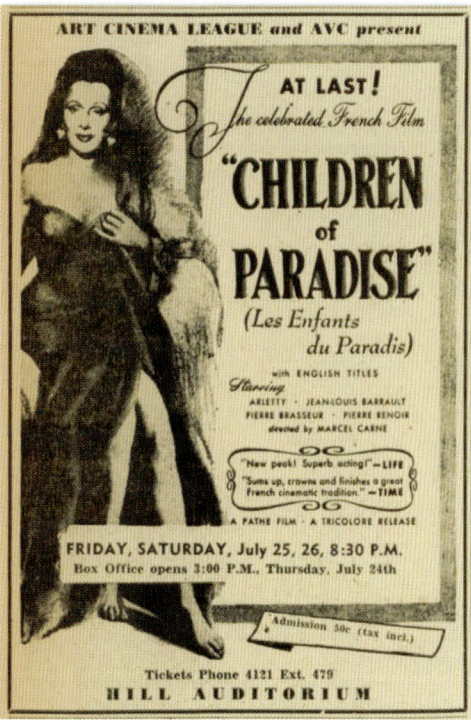

OPPOSITE: Shooting *Metamorphosis*. Courtesy William Hampton IV

LEFT: The Art Cinema League's Norman Rappaport

ACL's Norman Rappaport told the *Daily* that students found the imports appealing due to "an appreciation of the simple directness of the French and Italian films. People act like human beings in the foreign films, not like papier-mâché dolls."

In the late 1940s, the Art Cinema League expanded its programming to show films every weekend in either Lydia Mendelssohn, Hill, or the College of Architecture's 400-seat lecture hall. The latter's tiny projection booth was equipped with only 16 mm machines, whose images were not as bright or sharp as the 35 mm theatrical standard of the other venues. Though this technical limitation reduced the group's ability to show

POST-WAR EVOLUTION

1948 Art Cinema League flyer. BHL

the latest releases, as such films were generally distributed exclusively in 35 mm, 16 mm had been widely adopted for educational, news, and military purposes during the war, and the format was becoming the preferred medium for both the burgeoning film society market and a new generation of experimental filmmakers.

In 1947 a major change was also made to the Art Cinema League's mission. Having long generated surplus funds, in the fall the group adopted a new policy of recruiting other student groups as co-sponsors. Chosen from petitions submitted prior to the start of each semester, these partners would now receive the majority of profits in exchange for providing ushers and promoting a specific weekend's film. Co-sponsors included campus organizations like the Inter-Cooperative Council, social justice groups like the Committee to End Discrimination, and student clubs like the Hot Record Society.

To maximize revenues, the ACL began to poll audiences and ask language associations for suggestions. While the film society would continue showing artistically important movies and new foreign releases, the sponsorship policy shifted its focus toward titles with broader appeal. The ACL's secretary, professor Richard Boys, summarized this evolution in a report to dean of students Erich Walter. "At one time the league functioned independently of other organizations on the campus and put on a handful of movies a year. Now, however, we look on ourselves as being entirely a service organization assisting student groups (as co-sponsors) in putting on movies for the purpose of making money for those groups."

Though now receiving just 10 percent of net profits, the Art Cinema League was still able to donate $100 per year to the library for film books and fund upgrades like replacing the screens in both Mendelssohn and Hill. The latter had been the source of numerous complaints. "It was like a huge sheet; it was some improvised thing. It didn't look too professional," Alvan Uhle recalled.

Competition Grows

As 16 mm equipment and rental prints became more widely available, movies began to pop up at a variety of places around campus. Free screenings of

Michigan Union projectionist, 1943. *Ensian*

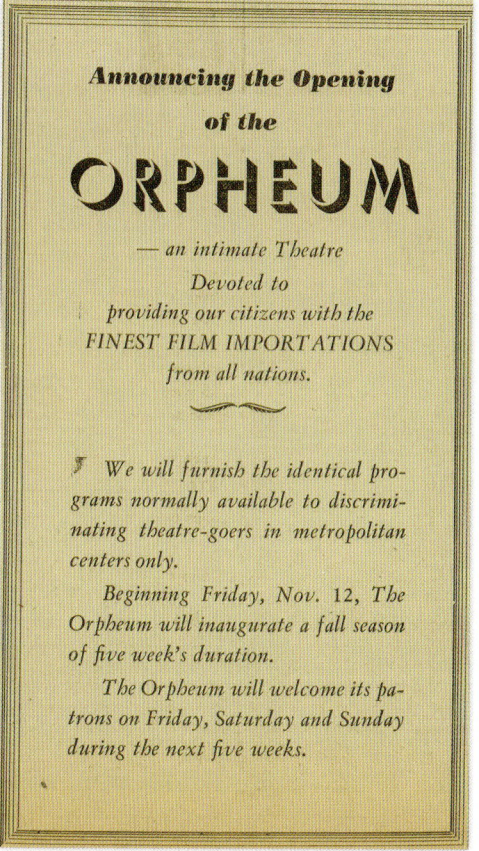

foreign features were sponsored by language departments or affiliated groups, such as the Russian Circle, La Sociedad Hispanica, and the Hindustan Association, and movies were also presented by social and religious organizations like the B'nai B'rith Hillel Foundation. At the Michigan Union, educational and sometimes Hollywood films were open to both men and women, and on Sunday nights during football season, silent 16 mm footage of the previous week's game was screened.

The Art Cinema League's competition increased dramatically in November 1948 when the W. S. Butterfield company reopened the 400-seat Orpheum Theatre on Main Street, which had been closed for several years. Now offering foreign films on weekends, this first local commercial "art house" began placing *Daily* ads for its new releases next to those of the ACL. Even financially strapped undergraduates like Alvan Uhle were willing to make the half-mile trek downtown: "They had these English films, the Alec Guinness films from Ealing Studios. We went to all of those. We loved those movies."

In the summer of 1949, the Art Cinema League also gained a new campus rival: the Gothic Film Society. Sparked by a well-received movie screening at a summer seminar on the Gothic tradition in American literature, its board was a mix of graduate students and English professors like Austin Warren and new hire Marvin Felheim. Primarily sourcing its programming from the Museum of Modern Art, Gothic would restore to campus the thematic historical offerings the ACL had dropped after the war, with program notes distributed at showings to provide contextual information. Subscribers paid $3.50 for nine Monday screenings spread over the school year, with shows in the plush 238-seat, fourth-floor Rackham Amphitheater open only to faculty, graduate students, and their spouses.

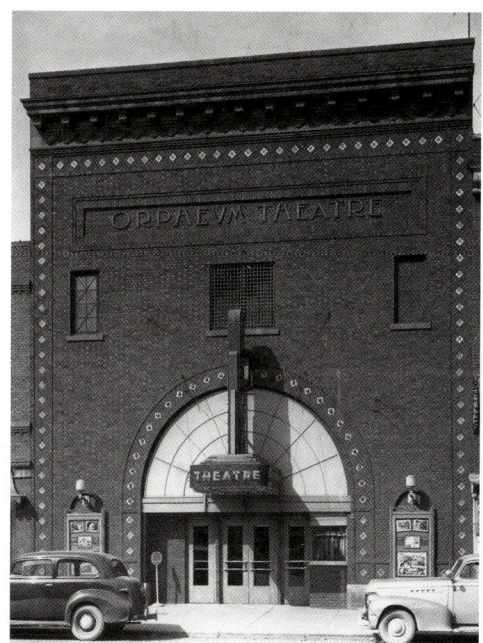

The Orpheum Theatre

POST-WAR EVOLUTION

Please publicize the following material to those who you believe might be interested. The short film subject will not have universal appeal, and therefore discrimination is suggested in disclosure of the following information. This motion picture program is undoubtedly the very best of the entire summer program.

Friday, Saturday, July 25, 26, 1947.
Hill Auditorium, 8:30 PM.

The Art Cinema League and Campus Chapter, American Veterans Committee will present a great first-run French film, CHILDREN OF PARADISE, which deals with Paris during the reign of Louis-Philippe, and the tumultous life of the people of that time. French dialogue; English titles.

Also— 20 min. short film, a documentary on Nazi death factories. For adult audiences. " This film is a photographic record of the German concentration camps. It is a factual eyewitness account of conditions when the Allies arrived and covers eight different camps at Dachau, Buchenwald, Belsen, Ohrdrus, Tehkla, and others.

"The film record gives evidence of the unbelievable death rate which existed in the camps. It shows the living and the dead- men, women and children. At Dachau, women were used for socalled 'scientific experiments'. The living are emaciated, walking corpses, many of whom Allied medicine could not help even after liberation. The sadism of the SS men who ran the camps is seen in the collection of human tattoos kept by the wife of the camp's head, the charred corpses of escaping prisoner's, burnt in the flamethrowers at Tehkla."

Harold Lester, Mgr.
ART CINEMA LEAGUE.

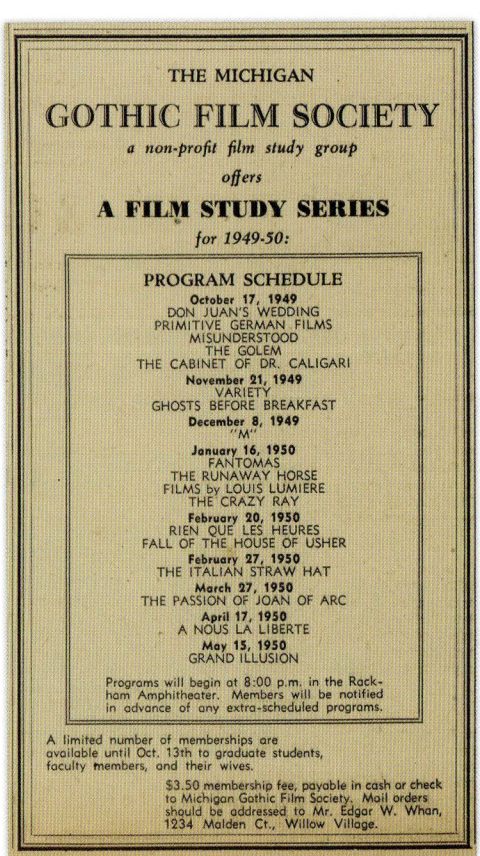

Though hamstrung by its pledge to make money for co-sponsors, the ACL continued to program interesting fare. In October 1948, it presented the first US screenings outside New York of Jean Delannoy's *Symphony Pastorale* as a benefit for the University Famine Drive, and the following March showed the Midwest premiere of Carl Theodor Dreyer's *Day of Wrath*. The ACL's 1949–50 schedule also included a W. C. Fields double feature, the Ingmar Bergman–scripted *Torment*, and *Marriage in the Shadows*, one of the first post-war German films to acknowledge the Holocaust. Visitors were invited to campus as well, including Oscar-winning producer-turned-academic Kenneth Macgowan and Screen Writers Guild president Valentine Davies. Davies, a U-M alumnus, had appeared in plays with pioneering campus-film programmer Amy Loomis and had also visited Ann Arbor for an author's premiere of *It Happens Every Spring* at the Michigan Theatre.

Birth of a Nation Brings Controversy

In the spring of 1950, the U-M speech department, which had just begun offering classes in television and radio production taught by former NBC director Garnet Garrison, announced that it was sponsoring a public screening of D. W. Griffith's

1915 *The Birth of a Nation*, ostensibly to demonstrate the many technical innovations it was credited with, including parallel editing, the use of flashbacks, and night photography. This first American blockbuster film, overtly racist and widely known as a Ku Klux Klan recruiting film, was already the fulcrum of a decades-long debate about censorship that pitted the American Civil Liberties Union (ACLU) against the National Association for the Advancement of Colored People (NAACP) and stoked fervent activism for both free speech and racial equity. The adaptation of Thomas Dixon's 1905 Reconstruction-era novel *The Clansman* presented demeaning caricatures of African Americans (many played by whites in blackface), while sentimentalizing white slave owners and social issues. From the time of its release the film had been objected to, picketed, and in some cases, banned. Griffith's presentation of the Klan as saviors of Southern society was also credited by many scholars as directly inspiring the hate group's resurgence, which saw upward of three million Americans join in the 1920s. *Birth* first played Ann Arbor at the Whitney Theatre in February 1916 with a 25-piece orchestra, but had apparently not been screened in town since the 1920s.

At this time the university was seeing a growing effort to combat racism, spearheaded by the Inter-Racial Association (IRA), a student group founded in 1942. A frequent sponsor of lectures and occasional film screenings, in 1947 the IRA had helped organize pickets of both Dascola Barbers, which refused to cut the hair of Black students, and the State Theatre, which had booked Disney's stereotype-filled *Song of the South*. But barber Dominic Dascola had been tried and acquitted of discrimination, while Butterfield's Gerald Hoag refused to pull *Song*, later telling the *Daily*: "We were picketed by a bunch of commies, because Uncle Remus was a Negro. Of course, we didn't submit to the pressure. The picture had a normal, healthy run." Then-undergraduate Alvan Uhle recalled: "There were enough liberal students on campus that cared about these things, but I don't think they, we, were the majority at all. It was more intellectual types. Most students were still pretty Republican and complacent, and racist, and you name it. Because there were very few African Americans on campus in those days, and not so many women either." There were occasional signs of progress, however, and in 1948 the senior class elected its first Black president, track star Val Johnson, who won decisively over football quarterback Pete Elliott.

Thus, soon after the May 1950 *Birth of a Nation* screening was announced, a group of two dozen students and faculty led by graduate student James Terrell demanded that it be either

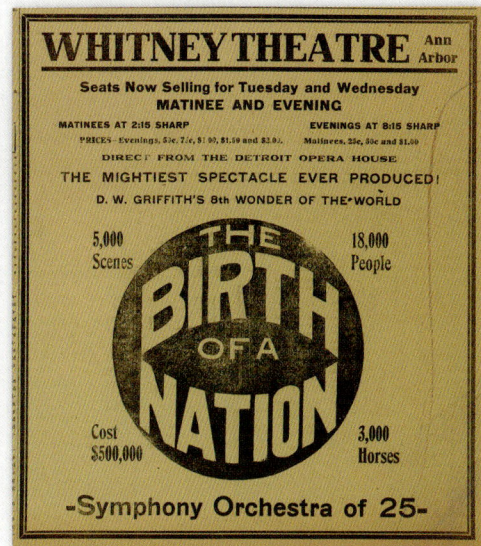

A *Daily* ad for the first Ann Arbor showing of *The Birth of a Nation* in 1916

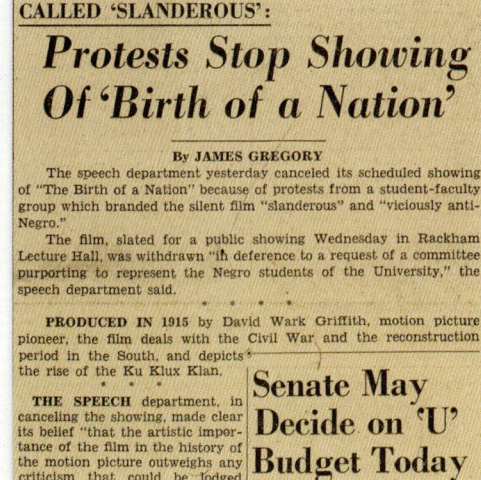

OPPOSITE TOP:
Art Cinema League
handbill, 1947. BHL

POST-WAR EVOLUTION 23

(PAID ADVERTISEMENT)

THE REAL STORY

Like all of our basic freedoms, freedom of expression is precious to us beyond calculations. A measure of the sincerity with which it is cherished is the care with which it is treated. That care must necessarily involve decency, dignity, good taste, high moral purpose and above all, responsibility. When that "freedom" is perverted by a failure to distinguish it from corruption, infamy, slander and lies, it becomes transformed into its very opposite: license.

A democratic society has its responsibilities as well as its freedoms. The Student Legislature assumed none of the democratic responsibility of exercising discretion, when, without any investigation at all on its part, it approved by a small majority the showing of the film *Birth of a Nation*.

HAD THEY INVESTIGATED THE BACKGROUND AND CONTENT OF THIS FILM, THEY WOULD HAVE FOUND THAT ACCORDING TO BOTH ITS WRITER (Rev. Thomas Dixon, author of "The Clansmen" from which the movie was taken) AND ITS PRODUCER (D. W. Griffith), THE SOLE PURPOSE OF THE FILM WAS TO "CREATE A FEELING OF ABHORRENCE IN WHITE PEOPLE TOWARD COLORED MEN."

Had they investigated, they would have found that the film "identified Negroes with cruelty, superstition, insolence, and lust. It judged the Negro unfit for freedom and civil rights and argued that his liberation was a grave error." At one point it bluntly editorialized that the South must be made "safe" for the whites.

Had they investigated, they would have found that the film thrillingly and gloriously justified the rise of the Ku Klux Klan, which was "deified as the savior of white womanhood."

Had the Student Legislature investigated before making a rash and unpardonable decision, they would have discovered that the producer-director, D. W. Griffith, "employed every resource of movie magic to stimulate his audiences to frenzied hatred of the Negro and admiration for his tormentors. It was often advertised as "calculated to whip audiences into a frenzy . . . it will make you hate . . ."

* * * *

Ever since the film's appearance in 1915, the National Association for the Advancement of Colored People, representing 15,000,000 and more Americans, has been waging a ceaseless struggle to have this vicious and insulting film withdrawn from circulation. At this very moment in New York City, the NAACP, the Urban League, The National Council of Arts, Sciences and Professions, Labor unions, Civic organizations, Church groups; all are staging a mass protest against the recent re-release of this picture.

Walter White, a recognized leader among the Negro people, has stated: "It is inexplicable why anyone should revive a film like "The Birth of a Nation" at this critical period of human history. During recent months in Asia, Africa, Latin America, and Europe, I have seen American prestige sinking lower and lower because of the foul propaganda of pictures like 'Birth of a Nation.' No decent theater owner who has any regard for the future of America would show such a film nor should any decent American pay money to see it."

We at the University of Michigan are at this moment in a position of immense moral responsibility. To withdraw the film now, once and for all, is to serve notice to the entire nation that we, student and faculty, Negro and white, Protestant, Catholic, and Jew stand immovable in our complete rejection and repudiation of all racist ideology in whatever form and under whatever pretension it masquerades. To withdraw this film is to prove that we are mature people, that we understand fully our responsibility to democracy; that we can intelligently distinguish between liberty and license.

This would not simply be an act of good faith, a hand of friendship extended to the Negro people; it is the profoundest service to the American People, to their democratic institutions, and to those freedoms, free from all taint of slander and insult, which we cherish in common.

Student-Faculty Committee to Protest the Showing of "Birth of a Nation."

(PAID ADVERTISEMENT)

Daily ad placed by *Birth of a Nation* protesters

cancelled or shown with an introduction explaining its "profoundly racist character" along with a film "treating the Negro in America on an intelligent level." But after conducting a search of his 5,000-title collection, University Audio-Visual Education Center director Ford Lemler reported that he did not own a single film that fit this criterion, and could only think of one example, which would have to be rented. Meanwhile, the Ann Arbor Police arrested two students passing out leaflets for the NAACP near campus, who claimed to have been held for over three hours "while police threatened them with jail and expulsion from the university if they ever distributed the handbills again." The *Ann Arbor News* reported that the police claimed to have taken the action because discarded leaflets that were found on the ground violated a littering ordinance.

While speech department chair G. E. Densmore told the *Daily* he "had no idea that the movie would offend anyone," as the screening date neared it was decided that *The Birth of a Nation* was "not sufficiently vital to the educational program of the department to warrant its presentation in face of the objections raised." The cancellation set off a second wave of protest from those decrying censorship, however, and the Gothic Film Society briefly made plans to show it until convinced to withdraw by the protest group. Then, the Student Legislature narrowly voted to present it, stating: "We believe that one of the best means of combating the discriminatory ideas presented in this film is to make it possible for students to see the film, sensitized to look for techniques by which such emotional and bigoted ideas are presented in popular communication media." But as the *Daily* published letters urging cancellation from the local branches of the NAACP and the United Auto Workers, the situation came to an abrupt conclusion when the Student Legislature's booking was turned down by the Museum of Modern Art on the grounds that it was not a film society.

The issue roared back to life a year later when the newly formed Triton Film Society declared that it was planning to show *The Birth of a Nation*, but the group soon fractured due to the controversy. In late May 1951, several Triton members formed an offshoot called Neptune expressly to play the film, but, unable to secure an auditorium, the first post-war Ann Arbor screening of D. W. Griffith's controversial film was held at a private home. The *Daily* reported that an audience of 25 watched. "Although all the doors of the house had been locked and a police car cruised around the house, the expected picketing did not occur." The local NAACP chapter had announced that, while strongly opposed to the film's revival, it would not publicly protest.

> "POLICE THREATENED THEM WITH JAIL AND EXPULSION FROM THE UNIVERSITY IF THEY EVER DISTRIBUTED THE HANDBILLS AGAIN."
>
> Arrested students distributing NAACP leaflets

Cinema Guild's Richard Kraus, right, at the *Michigan Daily* offices. *Ensian*

Though the Neptune group quickly vanished, its leader Alan Silver would subsequently become chairman of the Gothic Film Society, which in November 1952 presented the first campus screening of *The Birth of a Nation* as part of its sold-out subscription series. Because of the notorious feature's technical advancements, it came to be screened regularly over the years, while generating periodic protests.

Cinema Guild Founded in 1950

Nearing the end of its second decade, the Art Cinema League had begun to struggle. Having lost its lock on the art film market, it was no longer turning a consistent profit, and after dedicated manager Norman Rappaport graduated in 1949 the administrative demands of coordinating co-sponsors began to overwhelm the remaining members. They turned to the university for help, and in the fall of 1950 the Student Legislature took over the organization. Reconstituted as the Student Legislature Cinema Guild, the film society would be overseen by a four-person board while paid manager and English graduate student Richard Kraus chose the films and, with several assistants, staffed screenings.

Cinema Guild made its debut at Hill Auditorium on the weekend of October 13–14, 1950, with David Lean's 1946 *Great Expectations*, and carried on with weekly bookings of a single feature which played on Friday, Saturday, and occasionally Sunday. Along with imports like *The Bicycle Thief* and Eisenstein's *Alexander Nevsky*, Kraus also showed recent American hits, including John Ford's *My Darling Clementine*. There were special events as well, like the campy "A Night at the Flickers" silent double feature of *Tillie's Punctured Romance* and *The Eagle*, with one "Professor G"

FIRST PRESENTATION BY THE NEW

Cinema Guild

OF
STUDENT LEGISLATURE

CHARLES DICKENS'

"GREAT EXPECTATIONS"

with

JOHN MILLS, JEAN SIMMONS
MARTITA HUNT

Friday, Saturday at Hill
(this week-end)
Both Nights

ADVANCE SALE
2–4 P.M.

Cinema Guild

CINEMA ANN ARBOR

"I REALLY HAD TO MORTGAGE MY SOUL TO GET IT."

Richard Kraus, Cinema Guild manager on screening *Orpheus*

providing live piano accompaniment.

Though Richard Kraus had been largely forced to reinvent the organization from scratch, the Art Cinema League's co-sponsorship program remained in effect, and groups ranging from the Displaced Persons Committee to the Chess Club petitioned to take 80 percent of a weekend's profits. But Kraus also wanted to get closer to the group's original mission. In February 1951 he wrote the *Daily*: "The university is a cultural center, hence the few movies that are worthy of attention in any given year should be shown here as soon as possible. If we can show them without putting ourselves in financial jeopardy we feel it our responsibility to do so." His efforts paid off a few weeks later when Cinema Guild presented what it proclaimed to be the first US screening of Jean Cocteau's surrealistic *Orpheus* outside New York. Kraus told the *Daily*: "I really had to mortgage my soul to get it."

Despite occasional problems like the print of Robert Siodmak's film noir *The Killers* arriving with a reel missing, Cinema Guild's first year was a success. Ticket sales of $4,780 yielded a net profit for the Student Legislature of $650, almost one-fifth of its annual budget. Because 4 of the 14 films presented had lost money, profits were subsequently averaged to make each co-sponsor's share the same. To further improve the odds for success, the U-M Committee on Student Affairs also granted Cinema Guild a monopoly on weekend campus film screenings.

As the ACL had done, the new group sometimes added short subjects before features. One, *We'll Remember Michigan*, was a 33-minute color film that had

Photo by Alan Reid, *Michigan Daily*

FIRST TICKET—Walter Oberreit, '51, member of the Student Legislature's board governing the Art Cinema Guild buys the first ticket to the Guild's first production, "Great Expectations."

POST-WAR EVOLUTION

27

-2-

[handwritten left margin: PRELUDE?]

SEQUENCE 1: *(This can be reduced considerably. Eliminate clock sound. Carry Narrator's voice over, introducing family.)*

FADE-IN:

camera: Dinner table; family getting ready for breakfast. Mother brings in food; business of getting ready. No talk. Table set with bread, etc. Mother sets bowl of steaming potatoes on table. Sister pours coffee, sits down. Family looks at each other: impatience. They look at empty chair. Father shrugs quickly, annoyedly, begins breaking bread into his coffee. Camera to mother, who looks past camera toward Gregor's door.

MOTHER: (calls) "Gregor...Gregor..."

camera: behind Mother at second call, toward Gregor's bedroom door. Begins to move toward Gregor's door on third call. As it approaches, fade slowly. Cut.

SEQUENCE 2: *1 min. This is effective.*

camera: Screen black. Music. Title METAMORPHOSIS, from the short story by Franz Kafka. End Music. Silence; screen dark.

SEQUENCE 3: *TYMPANY —?*

camera: Slow fade in; camera focuses on ceiling. Establish shot; then narrator begins:

NARRATOR: "As Gregor Samsa awoke one morning from troubled dreams he found himself changed in his bed to some monstrous kind of insect."

camera: moves over ceiling. Flicker of eyelids. Return to overhead.

NARRATOR: "What has happened to me? he thought."

camera: remains overhead.

NARRATOR: "He lay on his back, which seemed hard as armor plate. It was only with the greatest difficulty that he could raise his head from his pillow."

[handwritten left margin: MUSIC HERE?]

The first page of *Metamorphosis* script. Courtesy William Hampton IV

"Preparing the Reeves synchronized tape recorder for a sound take in 'Metamorphosis.' Charles Broadhead, sound engineer, with headphones; Paul Lohmann, sound technician, seated." Courtesy William Hampton IV

METAMORPHOSIS
. . . a tale of violence and terror

WORLD PREMIERE

How would you feel if you woke up one morning transformed into a five-foot cockroach?

•

TONIGHT, MONDAY DECEMBER 10
& TUESDAY DECEMBER 11

8:30 P.M. HILL AUDITORIUM

A Gothic Film Produced in Ann Arbor

been shot on campus by the Audio-Visual Education Center's new filmmaking unit. Completed in the fall of 1951, it was directed by production supervisor Aubert Lavastida, with the narration and sound recording done by students.

Metamorphosis

Other U-M students were also working on films at this time. In 1951, the Gothic Film Society announced it would sponsor a feature-length adaptation of Franz Kafka's 1915 novella *Metamorphosis* to be produced and directed by group president William Hampton III. The graduate teaching fellow and twice-wounded World War II veteran had earlier made a humorous short called *The Well-Wrought Ern*. If not the first feature film made by college students, as claimed in the *Daily*, it was nevertheless an extremely ambitious effort for the time and appears to have been the first feature-length adaptation of Kafka anywhere in the world.

Shot in black-and-white 16 mm on a budget of $5,000, *Metamorphosis*'s cast and crew of three dozen included both students and members of area theater troupes. The film's script was written by five-time Hopwood Award–winner Bill Wiegand from an adaptation with Cinema Guild's Richard Kraus, while the cast was headed by recent U-M graduate Dana Elcar, who would later have a successful career in

"The family gets its first glimpse of the transformed son. Framed in doorway are the Chief Clerk (Ted Heusel), the father (Dana Elcar), and the mother (Bette Ellis). Guiding the camera is Chuck Elliott, left, and behind camera is director William Hampton." Courtesy William Hampton IV

POST-WAR EVOLUTION

> **gothic film society presents...**
> **MISS MAYA DEREN**
> **with her films**
>
> Wed., May 25 8 P.M. Rackham Amphitheater
>
> *"... Unquestionably the real spark of the American avant-garde movement has been the tireless Maya Deren ... no one has seen one of her films without being stimulated by the freshness of its imagery and its sheer technical virtuosity. No one has left a performance without sensing the fact that she had opened new fields for cinema—or more correctly had reopened a field that had lain fallow for almost twenty years..."*
>
> —Arthur Knight, *Saturday Review*
>
> OPEN TO THE PUBLIC 50¢

OPPOSITE: Courtesy William Hampton IV

films like *The Sting* and on television's *MacGyver*. After a six-week shoot in a house near campus, largely held at night to reduce extraneous sound pickup, *Metamorphosis* premiered at Hill Auditorium on Monday, December 10, 1951, under the sponsorship of Cinema Guild. The subject of much local press coverage throughout production, it received an encouraging review in the *Detroit Free Press* and was mentioned in publications like *Films in Review* and the *New York Times*.

William Hampton IV was just a small child during the shoot, but saw his father's film a number of times while growing up: "It's got a very quirky quality to it, in part because of the soundtrack. The original violin music is very insect-like in the way it sounds—it's not flowing strings." The score was written by future U-M music professor Edward Chudacoff, while Gothic treasurer and local dentist Dr. Paul Meagher created special camera effects. His jerky walking movement captured the action through the eyes of Kafka's man-turned-cockroach, whose full depiction onscreen was precluded by the tight budget. "There's a lot of camera angles from the ground, looking up at people who are kind of horrified and disgusted by what they're seeing. So there's a lot left to the imagination of whoever's viewing it," Hampton recalled. The film's naturalistic sets and lighting contrasted with the odd camera angles and atonal music to create a stark, claustrophobic effect.

Director Hampton assembled a preview trailer, poster, and still photos for promotion, and secured bookings for *Metamorphosis* at specialty theaters and campus film societies around the US and even abroad. "I recall my dad shipping out copies of the film all over the world," his son remembered. "It was being shown at film festivals, and that sort of thing, for quite a long period of time." The 70-minute original negative was later cut down to a half-hour in hopes of getting it broadcast on CBS television, but it is unclear whether it actually aired.

While *Metamorphosis* was the Gothic Film Society's only foray into moviemaking, the group continued to sponsor film screenings for more than a decade. Along with monthly MOMA-curated subscription programs and regular summer series at Rackham Amphitheater ("the only local movie theater where smoking is permitted," according to the *Daily*), Gothic sometimes organized special events. These included co-sponsoring a 1953 festival of work by documentarian Robert Flaherty, which included a visit by his widow, Frances, and a May 1955 personal appearance by experimental filmmaker Maya Deren, known for her *Meshes of the Afternoon*.

Made by an unsponsored group on the University of Michigan campus, this film has been hailed across the country as a significant pioneering effort in the field of 16 mm. film production. A full length feature adaptation of Franz Kafka's symbolic tale of a man who turns into a five-foot long cockroach, it has every one of the features of 35 mm. films, and represents the initial attempt to adapt Kafka to a feature production in this country on either the professional or amateur level.

The story is the tense, bitter, but broadly ironic classic about the young clerk who wakes up one morning to find himself changed in his bed into a monstrous insect. His efforts to adapt himself to his new form, to understand the reactions of his family, to hold on to existence itself are part of the symbolic tale of man seeking understanding in a hostile world. The growing tension, the almost unbelievable violence come to focus at last on the man who has lost his personality, who becomes an outcast in his own home.

The film is photographed entirely from the viewpoint of the protagonist, making the camera the insect eye surveying the strangely terrible world which is his own home. The strange kaleidoscopic atmosphere is something new in film-making. It captures what Edmund Wilson has called "the realistic nightmare of Kafka." It is original motion picture art in its newest and most searching form.

Gothic Film PRODUCTIONS
1102 BALDWIN · ANN ARBOR, MICHIGAN

ANNOUNCING THE RELEASE

OF

THE FILM YOU'VE BEEN READING ABOUT

METAMORPHOSIS

The New York Times.
The Saturday Review
Detroit News
modern PHOTOGRAPHY
Films in Review
Cinematographer

The Cast

The Father	Dana Elcar	The Maid	Nancy McGee
The Mother	... Ellis	The Chief Clerk	Ted Heusel
The Sister	Pat Newhall	The First Lodger	Jeremy Lepard
The Charwoman	Joyce Edgar	The Second Lodger	Gilbert Sloan

Produced and directed by William J. Hampton. Written for the screen by William Wiegand from an adaptation by William Wiegand and Richard Kraus.

Photographed by Paul W. Meagher. Score composed by Edward Chudacoff. Narrated by Jeremy Lepard.

CHAPTER 3
CINEMA GUILD BREAKS OUT

WITH GOTHIC dedicated to serving the more serious filmgoers on campus, Cinema Guild initially hewed to its dual mission of making money for co-sponsors while providing students with reasonably priced entertainment and cultural stimulation. As use of the larger, more expensive Hill Auditorium declined, the group adopted the 400-seat Architecture Auditorium as its permanent home, even as some complained about the hard seats and mediocre image quality. In early 1953, the film society installed a larger screen and new Bell and Howell 16 mm projectors, and public relations chair Ruth Rossner enthused to the *Daily*, "The improvement in the light and sound is amazing." At the same time the group also expanded its schedule to two features per week, each for two nights, to double its offerings to 28 titles per semester.

Sue Kaul joined Cinema Guild's now eight-member student board in 1953, and soon began selling 50-cent tickets to audiences from both on and off campus. Of the group's mission, she recalled: "We ran foreign films, we ran classics, and we ran anything that we could get our hands on that had been through the theaters. We were all discovering European filmmakers. This is after the war, and filmmaking was starting again in Europe. And that was a new thing, particularly for a lot of the students who came in from towns where they just hadn't been exposed to this."

In 1955 the U-M Student Legislature was superseded by the newly created Student Government Council. Though still subject to oversight, Cinema Guild would no longer contribute to its funding, which was instead drawn from a 25-cent-per-semester contribution from tuition. The group continued to give co-sponsors 80 percent of net profits, however, while retaining its status as the only campus organization allowed to regularly program movies for an admission fee. That February the film society celebrated the sale of its 200,000th ticket, and over the next several years again upgraded projection equipment while spending $4,400 on padded seats, "in answer to the many complaints and requests of the university students," chair Donna Wickham told the *Daily*.

Even as things seemed to be looking up, a new commercial competitor was about to open just a few blocks away. In March 1957 the Butterfield chain closed its tattered downtown art theater, the Orpheum, and aging sister, the Wuerth, and unveiled the new 1,054-seat Campus Theatre on South University Street. Touted as having "the latest in sound projecting equipment and refrigerated air conditioning," the stylish venue began programming a mix of imported comedies, occasional Hollywood blockbusters, and current art releases,

CINEMA GUILD BREAKS OUT

Patrons lined up to see a British comedy at the Campus Theatre, November, 1960.
Ensian

like Federico Fellini's *La Strada*. With European films in particular beginning to show a new openness about sex, for some titles the Campus inaugurated an "adults-only" admissions policy. But Butterfield remained sensitive to public pressure, and in early 1958 Gerald Hoag ended a run of the Swedish film *Time of Desire* after one night due to complaints about an implied sexual relationship between two sisters.

At the same time, Cinema Guild's board was beginning to chafe at the chains of the co-sponsor straitjacket. Occasionally now inserting experimental shorts by the likes of Stan Brakhage before features, when *Time of Desire* became available in 16 mm the film society jumped on it. Though the May 1959 screening attracted "crowds of stag males," *Daily* reporter Faith Weinstein noted that "the film was delicate and

> **Cinema Guild**
>
> ☆
>
> Saturday 7:00 and 9:00
> Sunday at 8:00
>
> ARTHUR LUNDQUIST'S
>
> **"THE TIME OF DESIRE"**
>
> SHORT:
> THE LONDON OF WILLIAM HOGARTH
>
> ☆
>
> ARCHITECTURE AUDITORIUM
> 50 cents

Michigan Daily advertisement

well-handled. It sold because it had been banned, as art has always been easily sold when banned by the local authorities." As the 1960s dawned, Cinema Guild increasingly began to make bolder programming choices that both attracted audiences and drew the scrutiny of university administrators.

The group had come to serve the university community in a variety of ways that ranged from providing cheap, date-night entertainment to improving language skills to provoking emotional catharsis. Hubert "Hugh" Cohen, who joined Cinema Guild in 1960, recalled a screening of *Children of Paradise* where stage and screen actress Rosemary Harris, on a night off from performing in Ann Arbor, exited the film "sobbing." At other times, patrons needed help to get in the mood: "Now and then during a Chaplin film, there would be no sound coming out of the auditorium and I'd go in, just puzzled. 'How could

CINEMA GUILD BREAKS OUT

Many old favorites are brought to campus by the Cinema Guild providing an outstanding program of "movie greats".

ABOVE: *Ensian*.

Student Organizations:

NEED CASH?

The CINEMA GUILD Announces

A *Limited* Number of

SPONSORSHIPS

For Fall, 1964

Pick up petitions starting today from the SGC secretary in the **S.A.B.**

Petitions must be back in the **CINEMA GUILD** mail box by October 10th. No petitions will be accepted after that date.

The SGC secretary and the **CINEMA GUILD** mail box are located on the first floor, west wing, of the Student Activities Building.

it be, with these hilarious films?'" he recalled. Down the hall was a sculpture studio. "There was this sculptor with this deep voice, and I used to go and get him and plant him in the middle of the theater. Get him laughing, to warm up the audience." Bonnie Dede attended often in the early 1960s. "I was a language student, so therefore all of the films that were shown at the Cinema Guild were of great interest, whether they were in Russian, or French, or German, or whatever," she recalled. "I even slept through one film because I was exhausted. So I have to say I had the full Cinema Guild experience!"

On its printed schedules the film society sometimes noted that certain titles were appropriate for children, and many Ann Arbor families became regular patrons. If kids showed up when something more adult-themed was scheduled, the group could handle it, as Thomas O'Brien recalled: "One time we went just to see a regular Academy

Award movie, and someone stepped up to the front of the room and announced that if anybody had kids there of a young age, it'd be a good idea to take them out into the lobby before the movie started. Everybody was wondering what's going on, and all of a sudden they start, and there's a cartoon on, and it's a nudist cartoon. They just wanted to show it the way it came; it was only a couple minutes long. And then everybody came back in, and the movie started."

Operation Abolition

Even as the city of Ann Arbor remained largely conservative, the University of Michigan was becoming a national center of political activism. Students for a Democratic Society was founded there in 1960, and as the civil rights movement grew and the Vietnam War escalated, campus unrest increased dramatically. In early 1961, Cinema Guild announced plans to show a film produced by the House Un-American Activities Committee called *Operation Abolition*, which purported to document how HUAC hearings in San Francisco had been protested by Communist-led dupes. The Student Government Council forbade the organization from running the film, which had been widely denounced as right-wing propaganda, but after it was screened by a campus political group and the SGC itself, Cinema Guild finally presented it. SDS leader and *Daily* editor Tom Hayden was invited to appear afterward, but when no pro-HUAC speaker could be found to offer counterpoint, a record album presenting the protesters' views was played instead.

Cinema Guild's expanded programming was now making the Gothic Film Society increasingly irrelevant, and with its subscribers dwindling, the rival organization was quietly shut

Cinema Guild's 1960–61 board of directors. *Ensian*

Front Row: Sandra Gentry, Fred Neff, Bonnie Cross; **Back Row:** Joel Jacobson, Henry Shevitz, Mike Lewis, Norris Weil, Doug Kirby, Harold Zanoff.

CINEMA GUILD SCHEDULE

FALL, 1962

ARCHITECTURE AUDITORIUM

(Thursday and Friday, Saturday and Sunday nights, at 7 & 9, unless otherwise noted)

Sept. 13, 14 Emlyn Williams' Night Must Fall. Rosalind Russell, Robert Montgomery, Dame May Whitty. A horror classic.

Sept. 15, 16 Blackboard Jungle. Glenn Ford, Sidney Poitier, Louis Calhern. SHORT: 1:00 A.M. (Chaplin)

✓ Sept. 20, 21 Zola's Gervaise. Maria Schell, Francois Périer, Armand Mestral. Magoo Cartoon.

Sept. 22, 23 Hitchcock's North By Northwest. COLOR. Cary Grant, Eve Marie Saint, James Mason. At 7 & 9:15.

Sept. 27, 28 The Lady Killers. Alec Guinness, Cecil Parker, Katie Johnson, Peter Sellers. SHORT: Golf (Larry Semon farce)

✓ Sept. 29, 30 A Place in the Sun. Montgomery Clift, Elizabeth Taylor, Shelley Winters. (Dreiser's American Tragedy). ACADEMY AWARD

Oct. 4, 5 All the King's Men. Broderick Crawford, Mercedes McCambridge, John Ireland. (Rbt. Penn Warren's novel about Huey Long). 3 ACADEMY AWARDS. Cartoon.

✓ Oct. 6, 7 Resnais's Hiroshima, Mon Amour. Emmanuelle Riva, Eyi Okada. SHORT: D W. Griffith's Broken Ways, with Blanche Sweet, Henry B. Walthall, Harry Carey.

Oct. 11, 12 William Wyler's Roman Holiday. Audrey Hepburn, Gregory Peck, Eddie Albert. ACADEMY AWARD. Cartoon.

Oct. 13, 14 Reluctant Debutante. COLOR. Rex Harrison, Kay Kendall, John Saxon, Sandra Dee, Angela Lansbury. SHORT: Sidney Peterson's The Cage.

Oct. 18, 19 Bombshell. Jean Harlow, Lee Tracy, Frank Morgan, Franchot Tone, Pat O'Brien, Una Merkel. (Comedy of Hollywood star not at all like The Goddess) SHORT: Songs of the Auvergne.

✓ Oct. 20, 21 Truffaut's The 400 Blows. Jean-Pierre Léaud, Patrick Auffay. Awards from Cannes, New York, Brussels. SHORT: Hans Memling (COLOR)

? Oct. 25, 26 Ugetsu. Michiko Kyo, Masayuki Mori, Kinijo Tanaka. Grand Prize, Venice Film Festival. . SHORT: Martha Graham's Night Journey (Oedipus and Jocasta)

Oct. 27, 28 The Court Jester. COLOR. Danny Kaye, Glynnis Johns, Basil Rathbone. SHORT: Cavalcade of American Serials (Pearl White and other Cliff-hangers)

✓ Nov. 1, 2 SPECIAL POST HALLOWEEN PROGRAM. Jean Vigo's Zero for Conduct. Masterpiece of a rebellion in a French boys' school. An uncensored version, with guaranteed clear new prints. PLUS: The Lost World, the first long successful science fiction film (1925), based on the Conan Doyle novel, with Wallace Beery, Lewis Stone, Bessie Love, and a starring dinosaur. This film will be shown first, for parents with children.

✓ Nov. 3, 4 George Orwell's 1984. Edmond O'Brien, Michael Redgrave. SHORT: Mack Sennett's Half Back of Notre Dame.

The Cinema Guild schedule for fall 1962 noted that its November 1–2 shows were appropriate for children

down in early 1963. Though Cinema Guild continued to share 50 percent or more of proceeds with petitioning student groups, this policy was fading as well. "It fell off pretty quickly," Hugh Cohen recalled. "Because film was becoming so important, we didn't have time to cater to anybody else's tastes. And we were making it on our own."

Film society rental contracts typically required that publicity be limited to campus to protect the interests of commercial exhibitors, but Cinema Guild had been running ads in the *Ann Arbor News* for the previous five years, while the *Daily* was readily available off-campus. In October 1963, a complaint about this practice reached a distributor, which canceled bookings of several titles, including *An American in Paris*. Cinema Guild initially quit the *News* and began to place only *Daily* teasers listing its office phone number, but the much-reduced publicity led to losses that wiped out its $5,000 savings account, and after a year the group resumed listing titles in the *Daily*. Butterfield's Gerald Hoag denied being the source of the complaint, but his firm's monopoly on local screens made such a claim appear suspect, and Hugh Cohen felt he acted as "a kind of villain" toward the group. At this time Cinema Guild was also ruffling feathers at the College of Architecture and Design, which expressed displeasure with its controlling the auditorium up to five nights per week and raised the weekly rental fee to $162.50. Though the group briefly considered moving or even constructing new quarters, it ultimately stayed in the space.

In the early 1960s, Cinema Guild also began to collect 16 mm film prints to save money on repeatedly screened classics, for use if a scheduled title failed to arrive, or to show something that was not available to rent. While it was easy to buy out-of-copyright silent films, more recent titles of dubious provenance could be obtained as well, either in the form of gray-market dupes or lost or stolen originals. Despite the fact that movie studios were zealous about pressuring law enforcement to go after those who showed their copyright-protected material, the film society began to assemble a sizable collection of features and shorts by Charlie Chaplin, Harold Lloyd, and many others, not all of which were in the public

"*Tonight the Cinema Guild Presents...*"

Our program information secretary is a Perfect 66-288-71... and is always available, night or day

WHY NOT CALL HER NOW?

What's playing at the CINEMA GUILD this week? Simply call 662-8871 and the CINEMA GUILD'S friendly and informative Program Secretary will help you find the best in motion picture entertainment.

The finest in film programs is always just a dial away.
Call the CINEMA GUILD soon

THE CINEMA GUILD

IN THE ARCHITECTURE AUDITORIUM
ADMISSION: FIFTY CENTS

CINEMA GUILD BREAKS OUT

> # Cinema Guild
>
> *Proudly Presents Tonight*
>
> ## MODERN TIMES
> *with Charlie Chaplin, Paulette Goddard*
>
> ———Plus Two Shorts———
>
> ### JOIN THE CIRCUS
> with SNUB POLLARD
>
> ### A STRANGER RETURNS
> with MARY PICKFORD
>
> Admisson 50c Architecture Auditorium
> Shows at 7 and 9

1964 Daily ad

domain. Hugh Cohen was in charge of purchasing, and stored the prints at his home: "I was quite unprincipled," he recalled with a smile. "There was so much film. I knew some was illegal, but I wasn't terribly concerned about it."

Though the group managed to avoid prosecution, at least one distributor took note of Cohen's fondness for Chaplin, who was then living in exile abroad but still controlled many of his copyrights. In 1967, Murray Glass, owner of the Em-Gee Film Library, wrote a chatty letter to the group praising Cinema Guild's programming, then added: "Even more astonishing, however, is that you have not run into trouble with *Modern Times* and *Monsieur Verdoux*. These two items are about as 'hot' as you can get, and whoever it was that booked these films has looked for an intimate conversation with the FBI. Would you listen to a well-meant, if perhaps impertinent suggestion? That is to cancel *Modern Times* while you still have the opportunity to do so. Violation of copyright is a federal criminal (not civil) offense."

Hitting Its Stride

Through the early 1960s, Cinema Guild continued to adhere to the format of showing two movies per week, each for two nights, but its programming was becoming increasingly adventurous. Expanding from their occasional appearance with features, full evenings were now devoted to programs of experimental films, while the group also began to curate special series highlighting individual directors, actors, and countries. Reflecting this growing seriousness of purpose, in 1965 board chairman Hugh Holland told the *Daily*, "The Cinema Guild attempts to reach a medium between entertainment and art. It provides an opportunity for students to view cinema as an art form, and a showplace for more significant motion picture achievements." Two years later, house manager Ed Weber told the paper that films constituted "the fundamental fact of the popular culture of young Americans. Unlike television, they present a common cultural heritage which needs to be preserved." Hugh Cohen also noted that film was "the most pertinent art form of our times. Many of us do not realize that it has become the dominant medium for the young; it expresses the world they know. Many of the best young talents are no longer writing novels or plays but are going into the films. Movies to a great extent have become their form of art."

Cinema Guild member Rick Ayers

had grown up in a family with strong cultural and political interests, as well as loyalty to the University of Michigan. Attending high school in the Chicago suburbs, he fell in love with French New Wave films like François Truffaut's *Shoot the Piano Player* at the Clark Theater, a ramshackle downtown revival house that changed its titles every day. After starting at the university in the fall of 1965, he joined both Students for a Democratic Society and Cinema Guild, of which he recalled: "It was all kind of artsy, outsider people. Critical people. And there was a certain amount of gay students in there who I didn't even understand that that's what the deal was. We didn't have language for that."

While his fellow members ranged from young "pop culture types" like Elliot Barden to British graduate student Andrew Lugg, who Ayers characterized as "more of a deep European intellectual," they all took the job of programming seriously: "We would read this French journal, *Cahiers du Cinema*. They were obsessed with John Ford, so we would show John Ford or Howard Hawks, and stuff like that." The group also presented the latest work of foreign directors like Ingmar Bergman, Michelangelo Antonioni, François Truffaut, and Jean-Luc Godard, then at their creative peaks, and whose films the Campus Theatre didn't always book. Ayers recalled: "It was a radical idea to consider that someone's serious aesthetic interest should be movies, and should be movies that weren't American. I think the way we saw ourselves was completely critical of the canon, such as it was."

Anti-war and other protest activity at the University of Michigan was continuing to intensify, and in the latter half of the 1960s Ann Arbor was the site of the first US teach-in on the Vietnam

"THE WAY WE SAW OURSELVES WAS COMPLETELY CRITICAL OF THE CANON, SUCH AS IT WAS."

Rick Ayers, Cinema Guild chairman

Rick Ayers, 1967. *Ensian*

CINEMA GUILD BREAKS OUT 43

War and the country's first draft board sit-in; a series of bombings that targeted military-affiliated buildings; and a three-night street riot that required 200 baton- and rifle-wielding police to quell. "They used to call it the Berkeley of the Midwest, but I actually think it was more radical than Berkeley," Rick Ayers remarked. While Cinema Guild remained focused on film as art, its members' political views couldn't help getting into the mix. "We showed *Hiroshima Mon Amour*, we showed *La Jetée*," he remembered. "Both of those are very powerful anti-war pieces. And I think even just by showing Kurosawa, that in itself was against the war." The Japanese director's films, like *Throne of Blood* and *Seven Samurai*, conveyed a clear message about the price of armed conflict.

While events in and out of the classroom could provide numerous distractions, movies often became a primary focus for film society members. Many of Ayers's friends were affiliated with Cinema Guild in one way or another, and their activities together frequently revolved around film. He dated both Guild chair Ellen Frank and her roommate Gilda Radner (later of *Saturday Night Live*), who, with fellow member Elliot Barden, were from Detroit and knew about a 24-hour theater there: "We might stay up till 1:00 and then drive down to Detroit and go to a movie at 2:00, until 4:30 or 5, when the bagels from this bagel factory would just be getting put out. And you could go get hot bagels just out of the oven at 5 in the morning. It was something that all of those Detroit kids knew about." Ayers's love for movies contrasted with his increasing political activism and deep opposition to the Vietnam War. In March of 1968 the classics major, now serving as Cinema Guild's chairman,

TOP: 1967 Cinema Guild program by Rick Ayers and Andrew Lugg. Courtesy Hugh Cohen

44

CINEMA ANN ARBOR

Gilda Radner, right, and Ellen Frank. © Rick Ayers

Ed Weber, left, and Hugh Cohen selling tickets at the Architecture Auditorium, February, 1961. *Ensian*

left the university on a personal odyssey of anti-war activity that would stretch to Canada, and finally underground.

Though the film society's student members brought energy and fresh perspectives, the glue that held it together was Hugh Cohen and Ed Weber, who had both joined in graduate school and remained involved after taking jobs with the university. "They were the continuity," Ayers remembered. "But they were very, very attentive to what we wanted to do. I was really on a learning curve about this kind of film, so I would certainly defer to both for their knowledge. But I never felt like they were bossing us around." The group's senior members sometimes had to rein in their charges, however. Ayers's predecessor as chairman, Hugh Henry "Jeep" Holland, had a reputation as a hustler that would mostly serve him well when he left school to promote rock bands like the Rationals and start label A-Square Records. But when he tried to get out of paying for a film the group had rented and then decided not to show, Weber wrote to Audio Film Center booker Dorothy Desmond: "Please ignore his letter. The chairman of the board is a very young man, trying to impress people with his efficiency, but he often neglects to check up on facts. He has the impression, common among students here, that people in business wish to overcharge or cheat, and no conception of courtesy and honesty in business dealings. I hope that you were not too annoyed by his jejune letter."

Ed Weber was a key figure in Ann Arbor film history. Born in Rochester, New York, in 1922, he came to the University of Michigan at 30 to attend library school, having already earned a master's degree in American literature from Columbia. Hired as a librarian by the university, in 1960 Weber was named curator of the Joseph A. Labadie Collection of social protest materials, the oldest public archive of radical literature in the US, which he would vigorously expand during a four-decade tenure. He joined Cinema Guild in the mid-1950s, and took the position of paid manager to supervise ticket sales at each show. Later Guild member Harry Todd recalled: "At the time that tickets were 50 cents, he'd have a neat arrangement of quarters, and you'd hand him a dollar and he'd push the quarters forward and sort of flip the ticket your way, all with a poker face. You would never have guessed how personable he actually was." Cinema Guild archivist Peggy Ann Kusnerz remembered, "He was always old, even when he was young. He had ruffled white hair, always wore a suit and a tie, even though the whole ensemble was kind of messy and unkempt. But he was a brilliant man,

and extremely well educated. He was soft spoken, but he always spoke in full sentences, paragraphs, and pages with footnotes. If you had a conversation with Ed of any length, you would learn something." Rick Ayers was impressed by Weber's dedication to documenting dissent: "He was an outsider and didn't give a fuck. Any time there was a demonstration on campus, Ed would come tiptoeing out and pick up all the leaflets and take 'em back for his archive."

Hugh Cohen recalled Weber as a "strange guy, but a wonderful guy," who had a profound influence on the campus film scene: "He brought films to campus that I probably would never have seen otherwise. Foreign films, all kinds of films. He had a wide taste in film and he just knew about these actors and actresses, and films and details. I've often thought about that. That the rich number of films that we saw, a large part of them were due to Ed." Renowned also for his love of classical music and drink, the group's most senior member sometimes seemed to inhabit his own world. Once, while Cohen waited in his car for Weber to emerge from the liquor store he liked to visit after they deposited the week's receipts, his friend got into the wrong vehicle. "I could see him sitting there waiting for me to drive away in this car in front of me. And I can see the guy turning and looking, 'Who is this guy sitting in my car with me?' And Ed just sat there. Finally

The account list from Cinema Guild's 1960s financial ledger

CINEMA GUILD BREAKS OUT

the guy said something to him, and Ed looked at him, and then he got out and looked around, and I waved him over to my car. That was Ed Weber."

Cinema Guild's other longstanding member, Hugh Cohen, was born in 1930 and grew up in Detroit, earning a bachelor's degree from Wayne State University before enrolling at the University of Michigan in 1952. While a student he joined the army to take advantage of the GI Bill, and after completing a two-year commitment returned to campus to finish his master's degree in English. Regularly attending screenings of the Gothic Film Society, Cohen also became friends with Cinema Guild members Don and Sue Kaul, who persuaded him to take Don's place in the group when he decided to leave. In contrast with the sometimes-remote Ed Weber, Cohen was highly approachable and enjoyed working with student members like Ellen Frank and Hugh Holland. He recalled becoming "sort of a father figure" to the latter, who also "introduced me to music I never would have known about." As he worked toward finishing the doctorate he would receive in 1970, Cohen began teaching English classes in the College of Engineering, and took the informal title of Cinema Guild's faculty advisor.

Finally relieved from the limitation of raising funds for co-sponsors, in the mid-1960s Cinema Guild became committed to a new mission centered on curation and education. The group attracted students who didn't necessarily fit into a standard degree program, and their deep immersion in film and the mentorship of free-thinking senior members Ed Weber and Hugh Cohen had a significant impact on many.

ABOVE: Patrons waiting in line, September 1967. *Ensian*

48

CINEMA ANN ARBOR

CINEMA GUILD presents
WINTER – SPRING 1967 SCHEDULE
THURSDAY and FRIDAY...SATURDAY and SUNDAY...At 7 and 9:05 P.M. (except where noted)

JAN. 5, 6 GOIN' TO TOWN
(dir. Alexander Hall, 1935)
Mae West, Paul Cavanaugh. Unrequited passion --- and Mae in hot pursuit. Adventure in Buenos Aires high society.
SHORTS: "IN THE GREASE", "FAST AND FURIOUS"

JAN. 7, 8 THE GOLD RUSH
(dir. Charlie Chaplin - 1925)
American, silent. Charlie Chaplin, Mack Swain. America's finest comedian in his most celebrated film.

JAN. 10-15 A FESTIVAL WEEK OF JEAN-LUC GODARD:

JAN. 10, 11 UNE FEMME EST UNE FEMME
(A WOMAN IS A WOMAN) 1961
French, subtitles. Godard's film tribute to his wife, Anna Karina.

JAN. 12, 13 ALPHAVILLE 1964
Science fiction with Eddie Constantine, France's gangster star.

JAN. 14, 15 BANDE A PART
(BAND OF OUTSIDERS) 1963
A comedy in the tradition of the American grade-B thriller.

JAN. 18 Special Wednesday Night Experimental Series Program #1
Jack Smith's "FLAMING CREATURES"
Mike Kuchar's "SINS OF THE FLESHAPOIDS"

JAN. 19, 20 THE BLUE ANGEL
(dir. Joseph Von Sternberg - 1930)
German, subtitles. Marlene Dietrich, Emil Jannings. The peak of Von Sternberg – the discovery of Dietrich.
SHORT: "KENOJUAK"

JAN. 21, 22 MONSIEUR VERDOUX
(dir. Charlie Chaplin - 1947)
Charlie Chaplin, Martha Raye. Subtitled: 'A Comedy of Murders'. "the most fascinating picture Chaplin ever made" --- James Agee. Film to be followed by a panel discussion with Writer-in-Residence, Leslie Fiedler.

JAN. 25 Special Wednesday Night Experimental Series Program #2
"SCORPIO RISING" & "FIREWORKS" by Kenneth Anger
"HALLUCINATION", "STUDIO OF DR. FAUST" and "RELIEF" by Peter Weiss (director of MARAT/SADE)

JAN. 26, 27 LOUISIANA STORY
(dir. Robert Flaherty - 1948)
American. Score by Virgil Thomson. A classic documentary. The moving account of the discovery of oil on a bayou and its effect on a Cajun family.
SHORT: "IN A DARK TIME", Theodore Roethke reading his poetry.

JAN. 28, 29 ZERO DE CONDUITE
(Zero for Conduct)
(dir. Jean Vigo - 1933)
French, subtitles. Rebellion in a boys' boarding school; an incredible black farce.
SHORTS: "WHAT'S HERE?" (Keaton), "ANOTHER FINE MESS" (Laurel and Hardy)

FEB. 2, 3 LA TETE CONTRE LES MURS
(Head Against the Walls)
(dir. Georges Franju - 1958)
French, subtitles. One of the greatest achievements of anarchist cinema.
SHORTS: Moiseyev Dancers in "THE STROLLERS"

FEB. 4, 5 THE LOWER DEPTHS
(dir. Akira Kurosawa - 1957)
Japanese, subtitles. Gorky's classic transposed to an Edo tenement by Japan's leading director.

FEB. 8 Special Wednesday Night Experimental Series Program #3
Stan Brakhage's "DOG STAR MAN: PRELUDE"
Stan Vanderbeek's "BREATHDEATH"
Jonas Mekas' "THE BRIG"

FEB. 9, 10 THE TRIAL
(dir. Orson Welles - 1963)
Anthony Perkins, Orson Welles. From Kafka's surrealistic story of human isolation.

FEB. 11, 12 SMILES OF A SUMMER NIGHT
(dir. Ingmar Bergman - 1955)
Swedish, subtitles. "An exquisite carnal comedy" ---- Pauline Kael.

FEB. 15 Special Wednesday Night Experimental Series Program #4
A night of Andy Warhol: "Harlot", "Blow Job".

FEB. 16, 17 ASHES AND DIAMONDS
(dir. Andrzej Wajda - 1958)
Polish, subtitles. Dilemmas of a resistance fighter after the war. "One of the most impressive anti-political films ever made" -- London Times
SHORT: "MOVIES AND MANIACS"

FEB. 18, 19 MODERN TIMES
(dir. Charlie Chaplin - 1936)
Charlie Chaplin, Paulette Goddard. Chaplin's comic view of American industrialist society in the 30's.

FEB. 23, 24 ORDET (The Word)
(dir. T. H. Dreyer - 1955)
Danish, subtitles. Perhaps Dreyer's most personal film, with its strange theme of a young farmer obsessed by the idea that he is Christ. Grand Prix, Venice Film Festival.

FEB. 25, 26 A DANCE FILM FESTIVAL
In cooperation with the Ann Arbor Dance Theater.
Feb. 25 A PROGRAM OF EXPERIMENTAL DANCE FILMS: "TOTEM" (Ed Emschwiller), THE VERY EYE OF NIGHT", "STUDY IN CHOREOGRAPHY FOR CAMERA", "HORROR DREAM", "MEDITATION ON VIOLENCE", "CLINIC OF STUMBLE", "YOUNG GIRL IN A GARDEN", "MESHES IN THE AFTERNOON" (Maya Deren), "DANCE CHROMATIC"
Feb. 26 - 2:30 MATINEE – PROGRAM OF EDUCATIONAL DANCE FILMS
"A TIME TO DANCE", "CLASSICAL BALLET", "THE LANGUAGE OF DANCE", "GREAT PERFORMANCES IN DANCE".
Feb. 26 - 7:00 and 9:05 - A PROGRAM OF FILM PERFORMANCES
"NIGHT JOURNEY" (Martha Graham), "MOOR'S PAVANE" (Jose Limon), "BRANDENBURG CONCERTO 4", "AIR FOR THE G STRING", "THEATRE OF ETIENNE DECROUX".

MARCH 2, 3, 4, 5, 6, 11, 12 THE FIFTH ANN ARBOR FILM FESTIVAL

MARCH 16-19 A WEEKEND OF FRANCOIS TRUFFAUT

MARCH 16, 17 LES QUATRE CENTS COUPS
(The 400 Blows) 1959
French, subtitles. Jean-Pierre Léaud. Memoirs of his delinquent youth.
SHORT: "AN OSCAR FOR MR. ROSSI"

MARCH 18, 19 TIREZ SUR LE PIANISTE
(Shoot the Piano Player) 1960
Charles Aznavour. A masterpiece done in the manner of B-gangster movies. "A stunning exposition of existential man" --- Jean-Paul Sartre.
SHORT: "THE WAR FOR MEN'S MINDS"

MARCH 23, 24 NUIT ET BROUILLARD
(Night and Fog)
(dir. Alain Resnais - 1955)
French, subtitles. The controversial documentary on German concentration camps.

LET THERE BE LIGHT
(dir. John Huston - 1946)
American. Huston's suppressed war film released for the first time.
SHORT: "TIME OF THE LOCUST"

MARCH 25, 26 LES PARENTS TERRIBLES
(The Storm Within)
(dir. Jean Cocteau - 1948)
French, subtitles. A brilliant study of neurosis and family life by the grand master of French film.
SHORT: Harry Watt's "NIGHT MAIL". Poetry by W. H. Auden, music by Britten.

MARCH 30, 31 EL (This Strange Passion)
(dir. Luis Bunuel - 1953)
Spanish, subtitles. An indictment of bourgeois repression and orthodox Christianity.
SHORT: "LONELY BOY" National Film Board of Canada's famous study of Paul Anka.

APRIL 1, 2 SHADOW OF A DOUBT
(dir. Alfred Hitchcock - 1943)
Joseph Cotton, Teresa Wright, McDonald Carey, Script by Thornton Wilder. Murder and suspense in a small American town.

APRIL 6, 7 MOTHER
(dir. Vsevolod Pudovkin - 1926)
Russian, silent. A brilliantly humanistic story of the 1905 Revolution based on Gorky's novel. Pudovkin's film was exactly contemporaneous to "Potemkin", but a complete antithesis.
SHORT: "SUGAR DADDIES" (Laurel and Hardy)

APRIL 8, 9 INTRUDER IN THE DUST
(dir. Clarence Brown - 1949)
A powerful translation into film from Faulkner's novel of bigotry and mob violence in the deep South. Shot on location in Oxford, Mississippi.
SHORTS: Christie comedies – "A TWO-CYLINDER COURTSHIP" and "HOLD 'ER COWBOY".

APRIL 13, 14 SALT OF THE EARTH
(dir. Herbert Biberman - 1953)
American. For the first time in Ann Arbor, this revolutionary workers' film, for which the writer, producer and director were blacklisted.
SHORT: "PAKHITA BALLET" (Bolshoi Troupe)

APRIL 15, 16 THE WILD ONE
(dir. Laslo Benedek - 1954)
Marlon Brando, Lee Marvin. The celebrated motorcycle morality play.
SHORTS: Three Magoo cartoons.

APRIL 17, 18, 19 AN EXAM PROGRAM OF COMEDIES

APRIL 20, 21 NINOTCHKA
(dir. Ernst Lubitsch - 1939)
American. Greta Garbo, Melvyn Douglas. Garbo as a top Red agent in Paris trying to sell the crown jewels. One of the handful of American "sound" comedies.

APRIL 22, 23 DUCK SOUP
(dir. Leo McCarey - 1933)
The Marx Brothers, Margaret Dumont. The wildest of them all. International intrigue with Groucho as the President of Fredonia and Harpo and Chico as subversives.

ARCHITECTURE AUDITORIUM
STILL ONLY 50¢

(CINEMA GUILD IS A SUBSIDIARY BOARD OF STUDENT GOVERNMENT COUNCIL)

CHAPTER 4
THE ANN ARBOR FILM FESTIVAL

WHILE CINEMA GUILD had begun to program experimental shorts before its features and sometimes as standalone shows, to a U-M art professor named George Manupelli this was not quite enough. Born in 1931 and raised near Boston, Manupelli had attended the Massachusetts School of Art, and, following army service, earned graduate degrees from Columbia University Teachers College. Skilled at most forms of visual art, he was particularly interested in film, and made a movie to complete his doctorate. *The Image in Time* featured an unusual-for-its-time electronic music score composed by Ann Arbor native Robert Ashley, Manupelli's neighbor at New York's International House. The pair became close friends, and in a joint ceremony married Massachusetts School of Art roommates Betty Johnson (Manupelli) and Mary Tsaltas (Ashley), each herself a talented artist.

After Manupelli began teaching art in 1957 at Central Michigan University, he continued to make experimental films scored by Ashley, who had moved back to Ann Arbor following graduation from the Manhattan School of Music. In early 1961 Ashley and several other local avant-garde composers, frustrated by the conservative U-M music school's lack of support, organized what they anticipated would be a one-off showcase for their work. The ONCE Festival of Musical Premieres featured compositions by Ashley, Gordon Mumma, George Cacioppo, Donald Scavarda, and Roger Reynolds, plus guest Luciano Berio and a screening of Manupelli's dual-projector, Ashley-scored film *The Bottleman*. When tickets unexpectedly sold out, the composers decided to repeat and expand the concept, and over the next several years ONCE grew to incorporate theater, dance, and performance art. In addition to sponsoring events in Ann Arbor, a touring unit appeared at colleges and museums in the US and occasionally abroad.

As ONCE put Ann Arbor on the national avant-garde cultural map, it also gave locals in-person exposure to artists like John Cage, La Monte Young, Pauline Oliveros, Eric Dolphy, the Judson Dance Theater, and Robert Rauschenberg. But despite the prominent guests, the work presented by ONCE was often controversial. "We attracted people who came thinking that this was part of the university music school," ONCE member and U-M architecture professor Joe Wehrer remembered. "They would disrupt our performances; they would do things like rolling bottles down the floor. The *Ann Arbor News* music critic was my neighbor, from the music school, and he was condescending toward us in his reviews. But the thing just grew and grew."

In the fall of 1962, George Manupelli joined the faculty of the U-M College of Architecture and Design. His films had by now been shown locally a few

OPPOSITE:

© Buster Simpson

DRAMATIC ARTS CENTER

presents

ONCE

A Festival of Musical Premieres

Tonight at 8:30—Instrumental and Electronic Music and Film: "THE BOTTLEMAN"

First Unitarian Church, 1917 Washtenaw

Fri., March 3 Paul Jacobs, Piano
Sat., March 4 Orchestra under Wayne Dunlap

Tickets: single $1.77, week-end $3, DAC members 10% less, on sale at Marshall's Book Shop

THE ANN ARBOR FILM FESTIVAL

times through ONCE, at the Ann Arbor Public Library, and at the annual Architecture and Design Open House in May 1962. The latter event incorporated two evenings of experimental film that also included work by Robert Frank, Rudy Burckhardt, and Stan Brakhage. Speaking afterward, Brakhage, already gaining recognition as one of America's most important experimental filmmakers, bemoaned the fact that his work was only seen by "a small coterie of friends," according to the *Daily*, and Manupelli felt just as unappreciated.

Seeking a wider audience, he tried to make inroads with Jonas Mekas, a Latvian-born filmmaker who organized screenings in New York and wrote an influential column for the *Village Voice*.

"The drill then was you sent your films to Jonas Mekas," Manupelli remembered at his 2009 Penny Stamps Speaker Series lecture. "If he liked them, he showed them and wrote about them. If he didn't, he didn't. I sent him three films. He showed them and wrote about them but said this: 'They all lack something.'"

Now convinced that the only way to find an audience was to do it himself, Manupelli decided to follow the example of ONCE and start an experimental film festival of his own. Joe Wehrer felt his timing was perfect: "Ann Arbor was being made a center for avant-garde artwork at the same time it was hitting big in New York and the West Coast. And the film festival was kind of a logical outgrowth of that, because the composers and graphic artists working in the ONCE Group were doing their thing, and George was working on films."

Manupelli quickly realized it would be necessary to organize the event without support from his employer. "Not only could the university not think out of a box, they *were* the box," he remembered. Fortunately, Ann Arbor was home to an exceptional funding body called the Dramatic Arts Center (DAC), which agreed to help. Founded in 1954 to develop a resident professional theater company, after unsuccessfully attempting to bring director Tyrone Guthrie to town it had begun underwriting a wide range of cultural programming, including ONCE. Primarily funded by U-M math professor Wilfred Kaplan, an amateur musician whose calculus textbook provided him with significant discretionary income, the DAC's shift toward avant-garde work was due in large part to the presence of ONCE member Anne Wehrer on its board.

Having secured startup money, Manupelli began planning an experimental film festival with input

"NOT ONLY COULD THE UNIVERSITY NOT THINK OUT OF A BOX, THEY WERE THE BOX."

George Manupelli, University of Michigan art professor

from a group that included the Ashleys, the Wehrers, and Marvin Felheim, a founding board member of both the Gothic Film Society and the DAC. The most obvious screening venue was the Architecture Auditorium, located in the building where Manupelli taught, so he reached out to Cinema Guild. "They needed the machinery to run a festival," remembered Hugh Cohen. "They had the ideas, and they would do the selecting of films." The Dramatic Arts Center and Cinema Guild were designated as co-sponsors, while additional funds came from locals like Dominick DeVarti, owner of nearby student hangout Casa Dominick's. "George Manupelli asked my dad to help him out with some support, so my dad gave him some cash," remembered Dave DeVarti. "A hundred dollars, probably. 'However you need to spend it, spend it.'"

The First Festival, 1963

With co-chairs Anne Speer, who headed Cinema Guild, and Michael Eisler, from the university's television unit, Manupelli began rounding up material for the planned May 23–26 event. "The documentary film group in Chicago was having a festival similar to the beginnings of the festival here," Manupelli recalled. "I asked them if we sent them $100 for awards there, would they ask permission for the filmmakers there to forward their films to Ann Arbor. In the first festival we got through Chicago some great entries by Bruce Baillie, Richard Myers, Ed Emshwiller, and many others." Another source was the National Film Board of Canada, which sent several titles, including *Lonely Boy*, Wolf Koenig and Roman Kroitor's cinema verité documentary about singer Paul Anka.

To promote the event, Manupelli created an elegant, lithographed brochure which featured his black-and-white photo of a woman with her face in shadow. His artful graphics immediately became one of the Ann Arbor Film Festival's hallmarks. Another enhancement came courtesy of its location in the art school, which provided the opportunity for an exhibit of work by students and professors, including Gerome Kamrowski.

Dominick's Restaurant, 1960s. BHL

THE ANN ARBOR FILM FESTIVAL

George Manupelli

films

The First Ann Arbor Film Festival
May 1963
23 24 25 26

Co-sponsored by the
Dramatic Arts Center of Ann Arbor
and the Student Cinema Guild
of The University of Michigan

Architecture and Design Auditorium
Screenings at 7:00 and 9:00 P.M.

Single Admission: 50c
Series Ticket: $2.50

First film festival brochure, designed by George Manupelli

LOBBY EXHIBIT: Gerome Kamrowski, Milton Cohen, Caroline Player, and students of the University of Michigan Department of Art. Special Festival sound and music by Robert Ashley and Gordon Mumma.

- **Thursday: Films by Ann Arbor Area Film-Makers and Late Arrivals: As They Arrive**

- **Friday: Films from the Midwest Film Festival 1963 and the National Film Board of Canada**

- **Saturday: The Second Annual World 8mm Home Movie Film Festival and An Act for Assembly**

- **Sunday: Films by Young American Independent Producers**

- **Screenings are at 7:00 and 9:00 P.M. Each Program is Different**

The inaugural festival kicked off on Thursday with a screening of nine works by Ann Arbor area filmmakers, including ONCE composer Donald Scavarda's *Greys* and Manupelli's *The House*. Unbilled was an educational short directed by the U-M Audio-Visual Education Center's Doug Rideout that starred DAC funder Wilfred Kaplan. The math professor had implored Manupelli to show a half-hour lecture film called *The Analog Computer and Its Application to Ordinary Differential Equations*. "It was awful," commented a sheepish Rideout, who noted he had tried to make it more interesting by commissioning a theme from ONCE's Robert Ashley and Gordon Mumma. "I had this big, long title, and then basically the camera slowly moves across it. And against this is this electronic music."

Another screening was hosted by artist/filmmaker and U-M alumnus Ed Emshwiller, while the event's roots in ONCE were brought to the fore on Saturday night. Two multi-screen Manupelli films scored by Ashley were shown, while Mary Ashley curated the "Second Annual World 8 mm Home Movie Film Festival." Projected on six screens stacked in pairs, the silent films were underscored with music by Gordon Mumma. Saturday night also featured a multimedia piece called *Extensions: An Act for Assembly* by U-M architecture professor and ONCE member Milton Cohen. He had put together an immersive environment called "Space Theater" in a leaky, former-photographer's loft near the Michigan Theatre that seated about three dozen in a dome-like structure. "He would make up slides," recalled Joe Wehrer. "And he would also do things with water and oil and whatnot, and have multiple projections directed in different parts of the studio. And usually electronic music that underlined it. Milton always wanted to have a dancer, so he'd get an aspiring dancer to come in and move around."

Attendance at the first festival averaged a solid 200 per show, with all of the roughly 65 films that had been received making it to the screen. While no prizes were awarded, the festival's donation of $100 to the Midwest Film Festival in Chicago had been given to

Cinema Guild ledger showing expenses for the 1964 AAFF

Gregory Markopoulos. *Michigan Daily*

Bruce Baillie's poetic documentary short *Mr. Hayashi*, which also screened in Ann Arbor. Alongside the DAC, Cinema Guild had provided significant assistance to the shoestring-funded operation in the form of both money and volunteer labor. Afterward, the film society spent $500 to purchase several of the entries for its own collection, including *Lonely Boy* and Ed Emshwiller's dreamlike dance short *Thanatopsis*.

The first festival having established Ann Arbor's credibility, in 1964 enough entries were received that the focus could shift to screening films in competition. They would be judged by a panel which included Cinema Guild's Hugh Cohen and film critic Pauline Kael, whose opening night lecture established another festival tradition of special juror presentations. The second year also added a Friday midnight program of 8 mm films that were shown off-campus, and a final Sunday screening of highlights and winners that appealed to more casual viewers.

Many of the country's top experimental filmmakers sent work, including Stan Brakhage, Stan Vanderbeek, and Kenneth Anger, whose *Scorpio Rising* had just weeks earlier sparked the arrest of Los Angeles Cinema Theater manager Mike Getz. Anger's homoerotic study of bikers set to pop songs like "He's a Rebel" was not initially chosen to be shown in Ann Arbor, however, because a selection committee member had blackballed it. "I'd never heard of *Scorpio Rising*, and I don't think that anybody else here had," Hugh Cohen remembered. "Pauline learned that *Scorpio Rising* had been submitted to the festival and she said, 'You've got to see it.' So we went to see it, and we loved it. We inserted it into the showings, and then we gave it an award." Though the festival organizers were "a bit irritated" at their decision, jurors would henceforth be given the opportunity to add rejected submissions, which were generally listed on the schedule under the heading, "Shown as time permits." The second year's top prize winner was the moody, meditative *Mass* by Bruce Baillie, who had recently founded the Bay Area–based film distribution cooperative Canyon Cinema.

Markopoulos Makes Waves

The Ann Arbor Film Festival was now gaining national recognition, and in 1965 New York tastemaker Jonas Mekas agreed to serve as lead juror. But at the last minute he canceled, sending in his place Gregory Markopoulos, a compatriot originally from Toledo, Ohio. On opening night Markopoulos's rambling, deliberately provocative talk drew sporadic laughter and a few hisses, and things unraveled further

THE ANN ARBOR FILM FESTIVAL

Milton Cohen and Betty Johnson, 1963

when he demanded that two as-yet-unseen films by his friends be added to the public screenings. Manupelli insisted that they first be viewed by the full selection committee of himself, his wife Betty, and several others, but when they saw *Jerovi*, a silent short by José Rodriguez-Soltero that depicted the lead character masturbating, it did not go as Markopoulos hoped. "I get devilish sometimes," Betty Johnson remembered with a smile. "It was a silent film about Narcissus, very gay. And I put on the Beatles' 'Mr. Moonlight' while it was showing, and offended him so badly, he left town."

Lead juror Doug Rideout recalled that Markopoulos had also been angry about a point system instituted by the jury, which also included Milton Cohen, Marvin Felheim, and future art gallerist Annina Nosei. "He was one of these artsy-fartsy guys from New York," Rideout remembered in his rich Boston accent. "He was sent to Ann Arbor to collect the loot, and I think it was the fact that he had to go back without much loot that bothered him. Because naturally, the films that he brought, that he expected to win, didn't win." Markopoulos's abrupt departure came as the jurors were assembled at the end-of-festival Sunday brunch at the Wehrers' home. "He walked all the way back to the bus station, and took the next bus back to New York," Rideout

58 CINEMA ANN ARBOR

recalled. The year's top prize of $250 would go to Ohio-based Richard Myers's experimental narrative *Coronation*.

Though the two films Markopoulos championed had in fact been added to the final public screening, once back in New York he sent telegrams to both the *Michigan Daily* and U-M president Harlan Hatcher declaring that he was "horrified that a sense of censorship should prevail." Then, Jonas Mekas gave his next "Movie Journal" column in the *Village Voice* over to Markopoulos, who wrote a lengthy denunciation of the film festival which referred to Ann Arbor as "the swamplands."

His screed was also published in the Bruce Baillie–affiliated *Canyon Cinema News*, which allowed Manupelli a rebuttal. Claiming that Markopoulos had threatened, "I'm going to tell every filmmaker I can reach not to enter your festival, ever!" Manupelli attested to Ann Arbor's growing passion for experimental film by comparing a screening of Markopoulos's *Twice a Man* he'd attended in New York with its two-night run at Cinema Guild. At the former, "it played to two other persons besides myself (one of whom—Robert Ashley—was sleeping) and the projectionist, who gave it a standing ovation when the film was over. Rave reviews followed in the next issue of the *Village Voice*. In contrast to this, about 1,000 saw *Twice a Man* in Ann Arbor, but because of the large audiences, there was no telling how many people were sleeping besides Robert Ashley, who attended each of the four screenings." Betty Johnson remembered how the country's two most prominent experimental film communities viewed the Ann Arbor upstarts: "There was a real enmity between the New York group, but good relations with the West Coast, Bruce Baillie, and some of the others."

A separate controversy was provoked at home by the film *Jerovi*. Immediately following the festival, widely distributed free advertising newspaper the *Huron Valley Ad-Visor* published an angry letter from David R. Knox about the screening of it he'd attended. "One film involved, in the guise of art, showed an act of gross monosexual indecency and abuse of nature impossible of adequate acceptable description in the public media. It was just plain filth." Knox went on to demand that, "The person or persons responsible should be arrested and vigorously prosecuted," and added, "The University of Michigan should summarily discharge or expel any faculty member or student responsible." The letter reached George Manupelli's boss. "The dean at the time dragged me, almost by the ear, literally, to the vice president," the festival founder recalled. "And I went into the office of this very powerful person, and he said to me, 'OK, Manupelli, did you or did you not show a film that depicted explicit masturbation?' And I said, 'Sir?' And he said, 'Don't give me any shit, Manupelli, you heard what I asked.' So I said, 'Sir, I

> **THE ANN ARBOR FILM FESTIVAL**
> AT THE UNIVERSITY OF VERMONT
>
> VOTEY AUDITORIUM
>
> friday, may 7 saturday, may 8 sunday, may 9
> 2-4 pm 7-9 pm 1-3 pm
> 7-9 pm 10-midnite 6-8 pm*
> 10-midnite 9-11 pm*
>
> *prize winners
>
> TWELVE HOURS OF EXPERIMENTAL CINEMA
> 75¢ PER SHOW $4.00 FESTIVAL PASS

A poster for festival tour in Vermont. Courtesy Rich DeVarti/Dominick's

have never masturbated, nor have I ever watched anyone masturbate. Could you please give me some idea of what it looked like?' He said, 'Get out of here.'"

In 1965 it was still very possible to be arrested for showing films considered "obscene," and afterward, Manupelli devised a scheme to protect festival entries from seizure. Only one show's prints would be allowed in the booth at a time, and if a screening was halted by the authorities, the projectionist was to quickly drop the offending reel out of the window to a volunteer positioned below. The rest of the evening's program was kept outside in a car, where it could be driven away at the first sign of trouble.

The Tour

As part of his effort to give experimental films more exposure, Manupelli also created a festival tour, which was launched in 1964 with shows in LA, Berkeley, and Paris. The jurors chose up to 12 hours of film for these subsequent screenings. "At the time there was a smattering, a sprinkling of film festivals," Manupelli recalled. "And if you were a filmmaker, you had to send a film here, pay an entry fee, send a film there." His tour would offer the potential for more prize money, as well as sparing artists the effort of applying to multiple festivals and the cost of making additional expensive, fragile prints. The tour grew exponentially each year and lasted as long as six

> Complete one entry form for each film entered and return before February 15, 1965, to: George Manupelli, 720 West Huron, Ann Arbor, Michigan. Enclose $2.00 entry fee per film maker.
>
> Title of film_____
> Minutes____ B&W____ Color____ Type of Soundtrack_____
> Place and year(s) of production_____
> Original gauge_____ Country of origin_____
> Name and address of film maker_____
> _____
> Return to:_____
> _____
> Signature_____

1965 filmmaker application form

months. "At the high point of all of this, we had maybe 26 places signing up," Manupelli recalled. "In addition, Mike Getz, whose uncle owned theaters in the Midwest and Far West, came, viewed the festival, and picked films that he wanted to show at these theaters. Maybe a dozen different theaters. And Bell & Howell also came and took three shows of winners and highlights. So, with one entry fee, you could maybe show to 50 or 60 different places." Alongside the now frequently sold-out Ann Arbor screenings, the tour further enhanced the festival's reputation as a top destination for experimental filmmakers to submit their work.

The Manupellis handled many of the administrative tasks during the festival's earliest years, and George's personal commitment and filmmaking credentials were critical to the event's success. "Filmmakers were suspicious of festivals, so it was important to gain their confidence," he explained. "To treat the films carefully once they arrived, and to return them immediately following the festival with the complete festival report. One of the first steps in that process was to design a brochure that was enticing and provocative, that would say to the filmmaker, 'We're up to anything you have in mind. We can handle it, don't worry, we have people who love films and people who are knowledgeable. And the festival certainly understands who you are and why you make films.'" Up to 5,000 of Manupelli's eye-catching solicitations were mailed out with the help of Cinema Guild members. Betty Johnson remembered: "They were sent to universities and film centers, and we'd get applications out everywhere. And once you had a film in, you got an application the next year. People flocked to it actually. It didn't take long to get it off the ground." Though it was his creation, the festival founder usually stayed in the lobby. "George himself almost never went in and watched films," she recalled. "He may have never seen an evening of films at the film festival. He'd seen a lot at the screening, but he didn't see it all. But even when it was being screened by others, he was just too keyed up to be able to sit down and watch."

THE ANN ARBOR FILM FESTIVAL

Brochure for the fifth AAFF

1966

Each early film festival was a big step forward from the previous year. For 1966, in addition to competition screenings that featured multiple entries from New York's Fluxus group (including two by Yoko Ono), special guests were booked. On Saturday night the festival presented *Up-Tight with Andy Warhol and the Velvet Underground*, a multimedia event that had so far been presented only a handful of times on the East Coast. The two shows, which quickly sold out, began with a screening of Warhol films *Vinyl* and *Lupe*, then segued into a live performance by the Velvet Underground, whose equipment barely fit onto the tiny Architecture Auditorium stage.

With guitarist Lou Reed sharing vocals with German-born actress/model Nico, John Cale alternated between viola and bass, Sterling Morrison played second guitar, and Maureen Tucker sat on the side pounding a stripped-down drum kit. Out front, Ingrid Superstar and Gerard Malanga, cracking a neon whip, danced and interacted with the crowd. "They were all 'out there,'" remembered Lewis "Buster" Simpson, who was sitting near the stage with a camera. "Whips, and a grindstone necklace on the viola player. I'm from this little town, so it was pretty revealing." To accompany the band's still-unreleased songs, like "Heroin," Warhol and several associates provided visual effects. "There was a lady walking around with a 16 mm projector," Simpson recalled. "Somebody was her grip, making sure that the extension cord kept up with her. She

CINEMA ANN ARBOR

was projecting on people as well as on the screen as the band was playing." A second projector was positioned on the side of the room, while Cinema Guild member-turned-projectionist Peter Wilde operated two more up in the booth. Doug Rideout spotted Warhol sitting next to one. "He had a card he was waving in front of the lens while it was being projected, just to create a kind of artsy look." Other *Up-Tight* effects included a silver balloon which bounced around the room and a flashing onstage light pointed at the audience. Buster Simpson remarked, "Everybody was really liking the sound. It was a happening, quite frankly." *Daily* reviewer Betsy Cohn wrote: "Electronic noises wheezed in the background while the raspy voice of the lanky female singer [sic]. Four projectors, one blinding, blinking light, and film flashes of mouths and eyes . . . added to the unique renovation of the Architecture Auditorium."

Warhol's 11-person troupe, who were paid $350, had driven from New York in a rented recreational vehicle. With no money for lodging in the festival budget, Anne Wehrer planned to host some of them and ask the rest to stay with friends, but, "They would have none of it, so they all ended up either in our house or in their RV outside of our house," Joe Wehrer remembered. The Wehrers' seven-bedroom home at 1502 Cambridge, just a few blocks from the Architecture Auditorium, was also the site of the popular Saturday night festival party. One guest that night was James Osterberg, a friend of the Wehrer children whose band, the Prime Movers, had performed live with their film *(No) Peace in the Valley* three evenings before. The future Iggy Pop met Warhol, his future girlfriend Nico, and John Cale, who would both produce and play on Osterberg's subsequent band the Stooges' debut album. Anne Wehrer herself would go on to appear in Warhol's film *Bike Boy*, while whip dancer Gerard Malanga returned the following year to serve as a festival juror, read poetry, and star in a short film by George Manupelli.

The Ann Arbor Film Festival and founder Manupelli were now helping to inspire a local experimental filmmaking scene. Along with the screening opportunity the festival provided and the example of his own work, Manupelli had started to teach the subject, albeit with limited support. "The dean agreed to let me teach a film course under very specific conditions," he recalled with much irony. "One, you would get no equipment; two, you would be provided no classroom space; and three, you would

```
THURSDAY, March 10, 7:00 P.M.

DEPARTURE by Abbott Meader
1864 by Denys McCoy, Harvey Foster, and Rea Redifer
FLUXFILMS, ANN ARBOR, PART II:
FLUXFILM NO. 15, Anonymous
NINE MINUTES by James Riddle
FOUR by Yoko Ono
ONE by Yoko Ono
SHOUTING by Jeff Perkins
FIVE O'CLOCK IN THE MORNING by Pieter Vanderbeck
END AFTER NINE, Anonymous
```

Excerpt from 1966 AAFF program with Yoko Ono films

THE ANN ARBOR FILM FESTIVAL

ABOVE and OPPOSITE: The Velvet Underground perform at the film festival, March 12, 1966. All photos © Buster Simpson

not receive any salary." His uncredited class met in a small room under the stairwell near the auditorium, which was primarily home to a Coke machine. Pat Oleszko was in it. "He had to ask the janitor to open up the door. We had one manual cutter, a splicer, and somebody had one Bolex. I mean, it was primitive." Joe Wehrer remembered, "It was never part of his contract, and you couldn't sign up for a course in filmmaking. But it was such an opportunity for him to discredit that." As U-M art students, film society members, and other locals increasingly submitted their work to the festival, it added another unique aspect to the event, and a number of their films ended up winning prizes and/or going on tour.

As it grew in stature, the Ann Arbor Film Festival also began to attract critics from publications like *Cahiers du Cinema* and *Variety*; curators from the Museum of Modern Art; and distributors like New Line, whose founder Robert Shaye, a U-M alumnus, came to scout for titles. Along with submissions from established experimental filmmakers like Brakhage, Vanderbeek, Baillie, Anger, Storm de Hirsch, and James Broughton, the festival screened the work of talented younger artists, including Robert Nelson, Curt McDowell, James Benning, and Sally Cruikshank; and future Hollywood directors Brian De Palma, John Milius, Penelope Spheeris, and George Lucas, whose student effort, *THX 1138 4EB*, won $50 at the 1968 event.

Restricted from films with adult content at the mainstream theaters, precocious teenagers also attended. "It was like all bets were off. It was just an amazing revelation," Ken Burns recalled. "When we were in late high school and on our own and could go to the Ann Arbor Film Festival, you'd sit there for four hours and look at 30 experimental films in a row." Burns felt it had a heady, artsy atmosphere. "We knew we'd snuck in. We knew it wasn't a place where people our age were. And even if it was because my dad was taking me, we were thinking we were pretty cool." He added, "I remember the inscrutability of the experimental things at the Ann Arbor Film Festival, and sitting there, and just feeling this awkwardness and yet this sort of burning curiosity, watching these films that were flash frames, and repetition, and strange imagery." Burns and his brother Ric, both later to become acclaimed documentary filmmakers, were sometimes given tickets by Allan Schreiber, a teacher at Pioneer High School who had married Betty Johnson after she and George Manupelli divorced.

The Festival Queen

One of the most popular features of the film festival, fostered by its

ABOVE: George Manupelli posing with 1968 festival cover girl Candy Brown

OPPOSITE: Andy Warhol, center, in the projection booth.
© Buster Simpson

THE ANN ARBOR FILM FESTIVAL

Final night of the 1967 festival.
© Pat Oleszko

The Astronut. © Pat Oleszko

location inside the U-M art school, was the performance art of Pat Oleszko. Arriving on campus in the fall of 1965, she quickly encountered both George Manupelli and the ONCE Group. "It radically changed my mindset," Oleszko recalled. "I came wearing a circle pin and matching twinsets from the burbs and got completely transformed within half a semester." The striking, six-foot Oleszko soon began developing a very personal kind of three-dimensional expression. "I had early discovered that my body was the platform to make art upon, because I couldn't make large sculptures that would stand up, frankly.

So I started working at home making things, and then hanging them on myself. And I became a pedestrian sculpture. I would make costumic apparitions that would comment on whatever I was attending, which was always these extraordinary events the folks from the ONCE Group would organize, or the film festival, or whatever."

Blown away by her first festival in 1966, the next year Oleszko decided to make a public statement. "I said, 'OK, I'm gonna see every minute of the festival, and so I deserve my own chair. So I came dressed every night with my own chair so that the design and the presentation were sympathetic. And each night was much, much more elaborate. On Sunday night I brought a TV and I was like a housewife watching reruns on TV 'cause we were watching the winners we had already seen. That was the start of it."

From this guerilla-style beginning, Oleszko's multimedia performances and increasingly elaborate self-

Pat Oleszko as the Hippie Strippy. © Pat Oleszko

ABOVE: A chair piece from 1967. © Pat Oleszko
LEFT: Patturncoat: Pat Oleszko performing with herself on 16 mm film. © Pat Oleszko

made costumes would become the official starting point for each night of the festival. "I would do six quasi-cinemagraphic shorts, a different piece every night," she recalled, "as a sequence that was thematically related. One popular series was the Comic Strips, as I was working in burlesque in Toledo, Ohio, at the time, while I was going to school." She recruited several kindred spirits to help. "The magnificent Peter Wilde, who, no matter what hare-brained idea I wanted to project, there he was in this closet-sized projection booth up there. He'd help me, he'd make it happen. And other people, like 'Blue' Gene Tyranny, fantastic composer-musician was there. 'Hey, yo, Blue, I need music.' So he'd create something. In my particular realm I was creating these six five-minute bits that were still complete pieces. With the collaboration of a real range of brilliance." Tyranny, a.k.a. Robert Sheff, was also a member of ONCE, the Prime Movers, and the Cinema Guild board, and was gaining recognition for his own avant-garde compositions.

Vicky Henry was a classmate of Oleszko's. "When she came into class, you'd always smell patchouli. And she usually wore bells on her ankles or something, so when she entered the classroom, she came in with both sound and aroma. She's a tall presence, so you were always aware of Pat." Henry saw many of her festival performances. "It was always a highlight: 'What's Pat going to be this year?'" she recalled. In one of Henry's favorite pieces, "She was wrapped head to toe, like a mummy, in multicolored, rainbow fabric. And she stood on a little platform that turned, and behind her was a film being played, about when she entered a contest to be Miss Polish America. And while there was this little documentary about this thing she did in real life, she stood on this twirling little platform, and another person was pulling on the fabric. So as the fabric came off Pat, she spun. She turned, not fast, on this platform and the colors went sort of up and down her body, because these long, almost like bandages, wide fabric, had been dyed multi-color. So it changed, up and down, up and down, until in the end she was naked." Betty Johnson remembered another memorable piece: "She came out dressed as an alien from another planet, and her tits were eyes and her pussy was the mouth on this face. And she talked with her vagina and it was absolutely hilarious. It was fantastic."

© Pat Oleszko

The performance artist made an impression on the males in the audience as well. "I loved her," Ken Burns recalled. "I was a teenage boy. I was madly in love with Pat." As Oleszko remembered, "I was finding my way through my work, and I was finding what I was doing with myself. But it was always, 'Oh, I did that last year?' The next year has to be bigger and better. And the next year."

After graduation in 1970, Oleszko moved to New York to pursue a career in performance art, appearing in her custom costumes everywhere from the Macy's Thanksgiving Day Parade to *Ms.*, *Esquire*, the Museum of Modern Art, Lincoln Center, and beyond. Loyal to her roots, she returned almost every year to perform at the Ann Arbor Film Festival.

Lobby Installations

In addition to what was presented on and in front of the screen, the festival's lobby art installations were also continuing to evolve. The long row of showcases lining the hall where audiences waited to buy tickets were filled with work, while the outer lobby had larger, sometimes interactive pieces.

Decorating the lobby at the 1970 festival. Photos by Jim Judkis, *Michigan Daily*

THE ANN ARBOR FILM FESTIVAL

Joe Wehrer performing in Eric Staller's lobby piece. © Eric Staller

A lobby installation by Eric Staller. Buster Simpson at left, professor Gerome Kamrowski facing camera. ©Eric Staller

© **Eric Staller**

Students, including Buster Simpson and future *Jumanji* author/illustrator Chris Van Allsburg, helped add this festive, sometimes provocative touch, and faculty were often involved as well, including painter Al Loving and ONCE's Joe Wehrer. "I had an architectural student at the time who we gave the task of designing the setup in the hallway," Wehrer remembered of the 1970 festival. "We set up a television set, with a chair and a little table. And he built a brick wall between the chair, in which I sat, drinking beer with a bag of chips and staring at the TV." The piece was created by Eric Staller. "The original plan was to have a bricklayer come," Staller recalled. "I think that maybe I couldn't afford the bricklayer, so it turned out to be me. I had a pile of bricks and concrete and I started building this brick wall in front of the TV while Joe was watching and pretending to be unaware that a brick wall was being constructed. By the end of the performance, the TV is completely obscured by the brick wall,

1969 tickets featuring Pat Oleszko

and Joe remains there, staring at it."

Staller contributed other memorable temporary works to the festival, including a row of haystacks with protruding ear buds that played the taped sounds of cows, and a piece that featured Wehrer's teenage son Stephen sitting at a desk in a large plywood box painted black inside and out. Pretending to study, he was visible only via tiny, apartment-door fisheye lenses on each of the four sides, "so you would essentially see this child who was imprisoned by the educational system." Another piece used a frosted window behind which silhouetted people appeared to be engaged in amorous activity. Though it was an illusion created with a film loop of Staller and his girlfriend, "Some people thought it was real and tried to get behind it and look." Inspired by the response to his festival pieces, and another in which he attached $2,200 in dollar bills to lobby-positioned bulletin boards, Staller switched his major from architecture to art and went on to a prolific career creating public artworks.

Other creative touches of the festival included the tickets that Manupelli designed for each screening; announcements projected on glass slides, some made by art students like Buster

Current program information can be obtained by calling CINEMA GUILD: 662-8871. These recorded messages will be updated several times each night by the voice of Cinema Guild: TICKET FRED.

THE ANN ARBOR FILM FESTIVAL 73

Peter Wilde explains CinemaScope in *Cinema Street*, **1971. Courtesy Jay Cassidy**

Simpson (himself later an acclaimed sculptor/environmental artist); and even custom films. In 1971, a series of nine 16 mm shorts called *Cinema Street* were shot by Jay Cassidy that starred Cinema Guild usher "Ticket Fred" LaBour, who had already achieved notoriety when a tongue-in-cheek *Daily* article he wrote helped ignite the rumor that Beatle Paul McCartney had died when it was syndicated nationally. Cassidy recalled: "The theatrical immediacy of Fred as live ticket-taker and Fred as image on the screen, speaking directly to the fourth wall, was what intrigued us. We hoped the *Cinema Street* series would be a good tonic for what could be heavier stuff in the programs that followed."

Filmed in a single night on rental equipment left from another shoot, LaBour, later to adopt yet another alter ego as bassist Too Slim in cowboy band Riders in the Sky, cheerfully discussed topics like the scratchy voice of Western actor Andy Devine. Honking a toy horn, he also advised patrons not to smoke, answered questions "for the cinematically immature," and asserted that the uncomfortable seats had been "designed by secret Swedish engineers in a secret Volvo factory in Oslo, Sweden." One short featured a guest appearance by Peter Wilde, who was simultaneously visible onscreen and manipulating the image from the projection booth: "I'm going to place a Bausch and Lomb CinemaScope attachment in front of the camera. Suddenly you notice I am squished sideways. Now we'll put another Bausch and Lomb CinemaScope attachment in front of the projector. Behold, you notice, all of a sudden I have all kinds of space on either side of me. And I can have a hand over the exit sign, a hand over the ladder."

Live music was also becoming an important part of the festival. After both the Velvet Underground and Prime Movers had performed in 1966, at the 1967 festival three bands appeared: the Prime Movers, Dixboro County Breakdown, and a local psychedelic group called the Seventh Seal. The *Ann Arbor News* noted that the latter had played "while new wave films whirled on the screen. With its amplifiers going full tilt in the small Architectural Auditorium, the result was loud and almost deafening." Seventh Seal guitarist Bill Kirchen, who had attended Cinema Guild screenings growing up, recalled festival juror Gerard Malanga "dancing in his chains" to the band in a reprise of his Velvets appearance the year before.

Two members of the audience that night were recent U-M graduates George Frayne and John Tichy, who had been playing together in fraternity bands like the Amblers for several years. It was a pivotal encounter for all concerned, as Kirchen remembered: "They saw me and said, 'Well, this guy's OK. Let's get him in, let's get started playing with him.' So that was the genesis of Commander Cody." When the Seventh Seal splintered a few months later, Frayne, Tichy, and Kirchen recruited fiddle/sax player Andy Stein,

"THERE WAS THIS ENERGY, THIS KIND OF ELECTRICITY, THAT WAS RUNNING THROUGH THE PLACE AT ALL TIMES."

Pat Oleszko, AAFF performer

and several others, to form Commander Cody and His Lost Planet Airmen, whose name was derived from 1950s Republic movie serials. Named Festival Orchestra in 1968 along with the Innergalactic Twist Queens, a troupe of dancers that included Pat Oleszko, the pioneering country-rock band also appeared at the event the following year before relocating to San Francisco. Cody and the Airmen played once more in 1971, though without having been listed on the schedule. "They just showed up, got the instruments out of their van, and played a set before the 9:00 winners' program," Jay Cassidy recalled. "Much to the delight of the audience." As Kirchen remembered, "Andy Stein had this fantastic kind of quasi-classical fiddle piece. And we performed it acoustic at the film fest in tuxedos."

Finding Its Groove

To the dismay of some College of Architecture and Design faculty members, the Ann Arbor Film Festival came to assume a larger-than-life presence in its home base. "It was absolutely the focus of the entire art school year," Pat Oleszko remembered. "And everybody did stuff. George certainly did all the fantastic graphics, and everybody was helping him organize stuff, but it was kind of a free-flowing performative party. And with all these people, the filmmakers coming from all over the country, and the judges, some of them getting pissed off and running out. And Dominick's was just as much part of the film festival as anything. There was this energy, this kind of electricity, that was running through the place at all times."

The audience was part of the experience as well. "During the shows themselves, not just me but other people would spontaneously do stuff," Oleszko recalled. "If it was a particularly terrible film, booing. And people suffering through these goddamn chairs. There was this real camaraderie of enjoying the fact that you're going to have 30, 36 hours of watching films together. And it's gonna be like, 'OK, it's gonna be hard,' and a lot of films were watched from the lobby, maybe through an occasional open door. But then of course it was the '60s, and there was a lot of dope being smoked, and there was a lot of beer." The festival attracted a coterie of loyal fans like Doug Rideout and his wife Betty, who didn't miss a show for four decades. "We used to have a group of people who'd all get together," he remembered. "And Betty would bring cookies, and we'd bring our own cushions to sit on." For them, and many others, the joy of discovery won out over the challenge of endurance. "The films were terrible, some of them. And we were there till 1:00, 2 in the morning watching films, and still excited about the film festival."

FOLLOWING SPREAD: Audience members watching the Velvet Underground, March 12, 1966.
© Buster Simpson

CHAPTER 5
DOUBTFUL MOVIES

NOTICE: The sexual frankness of tonight's last film may be objectionable.

UNIVERSITY OF MICHIGAN

STUDENT GOVERNMENT COUNCIL
STUDENT ACTIVITIES BUILDING
ANN ARBOR, MICHIGAN

January 27, 1959

Mr. Edward C. Weber
320 General Library
University of Michigan
Ann Arbor, Michigan

Dear Mr. Weber:

Recently, it was called to my attention that the movie "Flesh in the Morning" was shown at Cinema Guild. Numerous complaints have been received through many channels, and indignant letters have been written to prominent members of our administration and to members of the Board of Regents.

The Student Government Council has always been pleased with the fine movies shown at Cinema Guild. However, we must ask that movies of this nature not be shown in the future and, in case of a doubtful movie, that it be reviewed before it is shown.

I know that you will understand the position of Cinema Guild, Student Government Council, and myself in the matter, and that you will take whatever steps are necessary to rectify the situation and to assure that such showings will not be repeated

Sincerely yours,

Maynard Goldman
President

First Name	8/18/30 Middle Name	Color	Fingerprint	Class	Picture No.		
Hubert	I	W					
AA, Mich.		Age 36	Sex M	Weight 160	Height 5-8	Hair Brn	Eyes Blu
		Complexion		Place of Birth Detroit, Mich.			
		Occupation	College Teacher				

| EST NO. 3 | OR 67-272 OFFENSE Showing Obscene Films | DISPOSITION 2-26-68 dismissed |

IN LATE JANUARY 1959, Cinema Guild received a letter from Student Government Council president Maynard Goldman. "Recently, it was called to my attention that the movie 'Flesh in the Morning' was shown at Cinema Guild. Numerous complaints have been received through many channels, and indignant letters have been written to prominent members of our administration and the Board of Regents. The Student Government Council has always been pleased with the fine movies shown at Cinema Guild. However, we must ask that movies of this nature not be shown in the future, and in case of a doubtful movie, that it be reviewed before it is shown. I know that you will understand the position of Cinema Guild, Student Government Council, and myself in the matter, and that you will take whatever steps are necessary to rectify the situation and to assure that such showings will not be repeated." Stan Brakhage's experimental short *Flesh of Morning*, which appeared to show the filmmaker masturbating in a distorted vase reflection, had played before Clarence Brown's 1949 Faulkner adaptation *Intruder in the Dust*.

A reply was composed by manager Ed Weber, who had recently begun helping program the work of experimental filmmakers. On a sticky manual typewriter, he thanked Goldman for writing: "You may be sure that I will take into consideration your request about future showings of Cinema Guild movies." But then his tone grew firm: "I am not sorry to have shown *Flesh of Morning*, though I will not show it again. Its merits as a film seem to me slight, though it is on its merits that it is subject to attack, taking sex seriously and carefully avoiding glamorization and sugar-coating." Noting that some students might have been glad to see a movie that would not be shown in a commercial theater, he addressed the issue of censorship: "All the discussion seems to be about peoples' reactions to the film and not about the film itself. I cannot say that this university community comes out very well officially with its Grundy-ish concern for 'indignant letters' and its failure to perceive that a mature individual, such as the university should be concerned with developing, would be able to take a film, a book, a lecture in his stride."

Changes to Cinema Guild's programming were difficult to spot, however. In the early 1960s, the group began increasing the number of experimental films and sometimes devoting entire evenings to them, while the affiliated Ann Arbor Film Festival added even more such content. As filmmakers regularly began skirting the limits of what could legally be shown, exhibitors in cultural centers like New York and Los Angeles were arrested and charged with violating obscenity laws, and it appeared to be just a matter of time before the same thing would happen in Ann Arbor.

When Cinema Guild members began planning their fall 1966 schedule, Weber submitted one of his typical annotated suggestion lists on three mimeographed sheets. Its 77 entries included silent films like Erich von Stroheim's *Greed*, recent foreign releases such as François Truffaut's *The 400 Blows* ("We have shown this once, a few years back. Could draw"), festivals of work by Jean-Luc Godard and Tennessee Williams, and two controversial experimental films, *Scorpio Rising* and *Flaming Creatures*. While the former had already been screened in town without incident, *Flaming Creatures* had not. Shot with

OPPOSITE LEFT:
Courtesy Hugh Cohen

OPPOSITE RIGHT:
Labadie Collection

DOUBTFUL MOVIES

> **Film Makers Cooperative**
>
> 46. Scorpio Rising. We have shown this short before, and it is as expensive to book as a feature-length film. It is good, and there is probably an underground demand. We've done our part, however, in resisting censorship. If a Kenneth Anger short is needed, we might rather book his initial effort, Fireworks; this would épater les bourgeois more keenly; shocked reactions were noted in 1958 when we last showed this.
> 47. Flaming Creatures. From reports, this film by Jack Smith is one of the most far-out and hairiest yet released. Year before last we showed The Blonde Cobra, which is said to be as controversial, but we had no real trouble. However, before taking the responsibility of booking Flaming Creatures, I would suggest that we back a current film to be shown November 19 and 20, Jean Genet's Un Chant d'Amour. Unless Un Chant d'Amour gets its showing here, without trouble from police, University authorities, and indignant citizens, it would be folly to book Flaming Creatures. Genet's reputation as author and playwright would seem to be sufficient.

From Ed Weber's fall 1966 suggestion list. Labadie Collection

a constantly moving camera on hazy, outdated black-and-white stock, much of the 43-minute film consisted of close-ups of women and men in drag putting on makeup or dancing in exotic costumes. There were also frequent shots of bare breasts and (flaccid) penises, sometimes being touched or shaken in closeup, and an extended scene that depicted a screaming woman being sexually assaulted by multiple individuals. After a March 1964 screening in New York, Jonas Mekas and two associates had been arrested, convicted, and given suspended 60-day sentences.

"From reports, this film by Jack Smith is one of the most far-out and hairiest yet released," Weber wrote. "Year before last we showed *The Blonde Cobra*, which is said to be as controversial, but we had no real trouble. However, before taking the responsibility of booking *Flaming Creatures*, I would suggest that we back a current film to be shown November 19 and 20, Jean Genet's *Un Chant d'Amour*. Unless *Un Chant d'Amour* gets its showing here, without trouble from police, university authorities, and indignant citizens, it would be folly to book *Flaming Creatures*." Both of Weber's proposed experimental titles were approved by the board, and per his suggestion the grim, sexually frank 1950 prison drama *Un Chant d'Amour* (which had only recently become available in the US) was scheduled for late November 1966.

Though someone apparently did complain to the Ann Arbor police after the film ran, there was no serious fallout, and Cinema Guild scheduled *Flaming Creatures* for its next experimental film night on January 18, 1967, paired with Mike Kuchar's sci-fi satire *Sins of the Fleshapoids*. Because Smith's film had been judged obscene in court, the New York–based Film-Makers Cooperative required that it be shipped to Ann Arbor via air freight rather than through the US Postal Service, where it could be subject to seizure.

As the screening date approached, there were clear signs of trouble. "I got a call from the chief of police saying they were going to come look at the film when it was showing and arrest us," Hugh Cohen recalled. "And he suggested we not show it." University administrators had also been notified, and after calling New York state police to verify the film had been judged "pornographic and without redeeming social value" there,

requested a meeting with the Cinema Guild board. Only co-chair Ellen Frank showed up, and she informed them that several members had viewed the film and that the group planned to proceed with the screening. U-M vice president for student affairs Richard Cutler noted in a subsequent memo that the university had told her it "would not act as a censor," but "would also not become a party to the defense of Cinema Guild" if the group got in trouble.

The news spread quickly. "The line to the auditorium was out of the building and down the street," Cohen remembered. "Everybody on campus seemed to have heard about this 'porn film.'" One of the people waiting to get in was undergraduate William Hampton IV, whose father had helped found U-M's Gothic Film Society and directed its production of *Metamorphosis*. "The word had gotten out that this was going to be some interesting stuff," he recalled. "Everyone was expecting to see the police show up and seize the film, or at least shut things down. And sure enough, we all got in there and things started up. And I would say they played maybe five or six minutes of it, and that was the end of the movie." The crowd was outraged. "We thought this was terrible that somebody was deciding what was OK to show and not show."

The screening had been halted by Washtenaw County Assistant Prosecutor Thomas Shea and Ann Arbor Police Department vice officer Lt. Eugene Staudenmaier, who already had a reputation on campus. "He was a plain-clothes detective, which I guess starts down the road to trying to be undercover," remembered Cinema Guild's Andy Sacks. "But he had a butch crewcut, and just kind of a white-bread face. And we all recognized him after a couple encounters." Having seen what he was looking for, Staudenmaier exited the auditorium, climbed the stairs to the projection booth, and demanded the film print from projectionist Ralph Walda. Following close behind was Hugh Cohen, who insisted on a receipt. As the officer headed back down to the lobby, audience members booed and tried to

TOP: Warning slide shown before the *Flaming Creatures* screening. Courtesy Hugh Cohen

BOTTOM: Receipt for the confiscated film. Courtesy Hugh Cohen

DOUBTFUL MOVIES

81

stop him from leaving. Vince Cerutti was on the stairs, and feigned grabbing the film. "I was just trying to get his goat a little bit," Cerutti remembered. "He really gave me the evil eye."

With the screening shut down, a group of about 100 attendees marched through the 10-degree night air to Ann Arbor City Hall, where they held an evening-long sit-in while Ellen Frank and other Cinema Guild members appealed for the print's return. Andrew Lugg was one of those who got up to speak. "It was very peaceful, there wasn't any violence or anything," he recalled. "People just went there, and we just complained. And made a statement."

Guild Members Arrested

Ann Arbor police soon issued warrants for the arrest of Cohen, Frank, her co-chair Mary Barkey, and member-at-large Elliot Barden, along with projectionist Walda. Though Ed Weber had suggested showing *Flaming Creatures*, he was left out in favor of the 36-year-old Cohen, who admitted having seen the film in advance, and the students, all 20, who had allegedly been involved in publicizing it. Cohen initially reached out to a local attorney, but Frank's well-connected father hired the Detroit law firm of Goodman, Eden, Robb, Millender, Goodman, & Bedrosian to represent the group. Two days after the screening, Robb and the younger Goodman accompanied the Cinema Guild members to the police department, where they were arrested, fingerprinted, and had their mug shots taken. All were charged with "showing or offering to show an obscene motion picture," a high misdemeanor with a maximum penalty of a year in jail and a $500 fine. The charges against Ralph Walda were quietly dropped, however.

Across Michigan the arrests generated headlines and heated letters to newspaper editors, while national publications like *Variety* and the *New York Times* also covered the story. Opinions on campus differed widely, with the engineering school faculty voting to condemn Cinema Guild's screening, and College of Architecture and Design professors issuing a statement in support of the group, even as a member of their cohort was suspected of having tipped off the police. *Gargoyle*, a student humor magazine, got into the mix as well, challenging Cinema Guild to an "obscenity duel."

The university's position was made clear by outgoing president Harlan Hatcher, who in 1954 had infamously forced two professors to resign when they refused to appear before the House Un-American Activities Committee. While telling the regents, "We don't

Architecture Auditorium lobby after *Flaming Creatures* was confiscated.
© Andy Sacks

want censorship," he commented: "We are in a period of moral evolution and a general decline in taste, a vulgarizing and destructive period, as I view it." The university issued an official statement which declared: "If a public law is allegedly violated, established procedures should be used to make the determination. When such violations take place, it is the responsibility of the law enforcement agencies to take appropriate action. If a citizen is guilty, he takes the consequences." Hugh Cohen had been given a brief chance to read the statement when a university attorney brought it to the next night's Cinema Guild screening. "I couldn't study it; it seemed all right but I was aware that the administration was washing its hands of us."

Though Cohen's College of Engineering dean advised him to find a way to get out of the situation, and one fellow professor became so upset about his actions that, "I later heard that his department colleagues were worried about his state of mind," the Faculty Senate offered its support. It formed a civil liberties board, which started a defense fund and filed an amicus curiae brief drafted by several law professors. The Student Government Council also sent a supportive letter, initiated a fundraising drive, and provided $1,000 in bail money. Beyond the university, the American Civil Liberties Union offered assistance and letters were received from Audio Film Center, Em Gee Film Library, the Catholic Adult Education Center, and Contemporary Films, whose Midwest office manager Charles Boos wrote of Cinema Guild: "We have always felt that it is perhaps the best film society in the nation. Unlike most groups, it has

Andrew Lugg speaking at City Hall sit-in. SDS founder Alan Haber turning toward camera at lower left.
© **Andy Sacks**

DOUBTFUL MOVIES

Lieutenant Eugene Staudenmaier, center, watching City Hall sit-in. © Andy Sacks

Hugh Cohen's mug shot. Courtesy Hugh Cohen

had a continuity of leadership which has made possible a comprehensive study of the film exceeded only—possibly—by the showings conducted by the Museum of Modern Art."

For his part, 18-year Ann Arbor police veteran Lt. Eugene Staudenmaier told the *Daily* that he had "no objection to a good intellectual flick," but when *Flaming Creatures* was only partially unspooled, "I saw enough. There was nothing left to the imagination." He added: "Today's university students are tomorrow's leaders. I want to do what's necessary to protect them from pornography. Otherwise they'll come out of school with no backbone." He also saw dark trends on the horizon. "The students are trying to make themselves a group immune to the law. When laws break down, that promotes anarchy, which leads to dictatorship." Halting the film was ultimately part of a personal mission. "I've been a public servant fighting for freedom all my life. Like a doctor, I'm a humanitarian working for the good of society."

The Year Drags On

After the charges were filed, Cinema Guild sued Staudenmaier, Police Chief Walter Krasny, and Assistant

84 CINEMA ANN ARBOR

"I'M A HUMANITARIAN WORKING FOR THE GOOD OF SOCIETY."

Ann Arbor Police Lt. Eugene Staudenmaier

Prosecutor Thomas Shea in Federal District Court for $15,000 in damages, return of the film print, prohibition of prior censorship by the police, and an injunction against future arrests and seizures, though their suit was held in abeyance until the criminal case was settled. As it slowly wound through the courts, a faculty panel debated censorship, *Realist* founder Paul Krassner visited campus, and benefit screenings were put on by Cinema Guild and recently formed rival Cinema II.

The film group had scheduled another experimental movie night one month after *Flaming Creatures* that was to include Andy Warhol's controversial (if non-explicit) *Blow Job*, but after the arrests it was canceled in the interest of avoiding further trouble. Then it was announced that Warhol himself and the Velvet Underground

Photo by Tom Copi, *Michigan Daily*

—Daily—Thomas R. Copi

ARRAIGNED IN MUNICIPAL COURT on obscenity charges yesterday afternoon were Cinema Guild leaders Mary Barkey, '68, Elliot Barden, '68, the group's advisor Hubert Cohen, an instructor of engineering English, and Ellen Frank, '68.

> **U-M Cinema Guild Attitude Decried**
>
> *Flint Journal Feb 10 67*
>
> WHAT DO WE HAVE in Ann Arbor on the university campus? Their so-called Cinema Guild has no place among decent society, or any other for that matter. Where is the school authority? By staying on the fence, they are tearing down the character of our present students, building up a student body of immoral radicals, and holding Michigan up for shame before the world.
>
> As a mother I am reluctant to trust the faculty with the future education of my children. Why are we taxpayers forced to support such an institution? How do they qualify for state support while allowing such immoral and indecent activities sponsored by the Cinema Guild. Where are the voices of those who represent real art? The guild leaders apparently feel they deserve the protection of some laws while they break others to force their liberal ideas on society.
>
> Well, I hope Lt. Staudenmeier and the Ann Arbor police force gets the backing needed to clean up that mess, because if that's an example of the education offered at the University of Michigan I'd rather keep my family home to be clods.
>
> Rachel Haneline

Letter to the editor of the *Flint Journal*.
Courtesy Hugh Cohen

were coming back to campus for two *Exploding Plastic Inevitable* performances at Hill Auditorium. Rick Ayers, who had been elected Cinema Guild chairman that March, recalled: "We wanted people like Krassner and the Velvet Underground to come to build momentum and to make it visible. It was a fundraiser, but it was really just an act of solidarity, and would get more national eyes on it."

The concert's boost to public relations appeared minimal, however. Returning a year after their ecstatically received performance at the Ann Arbor Film Festival, the New York group's second visit to campus drew a more mainstream crowd that seemed to expect something other than avant-garde films and loud, droning songs. Two *Daily* reviews captured the reaction. Cinema Guild member Andrew Lugg praised the event as "one of the finest 'film-pieces' Ann Arbor has witnessed for a long time," though he noted that much of the audience walked out and "about 80 percent of the remaining viewers were hostile." Future *Big Chill* writer/director Lawrence Kasdan, soon himself to join Cinema Guild, was in the latter camp. "The movies are long and boring—true Warhol," he wrote. "The Velvet Underground is totally unimpressive. Each one of their songs seems to last about three hours. The audience, filled with frustration, starts to produce its own entertainment. While one man plays harmonica, others create moving jungle yells—many just hiss."

In late May, the *Flaming Creatures* case began to move forward when the judge and attorneys for both sides watched the confiscated print over the defense's objections. Not long afterward, the US Supreme Court affirmed the conviction of Jonas Mekas and the others who had shown it in New York, with Chief Justice Earl Warren writing, "This film falls outside the range of protection offered by the First Amendment."

In August, Ann Arbor Municipal Court Judge S. J. Elden concluded his pre-trial examination. Having viewed the movie twice and heard testimony from U-M history professor Robert Sklar that the film did not violate the university's "community standards," Elden ruled that *Flaming Creatures* was in fact obscene. "Not only is the film outrageous," he wrote, referencing Cinema Guild's quote of Susan Sontag's review, "it tends to be a smutty purveyance of filth and borders on the razor's edge of hardcore pornography." Elden added that his court "cannot and will not believe that contemporary community standards will accept showing of films vividly portraying

masturbation, oral sexuality, the erect phallus, cunnilingus, and other acts of perversion and sexual deviation."

After his ruling, the four defendants were bound over for a September 15 appearance before Judge William F. Ager Jr. in Washtenaw County Circuit Court. By this time Cohen and Frank had both received hostile, if not threatening, phone calls and letters, and Cinema Guild was operating in the red. The case's mounting legal costs and several new competitors were partly to blame, but chairman Rick Ayers told the *Daily* that he believed controversy-shy students had also begun avoiding the group's movies.

In late November, the preliminary trial in the criminal case finally began, with Judge Ager denying the defendants' request to depose critics Susan Sontag and *Saturday Review*'s Hollis Alpert, as well as MOMA film curator Willard Van Dyke. The parallel civil suit over the seized print also began in Detroit Federal Court, where Judge Thaddeus Machrowicz chided both the regents and the university for their wishy-washy responses to the case.

With the group's defense fund now nearly depleted as the cost of legal representation approached $4,000, on December 3, another benefit concert was held in the Michigan Union Ballroom. Coordinated by former Cinema Guild chairman Jeep Holland, it featured a lineup of bands from his A2 Productions booking agency, including the Rationals, Thyme, and MC5.

Their Day in Court

On the morning of December 11, 1967, the *Flaming Creatures* trial finally began. Prepared to take a strong

Soliciting donations for the Cinema Guild defense fund on the Diag, January 1967. *Michigan Daily*

DOUBTFUL MOVIES 87

CINEMA
GUILD

UNDERGROUND FILM

& FLAMING
CREATURES

Informational booklet handed out at Cinema Guild screenings

Nico performing with the Velvet Underground at Hill Auditorium. *Ensian*

CINEMA GUILD
DEFENSE FUND
BENEFIT

RATIONALS
MC-5
BILLY C. & THE
SUNSHINE
THE THYME
THE CHILDREN
LEN CHANDLER

UNION BALLROOM
SUNDAY, DEC. 3
3–7 P.M.
$1.00

FOR DEC. 11
"FLAMING CREATURES"
TRIAL

		8/18/30					
Last Name	First Name	Middle Name	Color	Fingerprint	Class		Picture No.
Cohen	Hubert	I	W				

Address	Age	Sex	Weight	Height	Hair	Eyes
219 Packard, AA, Mich.	36	M	160	5-8	Brn	Blu

Aliases	Complexion	Place of Birth
		Detroit, Mich.

Occupation
College Teacher

Marks, Scars, Moles, and Other Features

DATE	ARREST NO.	OFFENSE	DISPOSITION
1/20/67	49933	OR 67-272 Showing Obscene Films	2-26-68 dismissed

Criminal History ANN ARBOR POLICE DEPARTMENT

Hugh Cohen's arrest card showing his charges were dismissed. Courtesy Hugh Cohen

stand against censorship and for academic freedom, Hugh Cohen sat with his fellow defendants as the panel of 11 women and 3 men, average age 49, listened from across the room. Following testimony from Lt. Staudenmaier, court was adjourned for lunch, after which a showing of the film was planned. But when he returned, Cohen was stunned to learn that the trial was over. "They'd said they would drop the charges against us if one of us would plead guilty to a minor charge," he recalled. "I'd forgotten about it completely." While both Cohen and Ellen Frank had been prepared to see the case through to the end, the other defendants had been less invested in its outcome, and during the break, Mary Barkey had suddenly decided to accept a reduced charge of being disorderly in a public place by showing an obscene motion picture, as well as admitting

to the judge that she now believed the film was obscene. She was fined a total of $235, which Cinema Guild and the nearly empty defense fund would cover.

Afterward Barkey steered clear of the press, but Elliot Barden told the *Daily* that he thought "the cops sold out," and added: "When I heard what she did, I thought, 'Man, that was a great thing. Why didn't I?'" Defense Attorney William Goodman called the result a "stand-off rather than a victory" which indicated "the prosecutor felt Cinema Guild was willing to fight to make a show of legal and moral strength." It appeared that the case might have been difficult to win, however, as Cohen later learned from colleague and Ann Arbor City Council member Robert Weeks that he had heard the judge say, "He was out to get me because I was the faculty. I was the adult in the crowd."

As part of its settlement the group

agreed to drop the lawsuit over seizure of the film print, which was never returned, though Barkey later had her conviction expunged. Like the others involved she would remain on the board of Cinema Guild, whose members had respected her difficult decision to take a plea. "I think Mary and Elliot's parents were totally freaked out and putting a lot of pressure on them," Rick Ayers remembered. "So, we didn't get our big day in court. We would have had to be more unified as defendants, I guess."

Hugh Cohen took away several things from the year-long ordeal. "When people find this out, it gives me a reputation that I don't know that I absolutely deserve, because they see that here's a guy who really stood up for these principles and for art and all of this. And that doesn't take into consideration that so much was out of our hands. But it did give me a heroic reputation." He also discovered that many so-called liberals were not ready to walk the walk. "I just learned not to trust people's political positions. They may be your friends or your colleagues, and you may think they're on your side and will back you in anything. But when it comes to certain issues, especially the moral issues, and certainly sexual issues, they really did back off. And I was surprised." He was ultimately strengthened by the experience, however. "Having been arrested and gone to trial, even though the trial was short-lived, it made me a bit more daring. And less afraid of repercussions and standing up for certain issues."

The trial also had an effect on Cinema Guild. "As is often the case, we were a lot more cautious," Cohen recalled. "We were a lot more self-censoring than we had been before. Not wildly, because that was the turning point of the whole culture, so everything was changing. The board was. Ed Weber wasn't; he was marvelous. But I think that would be the main effect." As had been the case after *Flesh of Morning*, the group's inhibitions appeared minimal. On the eve of the first anniversary of the fateful screening of *Flaming Creatures* and Mike Kuchar's *Sins of the Fleshapoids*, Cinema Guild presented an experimental film program that featured the Ann Arbor premiere of Kuchar's brother George's nudity-filled *Hold Me While I'm Naked* and another short by Jack Smith called *Scotch Tape*.

In the summer of 1968, the confiscated 16 mm print of *Flaming Creatures* was personally flown by Lt. Staudenmaier and Chief Krasny to Washington. After they testified before senators debating President Johnson's nomination of Abe Fortas as Chief Justice of the Supreme Court, the film was screened behind closed doors. Fortas had written a dissenting opinion stating that the film was not obscene when the New York convictions were reviewed, and the *Flaming Creatures* controversy and other issues ultimately led him to withdraw his name before his resignation from the court a year later.

Chief Krasny with interviewer Fred LaBour and photographer Andy Sacks. Photo by Jay Cassidy, *Michigan Daily*

DOUBTFUL MOVIES

CHAPTER 6
BEYOND BUTTERFIELD

ALTHOUGH THE U-M Student Government Council had voted to end Cinema Guild's official monopoly on weekend screenings in the early 1960s, it wasn't until 1966 that a new film society was launched. With a charter approved by the SGC over Cinema Guild's objections, Cinema II was started with funds from nearly two dozen donors and led by sophomore and budding filmmaker William Clark. Dedicated to presenting "more recent movies at student prices," according to the *Daily*, the group commenced operations on February 4–5, 1966, with sold-out screenings of the 1963 Sidney Poitier hit *Lilies of the Field*. Its home base would be Auditorium A of Angell Hall, a fan-shaped, nearly 400-seat room located in an imposing, column-fronted building that also housed departments like English and classical studies.

While Cinema II initially stuck with popular fare like *Bridge on the River Kwai* and Hitchcock's *Vertigo*, it gradually began mixing in lesser-known titles like Henri Colpi's 1963 *Codine*, which it claimed to be the American premiere, and encouraged student filmmakers to show their work before features. After signing on as a co-sponsor and prize donor to the Ann Arbor Film Festival, in April 1969 Cinema II held a festival of 8 mm films which drew 65 entries and awarded $215 in prizes.

Cinema II was just one of many new competitors that Cinema Guild now faced on and around campus. Portable 16 mm projection equipment and rental titles were becoming increasingly easy to obtain, and in the late 1960s movies suddenly began popping up almost everywhere. Reviving an idea that dated to the 1910s, free or inexpensive film screenings were frequently used to draw students to faith-affiliated gathering spots, like Hillel, the Presbyterian Center, the St. Mary Student Parish's Newman Center, and the Episcopal Church–sponsored Canterbury House, whose wide-ranging arts programming also included an 8 mm film festival. Other campus-area venues that sometimes showed movies included popular bohemian hangout Mark's Coffee House, folk music performance space the Ark, and even a tiny Lincoln Avenue apartment that briefly operated under the name Cinnamon Cinema. Screenings were also regularly presented by campus interest groups, like the Indian Students Association, at the undergraduate

BELOW: Mark's Coffee House. © 1968 MLive Media Group. All rights reserved. Used with permission

OPPOSITE: Angell Hall Auditorium A, 1950s. BHL

BEYOND BUTTERFIELD

TOP: Canterbury House, 1968. BHL

BOTTOM: A film screening at Canterbury House. © Andy Sacks

library, and in dormitories, many times free of charge. At the end of the decade, 16 mm films even became available for checkout from the Washtenaw County Film Library, along with projectors.

In addition to this dramatic increase in nontheatrical exhibition, Cinema Guild's commercial competition was heating up. Along with the Butterfield-owned Campus Theatre's continued focus on art films —whose programming included the US premiere of Orson Welles's *Falstaff (Chimes at Midnight)* on February 9, 1967, five weeks before it played New York— the new Vth Forum Theatre was launched to offer similar fare. It had been built by a group that included lawyer Bill Conlin, an Ann Arbor native whose parents were friends of Butterfield's Gerry Hoag and who as a child had preferred Saturday movie matinees to U-M football games. "The big problem was that Butterfield controlled this town completely," Conlin recalled. "So you couldn't see anything but what they were bringing. And there was no way to break into that." His partners included Roger and Kenneth Robinson of Detroit, who operated the small Studio art house chain there, as well as the Scio, Ypsi-Ann, and Willow drive-ins near Ann Arbor. "They said, 'Oh hell, we can do some things like that.'"

After purchasing a dry-cleaning shop halfway between campus and downtown that they planned to raze, Conlin and his partners sought out an architect with audio expertise. "Everybody said when you're doing a theater the most important thing is to be sure you have got your acoustics so that they work fine. So we worked very hard on that." U-M architecture professor Lester Fader designed

94 CINEMA ANN ARBOR

the sleek 556-seat venue, which also featured a second-floor gallery space.

Opened in early December 1966 with Jean-Luc Godard's *A Married Woman*, the Vth Forum soon found success with the slightly racy British import *Georgy Girl*, then the even more controversial *Ulysses* by Joseph Strick, which had been banned in several countries. Though Conlin was raised in the Catholic Church, which had come out against the film, "I said, '*Ulysses* is a classic movie, so we'll do that one,'" he remembered. Lt. Eugene Staudenmaier was concerned enough to attend a screening of it, though he found "no cause for acting," according to the *Ann Arbor News*.

But it became apparent that the only way for the Vth Forum to secure profitable titles outside the Butterfield stranglehold was with even edgier fare, as Conlin recalled. "The next movie that they wanted to show from Detroit was *I, a Woman*, and I said, 'We can't do that.' And they said, 'Come on in to Detroit and we'll show it to you, then you can determine whether it's OK or not.' So I went in to Detroit, and sat there in their little movie theater, and they showed *I, a Woman*. They got done, and they said, 'What do you think?' And I said, 'Well, the only redeeming social quality for the movie is, while she's getting laid, there's a picture of the *Mona Lisa* on the wall.'" The Robinsons got their way, however, and the Danish-Swedish film about a promiscuous nurse (which Andrew Lugg dismissed as "very boring" in a *Daily* review) ran for a full month in the summer without police intervention. Facing the likelihood of programming increasingly "sordid" fare, and with the new French restaurant he was also a partner in, La Seine, steadily losing money, Conlin decided to exit the theater business. "It was *I, a Woman* that did it," he recalled. "I was a lawyer, and you don't need to get on top of that."

In late 1967, Conlin and fourth partner Charles Adams sold their combined 50 percent stake to U-M Law School professor Donald Shapiro, after which the Vth Forum would continue to program art titles, imports, and an increasing number of one-offs like a two-night stand by the Psychedelic Stooges paired with a festival of cartoons. Along with the Campus, the Fifth Forum (as its name was soon rendered) also began to mimic the programming of the student film societies, showing revivals of foreign and domestic classics as well as experimental titles. Sometimes curated by "Mad Marvin" Surowitz, who presented similar films in Detroit,

Canterbury House program brochure, late 1960s

BEYOND BUTTERFIELD

Cinema II schedule for fall 1968, designed by David Baker. BHL

the venue's more offbeat material ranged from a show of "revolutionary underground films" to the Ann Arbor premiere of Andy Warhol's dual-screen epic *Chelsea Girls*. Limited by Butterfield's grip on product as well as a location with minimal foot traffic a few blocks from campus, in Bill Conlin's view, "They were desperately trying to find anything they could at that point to make some dough, to keep it going."

During this period, two other commercial venues appeared on the outskirts of town that focused on mainstream fare. In July 1967, the National General Corporation–owned Fox Village opened on the west side at the Maple Village shopping center, offering "acres of free parking," "Stereophonic Sound," and "American Bodiform Seats," and a few months later, Butterfield added a similar theater called

TOP: The Vth Forum. © 1966 MLive Media Group. All rights reserved. Used with permission

BEYOND BUTTERFIELD 97

the Wayside between Ann Arbor and its eastern neighbor of Ypsilanti.

With competition growing and the *Flaming Creatures* ordeal having taken a toll on its finances, Cinema Guild began seeking ways to cut expenses. The campus film societies had long relied on staff from the university's plant department to project their films, but in 1967 the rate they paid for this union labor was $5.24 per hour, nearly four times the federal minimum wage and substantially higher than the $3.48 that local union projectionists were receiving. At the same time, according to the *Daily*, auditorium rentals had risen to more than $60 per night. When Cinema Guild threatened to merge with Cinema II and reduce programming, an

TOP: Flyer for Stooges show at Fifth Forum. BOTTOM: The Stooges at the Fifth Forum, June, 1969. © Peter Yates
RIGHT: Iggy Pop at the Fifth Forum. © Peter Yates

98 CINEMA ANN ARBOR

agreement was reached for movies to be shown under the supervision of Cinema Guild member Peter Wilde, who had already been helping project the film festival. "He saw a need for people to do this for the film societies," remembered fellow projectionist John Briggs. "The plant department projectionists were electricians; they came out of the electric shop. But they really wanted to be electricians, they didn't particularly want to spend their nights in the booth. So he just started chipping away at it." Though helped by the reduction in labor charges, other costs were rising, and in 1968 the student film groups reluctantly increased ticket prices from 50 to 75 cents, even as the Butterfield theaters were now charging up to $1.75 for evening shows.

As interest in film on campus continued to grow, inexperienced presenters sometimes organized one-off benefit screenings in the hopes of pulling in some quick cash. When an underground newspaper called the *Ann Arbor Argus* began to lose money after its early 1969 launch, 19-year-old undergraduate founder Ken Kelley seized on the idea of showing a television film by the Beatles that had aired in the UK, but had not yet been broadcast or distributed in the US. Several alternative press organizations had been permitted to run *Magical Mystery Tour* to raise funds, however, and after working out a deal with the Beatles' US affiliate Nemperor Artists, seven shows were scheduled for Sunday and Monday, March 17–18, 1969. Tickets to screenings in the 400-seat Natural Science Auditorium were priced at $2, nearly three times the standard campus rate, but the film's booking fee was an astronomical $1500 plus one-third of the gross take.

Things quickly went wrong. According to the *Argus* report sub-headlined "Step Right Up to the Magical Mystery Fraud, Right This Way," the 16 mm film print was to be delivered in person by Beatle associate Jock McLean, but when his plane was delayed the first three shows were canceled. Yippie leader Jerry Rubin happened to be in town and filled the time with short movies he had brought along, and when McLean finally did arrive, the *Argus* added Sunday late shows and a Tuesday classroom screening that was promoted only with flyers and a plug from Detroit underground DJ Dave Dixon. Despite the fact that the many scheduling changes had pushed attendance far

TOP: *Ann Arbor Argus* letterhead

BOTTOM: Ken Kelley. Photo by Jay Cassidy, *Michigan Daily*

"WE NOW HAVE $500 IN EXPENSES JUST TO PAY OFF THE GODDAMN THING."

Ken Kelley, *Argus* Editor

below expectations, Nemperor still wanted its $1500. *Argus* editor Kelley fumed: "We now have $500 in expenses just to pay off the goddamn thing. Plus all the bread we were counting on to pay off the other debts. Plus we can't rent another university building for another benefit until that debt's paid off." Beatle fans who paid a premium price to see the apparently drug-inspired film were also unhappy. David Swain had started his own underground newspaper in high school and was aware of the "big fuss" it took for the *Argus* to book *Magical Mystery Tour*, but felt let down when he finally saw it. "My friends and I were just annoyed at how poor it was. We were all potheads and we took LSD and stuff, but it seemed like they were just making it up as they went along. And it didn't turn out so good." After the *Argus* folded in 1971, Ken Kelley moved to the Bay Area, where his activities included co-founding the short-lived *SunDance* magazine that was funded by, and featured contributions from, John Lennon and Yoko Ono.

Along with University of Michigan students and movie-loving area adults, the broad spectrum of film available in town also appealed to local teenagers. Ken Burns moved to Ann Arbor with his family in 1963 when his father began teaching at the university. His mother died two years later, when he was 11, and his family found solace in part by going to the movies. "This is really where my interest in film was awakened. It was just the environment, the soup, the thick soup of cinema that is Ann Arbor," Burns recalled. "My dad had a really strict curfew for my younger brother and me. He forgave it if there was a movie on TV, even on a school night, that might go to 1 a.m., or if there was something playing at the Campus Theatre on South U, which was just a ten-minute walk, or if there was something at the Cinema Guild." The combination of family tragedy and escape at the movies led him to an early career choice. "My dad had never cried,

Michigan Daily ad for *Magical Mystery Tour* benefit

Ken Burns, 1969

that I had seen, when my mom was sick or when she died, or at her funeral. But he cried at a movie he showed me one night on TV, and I realized what a powerful tool movies were. And I vowed right then and there, that's what I wanted to be, was a filmmaker."

The future Emmy-winning *Civil War* director began reading the work of critics like Pauline Kael and Andrew Sarris, and campus-area screenings became a key part of his self-directed film study. "I certainly found Sarris's *American Cinema* to be like a bible that I would memorize. I tried to see as many films of the directors as possible. Whether it was F. W. Murnau, or Ernst Lubitsch, or Keaton and Chaplin, or Welles, or Nicholas Ray, or whatever, I was digesting as much as I could. Plus the French New Wave, plus the Hollywood shit that was coming to the State and the Michigan. Plus whatever I would see at the Cinema Guild that was experimental." The immersion Ann Arbor offered helped him develop a groundbreaking take on the documentary form. "With the exception of Pennebaker, Leacock, and Pincus, a couple of other people, there weren't very many documentaries. Documentaries actually meant something didactic and audio-visual, something you got shown at school, and that was educational, you know? What was so great is that I moved into that being armed with all of what I'd understood about storytelling from feature films. And I thought, 'They are obeying the same narrative laws that everybody else has to obey, why are we suddenly turning them into bastard stepchildren?' So I just decided to make documentaries that were as dramatic as feature films in this construction of the narrative, but hewing to the truth." After graduating from Pioneer High School in 1971, Burns enrolled at Hampshire College, where he founded a film society in the mold of Cinema Guild.

Marvin Felheim lecturing at Rackham Amphitheatre, 1967. *Michigan Daily*

Felheim Gets His Film Course

On top of the expanded offerings of the film societies and the local art theaters, the university was finally preparing to make a film-related announcement of its own. Students had been interested in taking classes on the subject since the days of the Art Cinema League, and the *Daily* had periodically run editorials begging for its inclusion in the curriculum, but the administration had ignored their pleas. In 1953 Debra Durschlag's essay "The Case for a Film Course" had noted the existence of a film major at USC while praising the U-M societies and *Metamorphosis*, and associate professor of English Marvin Felheim had laid out the basics of such an offering in his 1960 column "The Distinctive Art Form of Today," but other than several TV-oriented production classes offered by the speech department, there had never been a course on film as art.

Born in 1914, Marvin Felheim had earned his PhD from Harvard and served in World War II as an intelligence officer for the 392nd Bomb Group, where he briefed B-24 crews flying out of England. While in training he had been quartered with Nelson Eddy, Burgess Meredith, and *Cisco Kid* star Gilbert Roland, completing a substantial portion of their assigned work while mingling with visiting wives Paulette Goddard and Constance Bennett. Joining the U-M English faculty in 1948, Felheim had helped found the Gothic Film Society and in the mid-'50s taught an extension course on film history. His 1960 *Daily* essay proposed a class that would "study the history of the cinema," "evaluate films as works of art," and "comprehend the cultural role of the cinema." He continued to push the matter until the administration's resistance gave way. As his teaching assistant Diane Kirkpatrick remembered: "Marvin finally achieved enough status as a senior, much awarded, well-recognized academic-professor-teacher, that they said, 'Well, if you want to do a film course, go ahead. And we will allow you the money to have some TAs so you can have one discussion section.'"

Launched in January 1968, American Studies 498 was co-taught by Felheim and history professor Robert Sklar (later to write the influential book *Movie Made America*), while a similar course, Speech 220, was given by Robert Davis, who was also that department's cinematography instructor. Integral to

1968 *Daily* ad for Godard visit that was canceled

BEYOND BUTTERFIELD

> ## "FILM IS THE ART FORM OF THE TIME. IT HAS ALL THE VITALITY AND POPULARITY THAT THE THEATER HAD FOR THE ELIZABETHANS."
>
> Professor Marvin Felheim

the effort were film societies Cinema Guild and Cinema II, which agreed to program the courses' required movies on Tuesday and Wednesday nights respectively. Students paid a nominal fee to help underwrite the screenings, which were also open to the public.

Felheim's class was an immediate hit. "It filled Auditorium A, which was the largest classroom on campus," Diane Kirkpatrick recalled. She enjoyed the assignment. "He had this naturally generous, 24/7 spirit. He would make sure that he took us to a good Chinese meal every once in a while over in Ypsilanti," to make up for the TAs' low rate of pay. Teaching film also had a perk for the professor. "On his income taxes each year, he deducted his film tickets. His accountant said he could do that because he was a film scholar who had made a name for himself with articles and so on. I was impressed!"

The *Daily* hailed the new courses as the "runaway best sellers in this semester's time schedule," and quoted Felheim on the subject's relevance: "Film is the art form of the time. It has all the vitality and popularity that the theater had for the Elizabethans." The newspaper cited a cautionary note from Cinema Guild's Rick Ayers, however: "I'm real skeptical about starting a film course, because it's institutionalizing a popular art form—one of the last arts free from the academic doctrine, which generally tends to sterilize." Ayers recalled his feeling that it clashed with the film society's mission: "We were training ourselves before anyone had ever thought about having a university course on cinema. I remember us squealing and saying, 'This'll be terrible; this is going to ruin film because it's going to academicize it.' We considered ourselves the center of reflection on film, and we didn't want an academic department doing it."

Guest Artists

Despite such misgivings, the new courses did help facilitate bringing more filmmakers to campus. In the past, guests had occasionally been sponsored by the Art Cinema League and Gothic Film Society, while the Ann Arbor Film Festival and Cinema Guild had more recently brought a number of experimental filmmakers to town. In December of 1966 Cinema Guild had hosted a meet-and-greet with silent star Harold Lloyd when he was appearing with a re-release of his work at the Michigan Theatre. Despite a delay caused by driver Andrew Lugg getting lost en route from the airport, the visit went well, and Lugg and Hugh Cohen both subsequently published interviews with the actor/director, the latter in the 1971 re-issue of Lloyd's autobiography *An American Comedy*. Cinema Guild also set up an early 1968 visit by French director Jean-Luc Godard, which fell through to Cohen's ultimate relief. "I

was supposed to introduce him, and I had worked up this elaborate metaphor about a racehorse that had left the track and was going off on its own. But he canceled, thank God, because I later learned that he made fun of academics!"

Another sponsor of filmmaker visits was the University Activities Center's annual spring Creative Arts Festival, which organized a wide variety of events and brought guests ranging from authors Norman Mailer and Ayn Rand to musicians Miles Davis and John Lee Hooker. Following a 1967 appearance by experimental filmmaker Stan Vanderbeek, the series' film programming took a major step forward with February 1970 visits from *Ulysses* director Joseph Strick and maverick Hollywood auteur Sam Fuller.

Strick appeared for one night with the "Midwest World Premiere" of his new (and X-rated) film, *Tropic of Cancer*, while Fuller, a director of genre movies revered by French filmmakers like Godard, would participate in one of the first US retrospectives of his work, which was sponsored by Cinema Guild. It was teased with a December 1969 screening of Fuller's personal print of his 1963 *Shock Corridor*, and Bruce Henstell and chairman Jay Cassidy traveled to California to interview and photograph him for the program

Harold Lloyd visiting campus, 1966. Lloyd at far right, Hugh Cohen, second from right. Courtesy Alan Young

BEYOND BUTTERFIELD

TOP: Sam Fuller visiting Frank Beaver's class. Photo by Jay Cassidy, *Michigan Daily*

RIGHT: Sam Fuller speaking at Cinema Guild, 1970. Photo by Jay Cassidy, *Michigan Daily*

booklet. Upon his arrival in Ann Arbor, Fuller kept to a tight schedule, taking questions at a sold-out screening of *Pickup On South Street*, giving a radio interview to Marvin Felheim, and visiting a number of classes. Frank Beaver, who had recently taken over for Robert Davis in the speech department, recalled how Fuller talked about a trick he used to keep a cast on its toes: "He did this thing about moving ashtrays after the rehearsal, when the actors were off the set and didn't know it." The director also visited Hugh Cohen's Engineering English class. "Afterward, he said he loved my engineers," Cohen remembered. "He loved the real down-to-earth, practical questions, not these arty questions that film students asked." The chain-smoking

Fuller, who is seen in the dozens of pictures Cassidy shot for the *Daily* alternately holding a pipe, a cigar, or a cigarette, also spent time mentoring local filmmakers. "We went out with Sam to a farm in the Ann Arbor burbs," Cassidy remembered. "He directed a short scene which I shot on my Bolex."

ABOVE: Sam Fuller shooting a film with students. Photo by Jay Cassidy, *Michigan Daily* FOLLOWING PAGE: Sam Fuller speaking at Cinema Guild, 1970. Photo by Jay Cassidy, *Michigan Daily*

BEYOND BUTTERFIELD 107

CHAPTER 7
IF THEY'RE DOING IT, WHY CAN'T WE?

LESS THAN AN hour's drive east of Ann Arbor, Detroit had become a center of industrial/educational/advertising film production that primarily served the needs of the auto industry. It spawned labs, rental companies, and producers like the prolific Jam Handy Organization, whose namesake founder had briefly attended the University of Michigan before being kicked out for mocking a professor in a newspaper column. With rare exceptions like *Metamorphosis*, filmmaking in Ann Arbor had largely been confined to educational, athletic, or research purposes, but in the mid-1960s dozens of students and other locals began taking up cameras to produce everything from experimental shorts to features.

Jay Cassidy recalled the inspiration for this burst of activity: "You looked at *Bicycle Thief* or the early films of Truffaut, and it looked like you could do it yourself. Because it looked like they were doing it themselves. And there was a technological innovation in the kind of lightweight handheld cameras that came through the documentaries, the Maysles brothers and Pennebaker and all those. Sixteen millimeter as a production medium was quite possible, which it hadn't been five or six years before. And you could go to the film festival, and you'd see people making films. So you said, 'Well, you know, if they're doing it, why can't we?'"

American studio films were also starting to go in a new direction, as exemplified by *Bonnie and Clyde*, which had been co-scripted by U-M graduate David Newman. Cassidy watched it multiple times at the State Theatre in early 1968. "That was such a shocker for everyone, a real seminal influence in American cinema. And obviously it was Warner Brothers and a movie star movie, but the fact that it was made the way it was, and that it embraced the subject the way it did, was so nontraditional. It was so outside the mainstream of what had been done in Hollywood."

Dr. Chicago

The local filmmaking scene's chief instigator was film festival founder George Manupelli, who by the mid-'60s had completed more than a dozen experimental shorts ranging from mood pieces like *The Bottleman* to the conceptual *Film for Hooded Projector*. Doug Rideout was in the audience when

OPPOSITE: AVEC audio dubbing station, Alan Young at left. Courtesy Alan Young

BELOW: A still from George Manupelli's *The Bottleman*

IF THEY'RE DOING IT, WHY CAN'T WE?

the latter was screened. "George was up in the booth, and I remember that he just covered the projector, and you couldn't see anything. And here was a film that he had quote 'made,' but was not a film."

In 1968, Manupelli began his first feature-length production, which was also his first with dialogue and a plot. He recalled its genesis at his 2009 Penny Stamps lecture: "I got a Rackham grant, surprisingly, of $5,000. My closest friends and collaborators, Bob Ashley and Mary Ashley, revolted: 'No more ambient narratives, no more portraits. Action!' Mary Ashley punned on *Dr. Zhivago* and called the film that we were about to make *Dr. Chicago*." The title role was played by Alvin Lucier, director of the Brandeis University Chamber Choir, who had befriended the Ann Arbor artists while performing with ONCE. "One problem was that he had a ferocious stutter, which was absolutely uncontrollable," Manupelli remembered. "The first lines in the film were Martin Luther King's four most important

George Manupelli's portrait of the cast of *Dr. Chicago*. Courtesy Rich DeVarti/ Dominick's

words, perhaps of the 20th century, 'I have a dream.' So Alvin began—his first words on camera, my filming of anybody's words on camera—'I have a d-d-d-d . . .'" At first Manupelli asked the rest of the cast to leave the set, but it turned out that the amiable Lucier had no problem with his stutter being incorporated into the role, and lines were even given to him that triggered it.

The other characters were also based on the actors' own personalities, which gave them a lot of freedom. "I would feed the cast a few lines and hopefully they could weave it together into something resembling a scene. And I was to make a film out of that, even though I had no sense of the dramatic art," Manupelli recalled. Another key participant was Robert Ashley, who handled sound recording and music. "The Dr. Chicago films were, to a large degree, the last great project of the ONCE Group," Ashley wrote in a 2006 letter published with the films' DVD release. "The ONCE Group thought of performance and film as part of a continuum with only a difference of technique and participation."

Manupelli's chiaroscuro camerawork, the long takes, and the bizarre, semi-improvised story and dialogue lent a sometimes Warholian flavor to the film. The meandering plot concerned illicit sex-change doctor Lucier evading the authorities with his shades-wearing accomplice Sheila Marie (Mary Ashley) and their mute friend Steve (dancer Steve Paxton, who had also performed with ONCE). Filmed west of Ann Arbor in woodsy Grass Lake, *Dr. Chicago* premiered at the film festival in March 1969 out of competition, and found favor with local audiences as well as at other festivals. "What George did is he had that wicked sense of humor about it all, and I think that a lot of what interested him was the language," Jay Cassidy recalled. "I remember being pretty knocked out by it at the time, as were a lot of people. And it partially was that he had a perfect venue in the film festival. An audience of people who were predisposed to, and had a body of experience, watching films by artists. So that made it. It was never even shown in any kind of commercial venue."

A sequel was filmed at the end of 1968 in Champaign-Urbana, Illinois, but before it was completed, a third

Flyer for a 1970 Cinema Guild screening of the first two Dr. Chicago films, designed by George Manupelli. Courtesy Rich DeVarti/ Dominick's

IF THEY'RE DOING IT, WHY CAN'T WE?

TOP: Shooting *Ride Dr. Chicago Ride* at Joshua Tree. © Jay Cassidy. ABOVE LEFT: Joe Wehrer, Claude Kipnis, and Viera Collaro in *Cry Dr. Chicago.* ABOVE RIGHT: The cast at Cranbrook House in *Cry Dr. Chicago*

ABOVE LEFT: Alvin Lucier and Steve Paxton in *Cry Dr. Chicago.* ABOVE RIGHT: Mary Ashley and Alvin Lucier in *Cry Dr. Chicago*

IF THEY'RE DOING IT, WHY CAN'T WE?

LEFT: Flyer for first screening of *Cry Dr. Chicago*. Courtesy Rich DeVarti/ Dominick's

RIGHT: Dominick DeVarti at his restaurant. Courtesy Rich DeVarti/ Dominick's

Dr. Chicago feature was shot with a $12,000 grant from the American Film Institute. With a host of new characters, including Israeli mime Claude Kipnis as archenemy Clo Clo and ONCE guest performer Pauline Oliveros playing accordion, *Ride Dr. Chicago Ride* was largely filmed in December of 1969 at the arid Joshua Tree National Monument in Southern California. "By the desert film, the people in the cast were experienced in working with one another and they were comfortable and could play things out," Manupelli recalled. "And rather than just feeding them a few lines, I wrote what I called bulletins."

The cast and crew of nearly three dozen subsisted on food driven cross-country in Buster Simpson's van by Simpson, actress/artist Viera Collaro, and editor Tom Berman. It was supplied by Dominick's. "My father and George Manupelli were pretty close friends," Rich DeVarti remembered. "He donated a bunch of food when they did the Dr. Chicago movies." Having supported the film festival from its start, the restaurant had begun covering its walls with framed flyers, tickets, and other memorabilia, and even had a breakfast pizza named after the filmmaker. "Instead of a marinara pizza sauce we put liquid egg on it, and then put the cheese on top of that and baked it. It was sort of like an omelet. You could put whatever toppings you wanted on it." *Ride Dr. Chicago Ride* premiered in Ann Arbor on April 20, 1970.

The series' final installment, *Cry Dr. Chicago*, was shot on a much larger budget of $75,000. "Tom Berman and a friend of his from New York both got their families to put up money that paid for the color, third version," Joe Wehrer recalled. Filmed at photogenic venues like Cranbrook House in Bloomfield Hills and the University of Michigan's Rackham

Building, it was shown for the first time in June 1971 at the Architecture Auditorium. The Dr. Chicago series' cast and crew had featured a host of notable locals, including Joe and Anne Wehrer, Bill Finneran, Cynthia Liddell, Allan Schreiber, Jay Cassidy, Buster Simpson, Betty Johnson, Ruth Reichl, Nick Bertoni, Robert Sheff, and Pat Oleszko, who handled costumes and also did an energetic riff on her "Hippie Strippy" burlesque routine in *Cry*.

Periodically revived at the Ann Arbor Film Festival and by Cinema Guild, the Dr. Chicago trilogy remains George Manupelli's best-known work. Unfortunately, an attempt in the mid-1970s to complete unfinished second entry *Dr. Chicago Goes to Sweden* came to naught. After an unhappy experience screening the work print in Toronto, Manupelli and his girlfriend drove around town unspooling all of the film's elements from the window of their car, ensuring that it would never be seen again. The surviving Dr. Chicago films have been preserved by Anthology Film Archives of New York.

Student Filmmakers

With Manupelli leading the way, a growing number of University of Michigan students and other locals also began to make films. While some used the cheaper 8 mm format, the more ambitious worked in 16 mm, which was necessary for the Ann Arbor Film Festival screening many strove for. Film society members comprised a significant portion of this wave of Ann Arbor filmmakers, and included Cinema II founder William Clark and Cinema Guild's Jay Cassidy, Elliot Barden, Ellen Frank, Bruce Henstell, and Andrew Lugg. The latter's many experimental shorts included festival award winner *Gemini Fire Extension*, which featured artist/performer John Orentlicher repeatedly breathing fire while a second take of the scene slowly wiped across and replaced it. Another of Lugg's films starred ONCE's Anne Wehrer. "It was an excerpt from one of Bob Ashley's 'operas' (unimaginatively titled *Excerpt*)," Lugg recalled. "Bob asked a few female friends to write down something embarrassing that had happened to them. None of them came up with anything much and Bob wrote a text himself."

> ## "IT WAS LIKE ONE SHOT, ONE TAKE. 'CAUSE THREE MINUTES OF FILM COST A LOT OF MONEY."
>
> Filmmaker Pat Oleszko

Filmmaker Andrew Lugg. © Jay Cassidy

IF THEY'RE DOING IT, WHY CAN'T WE?

RIGHT: A still from Pat Oleszko's *Footsi*, 1978. Courtesy Pat Oleszko

BOTTOM: Shooting Andrew Lugg's *Boetticher's Roost*. Anne Wehrer at right. © Jay Cassidy

Other local filmmakers included art students like Chris Frayne and Pat Oleszko, whose films reflected her playful sense of humor and were often used in her performance pieces. Like most such efforts, they were self-funded, which proved a challenge in itself. "You'd have to find the means to make the film," Oleszko recalled. "Back in the day it was like one shot, one take. 'Cause three minutes of film cost a lot of money." Buster Simpson found a way to work even cheaper, using film scrounged from the Audio-Visual Education Center's lending library. "They kind of liked me," he recalled. "They let me come in and go through their trash can and pull out all kinds of footage that I collaged together." He spliced the clips backward and recorded an authoritarian-sounding audio track. "It unified unrelated images that ended in the collapse of a

large factory smokestack." Simpson's film was added to the festival tour.

Another group of filmmakers came from Robert Davis's speech department cinematography class, which was oriented toward more conventional narrative styles. Unlike the off-the-books course George Manupelli had started at the art school, Davis had official backing, and in 1966 added several new cameras and more editing equipment to the Bolex camera that was already available. His students' work included *Inevitably*, a documentary about nursing-home residents by Ida Jeter and Doug Vernier that author Thomas Fensch described as "such a strong psychological study of old age that most college-aged audiences refuse to watch it." Fensch's 1970 book *Films on the Campus* also praised efforts by Davis students Jan Onder, Ed Van Cleef, Morleen Getz, Terry Jones, and Alexander Keewatin Dewdney.

Dewdney was a Canadian graduate student in mathematics who had also begun working with Manupelli. After making several experimental shorts including *Scissors* and *Malanga*, he conceived his 1967 film *The Maltese Cross Movement* while taking the hallucinogenic drug DMT, according to Fensch. Mixing black-and-white and color footage, it featured quick cuts between people, objects, and an animated image of a projector gear over a fragmented, repetitive soundtrack of voices and music. The film was accompanied by a 24-page booklet of collages and poetry Dewdney had designed. "It's actually my whole life," he told Fensch. "All the experiences I have ever had, all the emotions that I have ever felt, are in the film in some fashion or another." Late 1960s experimentation with psychedelic drugs seemed a natural fit for the no-rules, non-narrative style of experimental

ABOVE, FROM LEFT: Paula Shapiro, Richard Rattner, and Terry Jones in a film directed by Morleen Getz. © 1966 MLive Media Group. All rights reserved. Used with permission

LEFT: Cover of *The Maltese Cross Movement* booklet

IF THEY'RE DOING IT, WHY CAN'T WE? 119

Frames from *Best of May*, 1968. Courtesy Jay Cassidy

filmmaking, and while Andrew Lugg recalled that, "There were a fair number of trippy films back then," it was not necessarily a primary influence. "Drugs were around but not everywhere." *The Maltese Cross Movement* and Dewdney's 1971 short *Wildwood Flower* have been preserved by the Academy Film Archive.

Future Oscar-nominated editor Jay Cassidy remembered his own days as a student filmmaker: "You're doing it with your friends, that was pretty much the structure. You knew that you had an audience in the Ann Arbor Film Festival, so it wasn't an endeavor that no one would ever see." Acknowledging that "our writing ability was probably not as evolved as our photographing ability," Cassidy said Manupelli's annual forum for the best in experimental filmmaking upped his game. "You knew if you made a film and it was accepted by the film festival, even though there might be prejudice for the local folk, you were going to be judged right up against them. So you'd better be careful what you do." One Cassidy short, *The Best of May 1968*, used material obtained while he worked for Guggenheim Productions on ads for George McGovern's 1972 presidential campaign. "That was made from found film of camera footage from American fighters, dropping a variety of different kinds of ordnance over Vietnam, and some home movies that a guy shot in Vietnam," he recalled. Cassidy's silent, unsettlingly beautiful commentary on the war has also been preserved by the Academy Film Archive.

The experimental aesthetic did not always translate well beyond the film festival, however, and could shock people on both ends of the political spectrum. When Commander Cody and His Lost Planet Airmen headlined Hill Auditorium in April 1971, just a month after their impromptu acoustic performance at the festival, a 16 mm documentary short called *Summer '70: Ann Arbor* was also on the bill. With Peter Wilde in the projection booth, someone had the idea of showing Buster Simpson's recent festival entry *Rumpf Truck Company* during one of Cody's songs. It started off well, but when footage of 18-wheelers transitioned to a driver's inner fantasy life, some attendees became outraged. John Briggs was with Wilde in the booth. "It showed the cab of a semi-truck, and stretched

"THERE WAS NOTHING GOING ON SEXUALLY AT ALL. I THOUGHT THIS WOULD BE ART, YOU KNOW?"

Actress Ann Levenick

across the dash was a naked woman. All of a sudden there's a pounding at the door. There's this woman, and she is incensed. She's just beside herself. 'This is not right! You shouldn't be doing this!'" As the film continued to play, Wilde tried to reason with the angry visitor. "He's engaging her in a conversation, and all I'm thinking is, 'She's shooting herself in the foot.' Because while she's talking and he's talking, the film is still going on and it's not that long. And pretty soon it was done and she's going, 'Oh, crap.'" According to Genie Plamondon's report in the *Ann Arbor Sun*, "People started yelling from the audience, calling the band sexist pigs. A group gathered in back. The band got uptight about the show being stopped and being called names, and eventually about 30 people took over the stage." After bandleader George Frayne, who had not seen the film beforehand, apologized, "finally one sister got up and suggested that all the people who supported the action should leave the building together—it was unanimous that it was a good idea, so they split and the music continued and everyone got down

Poster for the April 1971 Commander Cody concert by Chris Frayne. Courtesy Michael Erlewine

IF THEY'RE DOING IT, WHY CAN'T WE? 121

to a good time again."

Lost Planet Airmen guitarist Bill Kirchen was facing the audience and couldn't see the movie playing above him, but sympathized with the protesters. "It's serious shit. I understand that. But on the other hand, that was kind of early in its genesis, I think, for public awareness of that. And it was all in the Ann Arbor sort of semi-lighthearted spirit. I don't want to make light of it." Noting that he had had a friendly conversation with one of the women who climbed onstage, he added, "I have kind of good memories of it. You know, 'Point well-taken.' It wasn't ugly. It was sort of OK." Tape was rolling at Hill that night and boogie-woogie novelty "Beat Me Daddy, Eight to the Bar," a hit for the Andrews Sisters and others in the 1940s, was chosen for inclusion on the band's debut album. "At one point during a piano solo, you could hear 'Sexist pigs!' in the background. You can listen to it and hear that," Kirchen recalled.

Having received praise for his work at the film festival, Buster Simpson didn't anticipate that the movie would cause such a reaction. "It was intended as a riff on pop dashboard art, a plastic Jesus, a plastic nude. Whatever a trucker would adorn the dashboard of their truck cab. Trucker art. I still see truck mud flaps with the shiny metal figure of a nude attached to the rubber." He characterized his attitude as "less exploitive, just young and naive to issues that it could be judged by." The actress who lay across the dash had no problem with it, however. "I just thought it was sort of funny," Ann Levenick remembered. "There was nothing going on sexually at all. I thought this would be art, you know?" The low-budget shoot, which took place as Simpson's van headed west on I-94, required ingenuity. "I took my clothes off, I wrapped up in something, and then I sat in the front seat. And then when we got out on the expressway, I had to climb up on the dashboard, and every time a car would come by, I had to jump back down and cover up, 'cause they were so worried. It wasn't like we were just driving down the road, doing this. It wasn't like we had a crew or anybody. It was just real." Though the police didn't spot them, another driver apparently did. "I remember that there was a person that did drive by and see me and then would get off the expressway and come back around again."

As interest in filmmaking surged on campus, many of those who wanted to get involved were stymied by a lack of access to equipment. In December of 1966, Cinema Guild's Andrew Lugg wrote a detailed proposal to the group's board urging the purchase of $4,000 worth of camera and editing gear for use by all students on campus, but the *Flaming Creatures* case quickly short-circuited the plan. The idea was taken

(Photo J. Tiboni)
ANDY, AIRMEN FIDDLER, FACES SISTERS' SCORN.

Protester on stage at Commander Cody concert. Photo by Joe Tiboni, *Ann Arbor Sun*

up again several years later by a group of Residential College undergraduates led by aspiring filmmaker David Greene, a junior who was also a member of Cinema Guild. "I founded the Ann Arbor Film Cooperative as a student organization in the fall of 1970 with myself as president, Michael Priebe as treasurer, and Neal Gabler as secretary. Freddy Sweet was our faculty advisor," he recalled. "The university had no resources available to students for making films. Since I wanted to make a film, I started the Coop as a way to raise money that would defray some of my costs." Over the next few months, more than three dozen interested people joined the group.

Showing movies one night per week in Angell Hall Auditorium A to frequently sold-out audiences, in its first semester the AAFC recorded a profit of $3000, enough to buy 16 mm editing equipment and help support production of Greene's experimental feature *Pamela and Ian*, which was filmed between November 1970 and March 1971. Inspired by the writing of Alain Robbe-Grillet, the title characters, who are involved in a bisexual love triangle, sometimes interact with their offscreen director, who makes comments like, "Once the projector is turned off, you will all disappear. You cannot exist when the film is over."

Cinematographer Freddy Sweet took on several technical challenges, including a scene in which the camera rotates between three characters without cuts for six minutes, gaining speed as it goes along. Because it had to be tethered to the sound recording equipment, Sweet devised a way to

Some of the cast and crew of *Pamela and Ian* in front of East Quad. Left to right: Michael Priebe, Ian Stulberg, David Greene, Ellen Frankel, Katie Reifman, Jim Watson, Pam Seamon, Ruth Rankin, and Geoff Stevens.
© David Greene

IF THEY'RE DOING IT, WHY CAN'T WE?

TOP: Shooting *El Triciclo*. Left to right: Andre Butts, Ken Schultz, John Caldwell, Jim Watson, unknown, Luis Argueta, and David Robinson.
© Luis Argueta

wind enough cable around the tripod to keep the devices connected while it spun for the length of the scene. To hide the lights during the 360-degree pan, he put aluminum foil on the ceiling and used floor-positioned lamps to illuminate the actors. Produced on a budget of $6,000 (much of it borrowed from friends), the 87-minute, black-and-white *Pamela and Ian* premiered on campus in September 1971 and was also shown at the film festival.

While few if any other films were produced by the AAFC, its members helped out on another ambitious local feature two years after completing *Pamela and Ian*. Director/writer/editor/actor Luis Argueta had originally come to the university from Guatemala to study industrial engineering, but became interested in film after taking an uncredited Free University class. After making a pair of 8 mm shorts, when his first 16 mm effort made back its $300 production cost via the Ann Arbor Film Festival tour's $1 per minute screening fee, in January 1973 Argueta began a full-length project. Based on three plays by Fernando Arrabal, the interconnected stories of *El Triciclo* center on a trio of ne'er-do-wells whose surreal adventures bring to mind the work of Fellini and Buñuel. With the AAFC's Jim Watson on assistant camera and film festival co-manager John Caldwell on sound, the cast also included Peter Wilde as a policeman and Anne Wehrer as a hotel maid. Locations included the Wehrer home, the Michigan Theatre, and a Marshall, Michigan, junkyard owned by the parents of *Pamela and Ian* co-star Ian Stulberg.

Cinematographer David Robinson borrowed camera and sound gear from the better-equipped filmmaking program at Ohio University, but Argueta used local resources to complete his edit. "The Coop helped by providing the office space where I placed a two head (one sound—one picture) upright (black) moviola that often would chew many sprocket holes of the work copy which I bought to edit the film." The shoot had also presented challenges. "On the first day of filming we arrived at Dexter-Huron Park and found the trees and the ground covered with about a foot of fresh snow. Without any hesitation we went

to Dexter, bought high rubber boots for everyone in the crew and cast and proceeded to plow a path with a four-by-eight sheet of plywood so as to provide a tricycle track. We were making movies and in the movies everything is possible." With dialogue primarily in Spanish, *El Triciclo* debuted at the 1975 Ann Arbor Film Festival and officially premiered at the local Matrix Theatre two weeks later. Continuing to work with Coop members like Jim Watson (himself later a director/producer of documentaries and children's television programs), Argueta went on to a career in film that included the migrant worker documentary *The Cost of Cotton* and *El Silencio de Neto*, the first film submitted by Guatemala for consideration for a Best Foreign Language Film Academy Award.

Destroy All Monsters

Perhaps the most wildly experimental Ann Arbor filmmaker of the early 1970s was Cary Loren. As a suburban Detroit teen, he had begun making movies with friends, and submitted several of his early efforts to the Ann Arbor 8 mm Film Festival. Intrigued by articles he read about *Flaming Creatures* director Jack Smith but unable to see his films, he wrote Smith a letter and was invited to visit him in New York, where Smith exhibited Loren's films at the Millennium Film Workshop. In the fall of 1973, the 18-year-old Loren moved to Ann Arbor with his girlfriend and collaborator Niagara, and they began producing multimedia performance art that incorporated film. "We found a loft on Hill Street across from the White Panther Party house. We did midnight screenings and weird theater things with odd music. Freaks and local artists became our actors and helped out. We built sets and had midnight happenings which were free. And we'd start filming those too."

U-M art school students Mike Kelley and Jim Shaw took a liking to the couple's work, and the four of them soon formed a creative collective they called Destroy All Monsters, after a 1968 Godzilla movie. It also incorporated

"WE WERE MAKING MOVIES AND IN THE MOVIES EVERYTHING IS POSSIBLE."

Director/writer/editor/actor Luis Argueta

DAM flyer from Hill St. event, 1973.
Courtesy Cary Loren

IF THEY'RE DOING IT, WHY CAN'T WE? 125

an experimental noise-rock band. "We would go to different frat parties and say, 'Do you want a band?' We were holding our instruments. We looked like a band. We had long hair and were weird, and Niagara was really stunning. All of a sudden we'd start playing and screaming, and blood would be flowing. It would just be something they did not expect." With film equipment borrowed from Eastern Michigan University or bought with money he earned delivering pizzas, utilized a mermaid costume liberated from the U-M drama department. "It was really beautiful, sequined, and had a big tail. So we decided to make this mermaid film. We got in a car, drove to Miami Beach, and did it." Most of Loren's films were made in Super 8, with just *The Blood of God* shot in 16 mm, but many of his ideas were never filmed due to budget limitations. "I would sketch out what the subject would be and what the outline was and

Niagara in *The Horror of Beatnik Beach*, 1974.
© Cary Loren

Loren's work came to incorporate a wide range of elements, including scenes from the group's theater pieces, found footage from silent or monster movies, stop-motion animation, scratching and drawing on the film stock, and primitive video effects, often layered on top of each other with rapid cuts. One film, *The Horror of Beatnik Beach*, would photograph them as Polaroids or black-and-white stills. So I made little films like that, I guess they were sketches you'd make before you filmed, with actors in costumes and scenes that I'd write down and photograph. Most of those never were made into movies. They just remained outlines."

Despite prolific efforts on multiple

126

CINEMA ANN ARBOR

fronts, Destroy All Monsters initially made little impact. "This was a cult thing when it happened. And I don't think we had an audience. There were no more than 30 or 40 people that maybe knew about us." In 1976 Kelley and Shaw moved to LA to pursue successful art careers, and the band morphed into a popular Niagara-fronted punk rock outfit with ex-members of the Stooges and MC5. But when the original collective's work was rediscovered by Sonic Youth's Thurston Moore (whose bandmate/wife Kim Gordon was close friends with Kelley), the broader spectrum of Destroy All Monsters' early efforts were anthologized in archival music, video, and print collections. Loren himself continued to produce a variety of art and film projects of his own, sometimes with his old compatriots, as well as running the eclectic Detroit-area shop Book Beat.

The highest-profile movie shot in Ann Arbor during this era was never officially released. *Ten for Two* was made to document the December 1971 John Sinclair Freedom Rally, held at Crisler Arena to raise funds and awareness for the ten-year prison sentence the Ann Arbor–based writer and political activist had received for possession of two joints. It was headlined by John Lennon and Yoko Ono, who appeared along with Stevie Wonder, Phil Ochs, Allen Ginsberg, Commander Cody, Bobby Seale, Jerry Rubin, and a host of other musicians and activists. The film was directed by Steve Gebhardt, who had worked with Lennon and Ono on several short films, including *Fly*. Jay Cassidy recalled that Gebhardt "had gotten to know George through the film festival," and Manupelli was hired to be one of four camera operators, with other locals, including Cassidy and Joe Wehrer, also on the crew. Shot in 16 mm and blown up to 35, after the Lennon-Ono produced film was completed, a print was given to Sinclair, whose release from prison had serendipitously occurred just three days after the event. The world premiere was held at the Fifth Forum in December 1972 to benefit Sinclair's Rainbow People's Party, and it was shown in Ann Arbor occasionally, including by Cinema Guild, but *Ten for Two* was not widely seen. A few weeks after the concert, the US government

George Manupelli filming *Ten for Two* at Crisler Arena, December 10, 1971.
© Andy Sacks

IF THEY'RE DOING IT, WHY CAN'T WE?

had ordered John Lennon's deportation due to his own British cannabis conviction, and the film's release was put on hold and Lennon's political activism curtailed as his lawyers fought to keep him in the country. "Though we did have local screenings, Yoko Ono chose not to release it for general viewing," Joe Wehrer recalled.

The AVEC

A less visible but important contribution to the local filmmaking scene sprang out of the vast body of work sponsored by the university itself. Along with countless feet exposed by the athletic department, hospitals, and researchers, and dozens of educational productions made for broadcast by the speech department–affiliated U-M Television Center, a unit called the Audio-Visual Education Center sometimes took on more creative projects. Growing out of the 16 mm lending library established in 1937 by the university's extension service, in the late '40s the AVEC began making films of its own for both educational and promotional purposes. The latter had been deemed important as early as 1915, when the Alumni Association distributed a silent short featuring campus scenes.

The AVEC's output ranged from color films showcasing the school, like the 1951 *We'll Remember Michigan*, to purely educational titles, like 1955's *The Locks of Sault Ste. Marie*, which used scale models and staged re-creations to mark the centennial of the state's famous waterway. By that time the unit was producing a half-dozen or more films per year, which were overseen by Cuban-born production supervisor Aubert Lavastida. "He was one of the most interesting people to work for because he was a travel adventurer, and he made lecture films," recalled Doug Rideout, who joined the unit in 1962 after studying filmmaking in Boston. Lavastida's own efforts, like *South America Coast to Coast*, billed as a document of the first surface crossing of the continent, were regularly presented to interest groups and on television.

Though Rideout recalled that when he started, "They didn't have the technical capability to do a lot," in the 1960s production began to increase. "You name it, medical, athletic, in the classroom, they were all quote 'educational' oriented," he remembered. "But they really weren't. They were all kinds of subjects." His work ranged from filming the historic first heart transplant on a dog to shooting color footage of the 1965 sit-in at the Ann Arbor draft board, which was later incorporated into a film commemorating U-M's sesquicentennial. Other projects included a short about amputees that he persuaded George Manupelli to act in, and another on football fatalities, which Rideout edited

1960s AVEC logo sticker from a 16 mm film can

Shooting the AVEC film on the Soo Locks, 1954. BHL

for medical school professor Dr. Richard Schneider. "He gathered film of the moment of impact when these football players had been killed on the field. I froze the frames when the student was about to be killed. All the tactics are there, and I had arrows and everything that pointed exactly to 'watch this runner, see what happens.'" Because of Schneider's efforts, the NCAA instituted changes to helmet design.

While his day job was making educational films, Rideout was a dedicated attendee of the Ann Arbor Film Festival, and made himself available to students seeking assistance or professional experience at a time when the university's film classes were minimal. In addition to hiring local experimental filmmakers like Andrew Lugg to crew shoots, he advised others like Cinema Guild member and future Oscar-winning visual effects supervisor John Nelson. "We did a lot of work with students who were interested in film," Rideout remembered. "A lot of them had nowhere to turn, so they saw me, and they said, 'Hey, can you help us?' A guy had shot a film in Thailand, and he just had all this footage, and he didn't know what to do with it. So I said, 'I know what to do with it,' and made a little film called *The Rice Cycle of San Sai Thailand*. It turned out to be a halfway decent little film."

Andrew Lugg was one of those who depended on the

Advertisement for one of Aubert Lavastida's film screenings, 1949

IF THEY'RE DOING IT, WHY CAN'T WE? 129

AVEC 16 mm film library, 1950s. BHL

Though Rideout had begun making the film in 1966, it was not completed until 1972, when ONCE had been disbanded for several years and the subject was less current. Available for rent through the Audio-Visual Education Center catalog, this important document of Ann Arbor's avant-garde was not widely seen.

Other local films made by non-university affiliates ranged from the efforts of Super 8–wielding high school students to those of future Ann Arbor Silent Film Society founder Arthur Stephan. Having shot occasional bodybuilding competitions and a black-and-white industrial film for local manufacturer American Broach (*Let's 'Broach' the Subject*) which incorporated poetic, silent-inspired lap-dissolves, in 1975 Stephan tackled a more personal project. *The Shlamozzle* was a 55-minute, 8 mm silent comedy produced with members of the Ann Arbor Comic Opera Guild. The organization had originally recruited the Vienna-trained composer/conductor to direct its production of *Die Fledermaus*. "In the course of getting to know Art, we found out that he was a film buff," the Comic Opera Guild's Tom Petiet recalled. "He wanted to make a silent film. I said, 'That'd be kind of fun.'" Petiet wrote and directed the story of the hapless title monster emerging from radioactive Huron River sludge, with Stephan shooting, editing, and creating the music score. "It looks like something that could have been made in the '20s," Petiet remembered. "That's what Art wanted." Shot at familiar spots around Ann Arbor, *The Shlamozzle* incorporated evocative moments like a backlit pistol duel staged in obvious tribute to Clarence Brown's 1926 *Flesh and the Devil*. Following its November 1975 premiere at the Michigan League, the film was screened at the Ann Arbor 8 mm Film Festival. "Of course, there was no category for something like this, so they gave it honorable mention," Petiet recalled.

While films would continue to be made in and around Ann Arbor (including a brief spate of Hollywood productions ca. 2010–12 facilitated by a state tax incentive), experimental filmmaking appeared to peak around the time George Manupelli left town in 1972. That year, formation of a distribution cooperative called Ann Arbor Eye was announced, modeled on organizations like Canyon Cinema, but it failed to reach critical mass and quickly vanished. Motivated students, particularly those at the art school and in the more commercially oriented production classes of Robert Davis's successor Frank

Beaver, would nevertheless continue to make short experimental films, some of which were screened at the film festival. Several ambitious efforts did not get off the ground, however, including the Ann Arbor Film Cooperative–sponsored, member-made "Street Stuff," which was never completed, despite considerable effort and expense.

One additional local filmmaking phenomenon of note was the production of low-budget horror features inspired by the success of drive-in hits like George Romero's *Night of the Living Dead* and Tobe Hooper's *The Texas Chain Saw Massacre*. Probably the first of these was the 1976 release *The Demon Lover*, filmed near Jackson, Michigan, and featuring *Chain Saw* actor Gunnar Hansen. Co-director Donald G. Jackson had grown up in Adrian, an hour southwest of Ann Arbor, and was a regular at the film festival. Friendly with George Manupelli, he had served as a festival juror and chose *Demon Lover* cameraman Jeff Kreines after seeing a film Kreines had submitted. To Jackson's dismay, a documentary Kreines's girlfriend, Joel DeMott, made during the shoot, *Demon Lover Diary*, portrayed him harshly and garnered better reviews than his own film. Jackson nevertheless continued to write, direct, and shoot dozens of ultra-low-budget, sometimes-unscripted features, like *Hell Comes to Frogtown* and *Roller Blade*, until his death in 2003. In his final interview, Jackson cited Manupelli's *Dr. Chicago* as one of the films that had most inspired him.

Other area exploitation productions included a pair of late-1980s efforts which used numerous Ann Arbor crew members. Tom Chaney's *Wendigo* (a.k.a. *Frostbiter*) starred Stooges guitarist Ron Asheton, who also composed the music, while epidemic-themed *The Carrier* was shot in nearby Manchester by U-M alum Nathan White and included his former professor Hugh Cohen in the cast. "I remember being an extra in *The Carrier*, all wrapped up in plastic on an excruciatingly sweltering day. I remember his one direction when I shouted out my—one—line: not to articulate so precisely, to sound more like the locals. He was right, of course."

A frame from *The Shlamozzle*

The Carrier, 1988

IF THEY'RE DOING IT, WHY CAN'T WE?

CHAPTER 8
REVOLUTIONARIES AND RIPOFFS

IN THE EARLY 1970S, the University of Michigan film scene began a period of rapid growth led by the Ann Arbor Film Cooperative (AAFC). Though it had been founded to raise money for filmmaking, from its September 1970 debut, the group's screenings drew sizable audiences, making it clear that campus filmgoers had a much larger appetite for movies than Cinema Guild and Cinema II could satisfy. In early 1971 the AAFC also added to the local calendar a festival of 8 mm films, the latest iteration of a concept that had been offered by the Ann Arbor Film Festival, Canterbury House, and Cinema II, which became an annual weekend-long event.

Two other new exhibitors were emerging around this time as well. One was the Orson Welles Film Society, which, despite its lofty name, appeared a more or less solo operation with no clear mission, while the second was tied to a political collective called American Revolutionary Media (ARM). Many of ARM's members had moved to Ann Arbor from Detroit, and in 1969 the organization became involved with the Radical Film Series that Canterbury House launched to screen topical films, like *Dutchman* and *Hanoi 13*, before splitting off to start the University of Michigan Film Society. ARM's appearance in town had followed a similar migration from Detroit by John Sinclair's Trans-Love Energies community and rock band the MC5, which had launched the revolution-promoting White Panther Party and sometimes clashed with other local activist organizations, especially ARM.

ARM had other enemies as well. On March 16, 1971, the *Daily* published an editorial by the group which claimed that University of Michigan Film Society screenings, from which it admitted, "We derive our basic subsistence," were being sabotaged by a mysterious opponent called DisARM. This adversary was said to have made threatening phone calls, defaced flyers, and even falsely placed ads in the paper announcing its screenings were canceled. The jargon-filled statement went on to note: "ARM is a small collective—nine women and men in all, five regularly in Ann Arbor. We are committed (existentially) more than either politically/culturally to develop ourselves and our example of Liberation through Self-Determination for some masses of people, in media practice."

ARM also fought with the Orson Welles Film Society. In August 1971, both groups announced screenings of the recent hit *They Shoot Horses, Don't They?* for the same night, then issued ads and leaflets blaming each other for the confusion. When the Welles organization was subsequently accused of fraudulently booking films under the names of other groups, including Cinema II, reserving auditoriums under false pretenses, damaging projection equipment, and even chaining the doors of the Natural Science Auditorium shut to prevent a competing screening, the Student Government Council launched an investigation. It soon came to light that the group's founder had, while a student at Cornell, twice been tried and acquitted of grand larceny for similar film-related misbehavior and was facing charges in Ann Arbor of stealing $2,000 worth of projection gear. "It was completely sketchy," Cinema Guild's Jay Cassidy recalled. "It was in the summer, so he could get away with it." In October 1971, the Orson Welles Film Society agreed to disband and transfer any remaining funds to the student government for the purchase of projection equipment.

OPPOSITE:

© Laura Wolf

REVOLUTIONARIES AND RIPOFFS

the ann arbor film cooperative
winter 1971

january

12 yellow submarine
14 yellow submarine
19 psycho
21 east of eden
26 repulsion
28 8 ½

february

2 2001
4 2001
9 elvira madigan
11 bedazzled
16 goodbye columbus
18 the trial
23 z
25 z

march

9 taming of the shrew
16 phantom of the opera & 7th voyage of sinbad
18 alfie
23 loves of isadora
25 african queen
30 casino royale

april

1 night at the opera
6 the fox
8 last summer

angell hall
auditorium a

7 & 9:30
tuesday & thursday

75¢

The Ann Arbor Film Cooperative's second semester schedule, designed by David Greene. Courtesy David Greene

The AAFC's Off-Campus Experiment

The Ann Arbor Film Cooperative, meanwhile, was looking to expand following a successful summer in which it had added screenings halfway through. In September of 1971, its programming was doubled to include both weeknight shows in Angell Hall and Monday through Thursday screenings at the recently opened Alley club at 330 Maynard, which Canterbury House had just vacated to cut costs. Located a block from campus, the new venue's primary draw was weekend blues concerts by artists like Muddy Waters and Albert King, booked by local impresario Peter Andrews. It also incorporated a record shop and pinball parlor that offered a generous "five balls per game," according to its *Daily* ad.

Touting installation of a projection booth, a new screen, and new sound equipment, the AAFC's Alley Cinema began to feature more experimental fare, including a night of films by Maya Deren and recent film festival winner *Akran* by Richard Myers. AAFC founder David Greene remembered, "We wanted a place to show independent/experimental films, since those weren't typically included on the larger film societies' programs." Titles were selected by a group that included Greene, Jim Watson, and future *Celluloid Closet* cinematographer Nancy Schreiber, who recalled: "I learned so much about filmmaking while managing and watching mostly foreign and experimental films every glorious weekday evening. I really immersed myself in the Nouvelle Vague and it was truly a film school for me."

But as the fall progressed, it became

In the Natural Science Auditorium the screen for an ARM movie is blocked by a jammed chalkboard. "Sorry, compliments of DISARM" has been partly erased. Photo by Denny Gainer, *Michigan Daily*

REVOLUTIONARIES AND RIPOFFS

clear that things were not going well, with at least one screening attended by more staff members than paying customers. In November the film society ran a half-page *Daily* ad promoting a chartered flight to the Rose Bowl in an apparent bid to raise funds, but within a few weeks the entire Alley operation was shut down. "While the scope and quality of our curating were excellent, the project was an abysmal failure financially," Jim Watson remembered, noting that an AAFC board member who had originally opposed the project "led the move to kill us off." Blues booker Peter Andrews attributed the venue's closure to several other factors as well. "There was no liquor license," he recalled. "And it wasn't the ideal club. It wasn't that big."

Following the demise of the Alley, the AAFC was again reduced to screening films in Auditorium A of Angell Hall on Tuesday through Thursday nights. Along with recent hits like *Yellow Submarine*, in February 1972 the group advertised a "'Cult' Film Double Bill" of *The Abominable Dr. Phibes* and *Psych-Out*. The pairing of a campy Vincent Price horror film with one starring a pre-fame Jack Nicholson as the ponytailed leader of a San Francisco rock band signaled a new shift toward offbeat subject matter. Exploring the outer fringes of cinema would soon come to replace the organization's original mission of supporting filmmakers through equipment purchases and education.

AAFC founder David Greene recalled: "There was always quite a bit of controversy in the early days of the Ann Arbor Film Coop about what films to show. The original mission was to make money to support filmmaking. For some that meant showing highly commercial films, regardless of their pedigree.

TOP: Alley poster by Gary Grimshaw. Courtesy Michael Erlewine
BOTTOM: Advertisement for the opening show at Alley Cinema

Others wanted us to concentrate on popular films with artistic merit. Others wanted to only show films that were important, artistic films. Eventually, the programming of films became such a primary endeavor for the board that the AAFC morphed into a film society that was more like Cinema Guild and Cinema II, that is, concerned with programming films liked by the board members. After I left, the goal of acquiring filmmaking equipment, editing equipment, and funding film projects were all abandoned, much to my dismay. I gave an impassioned speech about it when I left, but it didn't change anyone's mind, and by then AAFC was much bigger than me, so I let it go."

It was only a short time after the Alley was shuttered that the space was taken over by ARM. Renamed Conspiracy, it was advertised as "a social, cultural, political space positively oriented to the question of liberation" and offered coffee, natural food, theater, music, and movies. Plans were also announced to create a media access center with "$10,000 worth of new half-inch video equipment" that was to be funded in part by a summer 1972 concert series at Hill Auditorium. Slated to include the Coasters, Drifters, Captain Beefheart, Charles Mingus, and the Mahavishnu Orchestra (the Rolling Stones having "turned down our offer of $40,000"), the ambitious series quickly collapsed, and tickets were refunded for all but solo performer John Fahey amid grumbling about the exorbitant costs and claims of a lawsuit against Captain Beefheart. ARM did manage to open a scaled-down media center with two Sony Portapak cameras, which sponsored a production seminar and made a video with inmates at nearby Milan Prison.

Along with the usual campus film fare, Conspiracy's movie offerings included Ann Arbor premieres of Steven Arnold's erotic art feature *Luminous Procuress* and Norman Mailer's vanity project *Maidstone*. Its programming was strong enough that Neal Gabler briefly proclaimed it "the second-best society on campus" in a September 1972 *Daily* story. "It looks like some half-finished, cinder-block basement rec room," he wrote. "Before each film there is usually a short spiel about upcoming Conspiracy events with a pinch of radicalism for flavor—a raised fist and 'All power to the people!'"

By the fall of 1972, ARM had also resumed showing films in University of Michigan venues like the recently

Conspiracy calendar cover

REVOLUTIONARIES AND RIPOFFS

UAC · DAYSTAR presents

April 21 Fri
(day classes end)
Hill Aud
8 p.m.

Reserved Seats
$4.50
$3.00
$1.50

KRIS KRISTOFFERSON
also Bonnie Raitt and Jonathan Round

help keep our music in Hill - smoking only in Lobby please

Tickets go on sale Monday, March 20
Michigan Union 12 noon-6 p.m.
Starting Tuesday at Salvation, Maynard St.
and in Ypsi at Ned's Bookstore.
SORRY, NO CHECKS

COME

Spring approaches

we now have:

seeds, all kinds, for the organic garden
- organic & natural fertilizers, compost starter
- gardening books & tools
- ice cream makers - fruit presses
- food & grain mills and more...........

not to mention all our natural regulars
- organic grains, nuts, seeds, beans, oils, dried fruits, soy products, stone ground flour, vegetables, cider, sprouts, soybean curd, cheeses, yogurt, etc............

questions, answers, news, information
all about natural foods

Eden Foods
211 S. State St.
Ann Arbor
761-8134

come
see
us
&
chat

Conspiracy CALENDAR

Wait Until Dark
-Academy Award Winning Chiller-
AUDREY HEPBURN ALAN ARKIN
Blind upper-middle class housewife beset by Syndicate killers. Builds enormous tension to a stunning conclusion. 7:30 & 9:30 p.m.
$1. contribution free cider, etc.
Tues., Mar. 21

Dada-Loco
farout 8-piece jazz-rock DANCEBAND from Madison, Wisconsin
sets at 7:30 & 10:00 p.m.
DANCE ALL NIGHT for $1.50
Wed.-Thurs. Mar. 22-23

Whatever Happened to Baby Jane?
BETTE DAVIS JOAN CRAWFORD
Two of Hollywood's greatest stars in a geriatric tour-de-force of horror.
7:00 & 9:30 p.m. $1. free cider.
Fri., Mar. 24

Going Down the Road
Excellent Canadian film of two drifters from the Maritimes trying to get something together -- anything -- in Toronto. The ultimate rarity; a vital, realistic film about working class life; earthy and quite intelligent.
Canadian conversation after the film. $1. free cider
Sat.-Sun., Mar. 25-26

SALAMANDER
& Carl Adams
food, music and vibes.
$1. all night cider.
sets: 7:30 & 9:30
Tues., Mar. 28

Loves of Isadora
-Cannes Festival Prizewinner-
VANESSA REDGRAVE's brilliant recreation of the romantic dizziness and brilliance of Isadora Duncan, "high priestess" of modern dance. 7:30 & 9:30 p.m. free cider
Wed.-Thurs., Mar. 29-30

Anne of the Thousand Days
-Academy Award Winner-
GENEVIEVE BUJOLD RICHARD BURTON
Unforgettable performance by Bujold in distinguished adaptation of Sherwood Anderson play. 7:00 & 9:30 $1. free cider
Fri.-Sat., Mar. 31-Apr. 1

Diary of a Mad Housewife
CARRIE SNODGRESS RICHARD BENJAMIN FRANK LANGELLA
Frank and Eleanor Perry's best film; oppressed and restless wife of rising young New York corporate lawyer steps out with brilliant, self-centered young novelist. Things are bumpy all over, but you feel you understand them better with this fine film. 7:30 & 9:30 p.m. $1. free cider
Tues.-Wed., Apr. 4-5

Mark R.
& Rick Rubarg
original contemporary folk
12-string guitar $1. cont.
sets at 7:30 & 9:30 p.m.
Thurs., Apr. 6

Maidstone
- Ann Arbor Premiere -
NORMAN MAILER's new film - "Brilliant"
sez N.Y. TIMES.
Fri.-Sun., Apr. 7-9

Ann Arbor Theater Co.
TOBACCO ROAD
- PREMIERE SHOWCASE PRODUCTION -
Original adaptation of Erskine Caldwell novel by Ann Arbor's newest theater co.
8:00 p.m. $1.50
-Note: CONSPIRACY will be closed Tuesday and Wednesday nights for set rehearsal.
Thurs.-Sun., Apr. 13-16

First Annual Independent Video Process
Mon.-Fri., Apr. 17-21

Luminous Procuress
MIDWEST PREMIERE
Steven Arnold's first feature: head film of sexual discovery.
Sat.-Sun., Apr. 22-23

N.Y. Erotic Film Festival
EXORCISE YOUR DEMONS!
Mon.-Sun., Apr. 24-30

completed Modern Languages Building, whose ground-floor auditoriums 3 and 4 seated 550 and 390, respectively. But like the Alley before it, the Conspiracy coffee house project soon faded away, and the group adopted yet another identity as student film society Friends of Newsreel. The frequent name changes and sanctimonious self-promotion rubbed some the wrong way, including projectionist Peter Wilde, who commented in a 1973 letter to the *Daily*: "Newsreel has the services of a Madison Avenue mind which can manipulate civil libertarian sentiments as surely as a blue package sells soap."

New World

ARM was no longer the only activist group showing movies on campus, however. The New World Film Cooperative had begun operations as Collective Eye at the People's Ballroom, part of a community center located in a former car dealership behind the Michigan Theater. When it closed following a December 1972 arson fire, the rechristened New World also began using the Modern Languages Building. Group spokesman Dallas Kenny told the *Ann Arbor Sun*: "We try to show people's films, that will expose the root causes of society's problems; we want to create a democratic forum of issues that will let people get to the truths that are not available elsewhere and educate people about third-world liberation struggles and the nature of modern imperialism and the consumer-oriented cultures that imperialism and colonialism seek to establish." Along with student-appeal music films like *Monterey Pop* and *Gimme Shelter*, New World presented a free international documentary series at the undergraduate library. While access to campus auditoriums was theoretically only granted to organizations with student members, such status was not hard to achieve at the time. According to the *Ann Arbor News*, Kenny was considered a U-M freshman because he had taken a single economics class during the spring-summer term, paying tuition of just $156.

Facing so many new competitors, Cinema Guild and Cinema II fought back by boosting their own weekly offerings. Combined with what New World, Friends of Newsreel, and the Ann Arbor Film Cooperative were showing, local moviegoers now had nearly triple

OPPOSITE:

Conspiracy calendar, 1972

New World calendar, 1974

Flyer for a New World screening

By 1971 Cinema Guild was sometimes showing films seven days per week

the number of repertory and alternative movies to choose from than just a few years earlier. In a 1972 survey prepared for university administrators, Marvin Felheim wrote: "We have the greatest number of student film organizations of any campus in the Big Ten and probably of any campus in the United States; we have in the organization of Cinema Guild alone a student organization which is the oldest in continual operation in the United States, which offers the widest range of programs, and which owns itself the largest number of films."

Mediatrics Mixes It Up

Despite the presence of five very active film societies at the University of Michigan, in January 1973 yet another new group, Mediatrics, was formed. Expressly dedicated to programming recent popular hits like *2001* and *Harold and Maude* for the greater student body, it also had an ulterior motive. "One of the reasons we're in business is to get Friends of Newsreel out of business," founder Mark LoPatin told the *Daily*. Noting Newsreel's admitted use of income for its own purposes, he added, "Groups like these make distributors think the city is full of freaks trying to rip them off."

"I was on the board of the University Activities Center from my sophomore year on," LoPatin remembered. "It did everything from travel to cultural events to theater to rock-and-roll concerts, but it was all student run. And it did not have a film society." He believed that Friends of Newsreel had crossed a line. "What they were able to do is to rent a room in the university and pay student

Patrons in line for a 1971 Cinema II screening of *Finnegan's Wake*. © Rolfe Tessem

1971 Cinema Guild postcard with (top row, left to right) Peter Wilde, Ed Weber, and custodians Al and Nate. Courtesy David Greene

prices because they had a student, or a couple of students, as part of the organization, and to show shows. And that became how they made a living. They lived in a house, I'm gonna call it a commune. Although I thought that was a wonderful idea back in the '70s, I really didn't think that it was appropriate for the university to be offering up—to really what was nothing more than a private, for-profit organization—an opportunity to make money." Already involved in student-run performance groups like MUSKET and Michmimers, LoPatin became the sole proprietor of a film society whose goal echoed that of Cinema Guild in 1950. "Whatever money the students spent

REVOLUTIONARIES AND RIPOFFS 143

"I SAID, 'WHO ARE YOU?' AND HE GOES, 'I'M GENE RODDENBERRY.'"

Mediatrics founder Mark LoPatin

Courtesy Mark LoPatin

or anybody spent in going to the movie, was going to go back to the university and to the students."

Not surprisingly, this didn't play well with the increasingly combative Friends of Newsreel. "At one point they were actually passing out literature saying horrible but probably true things about me, about wanting to put them out of business. But when you look back on it, and even back then, it was far more political than it needed to be. And students cared far less about it than I did. Students were looking to go to a good movie, and an opportunity to escape, and whether it was that group or our group, it really didn't matter." Despite riling up both Newsreel and the older film societies, Mediatrics was an instant success. "I had promised that it was gonna be self-sustaining, and it was," LoPatin recalled. "We had actually accumulated so much money that during finals week we ran everything for free. It just was silly not to."

Mediatrics initially priced tickets at 75 cents, below Newsreel's occasional $1.25 and the $1.00 recently adopted by Cinema Guild, the AAFC, and Cinema II. Shut out of what had become known as the Architecture and Design (A&D) Auditorium, the Modern Languages Building (MLB), and Angell Hall by the existing groups, LoPatin was stuck with the 400-seat Natural Science Auditorium, where filmgoers had to put up with hard wooden seats, a lack of image masking, and a substandard sound system. His programming was so successful, however, that several years later the organization purchased new audio equipment for the venue.

The group often enhanced its screenings with cartoons or other shorts, and LoPatin sometimes put in quite a bit of effort to find these extras. While on winter break, he saw a reel of outtakes from the *Star Trek* television series in a bar. "It was hysterical," he recalled. The owner refused to reveal where he got it, so LoPatin decided to track it down himself. He dialed different offices at series owner Paramount until he was put through to an unidentified person who seemed to have more authority. LoPatin recalled: "He said, 'There is no

movie and there are no outtakes that are authorized about *Star Trek*.' And I said, 'No, I was at this bar and I saw it, I was there personally.' And he repeated it again, and he said, 'Absolutely it doesn't exist.' And I said, 'Who are you?' And he goes, 'I'm Gene Roddenberry.' And I went, 'Shit.' And then he said, 'What's the name of the bar?' And I go, 'Uhhh . . . I don't remember.'" *Star Trek* creator Roddenberry would soon begin to tour colleges and fan conventions using the same blooper reel to warm up audiences. LoPatin also tried to book Cleveland-based TV horror movie host the Ghoul, whose anarchic show had just begun airing in Detroit. "I was constantly harassing him, saying, 'Come on, you've got to come out here. What's it going to cost? It'll be great.' Just couldn't get him to come."

Screening Pornography

In the half-decade after Cinema Guild's 1967 *Flaming Creatures* bust, softcore and then fully graphic, hardcore sex films had begun to appear in American movie theaters, breaking down most of the remaining barriers to what audiences, and courts, would tolerate. In the late 1960s the Fifth Forum, Campus, and even State theaters had begun to regularly present R-rated softcore titles like the Swedish import *Inga*, while the student groups themselves began to occasionally screen "nudie-cutie" films like *Sinderella and the Golden Bra* with few consequences. To no one's surprise, they proved as strong an audience draw as taboo-breaking predecessors like Cinema Guild's 1959 showing of *Time of Desire*.

In February 1970, the Washtenaw County prosecutor's office blocked the Fifth Forum from running the X-rated *I Am Curious (Yellow)*, a mostly political 1967 Swedish film that included some explicit sex scenes. The movie had already been banned in several cities, and when presented in Ann Arbor just a year after the clothes-doffing cast of the play *Dionysus in '69* were arrested at the Union Ballroom, its censure was predictable. Fifth Forum founder Bill Conlin watched the situation unfold from the sidelines. "I remember telling the owners, the Robinsons, 'Why the hell did you do that? It'll just get publicity.'" But within two years the US Supreme Court would strike down the restrictions against showing *Curious*, and filmmakers began to see what further limits they could breach.

Mediatrics flyer, 1977

REVOLUTIONARIES AND RIPOFFS 145

The State Theatre draws a crowd for German import *Helga*, **October 1968.** *Ensian*

Emboldened campus programmers soon began to embrace softcore titles like *The New York Erotic Film Festival*, and then in, April of 1973, *I Am Curious (Yellow)* was screened by the New World Film Cooperative at Lydia Mendelssohn Theatre, the long-ago home of high-minded pioneers Amy Loomis and the Art Cinema League. Having encountered no serious effort to halt it, less than a year later New World decided to go fully hardcore with the Marilyn Chambers–starring *Behind the Green Door*. Scheduled for the Natural Science Auditorium in February 1974, the nine-showing engagement was a sensation, reportedly selling 4,000 $2 tickets and turning an estimated 3,000 other people

CINEMA ANN ARBOR

away, including some who had driven from as far away as Flint and Pontiac.

Green Door had been a huge campus draw even as it was simultaneously playing at the Art1 Cinema on North Washington Street in nearby Ypsilanti, which regularly advertised in the *Daily*. The same venue had also screened the even more notorious *Deep Throat*, though, as Donald Sosin recalled, "The first public run of *Deep Throat*, we all went over to Ypsi. Nobody wanted to show it in Ann Arbor." But two months after New World had successfully shown hardcore pornography on campus, student supporters of the re-election campaign of State Representative Perry Bullard announced they would screen *Deep Throat* as a fundraiser in the Natural Science Auditorium, albeit in the form of an apparently bootlegged black-and-white copy. Just days before the April 1974 screening was to take place, it was covered by both the *Detroit Free Press* and the *Daily*, which ran an editorial declaring it "an open insult to the women of Ann Arbor." With calls and letters coming in from angry alumni, the board of regents got involved, insisting that the university draw up content guidelines for all film groups, and ban them from campus if they did not comply. A moratorium was simultaneously placed on booking auditoriums until the end of June.

The university's growing roster of film classes had become dependent on the societies screening their required movies, and faculty members rushed to the groups' defense. "It would be disastrous to our program if the independent film societies were eliminated," Marvin Felheim told the *Daily*. "The arbitrary stoppage of film bookings is anti-educational." Representative Perry Bullard himself weighed in, writing U-M president Robben Fleming to say, "The university's proposed regulations are both a blatant example of conflict of interest and a violation of First Amendment rights." His letter referenced the fact that the university held a nearly one-third ownership stake in what was now called Butterfield Michigan Theaters, which it had acquired in 1950 after the US Supreme Court–ordered breakup of the Hollywood studios' theater chains. Though two U-M regents were in fact members of Butterfield's six-person board, the university claimed that

Michigan Daily ad for first campus screening of *I Am Curious (Yellow)*, 1973

REVOLUTIONARIES AND RIPOFFS 147

"IT WOULD BE DISASTROUS TO OUR PROGRAM IF THE INDEPENDENT FILM SOCIETIES WERE ELIMINATED. THE ARBITRARY STOPPAGE OF FILM BOOKINGS IS ANTI-EDUCATIONAL."

Marvin Felheim to the *Daily*

the approximately $100,000 it earned annually from dividends was not enough incentive to halt campus screenings.

After the controversy had simmered for a few weeks, President Fleming released a statement asking that the groups "exercise mature judgment in offering films." Though he refused to define "mature judgment," which even members of the film societies found overly vague, the regents agreed to lift their threatened ban. However, they voted to add restrictions to rentals of university facilities, requiring that any proceeds be used to benefit nonprofit organizations, a substantial segment of the student body, or the university itself. Groups were also required to report all income to the Office of the Controller.

With no limits on content, pornography began to make a regular appearance on most of the film societies' schedules. New World and the Ann Arbor Film Cooperative led the way, with the latter showing both rented titles like *Emmanuelle* and a print it had purchased of the X-rated compilation *A History of the Blue Movie*. "It always did really well," the AAFC's Nancy Stone recalled. "I think just about every schedule that was programmed, just because, 'There's a guaranteed moneymaker.'" Watching close-ups of throbbing genitalia in the same room where one might have heard a Great Books lecture earlier in the day could seem surreal, but porn became wildly popular on campus, especially with fraternity types who sometimes whistled and hollered at the screen. Showing it proved uncomfortable for the technician in the booth, however. "It was really upsetting to our service, at least to the female projectionists," Film Projection Service's Anne Moray recalled. "And probably some of the guys were not happy about having to staff it. Of course, they sold out."

Pornography's lure of easy money also drew in murky operators who managed to game the system by starting a "film society" that offered few apparent benefits to anyone but themselves. Anne Moray's brother and fellow projectionist Dan Moray remembered one such example: "There was a film group, I think they only existed for this one weekend, called Students United for Porn. And they showed *Behind the Green Door* three times Friday night and three times Saturday night in MLB 3 for five dollars a person." Taking in a cash haul he estimated at $12,000, "At the end of the night Saturday when I was all finished with the film, there was

LEFT: U-M president Robben Fleming. Photo by Jay Cassidy, *Michigan Daily*

BELOW: News story on Fleming allowing porn on campus

nobody there to give the film to. They just disappeared with no information at all." Not one to look a gift horse in the mouth, Moray himself slyly hustled the print to a few "men's specialty parties," until a coworker persuaded him to ship it back to the distributor.

Revolutionaries Reined In

Though most film society shows were not sellouts, and tickets priced at 75 cents or a dollar were still well below what commercial theaters charged, even at non-porn screenings the amount of money changing hands night after night added up. Auditorium charges and percentage-based film rental bills were typically not due for some time after a movie had run, and while this lag in payment sometimes caused grief for overly optimistic student programmers, it presented a temptation to others.

REVOLUTIONARIES AND RIPOFFS

149

MARILYN CHAMBERS

Behind The Green Door

The surprise smash of the '73 Cannes Film Festival. The victim of a corny kidnap plot, Ms. Chambers soon has everyone involved firmly in her grasp. America's original Ivory Soap girl comes to life in a spectacle of colorovision, animation, special effects and contemporary music. Probably the most superb technical accomplishment in modern erotica. Marilyn Chambers, Harry Reams

Sat. March 27

MLB 3 & 4, 7, 8:30, 10pm. Box office opens at 4 pm for $2.50

New World Film Coop

Students United for Porn were not the only ones who found the loosely regulated, cash-intensive situation ripe for exploitation, and the rogue Orson Welles Film Society turned out to be just the tip of an iceberg of malfeasance.

In late 1972, reports began to surface that several distributors were threatening to refuse to rent movies to any U-M film group because of issues that included undercounted attendance, unauthorized screenings, and outright nonpayment. The Student Organizations Board began considering a proposal that university film societies be licensed, and though Cinema Guild and the older groups declared that they were not opposed to tighter controls, this effort drew strong pushback from others. Friends of Newsreel called the effort "repressive and possibly illegal," while the New World Film Cooperative's Dallas Kenny told the *Daily*, "We don't want the university to know what we're doing. It's none of their fucking business." But when the regents tightened the rules following the 1974 *Deep Throat* controversy, a reckoning for both of these groups was drawing near.

After the closing of its Conspiracy coffee house, ARM opened the New Morning bookstore in downtown Ann Arbor, from which it subsequently launched the *Michigan Free Press* alternative newspaper. But the group continued to rely on earnings from Friends of Newsreel, which had largely shifted to running money-making titles that sometimes played in both Modern Languages Building auditoriums at the same time. Its payment record remained poor, however, and as distributors like Warner Brothers and New Line again pressured the university to take action, the *Daily* began an investigation.

In a June 26, 1974, front-page story headlined "Newsreel, New Morning Funds Linked," reporter David Blomquist wrote that the film society now owed back movie rentals estimated at over $10,000, but was buying *Michigan Free Press* ads at four times the going rate. Strongly implying that Friends of Newsreel was laundering proceeds from U-M auditorium screenings to raise funds for its other operations, the story went on to note that less than half of the group's 37-member board consisted of students.

Friends of Newsreel and New Morning both shared the same mailing address, and though they denied any business connection, the university soon placed the film society on probation. As more evidence emerged, in October 1974 the Student Organizations Board unanimously voted to cancel the group's auditorium bookings. The *Daily* reported that distributors were consulting lawyers about suing the university to recover their lost rental money, but U-M General Counsel Roderick Daane told the paper they were wasting their time. "Any damn fool can file a lawsuit, but it's quite clear that the university has no obligation." With typical bluster,

"WE DON'T WANT THE UNIVERSITY TO KNOW WHAT WE'RE DOING. IT'S NONE OF THEIR FUCKING BUSINESS."

Dallas Kenny, New World Film Cooperative

OPPOSITE:
Flyer for a New World screening of X-rated *Behind the Green Door*

REVOLUTIONARIES AND RIPOFFS

Friends of Newsreel member Laura Wolf in front of the New Morning bookstore. © Laura Wolf

Friends of Newsreel issued a defiant final statement asserting it would be willing to pay its bills if six demands were met, including the resignation of all U-M executive officers and department heads.

"Rich Kid Dupes and Harem Members"

In 1972 Laura Wolf had begun volunteering at a new campus-area bookstore called Polis while still in high school. When owner Glen Allvord merged it into ARM/New Morning a few weeks later, she decided to come along. Wolf moved into the political collective's roach-infested duplex on Liberty Street and started working to set up the New Morning bookstore in an aging building purchased with money from a young member's trust fund. She also became part of Friends of Newsreel. "Newsreel was a political film distribution and production group," Wolf recalled. "Glen Allvord was the original Newsreel guy in this area. I think we still distributed some of the Newsreel films when I was there, but really we just took the name for the film group."

Though parent organization American Revolutionary Media had recently changed its name to the New Morning Media Cooperative, it continued to focus on radical politics. "Apparently, before I was there, you were supposed to study different things, but it had sort of fallen by the wayside even by the time I moved in. There was so much work to do and things going on that we really just focused on work. There was political education when we were working on the paper or looking at books in the bookstore, but it wasn't organized."

Unlike the member-chosen schedules of groups like Cinema Guild, Friends of Newsreel's titles were selected by the leaders of the collective, which included George De Pue and his wife Barbara. "The only ulterior motive was to show films that people wanted to come to and showcase something that maybe another group wouldn't have shown. But mostly it was just a way of bringing in some money," Wolf recalled. While the university's regulations were

often skirted, she didn't see Newsreel's intentions as malign. "I'd say that, no, we weren't really a student group, and yes, we always owed money. Those are two true things. But we really enjoyed showing people movies that they liked."

George De Pue had a reputation for grandiose schemes that didn't always pan out, but he also had connections. "I can tell you that George was very good at manipulating people. That was one of his skills. So I bet he promised a lot of stuff that he couldn't come through on in the end. He did have a lot of contacts. I don't know how, but he had many, many contacts." De Pue had worked with White Panther Party/*Ann Arbor Sun* principal John Sinclair when both were still in Detroit, but they had had a bitter falling out. "John and George hated each other. At one point, the *Sun* published this giant exposé article and had a little cartoon of George looking like a raving maniac. Then of course George had to publish back, which I always found kind of sad. It's too bad they couldn't have come to some understanding of each other." Wolf was one of the collective's few members from Ann Arbor, with some coming from prominent families, like the daughter of New York Republican Senator Jacob Javits and a woman whose mother was a TV soap opera star. "You'd have all kinds of interesting people. Some people just came through for a short time and left, other people stayed for a long time." While Sinclair's own political collective lived in almost identical circumstances in two large houses on the other side of campus, his *Sun* article took aim at New Morning's members. "He said, 'All the people are either rich kid dupes or harem members.' And we laughed at that for so long. We were like, 'Hm, am I a rich kid dupe or a harem member? I can't figure it out.' Some of that stuff was really funny to us."

The bookstore housed a Gestetner printing machine that the group used to produce its many flyers and leaflets, but for bigger jobs, like Friends of Newsreel calendars and the *Michigan Free Press*, members drove to Inco Graphics in Mason, Michigan. Wolf recalled: "We always had money problems. Always there were people not getting paid. Like distributors or probably the people who we were getting books from for the store. One particular time I was the one bringing something to the printer to get printed, and they said, 'Oh yeah,

LEFT: ARM leader George De Pue. Photo by Jim Wallace, *Michigan Daily*

RIGHT: New Morning bookstore circa 1973

REVOLUTIONARIES AND RIPOFFS

White Panther Party members on the porch of their Hill Street house. Photo by Jay Cassidy, *Michigan Daily*

your check bounced. We're not going to print it.' And I said, 'Oh, that was a terrible mistake.' And I talked to them and talked to them. I finally convinced them they should go ahead and do it. And it was getting toward morning then, 'cause you're always bringing it in the middle of the night. And the mail came, and there was another bounced check. When I'd done such an excellent job of convincing them!"

Of collective leader De Pue, Wolf remarked: "George was a good talker, an intelligent person. He always had his own views on things. The other people I worked with who are still in town here apparently were very scared of him. Both men have told me they would have nightmares that he was following them. I thought he could be intimidating, but I never had nightmares about him." She summed up her feelings about being part of the ARM/New Morning collective: "Sometimes I was miserable, but you know, it was positive. I learned a lot. I learned how much I liked working and producing things, which I didn't know when I was in school. I didn't really like school, I just went through it. And when I actually started working, it was like, 'OK, this is what I really like doing.' I learned a lot of skills. I'm still friends with some of the people. So on the whole, it was positive. There were negative things. But you know what? At the age when you're just done with high school, you're going to have negative stuff anyway, no matter what. So I think I have a better attitude than some of the other people." Wolf subsequently put many of the skills she learned to good use running a successful handywoman business.

The End of New World

As Newsreel's final act was playing out, controversy was also beginning to surround U-M's other political film society, the similarly named and equally combative New World Film Cooperative. While it had once seemed an ally of Newsreel, Laura Wolf recalled it suddenly turning on her group when the chips were down. "When the university started doing whatever they did to shut us down, I was thinking, 'Well, New World is going to have the same problem.' But New World was championing whatever U of M was doing." Like its now-defunct rival, New World was affiliated with a for-profit organization, the New World

Media Project, Inc., which in February 1974 had opened the Matrix Theatre to offer food, films, and live events in the former home of campus hangout Mark's Coffee House, just a half-block from the Alley/Conspiracy. Though the organization claimed to have secured loans from several faculty members, the *Daily* reported that building renovation costs had ballooned to more than triple the expected $20,000. It soon began to appear that funds were being diverted to the Matrix from campus screenings of the New World Film Cooperative, which increasingly focused on porn.

As with Friends of Newsreel, New World had also begun to run up debt. Matrix office manager Vicki Honeyman remembered, "Because they didn't pay the bills, I got phone calls from very scary people for these softcore porn films that they had shown, that I had nothing to do with. They were threatening me." Fellow Matrix employee Dan Gunning, who characterized the owners as more "hipster hustler" types than serious political activists, recalled that the boss's telephone number was listed under the code name Texas Instruments "in case some thug came in and just picked the Rolodex up off her desk. I think it was a reasonable fear." As paychecks began to bounce, the Matrix closed in April 1976, claiming need of an additional $20,000 for operating expenses and to pay off investors. The New World Film Cooperative vanished not long afterward.

The film societies' cash flow also tempted others on a more

Final Matrix flyer designed by Dan Gunning

REVOLUTIONARIES AND RIPOFFS

RIGHT:
Daily article on the AAFC robbery

OPPOSITE:
Gene the Clown outside the Matrix Theatre. © 1975 MLive Media Group. All rights reserved. Used with permission.

Co-op ripped off

A young woman, aided by three accomplices, allegedly fled with $350 in cash receipts from the Ann Arbor Film Co-op's ticket table in Angell Hall around 9:30 last night, according to eyewitness accounts.

Eyewitnesses say the woman was apprehended without the money or her accomplices by co-op workers minutes later in People's Plaza near the Administration building and is apparently in police custody.

NEITHER LOCAL POLICE or University security would release information on the incident late last night.

According to one of the co-op workers at the table selling tickets, a young woman "about high school age" dressed in a dark colored windbreaker rushed to the table and fled with the cashbox toward the State St. exit of Angell hall.

Two other co-op workers and a University auditorium supervisor chased the woman and an older accomplice. The supervisor attempted to grab the man at the double door entrance to the Angell Hall staircase and was allegedly struck to the ground with a blow to the face.

THE WOMAN apparently transferred to box to one of the other alleged accomplices outside of Angell Hall before she was caught by the two co-op workers at People's Plaza.

immediate basis. At an Ann Arbor Film Cooperative screening in October 1975, a young woman stumbled up to the ticket table, grabbed the nearly full money box, and threw it to several male confederates, who took off running. Gerry Fialka was the house manager. "I'm like, 'Holy moly, what are we supposed to do?'" he recalled. "So all of us guys are like, 'Well, we'll have to chase her.' We finally catch her, and we go, 'What's going on here?' And she was just a tool of this operation that figured out how to do it." The stolen $350 was not recovered, but the group took steps to prevent future thefts, which included duct-taping the cash box to the table, "So it's not easy to just grab it. And we emptied that sucker all the time." Thieves also later broke into the A&D projection booth, and though they failed to crack the safe where Cinema Guild kept its nightly receipts, the projectionists insisted on its removal to the film society's office. The AAFC's Philip Hallman was less fortunate, however. Leaving the group's cash box in his car near the MLB while getting food after a show, he returned to find one of the windows smashed and the money stolen, though it was fortunately only the next day's startup funds.

CHAPTER 9
NEW PERSPECTIVES

AS A NATIONAL gay civil rights movement took shape following New York's Stonewall riot, in the fall of 1971 the University of Michigan became the first school in the country to officially provide support to gay and lesbian students through its new Human Sexuality Office. Two years later, Ann Arbor also became the first city in the US with openly gay public officials when two city council members came out to protest lax enforcement of the city's pioneering anti-discrimination law.

But the town and the university were still evolving away from decades of entrenched homophobia, and many gay people continued to hide their sexual orientation for fear of losing jobs or friends. Certain spots became known as locations for potential meetups or even furtive sexual encounters, including a men's bathroom near Angell Hall Auditorium A. Because the university did not have its own police force then, City of Ann Arbor officers periodically conducted sweeps using techniques that some felt constituted entrapment. One typical crackdown in the fall of 1959 had led to the arrests of 29 students, community members, and a professor, who was forced to resign. Some university officials were openly hostile, with U-M executive vice president Marvin Niehuss commenting to the *Daily* in 1962, "There aren't very many cured, and people have incipient tendencies. It is just not appropriate for the university to have on staff such encouragers." Despite some tentative steps forward, the sweeps continued.

Once, while relieving himself in the notorious Angell Hall restroom, projectionist Bill Abbott had an encounter with a police officer. "Fortunately I was the only person in there or anywhere near the building. 'Cause when I was starting to leave there was a cop there and he goes, 'Oh, wait a minute right there. You've got somebody else in there, don't you?' I said, 'What are you talking about?' It never occurred to me anybody would do something like that in a public bathroom. I got pissed off and put in a complaint, but nothing ever happened. But they watched that bathroom." Warnings were also stenciled high on the walls which stated: "Illegal activities will be prosecuted."

Several prominent members of the university's film community were victims of the sweeps. One was professor Marvin Felheim, whose job was saved by English department chair Warner G. Rice. "They would have fired Marvin, but Dr. Rice came to Marvin's defense, to his credit," Hugh Cohen recalled. "Marvin Felheim's whole career was dependent upon Dr. Rice." Though Cinema Guild's Ed Weber narrowly escaped a similar fate when an undercover officer came home with him, projectionist Peter Wilde was not so lucky, and was arrested in an Angell Hall bathroom in 1980. "We simply heard about it, and said to him, 'We're praying for you,'" Diane

"THE MOVIES WERE DEPICTING STEREOTYPES OF GAY PEOPLE WHICH HAD NOTHING TO DO WITH REALITY."

Jim Toy, Gay Liberation Front

OPPOSITE LEFT:
This 1971 Black Liberation Week symposium ended with a day-long film festival

OPPOSITE MIDDLE:
Flyer for a 1983 Cinema Guild screening of *The Birth of a Nation*

OPPOSITE RIGHT:
Women's film festival advertisement

NEW PERSPECTIVES

Gay Liberation Front members on the stage of Auditorium A, July 1973. Photo by Ken Fink, *Michigan Daily*

Kirkpatrick remembered. "He was banned from the campus for a while." U-M Human Sexuality Office co-founder Jim Toy recalled that those caught in the stings had their identification cards taken. "These guys whose IDs had been confiscated would come to me and ask whether I could do any kind of intervention," he remembered. But despite the city's gradual shift toward accepting its gay citizens, progress was slow. "Over time, yes, but it was a long, long process," Toy observed.

In 1970, Jim Toy also helped start both the Detroit and Ann Arbor affiliates of the national Gay Liberation Front organization, which sought to fight discrimination, sometimes using confrontational tactics. The group distributed leaflets and challenged patrons not to watch certain gay-themed Hollywood movies, including *Some of My Best Friends Are . . .* and *The Boys in the Band*. "We were of the opinion that the movies were depicting stereotypes of gay people which had nothing to do with reality, and that was the reason for our protest," Toy remembered.

The GLF had reached an agreement with the film societies to allow a representative to speak before such films, but when this was ignored at a summer 1973 AAFC screening of *The Boys in the Band*, the group decided to take action. "I remember getting on the stage and telling the audience there wasn't going to be a showing of the film," Toy recalled. GLF member Lionel Biron wrote an internal account of the incident. "We crashed Angell Hall's Auditorium A, tried to block the image on the screen, and chanted and foot-stomped our way through the first part of the film. This incensed the audience

and brought jeers, the management, university representatives, and the Ann Arbor police." According to the *Daily*, a protester also attempted to disconnect the sound system and a fistfight broke out when an angry patron in the front row jumped onstage. Biron concluded, "It was agreed that a discussion led by protesting gays would follow each showing, and the film continued virtually undisturbed." The *Daily* also reported that a bomb threat was called in after the group left, which the police discounted as a hoax. As a registered U-M student organization, the Gay Liberation Front went on to sponsor occasional campus film screenings of its own.

Efforts were also taking place around this time to present more diverse cinematic perspectives. After the Black Action Movement's 12-day shutdown of campus in 1970, the university pledged to increase enrollment of African American students, and more films by Black filmmakers began to appear. Some were brought by the film societies, while others were part of independent events, like the March 1971 Black Liberation Week symposium, as well as in a series sponsored by the short-lived Black Film Society. Each of the latter featured lectures by U-M professor Harold Cruse, author of the seminal book *The Crisis of the Negro Intellectual* and a

GLF protesters meet cops, 1973. Photo by Ken Fink, *Michigan Daily*

A SEEMINGLY BEWILDERED city policeman William Deneau informs Harry Kevorkian and other gay protestors last night that they are subject to arrest for their disruption of the film The Boys in the Band in Angell Hall. More than a dozen local gay males protested what they claimed was the film's oppressive treatment of homosexuality.

Daily Photo by KEN FINK

NEW PERSPECTIVES

> **THE BLACK FILM SOCIETY**
> exploring black images in film
> PRESENTS
>
> LECTURE—
> Harold Cruise MLB—Room B-115
> "Blacks in Film" 4-5:30 P.M.
>
> FEATURES:
> King Kong 6:30 & 10:00 P.M.
> Thief of Baghdad 8:00 P.M.
>
> MARCH 20 LECTURE RM 1
> MODERN LANGUAGE BUILDING

Harold Cruse speaking at the 1971 Black Liberation Week symposium.
Photo by Tom Gottlieb, *Michigan Daily*

director of the university's Center for Afroamerican and African Studies.

During the early 1970s, screenings of films by and about women were also increased, and a women's filmmaking collective was formed. In February 1974 a free four-day festival, Women in the Reel World, was co-sponsored by multiple campus organizations and presented in conjunction with a mini-course taught by Marvin Felheim. Held in a Physics and Astronomy Building auditorium, it featured everything from experimental shorts to Shirley Clarke's *Portrait of Jason* and *The Cool World*, along with special guests like *Popcorn Venus* author Marjorie Rosen and actress/filmmaker Meredith MacRae.

Premieres of the Mid-'70s

By the early 1970s, Butterfield was increasingly struggling to draw audiences to its shopworn Michigan, Campus, and State theaters, and the Fifth Forum appeared to be hurting as well. Their fortunes declined further in 1975 when the number of local

> **FINALLY GOT THE NEWS**
>
> FINALLY GOT THE NEWS has become a classic before its time. The organization it was designed to promote no longer exists, but its political and class perspectives are becoming increasingly relevant. What remains so distinctive and valuable about the film is its insistence on the primacy of the working class in making a revolution. The hour-long documentary gives a taste of what the masses can do. Scenes of the city of Detroit — people pouring in and out of the factory gates, the gigantic sign which records minute-by-minute car production figures standing over the expressway like a capitalist holy grail, the Diego Rivera murals in the Art Institute, the stench hanging over Ford Rouge — all fuse to give an impression of what the concept of working class revolt entails. We have learned that the Detroit Insurrection of 1967 was primarily carried out by workers and not by 'street people.' We have learned that a majority of the snipers caught by police were Appalachian whites! FINALLY GOT THE NEWS gives an insight into the fury that working people in cities feel. It is a look from the inside at what could happen all over America tomorrow.
> — DAN GEORGAKAS
>
> A DISCUSSION WILL FOLLOW THE MOVIE
>
> **Sat. Jan 17 6:30 & 8:30 $1**
>
> **Trotter House**
> A BENEFIT FOR THE ASSOC OF BLACK COMMUNICATORS
> AND THE ANN ARBOR VIDEO COLLECTIVE

ABOVE: Screening at campus multicultural center, 1976. TOP LEFT: 1972 Daily ad for a Black Film Society talk by U-M professor Harold Cruse

162 CINEMA ANN ARBOR

commercial screens nearly doubled with the opening of the city's first multiplex, a four-screen United Artists theater located at the south end of town. Though this served to draw even more people away from the campus-area for-profit venues, the film societies were conversely experiencing yet another surge in activity. No longer seen as a less-prestigious outlet for new releases, arthouse distributors like New Yorker Films increasingly booked first-run titles directly to the societies. Current theatrical releases were generally available only in 35 mm, but Peter Wilde had installed the necessary machines in both Angell Hall and the Architecture Auditorium, and by the latter half of the 1970s the film societies presented dozens of local or regional premieres each year. In 1976 alone these included noteworthy titles like John Cassavetes's *The Killing of a Chinese Bookie*, shown by Cinema II; Rainer Werner Fassbinder's *Beware of a Holy Whore*, presented by the Ann Arbor Film Coop; and the Maysles brothers' *Grey Gardens*, brought by Cinema Guild.

The film groups were also sometimes offered advance screenings by Hollywood studios. Cinema II's Ruth Bradley recalled a 1975 showing of *Taxi Driver* that took place a full month before the film opened in Detroit. "We got this super sneak preview to show on campus, and nobody really knew what the movie was about because it hadn't been out yet. And all we knew was it was Martin Scorsese, and it was after *Mean Streets*, and all these guys loved *Mean Streets*." An afterparty was planned for film society members, as well as local cab drivers invited by a colleague who was in Cinema II. "Everybody was speechless," she remembered of the notoriously disturbing film's impact on the audience. "That was one of the great moments. The anticipation of seeing a movie by a big auteur, but when they did see it, 'Holy smokes, what a movie.'"

On March 3, 1977, the AAFC presented the US premiere of Werner Herzog's 1972 television film *Aguirre, the Wrath of God* four weeks before it opened in New York. "I was an aggressive film programmer so I went for shit that might not have happened," Gerry Fialka remembered. "I called New Yorker. I said, 'You have *Aguirre*?' 'No, we don't have it quite yet but we'll be releasing it soon.' I go, 'Well, we've got a date, we could show it this date?' He goes, 'OK, you can have it. You're the

Meredith MacRae speaking at the Women in the Reel World film festival, February 1974. Photo by Karen Kasmauski, *Michigan Daily*

"HE GOES, 'OK, YOU CAN HAVE IT. YOU'RE THE FIRST PERSON TO PLAY IT IN AMERICA.'"

Gerry Fialka, on screening *Aguirre, the Wrath of God*

1975 Cinema Guild flyer

first person to play it in America.'" The group was running so many special screenings at the time that the national premiere status of what would become Herzog's breakthrough US release was not even highlighted in its ads.

Another regional premiere with a very local connection took place on May 28–29, 1976, when Cinema Guild showed Emile de Antonio, Mary Lampson, and Haskell Wexler's documentary *Underground*. The profile of radical group the Weather Underground featured secretly conducted interviews with five of its members, including Bernardine Dohrn and U-M alumnus Bill Ayers. Cinema Guild's *Daily* ad portrayed it as almost ancient history, noting that "Ann Arbor was the site of the earliest Weather activity," while calling the group "an offshoot of SDS and the 60s."

With the Vietnam War now over, campus activism had hit low ebb. A wire service story run by the *Daily* just two weeks before the screening quoted a 20-year-old activist about his peers. "They are very reluctant to do volunteer work. They'd rather do nothing. They see politics as unimportant, uninteresting, not exciting." But the Weather Underground, which had split off from Students for a Democratic Society in 1969 to proclaim that "protest and marches don't do it. Revolutionary violence is the only way," remained committed to an anti-imperialist, anti-racist mission. Its members were living under false identities, with some doggedly pursued by the FBI for a series of bombings that included explosions at the US Capitol and Pentagon.

Unbeknownst to friends like Hugh Cohen and Peggy Ann Kusnerz, and uncredited onscreen, was the participation of Bill Ayers's younger brother Rick. Less than a decade before, Rick Ayers had been chairman of Cinema Guild and led the group through the *Flaming Creatures* crisis before his studies were interrupted by the war. "I was torn between the political imperatives of the time and the artistic things that I was interested in," he remembered. "I was a Greek and Latin major. I definitely had this ambition to be an intellectual who couldn't do anything practical in the world. But I ended up drafted in 1967, while I was still an undergrad, because I had destroyed

my draft card. So they changed my status from student deferment to 1-A. I got drafted, I went to Canada for a while, and then I came back in '69 and went in the army as an anti-war organizer. Then I left the army, and I was in the Weather Underground from 1970 to '77. So I went full radical left."

Underground had been shot in May of 1975. "I was very involved in the production," Ayers recalled. "It was done in LA, and I rented a house. We did this whole dance to meet up with the filmmakers and make it so they didn't know where they were going. Transfer them from their car to our car, and get them down there with all their equipment, then babysit them for a few days while they did these interviews." It was a delicate situation. "Somehow the FBI had gotten aware that this was going on, so they were kind of looking for these filmmakers while we were trying to get them to the safe house we had. So it was quite a spy vs. spy thing."

Ann Arbor Film Cooperative's US Premiere of *Aguirre, the Wrath of God*

During the filming he also served as a production assistant. "If they needed food, or if they needed masking tape or something, I would be the one."

The FBI subpoenaed the footage, outtakes of which were reportedly burned by de Antonio, before the courts upheld the producers' right to keep it from investigators. By the end of the decade most Weather Underground members, including both Ayers brothers, had come out of hiding, and due to the use of illegal wiretaps and other FBI missteps, the prosecution of those suspected of crimes was limited. Having put their lives on the line to fight what they considered an unjust war, they would retain strong political beliefs, and many became educators, including Rick Ayers, who taught high school and college, and also worked with veterans' groups.

"Some people felt we should withdraw and live on the commune, and some people thought we needed to confront the war machine," he reflected. "And actually, we did a little bit of both. Because when I was underground, part of the time we were living on a commune. So I don't think it was a simple split between those two views. Everyone was trying to figure out what to do."

Even More Film Societies

In the summer of 1977, the *Daily* reported that the U-M film groups had collectively lost $15,000 over the previous year, forcing them to raise ticket prices from $1.25 to $1.50 and boost the percentage of money-making titles. Despite the fact that Ann Arbor's cinematic saturation point had seemingly been reached, another new film society was about to be launched. Alternative Action evolved out of the

TOP:
Local premiere
of Weather
Underground film

BOTTOM: A typical
Peoples' Bicentennial
Commission flyer

Peoples' Bicentennial Commission, the local affiliate of a national effort started by Jeremy Rifkin for the country's 200th birthday, "to draw some parallels between King George of England, back then, and the corporate power in America," participant Dan Gunning recalled. Coordinated by future ArtRock poster company founder Phil Cushway and Rod Hunt, the Ann Arbor body put on events and films in and around town, and after the Bicentennial Hunt decided to carry the movie programming forward through Alternative Action.

Explicitly focused on political advocacy, the new film society was provided office space on the fourth floor of the Michigan Union near the Ann Arbor chapter of PIRGIM (Public Interest Research Group in Michigan), the Ann Arbor Tenants Union, and several other student activist groups, with whom it would share some members. It was organized "to bring politically relevant film experiences to the campus community," member Dave DeVarti recalled. "Our goal was that, if we made some money by the end of the year, we would distribute it to those student groups." Along with films, Alternative Action sometimes helped organize events, like a teach-in on the draft when registration was reinstated under President Jimmy Carter.

Though the number of religious groups sponsoring film screenings had tapered off, the B'nai B'rith Hillel Foundation's Hill St. Cinema was becoming even more active, running movies most weekends at its facility just off campus. Michael Brooks took the job of director in 1980 while finishing his dissertation, and recalled that the organization's programs were not just focused on serving Jewish students. "The business of Hillel was about reaching all of campus," he remembered. "I said it'd be nice maybe once a year to do Israeli films or something, but the only thing is, it can't be schlock. It would be high-quality films. That's the standard." This form of outreach was considered so important that when a new building was constructed in the mid-1980s, Brooks made sure that its large event space

incorporated a projection booth. Hillel's underwriting would allow Hill St. Cinema's programming to carry on even when its peer student-run organizations began to struggle.

A number of other film societies were also formed to serve dormitories like Bursley, East Quad, South Quad, and Couzens, which had a particularly active group. One housing-affiliated presenter that sought a broader campus audience was the Gargoyle Film Society, which evolved out of Cook Memorial Films, founded in 1974 to provide social opportunities for Law School students. Its films were shown in room 100 of the law quad's Hutchins Hall and occasionally in the business school's Hale Auditorium. Though generally offering middle-of-the-road fare, Gargoyle gained some notoriety when it programmed X-rated *The Opening of Misty Beethoven* in November 1979 and was picketed by members of the Women's Law Student Association.

There were also several short-lived film groups that lasted only a semester or two, likely due to financial over-extension, member attrition, or both. One ambitious example was the Metropolis Film Society, which bravely tried to make a go of showing films on portable gear in the 80-seat Modern Languages Building Lecture Room 1. Among other interesting titles, it claimed to have presented the Ann Arbor premiere of John Waters's *Desperate Living* in January 1978.

In the latter half of the 1970s, both the AAFC and Cinema II held contests to create new logos to bring their images up to date, with the former adopting a sleek lowercase design and the latter choosing a riff on the MGM lion, replacing it with a mouse. Cinema Guild underwent a makeover as well, ditching its longstanding Western typecase for an assertive, hand-lettered design courtesy of member Rob Ziebell. His group, which was now showing movies seven nights most weeks, also invested $10,000 to have Peter Wilde install a huge new CinemaScope-width screen in its auditorium, improve the lighting, and finally replace the notoriously uncomfortable seats with upholstered ones cast off from another local venue. Ziebell assembled a small crew to do the work over the summer. "I was impressed that the university basically allowed us to put all the seats in that auditorium. It kind of underscored how far off the Richter scale what we were doing really was," he remarked. "I'm sure we got paid a little for doing it, but it was more for love than money."

Film & Video Program Launched

In the wake of Marvin Felheim's popular film course debut in 1968, more classes on the subject began to appear across campus, with nearly a dozen on offer by 1972. However, they were scattered across units like English, Engineering Humanities, American Studies, Speech, History of Art, and Romance Languages. As the number began to reach critical mass, a group of faculty, led by Felheim, approached the dean to seek better coordination of their efforts. Diane Kirkpatrick recalled, "It couldn't be a department because it was not yet a 'worthy subject.' Nor did we have enough

Advertisement for screenings in Couzens Hall

NEW PERSPECTIVES

the ann arbor film cooperative

The new 1970s logos for the three oldest film groups

CINEMA GUILD

courses to make it into something. But they allowed us to do a program. And they wanted to call it a program in film." Video technology was rapidly advancing at the time as well. "We were teaching courses in Portapak and all of that. And I said, 'We've at least got to say film and video.'"

In 1976 the Program in Film and Video Studies was launched, with Kirkpatrick serving as its first acting director. Finally, University of Michigan students could choose a major in film. Frank Beaver recalled: "Basically the courses were existing courses in various programs, like Diane Kirkpatrick's on avant-garde cinema in History of Art. There were just two required classes. One was 8 mm film, and the other was a video class." Another key course was one Hugh Cohen had started in 1970 on the basics of film language and technology. "We decided we needed an introductory course," Cohen recalled.

"I was already teaching what was 236 in the engineering college, so I just enlarged that to be the foundation course for the film program." His tightly scripted, clip-filled "Introduction to the Elements and History of Film," a.k.a. "The Art of Film," would serve as a primary entry point to the subject for the next four decades, often requiring two projectionists in the booth to manage the many slides and 16 mm film sequences marked with paper tabs.

"Hugh changed my worldview," Cinema Guild's Rob Ziebell remembered. "I loved the cinema in high school, but when I got to college, to have somebody basically strip everything away and start to demonstrate how deep you can really get into film itself as an art form. I had Neal Gabler as my first TA; he was so intense. To see someone so passionate about something, and Hugh being kind of like the grand domo, the maestro throughout the course, and to have your TA be Neal, it was kind of a one-two punch." Cohen's syllabus affirmed his belief in engaging with members of the class. "Film is alive to the student, and we proceed at a great risk if we make film untouchable (except to professors and critics), that is, if we treat it as if it

CINEMA ANN ARBOR

were an exhibit in an historical museum and place it behind the insulating glass of lectures. Avoiding this danger is more easily wished for than achieved."

Cohen and Gabler were just two of many ties the new program had to the film societies. Cinema Guild's Vicki Honeyman was hired to serve as its administrative assistant, and the unit's office was located adjacent to what was now called the Old A&D Auditorium following the art and architecture schools' move to U-M's North Campus. As they had since 1968, the film societies were also relied on for logistical and financial support. "They helped with making sure the auditoria were there," recalled Diane Kirkpatrick. "And if we were teaching a course, they would ask if there were some films that might be of interest to more people than just the people taking the class that we could recommend, that they didn't have on their list."

All the major film societies pitched in, with Cinema Guild showing films for Cohen, some supplied from the group's print collection; Cinema II working with Buzz Alexander; and Herb Eagle relying on the AAFC for his course in Slavic cinema. "Films had to be rented for every screening," Eagle recalled. "There were 13, 14 films, in some cases people were doing two films a week, so that was 28. And those rented for $200 each. So it was very helpful to cooperate with the film groups. They could advertise a series and they would do the rentals of the films and charge admission. The students in the course would pay a lab fee, but basically the general population would subsidize the cost to see these movies."

There were also now two distinct flavors of accredited filmmaking classes on campus. "Frank Beaver taught a

"FILM IS ALIVE TO THE STUDENT, AND WE PROCEED AT A GREAT RISK IF WE MAKE FILM UNTOUCHABLE."

Hugh Cohen's syllabus

Diane Kirkpatrick demonstrating the Sony Portapak from a 1974 video

certain kind of movie, with ambitions maybe toward the industry a little bit," Cinema Guild's Mary Cybulski recalled. "And at the art school, we were much more an Ann Arbor Film Festival kind of aesthetic." After nearly a decade of being offered unofficially by George Manupelli, his experimental filmmaking classes had finally been made part of the art curriculum. But Manupelli was not there to enjoy it, having left to teach in Toronto. "He had put in a grant for some film equipment, which was the first time the art school had any film equipment to speak of," Cybulski remembered. "And George decided not to come back. So the

art school suddenly had a bunch of cameras and equipment really for the first time, and no teacher." Recent hire Alfredo Montalvo had made industrial films, and agreed to step in. "He kind of got drafted into teaching. I think he was a good sport about it, because he really wasn't qualified to teach experimental filmmaking techniques," she recalled. But the students picked up the slack. "We just worked on one another's movies and kind of had our own momentum," Cybulski remembered. "There were six of us who just did everything together. We had slightly different sensibilities, and it was really, really fun."

More *Birth* Controversy

Due to its seminal role in the development of film language, D. W. Griffith's *The Birth of a Nation* was often required viewing in introductory film courses, and because of Cinema Guild's relationship with Hugh Cohen, regularly appeared on its schedule. The film society had created a pre-show warning slide and offered a program note quoting historian Arthur Knight's analysis, which decried its "repugnant" stereotypes, but the film's Klan-glorification and blatant racism could still be a shocking experience for unprepared viewers, especially people of color. But the film group (whose members were almost all white) didn't always make the offensive content clear. In 1968, a 22-page booklet prepared for a week-long Griffith festival had called *Birth* "the most important film ever made" while containing no mention of its racist themes, and the group's late-1970s calendar description described it merely as "flawed."

In January 1979, protesters from a group called the National Alliance Against Racist and Political Repression burst into Hugh Cohen's Film/Video 236 class to hand out flyers urging a boycott of the film. "I did my best to explain why I was showing it, and they left, peacefully," he remembered. A letter sent to Cinema Guild and a *Daily* op-ed highlighted the protesters' belief that the film society had a duty to better inform its audiences. "In its review, Cinema Guild describes the film as being a 'flawed but passionate history of the Civil War.' This, however,

OPPOSITE:
Flyer for an AAFC series for Herb Eagle's Slavic course

BELOW: *Daily* ad for Hugh Cohen's introductory course

THE ART of FILM

Film, Video, and RC 236 will be taught in Fall 1985 by Professor Hubert Cohen and is being offered on

TUESDAY and THURSDAY, 12:00 - 1:30

with Discussion Sections on Friday afternoon.

NO PREREQUISITES. FOUR CREDIT HOURS.

See LSA Course Guide and updated CRISP listings for more information.

EASTERN EUROPEAN FILM ⭑ FEST
AAFC

JAN 7
CLOSELY WATCHED TRAINS
(Jiri Menzel, 1967)
MLB 4 7:00 FREE AAFC
Menzel received an Academy Award for his tragicomic tale of a 17-year-old railroad employee's gradual sexual and political maturation in wartime Czechoslovakia. Czech with subtitles. (80 min.)

JAN 24
THE SHOP ON MAIN STREET
(Jan Kadar and Elmar Klos, 1965)
MLB 4 7:00 AAFC FREE
Set in Nazi-occupied Czechoslovakia, this moving film tells the story of a carpenter who becomes "Aryan controller" of a button shop and befriends its old, deaf Jewish proprietress. Academy Award for Best Foreign Film. Czech with subtitles. (128 min.)

JAN 31
ASHES AND DIAMONDS (A. Wajda, 1958)
MLB 4 7:00 FREE AAFC
This film bares the conflict of idealism and instinct in a young resistance fighter who assassinates the wrong men at the end of World War II. Ashes and Diamonds is one of the clearest portrayals of a communist society ever recorded on film. Polish with subtitles. (105 min.)

FEB 7
ANGI VERA (Paul Gabor, 1979)
MLB 4 7:00 FREE AAFC
A teenage nurse whose parents were killed during the war finds her talents for criticism and self-criticism have brought her to the attention of the new Communist party. She is sent to the party's school for further training. Gabor's subtle treatment of Vera and her associates provides a commentary on Hungary's turn to Stalinism in the late 1940's—and, in his words, "an illustration of the fact that it is possible to manipulate society only if there are individuals who are willing instruments." Hungarian with subtitles. (96 min.)

FEB 14
MAN OF MARBLE (Andrzej Wajda, 1977)
MLB 4 7:00 FREE AAFC
A young Polish film student sets out to discover "the truth" about a man named Birkut, an ordinary bricklayer promoted to the status of national hero, only to be later declared a non-person and disappear from public view. Using a multi-layered narrative structure reminiscent of Citizen Kane, director Wajda exposes the hypocrisy and deceit of the Stalinist post-war era in Poland. Polish with subtitles. (160 min.)

MARCH 7
Shadows of Forgotten Ancestors, 1964.
MLB 4 /7:00
This extravagantly rich and colorful drama is based on a Carpathian legend of two lovers separated by poverty and a family feud.
A Janus Classic

MARCH 14
NINE MONTHS (Marta Meszaros, 1977)
MLB 4 7:00 AAFC: FREE
The story of a love affair between a strong-willed young woman and an impulsive, often arbitrary fellow worker in a chilly industrial city. Director Meszaros, widely acclaimed for her studies of the feminine personality, has created a film which is moving yet unsentimental, affecting and yet totally without artifice. Hungarian with subtitles. (93 min.)

MARCH 21
Black Peter 700 mlb 4 FREE
Forman's first complete feature is also perhaps his freshest, and certainly one of the funniest. Like his later work, it deals with the incongruities of the younger generation, and particularly with the young generation in love. As his later films, the film narratively progresses as a series of tableaux.... marvelous scenes of Peter's first real date, and of the confrontation between parents and the young generation attaining maturity.

MARCH 28
WR: MYSTERIES OF THE ORGANISM
(Dusan Makavejev, 1971)
MLB 4 DBL/7:00 & 10: AAFC
A hilarious, highly erotic political comedy which quite seriously proposes sex as an ideological imperative for liberation — a plea for erotic Socialism. "It mocks with ferocious humor both the Marxist state and the American way, blending politics with pornography." — New York Times. "Satanically funny. The film is indeed likely to offend some, who should not, however, deny themselves the experience of seeing it." — Time. Serbo-Croatian with subtitles, some English dialogue. (84 min.)

APRIL 4
Slave of Love
It is 1918 and the Bolshevik Revolution has just taken place. In the south of Russia a film crew is attempting to finish a romantic melodrama, oblivious to the tide of change about to engulf them. Their film supply runs out, government troops invade their set and the turmoil of revolution draws closer.
Only the beautiful leading lady is able to recognize the political realities, as falling in love with a Bolshevik cameraman she finds herself caught up in the forces of transformation.
700 & 840 mlb 4

BIRTH OF A NATION CONTROVERSY
TO STUDENTS OF FILM COURSE 236 AND OTHERS CONCERNED:

At tonight's showing of <u>Birth of a Nation</u>, the Ann Arbor Chapter of the National Alliance Against Racist and Political Repression (NAARPR) will be picketing and will urge people not to attend. Students of Film Course 236 have been assigned to see the film and will need to decide what to do. We hope the following information will be helpful to you in making your decision.

The film presents a distorted and virulently racist picture of the post-Civil War Reconstruction, and glorifies the role of the Ku Klux Klan in destroying the democratic gains of that period. It is a dangerous incitement to racial hatred and violence.

The release of the film in 1915 coincided with the resurgence of the KKK, which grew to a membership of 4,500,000 by 1924. The film was greeted by massive opposition by blacks and whites. On April 19, 1915, in Boston, to cite just one eeample, 1,000 people led by William Monroe Trotter, W.E.B. DuBois and the N.A.A.C.P., marched through the streets to the State House, demanding that the governor ban the film. Theaters showing it were picketed until the film left Boston. For some time afterwards, Boston theaters refrained from showing many of the more offensive racist films. Despite the waves of protest, however, <u>Birth of a Nation</u> was viewed by millions of people in America. This contributed to the huge increase in the level of lynching and other forms of racial violence in the ten years following 1915.

Four years ago, following a showing of the film to a class at the University of North Carolina, four black students were severely beaten by white students.

<u>The freedom of all people is constantly endangered by the continued presence of racism and by organizations such as the Ku Klux Klan and the Nazis, which are currently on the offensive throughout the country</u>. In the past, Cinema Guild (the sponsor of this screening) has provided many fine films to the Ann Arbor community. This film, however, is an insult and an affront to all democratically-minded people. Cinema Guild needs to know that we, their patrons, do not want our money and cultural resources wasted on films that perpetuate racism. We urge you to boycott <u>Birth of a Nation</u>.

> Students who have decided not to attend this film should have the right to choose an alternative assignment for Film Course 236. We urge Professor Cohen to offer students this alternative.

Partial list of boycott supporters: Ann Arbor Chapter/NAARPR; Rev. Ann Coleman, Guild House Campus Ministry*; Rev. Don Coleman, Guild House Campus Ministry*; Shirley Powell, Infant Formula Action Coalition (INFACT)*; John Powell, Community Services, U. of M.*; Ellen Offen, Director, Project Community*; Margarita Tarres, Minority Student Services*; James Kubaiki, Disabled Student Services*; Marti Bombyk, President, Graduate Employees Organization (GEO)*; Kate Rubin, M.S.A.*

*organization listed for identification purposes only

is a gross understatement," they wrote. Noting that the unprecedented success of *Birth* in its original release was tied to the 1920s surge in Klan membership, the editorial asserted: "The screening of this film certainly played a role in the murders of hundreds of Black people that occurred through the nation in the next few years." By the late 1970s, the Klan and affiliated Nazi groups had again begun building strength around the US, regularly marching in public and sometimes showing *The Birth of a Nation* to recruits.

Philip Hallman had driven from nearby Plymouth to the Cinema Guild screening. "I had this high school teacher who encouraged us to go, in part because of the quote 'art' qualities of it. She was teaching us about the way films were made and edited and that sort of thing," he recalled. "When I got there, there were protesters, and I was surprised. Their chant was, 'Art yes, racism no, *Birth of a Nation*'s got to go!'" The large crowd attracted by the controversy also included vocal opponents of censorship, and Cinema Guild handed out an analysis written by professor Frank Beaver, whose soon-to-be published McGraw-Hill textbook *On Film: A History of the Motion Picture* would devote 13 pages to the movie. After duly noting its technical merits, he wrote: "Griffith demeans Blacks in every imaginable way—with a clear intention of building a case for the formation of the Ku Klux Klan. The Klan is depicted as a justifiable group of vigilantes helping to rid the South of undesirables." He concluded, "Even to this day the film can be viewed as a symbol of political excessiveness and a propagandistic display which works against equality and justice in our country." Visual storytelling had a long history of being used to propagate hate, even as groundbreaking techniques had sometimes been employed to do so. In spite of their objectionable content, both *The Birth of a Nation* and Leni Riefenstahl's Nazi propaganda film *Triumph of the Will* became staples of film courses due to their advancement of film language.

As the university's film program continued to expand, one of its leading

ABOVE: Warning slide shown by Cinema Guild before controversial films

LEFT: From the winter 1979 Cinema Guild schedule

OPPOSITE: Protest flyer given to students in Hugh Cohen's 236 class

NEW PERSPECTIVES

173

"ART YES, RACISM NO, *BIRTH OF A NATION'S* GOT TO GO!"

Protest chants

Protesting a Cinema Guild screening of *Birth of a Nation* at the Michigan Theatre, September 1979. Photo by Maureen O'Malley, *Michigan Daily*

FOLLOWING SPREAD: Students of Marvin Felheim listen to guest Frank Capra speak in MLB Auditorium 3, February 1973. © David Margolick

lights would not live to see it reach its full potential. Unbeknownst to many, Marvin Felheim had been fighting cancer for more than a decade, and in July of 1979, he died at the age of 64. "I don't ever remember him missing a class or being uncomfortable or expressing he was not prepared to teach," recalled Mediatrics founder Mark LoPatin. "He was just everybody's favorite teacher. Marvin just commanded your respect." Hugh Cohen remarked, "We couldn't have started the film program without him. He was the one professor who had that kind of authority." The program he had helped launch would go on to develop a sub-major in screenwriting, sponsor free movie series, bring in special guests ranging from Stan Brakhage to Spike Lee, and finally achieve full U-M department status in 2005.

Flyer for a 1983 Cinema Guild screening of *Birth of a Nation*

CHAPTER 10
PERFECTION, NOT PROJECTION

FROM THE TIME he started showing movies for Cinema Guild in 1966, Peter Wilde had taken it upon himself to make film society screenings in a U-M lecture hall as cinematically satisfying as possible. Blessed with enclosed projection booths that could hide the clatter of the machines, he found ways to add black masking around the screen to provide a sharp-edged image, and even focused colored lights on it before shows and played taped music to set the mood. Born in New Orleans in 1940, Wilde had moved with his family to Ann Arbor and started college at Princeton before dropping out and returning to town.

Purchased by the film societies and maintained without financial support from the university, his equipment was often a Frankenstein-like mélange of different components, some of them homemade. In Marvin Felheim's 1972 assessment of film on campus, he described the projection booth in Auditorium A as "a Rube Goldberg device capable of being operated only by Peter Wilde." Cinema Guild usher Fred LaBour knew Wilde well. "'It's not projection, it's perfection.' That was his motto," LaBour recalled. "I think he was a genius. Everything was held together with duct tape. The only guy I ever saw who had duct tape shoes. Everything in his cars. Oh yeah, he was inspiring." Liz Moray began showing films with Wilde in 1970 and became the first female projectionist admitted to Ann Arbor's stagehands and projectionists union. "You could either pay $50,000 for the new stuff or wait for Peter to build it for a few grand with bobby pins," she told the *Current* magazine in 1988.

Fellow projectionist John Briggs remembered that after U-M plant department staff had run movies during the day for classes, Wilde would switch to his home-built "red board" gear for the film societies. "Peter didn't like a lot of what the sound equipment was, so he would red board something that he liked. And it was funny because you go in there to show a movie, and you'd unplug the solar cell and plug his thing in and send it off to the amplifier. And, God love him, most of his red board projects were not completed enough to be put in a housing. Literally it was in a paper bag with the wires coming out. But it worked." At least, usually, as Bill Abbott noted: "He was always installing systems and fooling around with them. And then they might not work when you went to do the show, or they were different and you hadn't been told."

As Wilde himself wrote in an essay for the *Ann Arbor Eye* magazine in 1972, "I consider projection a curator function. Vast resources in equipment do not guarantee a proper presentation. Projection is unashamedly the best paid job in the operation. We tolerate any eccentricity as long as there is

ABOVE: Peter Wilde prepping a 16 mm film at the Michigan Theatre. © Rob Ziebell

OPPOSITE: Anne Moray threading one of the Lorch Hall Brenkert machines, 1988. © Gregory Fox

PERFECTION, NOT PROJECTION

humble dedication to focus, sound quality, and film preservation."

Over the years Cinema Guild and the other film societies had earmarked surplus funds to buy professional-grade 16 mm projectors with bright carbon-arc lamps, new audio systems, and better screens. In 1969, presentation quality took a major leap forward when 35 mm projectors were obtained. Purchased for $11 from surplus stock dating to World War II, two of the heavy Detroit-built Brenkert projectors were installed in Auditorium A, and six years later, a second set was shoehorned into Cinema Guild's tiny Architecture & Design booth, minus their cast-iron pedestals. In a typical bit of Wilde-an inspiration, those machines' powerful new xenon lamps would be shared with modified German-made Bauer projectors to create what Michigan Theatre technical director J. Scott Clarke called, "A Peter Wilde 16 mm device.' Which only those of us who've had to run them know what that means. It was a collection of parts cobbled together." As Clarke remembered of the 16 mm conversion, "He drilled about a hundred holes with maybe a quarter inch or less drill-bit, all the way around the housing. And then went at it with a hacksaw. Lopped off the old lamphouse, set this really bright Xenex xenon lamphouse behind it, and fabricated a sort of aluminum, cone-shaped connection between the lamphouse and projector." Mounted on a homemade Unistrut frame that resembled an erector set, "We ran that thing for years for the Ann Arbor Film Fest and for other things. And it worked great."

Such custom-designed systems required skilled operators, and with the number of campus auditoriums and film societies expanding, in 1973 Wilde established a formal organization to service the large rooms on U-M's central campus. "He basically filled a need," Scott Clarke remembered. "Departments needed film projection, but they didn't each have their own projection team. So he created Film Projection Service to provide the service to various departments." FPS

Nameplate from one of FPS's 35 mm projectors

180 CINEMA ANN ARBOR

was run as a cooperative, and generally consisted of equal numbers of men and women, many of them visual artists, filmmakers, or musicians. While FPS staff were not union members, their wages were set at a level just below what the university paid International Alliance of Theatrical Stage Employees (IATSE) stagehands to work shows at Hill Auditorium or the Power Center.

Carving out office space in a small Angell Hall room where WUOM radio had placed equipment for recording lectures, Wilde's organization operated as a rogue agency for nearly two decades. "When the U of M somehow discovered that there was this entity with no oversight," Scott Clarke recalled, "they said, 'Oh my God, we can't have this.' So they decided to put it under the College of Literature, Science, and the Arts." FPS's skilled projectionists eventually became a key component of the school's LSA Technology Services unit.

In addition to overseeing equipment upgrades and running films, most often in the increasingly complex A&D Auditorium booth, Peter Wilde began co-teaching Film/Video 200 with Diane Kirkpatrick. He and his staff also moonlighted at other area theaters, including the Ypsi-Ann, Scio, and University drive-ins, whose warm-weather schedules fit well with the typical drop in summer work on campus. Wilde even automated the 35 mm projectors at the Ypsi-Ann. "So instead of being engaged every 20 minutes, he would stretch that to 40 or so. It would strike the lamp too, carbon arcs," John Briggs remembered.

Teaching and drive-ins were not Wilde's only side gigs. "In the summer, he would usually get on a rock-and-roll tour, and he frequently toured with the band Kiss," Woody Sempliner recalled. "That was his other life." Also touring with Grand Funk Railroad; War; Supertramp; Earth, Wind, and Fire; and Olivia Newton-John, while on the road Wilde's creativity naturally extended to equipment design, including building a joystick-controlled spotlight with Jim Fackert that anticipated the future industry standard. "People talk about automated lighting, follow spots," John Briggs remembered. "These were before those. They were all analog, but you could do six color changes, iris, dowser, pan-tilt." Wilde also made a hum-reducing modification to a

Scott Clarke using Peter Wilde's custom 16 mm projector at the Michigan Theatre

PERFECTION, NOT PROJECTION 181

ABOVE: Anne Moray threading a Brenkert 35 mm projector.
© Gregory Fox

RIGHT: An FPS logo t-shirt

problematic model of Crown amplifier that Grand Funk Railroad was using. "Sent it to Crown. 'Not interested.' Six months later, 'Oh, we've got a new, improved amp,'" Briggs remarked.

Peter Wilde's constant tinkering and acquisition of cast-off items allowed him to build up a collection of dozens of boxes of obscure parts for use in future projects. He was always thinking of ways to enhance campus screenings, and the 35 mm projectors in Auditorium A featured both optical and magnetic soundheads so that films like *Woodstock* could be presented in stereo as had been done at premiere engagements. Wilde himself would sometimes even climb onstage to explain some of the technical fine points before a screening. FPS also took advantage of features unique

182 CINEMA ANN ARBOR

to a room, like hidden lighting panels in Angell Hall that could be flipped up to point at the screen. "The footlights had been installed when the room was built," remembered Dan Moray, who, like his sister Anne, had joined their older sibling Liz at FPS. "They'd dim the house lights down, then the only lights on would be the red, green, and blue on the screen. Then they'd fade those down and then hit the screen with the picture. And it was just beautiful."

The jury-rigged gear required special handling. To project in CinemaScope on a Kodak Pageant 16 mm projector, anamorphic lenses were placed in front of the machine on rickety adjustable stands that chemists used to hold beakers. "One time I had to change the lenses and we were using those chemistry stands, and I couldn't get the lens out of it," Dan Moray remembered. "So I was pulling on the lens and pulling, then the lens went out the window of the booth and hit somebody in the head out in one of the aisles out there. So I go out in the theater and, 'Anybody see that lens? You got my lens?' And this dude goes, 'Yeah, here it is.'"

Special Events

Not all FPS clients were film societies, and there were occasionally portable shows in rooms that were not equipped for film. These could turn into nightmares. "It was Greek Week and the fraternities wanted to see *Animal House* in the Michigan League Ballroom," Bill Abbott recalled. "And they came in somewhat drunk, and they brought in kegs of beer and just set them in the aisles. And I said, 'Guys, let's move them out of the aisles?' and proceeded to show *Animal House*. They were singing along with Otis Day and the Knights, so I had to turn it up, and turn it up." The rowdy

"THERE WAS NO SOUND, BUT THERE WAS SMOKE COMING OUT OF THE SPEAKER."

Bill Abbott

students soon overpowered his system. "I turned it up so loud you could hear it over the crowd, and shortly thereafter, there was no sound, but there was smoke coming out of the speaker. So I had to shut down, roll back to Auditorium A, come back—they were still drunk of course—and show the rest of the movie. Then my take-up drive failed. And I spent the last 20 minutes winding the film with my finger in the take-up reel."

Decades before it was a standard classroom feature, Peter Wilde also dabbled in video projection. The Ann Arbor Film Cooperative was home to several rabid Frank Zappa fans, principal among them Gerry Fialka. Learning that Zappa had produced a still-unaired television special, *A Token of His Extreme*, he called the musician's manager, Herb Cohen, and convinced him to rent it to the group for a nominal fee. It was only available on a three-quarter-inch videocassette, however, so for the program's November 1975 world premiere in Angell Hall, Wilde obtained a video projector of the type used to show closed-circuit boxing match

Magnetic-striped 35 mm print of *Woodstock* also showing its "squeezed" CinemaScope image

PERFECTION, NOT PROJECTION 183

University of Michigan Cinema Guild

Film Sizes and Picture Shapes

1.33-to-1 Old Silent Aperture ("Full Screen")

1.33-to-1 Academy Aperture (with sound track)

[1.55, 1.66, 1.75 +∞]

1.85-to-1 Wide Screen Aperture (modern "flat")

2.35-to-1 Cinemascope Aperture

35mm is shown in local theaters. 16mm is shown in Arch. Aud. 16mm & 35mm are shown in Angell Aud. A.

THE NORMAL 35mm FRAMELINE

THE REAL WIDE FRAMELINE

Old Silent
Academy
1.85-to-1
Cinemascope

a Peter Wilde presentation — 70mm — 2.2-to-1 — ← 6 stereo tracks →

The original 35mm perforated motion picture film developed by Edison is still foremost in use today. The silent picture filled all space between perforations (sprocket holes), and successive frames butted against each other.

An early act (ca. 1930) of the Motion Picture Academy was to standardize the optical (photographic) sound track position and the shape of the picture alongside. ==To preserve the 4-to-3 (1.33-to-1) aspect ratio of width-to-height, a wide blank line was inserted between successive frames.==

In 1953, to compete with Cinerama and TV, exhibitors began cropping the picture height and blowing it up bigger to produce a fake "wide screen." Eventually photographic practice was adapted to the new "standard." Ratios vary: 1.66, 1.75, 1.85, even 2-to-1.

Cinemascope and Panavision use lens which compresses a wide image onto 35mm film. The projection lens stretches it out again, doubling the width. Full frame height is used, so once again successive frames butt against each other. With narrower perforations, the film accomodates 4 magnetic stripe tracks of stereophonic sound.

==16mm copies of 35mm films extract the Academy Aperture image area.== *improperly printed* Thus old silent pictures lose the left side and part of picture height. Academy originals are reproduced completely. Wide Screen originals have a wide black frame line: reduced picture height, but all of it is there. Cinemascope originals lose some picture height as old silents do, and the aspect ratio is extreme: 2 X 1.33 = 2.66-to-1.

Modern "flat" (non-'scope) 35mm films are composed for 1.85-to-1 presentation, but the whole Academy aperture is usually photographed so it looks good on TV, which is 1.33-to-1.

70mm films use a 65mm picture with extra edge space for six magnetic sound tracks. 35mm versions crop height for 2.35-to-1 or width for 1.85-to-1.

broadcasts. Because the device only had a black-and-white image, color TV monitors were placed on the sides of the screen to give the audience a sense of the missing information. "It didn't matter, because the mag sound was so powerful," Fialka remembered of the high-fidelity music playback. "And it was just something I was so proud of."

Though it reached back to the silent era, perhaps Wilde's most technically daunting assignment came just three months later when 89-year-old Oscar-winning cinematographer Karl Struss visited campus for an exhibit of his photographs. Prior to the adoption of cellulose acetate film in the early 1950s, 35 mm motion pictures had used flammable nitrate-based stock, which had the same chemical composition as gunpowder. FPS's vintage Brenkert projectors still had their original fireproof film magazines and fire-damping rollers however, so Cinema II obtained archival nitrate prints of several films Struss had shot for a series of February 1976 screenings. There were concerns about running intensely hot light through 50-year-old film that was notorious for slowly becoming unstable over time, and Wilde did a test with a match to see what would happen. "He had a sample of that in Angell Hall, and he cut off about six inches of it and said, 'Watch this.' BOOM! It was, like, gone," John Briggs remembered.

As Cinema II's Kevin Smith recalled, "Peter Wilde was tasked with projecting this thing, and there was no safe way to do that. We got a bunch of aluminum lithograph plates from the art school, where I was in the printmaking department. And what he ended up doing was lining the projection booth."

ABOVE: Ad for an FPS show using early video projection in 1975

LEFT: A scrap of nitrate film found in the Michigan Theatre attic

"IF FILM FLARES UP AT ALL, SPLIT."

Peter Wilde on screening nitrate film

He remembered the nitrate print of F. W. Murnau's 1927 *Sunrise* vividly. "If you've never seen one, and most people haven't at this point, it was amazing. Solid blacks that were completely black-black-black. Probably one of the singular best film-viewing experiences I've ever had in my life. And it was all because of Peter Wilde. It was completely illegal and wrong to do, but he did it and it was fantastic." Out of town for the shows, Wilde had left detailed instructions for his fellow projectionists, which included the warning, "If film flares up at all, split."

OPPOSITE: Peter Wilde's film format reference sheet, 1970s

PERFECTION, NOT PROJECTION

BELOW: Flyer for a 1984 3D screening in Lorch Hall

In the early 1980s, the Old A&D Auditorium was also adapted to show 35 mm 3D films, like Alfred Hitchcock's *Dial M for Murder*, when the stereoscopic format made one of its periodic reappearances. Wilde rented polarized projector lenses, obtained the necessary glasses, and, to increase brightness, carefully spray-painted a derelict screen silver.

Scott Clarke recalled how Wilde helped upgrade Ann Arbor's historic movie palace when it shifted to nonprofit status in 1979. "When the Michigan Theatre reopened, Peter basically got the booth in shape," he remembered. The Ann Arbor Film Festival relocated there soon afterward. "He would show up with an array of electronics, and sort of move into the booth. Hang up his hammock and bring his coffee pot." Wilde's encounter with the local morals police was also turned into an equipment upgrade. "Peter had gotten arrested for doing something on university property that was frowned upon at the time. So, as his community service, he installed the surround system at the Michigan Theatre. Basically he and I built these speakers and installed them around the theater, and he had a little homemade Dolby processor which captured the signal and split it into right, center, left, and surround. So we got the signal we needed and sent it to these speakers. And it was our surround system for like the next 15 years." To also offer the recently introduced Dolby Stereo on campus at a time when many commercial exhibitors were balking at the expensive upgrades required, Wilde hand-built custom photocell sound pickups to retrofit FPS's aging Brenkerts. With the film societies underwriting the purchase of high-quality JBL speakers that could be rolled onto the stages of Angell Hall and Old A&D, Wilde's football-sized Dolby decoder was shuttled between campus and the Michigan Theater on a screening-by-screening basis for a number of years.

With his touring work increasing, and reportedly still unsettled by the circumstances of his arrest, in 1983 Peter Wilde moved to California to design video systems for rock concerts and corporate clients. The quality of the local film societies' projection was almost entirely due to his vision, even as those who carried on in his absence were sometimes unable to keep his complicated systems running. After Wilde's death in 1989 a memorial gathering was held at Dominick's, just steps away from the A&D Auditorium where his "Rube Goldberg" tinkering had reached its apex.

Silent Cinema Comes to Life

Another special part of film exhibition on campus was the effort to present silent movies with live musical accompaniment, as had been standard during their original release. From Amy Loomis's 1929 shows at Lydia Mendelssohn with an undergraduate pianist and the Art Cinema League's 1940 Douglas Fairbanks memorial series with specially commissioned scores, through a 1992 Ann Arbor Film Cooperative silents night featuring Detroit-based electronica group Ringing, the film societies strove, if possible, to recreate this essential part of the experience.

One of the most dedicated campus accompanists was Donald Sosin, a U-M music student who had been recruited in March of 1971 by the Ann Arbor Film Cooperative to play for *Phantom of the Opera* after a professor suggested him based on his ability to improvise. "At that point I knew zero about silent films, other than that I had watched a show called *Fractured Flickers* on one of the local New York stations," Sosin recalled. Enjoying the challenge of putting together a score for the 50-year-old film, he decided to seek out more opportunities. "I saw that Cinema Guild was doing all this silent repertoire as part of the film history class," he remembered. "I said, 'You should have music for these,' and I think the reply was, 'If you can get a piano in there, we can do it. We'll pay you twenty bucks.' So, as it turned out, a friend had an apartment that was kind of catty-corner to the south entrance of the A&D auditorium, and she said, 'You can have this piano if you can figure how to get it out of here.'" Rounding up volunteers to relocate her battered upright Steinway, "somehow we got it

TOP: 1974 AAFC screening with 35 mm magnetic sound
ABOVE: Dolby Stereo was available on campus in 1980

PERFECTION, NOT PROJECTION

> **the ann arbor film cooperative prsents**
> **David Ward Griffith's classic film**
>
> # INTOLERANCE
>
> 1916. Starring Lillian Gish, Miriam Cooper, Tod Browning, Erich von Stroheim, Constance Talmadge, Eugene Pallette, Minte Blue, Bessie Love. 121 min.
>
> ## with new piano score by Mr. Donald Sosin, performing!
>
> Mr. Sosin received standing ovations at our successful presentations last spring of The Phantom of the Opera for his score and performance.
> One of the most awesome spectacles ever filmed!
> Often hailed as one of the most influential of silent films, INTOLERANCE, two years in the making, intercuts four different episodes which depic cruelty and prejudice through the ages.
>
> ## TONIGHT — September 16 — ONLY!
>
> auditorium a 7:00 & 9:30 p.m.
> angell hall still only 75c
>
> **COMING TUESDAY**—Lindsay Anderson's **IF** . . .
>
> VISIT OUR ALLEY CINEMA—Monday through Thursday

ABOVE: One of Donald Sosin's early film gigs

OPPOSITE: Notes incorporating original intertitles and action cues for *Potemkin*. Courtesy Donald Sosin

out of her apartment and onto the street and into the back of the auditorium."

His scores were put together under the supervision of Hugh Cohen. "Before the screenings Hugh would take me into an office and we would watch the films together and he'd talk about them and say, 'Look at this, look at this, look at this.'" Mixing original themes with familiar melodies that he improvised on, the pair carefully coordinated the music with what was on screen. "It's all based on action, and events, and timing. It was years before I found out that other people were doing things like this also." After graduation in 1973, Sosin made silent film accompaniment into a career, working in New York for presenters like the Museum of Modern Art and Film Society of Lincoln Center, at international events like the Pordenone Silent Film Festival in Italy, and recording dozens of original scores for video releases.

Other Cinema Guild silent film pianists included board members Robert Sheff, a.k.a. "Blue" Gene Tyranny, and Andy Sacks, who took over when Sosin left town. Comfortable with improvising, he adopted a less rigorous approach than his predecessor. "Given the rate of pay that was budgeted for the piano player, I didn't really take a lot of time to preview the movie. Had I

Potemkin

Part 1 Men + Maggots
Sea, from Lenin
quote from Lenin
battleship
off duty
let's join the fight
 morning on deck
 complaints about food
 doctor
 maggots
 outrage
 cutting meat
 ready for meal
 anger of sailors
 swaying tables
 plate break
 ———
 Drama on the
 Quarterdeck
→ Bugle
 Capt. Golikov
 Those satisfied with food
 step forward
 All others will hang
 marines
 preparation to kill
 tarpaulin
 priest
 ready aim
 Chuk speaks
 marines falter
 battle
 argue with priest
 after shot of priest,
 steps on him
 men overboard, etc.
 Chuk shot,
 drowns

to the shore
Odessa
resting place
boats
sunrise

Part 3
An Appeal from the Dead
Cranes, etc.
curiosity about
Vak.
people start coming
in droves
uprising
We will remember!
Youlds + builds
down with the Jews
heads turn
shouting, etc.
more + more
back on the ship
shore watches
 as red
The Odessa Steps
sailboat
sails down
children
Suddenly
running
people
Cossacks
child + mother
Cossacks down
mother
appeal
gunfire

Cossacks
baby carriage
slaughtering
ship
generals headquarters
[catch - 3 lions]
Part V
Ship
Night full of anxiety
ship
waiting
enemy sighted
all hands on deck
→ bugle cuts
frantic activity
full speed ahead
naval battle
join us
will they fire?
brothers!
fadeout on boat
The End

DUBINUSHKA

♪ (musical notation) ♪

MANTA RAY FLEET·RECORDS and the ANN ARBOR FILM CO-OP
PRESENT
SILENT HELL
3 SILENT MOVIES WILL BE SHOWN.

MOVIE NIGHT
OCTOBER 30 at 8:00 p.m.

Witchcraft Through the Ages
(a Documentary depicting Witches and Devils historically)

Le Follies Du Dr. Tube
(a Scientist creates a powder that distorts reality)

Conquest of the Pole
(an expedition to the North Pole is met with an Icy Hell)

Live Electronic Soundtrack by
RINGING 92

NATURAL SCIENCE BLDG.

Off of STATE STREET, across from WAZOO RECORDS,
next to ANGEL HALL, in ANN ARBOR.
for more information, please call the FILM CO-OP phone number.
1-313-769-7787

watched it all the way through, that would have cut my salary to below minimum wage." Another issue was thirst, especially when accompanying the two-hour *Birth of a Nation*, regularly shown to film students using Cinema Guild's print. "I had to figure out a way to surreptitiously open a can of beer," Sacks remembered. "And I hit on this technique where if there was a section in the film where suspense was called for from the piano player, I could roll an octave with my left hand, the bass clef, and hold the damper pedal down to make it sound really ominous and loud. And then with my free hand, my right hand, I'd put the can of beer between my knees, and pop the top. And that was good for about 40 minutes. I think a few people might have heard if they were sitting close in the front row, but otherwise I think I got away with it." Hugh Cohen never found out. "I don't think I would have permitted that. But OK," the group's faculty advisor commented decades later.

Though he never worked for the film societies, another notable silent film accompanist/composer who hailed from Ann Arbor was Roger Clark Miller of the Alloy Orchestra. "The group formed in Boston, and I joined it six years later," Miller remembered. "I recall very well seeing Buster Keaton's *The General* when I was about 10 years old with my family at a U of M screening. I found it extremely moving! And Alloy Orchestra has created our own score to that film. So while there is no direct influence on the formation of the band, U of M film series certainly affected my life." The leader of rock groups like Mission of Burma fit in well with the futuristic "rack of junk" percussion and synthesizer-based approach of the Alloy Orchestra, whose scores for films like Harold Lloyd's *Speedy* and Dziga Vertov's *Man with a Movie Camera* have been performed from Lincoln Center to the Louvre to Pordenone.

OPPOSITE: Flyer for 1992 AAFC silent film screening with live music by Ringing. Courtesy Jim Pyke

CHAPTER 11
CULT MOVIES AND CAMPUS VISITORS

IN THE 1970S the local commercial theaters, especially ones near the university like the Campus, Fifth Forum, and State, began to program weekend-night "cult" or "midnight movies" with irreverent, sexually explicit, or drug-related subject matter that appealed to students. Along with popular titles, like *Monty Python and the Holy Grail*, *Barbarella*, and *Reefer Madness*, the theaters sometimes tried one-offs, like an all-night marathon of biker movies, which attendee Dan Moray recalled attracting both high schoolers and "the greasy element, the dive-bar guys."

Not to be outdone, the film societies developed their own cult titles. The leader in this field was unquestionably the Ann Arbor Film Cooperative, which had its greatest success with a 1966 Philippe de Broca movie about a World War I Scottish soldier in a French town full of escaped asylum inmates. "We rented *King of Hearts* from United Artists for $1,500 a year," Gerry Fialka remembered. "We would make, let's just guess, three to five thousand dollars a year. And then they got smart and said, 'We're not doing a flat fee like that anymore.' But it took four or five years for them to realize that." The group also had some surefire titles that it didn't rent at all. "We bought our own prints—*Magical Mystery Tour*, *Night of the Living Dead*, *What's Up, Tiger Lily?*, *Mystery of the Leaping Fish*." Other cult entries favored by the AAFC included John Waters's *Polyester*, which was accompanied by scratch-and-sniff Odorama cards; David Lynch's *Eraserhead*; and Bruce Lee films, like *Fists of Fury* and *Enter the Dragon*.

Cinema II latched onto Marco Ferreri's 1973 *La Grande Bouffe*. "It's this comedy about these six guys who decide to kill themselves by eating themselves to death," remembered Ruth Bradley. One night the group played mind games with the audience. "We knew what it was about, but a lot of the other people didn't—the description said, 'Suicide pact over food.' So we bought 20 really fancy French pastries, and we gave them out free to the first 20 people in line. We did really well; it was close to a sellout. And then the movie is so obscene—if you take a porno movie and then substitute food for sex, that's what this movie was." It gradually caused a reaction in the theater. "About halfway through, you hear those 20 people in the audience who'd been noshing on their fancy pastries go, 'Eww, I don't want to eat this anymore.' That was fun."

While they were exploring the more outrageous fringes of cinema, the film societies were also increasing their efforts to provide in-person visits from noteworthy artists. Following the well-received appearances of Joseph Strick and Sam Fuller at the beginning

OPPOSITE: Frank Capra speaking to Marvin Felheim's class, February 1973. © David Margolick

TOP: 1975 flyer for the AAFC's biggest cult hit

BOTTOM: A 1975 Fifth Forum biker film festival

CULT MOVIES AND CAMPUS VISITORS 193

of the decade, in October 1972 ARM/Friends of Newsreel scored a major coup by presenting French director Jean-Luc Godard and his creative partner Jean-Pierre Gorin at the Power Center, in conjunction with screenings of their new release *Tout Va Bien*.

Bracketing this, Cinema Guild hosted both *Bride of Frankenstein* star Elsa Lanchester, in town to work with poet/professor Donald Hall on a biography of her late husband Charles Laughton, and legendary Hollywood director Frank Capra. The latter's February 1973 appearance came a year and a half after his own memoir, *The Name Above the Title*, had been published, but Capra's vision of the common man rising triumphant had fallen out of favor in the Vietnam War era.

Neal Gabler remembered, "Cinema Guild brought Frank Capra to campus for a weeklong festival at a time when he was in low repute—a visit that was the doing of my roommate then, Richard Glatzer, and me. Capra came off the plane holding cans of film. (He had actually carried them onto the plane!) It was *It's a Wonderful Life*, which, due to some legal entanglement, hadn't been shown publicly in years. Capra introduced it to a packed auditorium, and it brought down the house." The director's lack of pretense won over his hosts, and Gabler recalled how he used a line of Donna Reed's from the movie. "Capra took no honorarium. All he wanted was lodging and travel for him and his wife, Lucille. I think we gave him $600 spending money in cash. He flipped through the stack and then said, I think without recognizing the source in his own film, 'I feel like a bootlegger.' He left out the 'wife.'"

Along with taking questions at two screenings, Capra spoke to several classes, including Diane Kirkpatrick's. "He had been for so long 'Capra-corn' in Hollywood," she remembered. "And he was so dumbfounded that people here were looking at the films the way they were meant to be looked at." One of her students was a football player whose main motivation for taking the course appeared to be a girl who was also in it. "Frank and I were standing at the back of the auditorium when people were exiting from *The Bitter Tea of General Yen*. Frank had tears in his eyes when this football player came up the aisle and was weeping with his girl. Big, hulking, nice guy, but he had a heart of gold, as they say." Capra later sent Kirkpatrick and other film professors massive baskets of fruit as a thank you. "That helped me entertain people for a long time afterward," she recalled. Cinema Guild's Richard Glatzer subsequently parlayed his Capra connection into co-editing a book about the director.

The Robert Altman Festival

The number of VIP guests increased in the second half of the decade. In 1976, campus visitors included cinematographer Karl Struss and directors Claudia Weill, Peter

1979 ad for a screening of La Grande Bouffe

Davis, and Marcel Ophuls, the latter speaking at a Cinema II screening of his documentary *The Sorrow and the Pity*. Then, in early 1977, an ambitious two-month Robert Altman festival began, co-sponsored by UAC, the Ann Arbor Film Cooperative, Cinema II, and Film/Video Studies, for which Diane Kirkpatrick was teaching a course on the filmmaker. Along with ten screenings, personal appearances were booked for actor Elliott Gould, screenwriter Joan Tewkesbury, assistant director Alan Rudolph, producer Tommy Thompson, production secretary Elaine Bradish, critics Molly Haskell and Andrew Sarris, and the filmmaker himself, speaking at Hill Auditorium on April 23.

Altman was known to enjoy marijuana, and Ann Arbor had recently passed the most lenient possession law in the country, a five-dollar fine for a personal-size amount. The AAFC's Gerry Fialka took it upon himself to make the director feel welcome. "I said, 'We've got to get the best pot in town because he's going to party with us,'" he recalled. Dan Gunning arrived early for the event. "I was sitting in the back of Hill Auditorium, and Gerry came running up to me while people were coming in, getting their seats. He goes, 'Take a hit off of this joint, Robert Altman was just smoking on it!'"

Before the director was to speak, a sneak preview of his new film, *3 Women*, had been planned, but the Michigan Theatre had booked it to open just two weeks later. Though protective longtime manager Gerald Hoag had finally retired, Butterfield still had enough clout to pressure the studio into limiting the festival to screening just the first of its six reels. As Altman's appearance drew near, student coordinator Michael Gildo tried desperately to reverse this decision.

TOP: Frank Capra and his wife Lucille outside the Student Activities Building. © David Margolick

MIDDLE: Frank Capra speaking to Marvin Felheim's class in MLB Aud 3. © David Margolick

BOTTOM: Book about Capra published in Ann Arbor and co-edited by Cinema Guild's Richard Glatzer

CULT MOVIES AND CAMPUS VISITORS

CLOCKWISE FROM TOP LEFT: Mark Deming, at right, in a scene from *A Wedding* with Carol Burnett, center. Robert Altman papers, University of Michigan Library Special Collections Research Center; Mark Deming with actress Lauren Hutton. © Mark Deming; Blurb in the *Detroit Free Press* seeking tongue-tied audience member

"The person in charge of the University Activities Center sat down with me and said, 'Do we have a contract?' And what happened is we did have everything in writing, but it wasn't confirmed," he remembered. "The university's attorneys got involved and they actually had Alan Ladd Jr. on the phone, who was the head of 20th Century Fox, and they were threatening to sue him. And he just laughed at them." As Gildo drove to the airport to pick up Altman, he still held out hope that the director might bring the full film. "I'm thinking, *Please, God, let there be six cans of film and not just one*. I was praying all the way there, because I said, 'Maybe they're just going to keep it a secret, maybe at the last minute someone changed their mind.'" But it was not to be. "So, anyhow, he showed up with the one can of film. I felt like someone put a pin in me."

After the 20-minute reel had ended and Gildo offered any dissatisfied audience members refunds, Altman was left with a lot of time to fill. Sitting with her students, Diane Kirkpatrick watched the now slightly buzzed director come out carrying a yellow umbrella. "He walked all around the stage, and he put it down and twirled it," she recalled. "He said, 'I don't really have anything planned to say. I want to answer your questions.' And for a minute there was a deep silence. And then either the first or second person who got up had a very long question which went on and on and on and on."

The tongue-tied audience member was Mark Deming, a Saginaw High School junior whose older brother had invited him to town for the event. Deming recalled the moment vividly. "I'm trying to figure out what I want to say, and I just sort of get lost in thought. And then somebody taps me on the shoulder and it's like, 'Oh, it's my turn.'

Sign That Man Up

- SO YOU WANT TO BE a movie star? Robert Altman, who directed the films "MASH" and "Nashville," is looking for the young man who did a bewildering five-minute monologue during Altman's question-and-answer session Saturday night at the University of Michigan. Twenty seconds into the monologue, Altman asked the young man, "Are you asking a question or are you auditioning?" Altman wasn't kidding. The young man has a part in Altman's next movie, "The Wedding," if Altman can find him. The director wants the individual to get in touch with Mike Geldo, who put on the recently concluded Robert Altman Film Festival.

196 CINEMA ANN ARBOR

"ARE YOU ASKING A QUESTION, OR ARE YOU AUDITIONING?"

Robert Altman to Mark Deming

And I got so flustered I couldn't speak. I just stood up there for a good minute. Just, 'Um, hi, I, you, I, oh . . .' Basically I couldn't form a word for some reason. And then Altman says, 'Are you asking a question, or are you auditioning?' Well, he laughs, the audience laughs, I laugh, I figure I'm making a fool of myself. I finally spit out my question. He answers, I go back to my seat." The ice broken, the Q&A session carried on in a friendly, low-key way, and afterward Altman went to Kirkpatrick's home to talk with her students. "He leaned against my refrigerator and smoked pot for the whole evening and was just very open to them," she remembered.

Back in Saginaw a few days later, Mark Deming got a call from his brother. "He reads me this short blurb that was in the *Detroit Free Press* saying that they're looking for the young man who was at Robert Altman's question and answer session." After getting in touch with the filmmaker's office, Deming was flown to Chicago, where associate producer Scott Bushnell and her assistant Kelly Cummins engaged him in a lengthy conversation. "After a few hours they just said, 'So, are you interested? Would you like to do it?' I said, 'Well, of course I would. When do I find out?' They said, 'Oh, you've got the role if you want it. We just wanted to make sure that you actually knew what was going on.'" His tongue-tied question had inadvertently earned the teenage film fan two salaried months in Waukegan, Illinois, shooting *A Wedding*, in which he would have a speaking role as one of the bride's cousins. "That was April, and we basically started shooting in June."

Bushnell had noted Deming's interest in horror films, and the lines for his character were rewritten to highlight this. "Altman gave the actors an extremely large amount of freedom. He didn't really ride herd over people very much. At the same

TOP: Altman and Kelly Cummins on the set of *A Wedding*. © **Mark Deming**
BOTTOM: Altman at Hill, April 23, 1977. Photo by Steve Kagan, *Michigan Daily*

CULT MOVIES AND CAMPUS VISITORS

THE ROBERT ALTMAN FESTIVAL

SEASON PASS INFORMATION

Films

1-20-77 THAT COLD DAY IN THE PARK 7:00/9:00
1-26-77 M*A*S*H 7:00
BREWSTER MCCLOUD 9:00
2-12-77 MCCABE AND MRS. MILLER 7:00/9:15

2-17 Alan Rudolph
with a sneak preview of his new film

2-18-77 IMAGES 7:00/9:00
3-25-77 THE LONG GOODBYE 7:00/9:00
4-1-77 THIEVES LIKE US 7:00/9:15
4-16-77 CALIFORNIA SPLIT/ in STEREO SOUND 7:00
4-21-77 NASHVILLE 9:00
4-20-77 BUFFALO BILL & THE INDIANS 7:00/9:30
4-22-77

MOVIE PASS: $12.00 YOU SAVE $4.50 plus are guaranteed a seat to ALAN RUDOLPH with a FILM PRODUCED BY ROBERT ALTMAN

Lectures

3-3-77 ANDREW SARRIS

3-26 Elliott Gould

3-26-77 ELLIOTT GOULD
3-29-77 MOLLY HASKELL
4-7-77 JOAN TEWKESBURY
4-15-77 TOMMY THOMPSON
ELAINE BRADISH

4-23 Robert Altman
Hill Auditorium
$3.50 $2.50 $1.50
LECTURE PASS: $10.00 YOU SAVE $2.00 and have top priority reserved seat for ROBERT ALTMAN
Tickets on sale now at UAC Ticket Central in the lobby of the Michigan Union

All films will be shown in Auditorium A of Angell Hall
All lectures will be held in Rackham Auditorium at 7:30 p.m.

Films held in conjunction with Ann Arbor Film Coop & Cinema II. The Robert Altman Festival is in conjunction with Film/Video 500.

MAIN FLOOR
SEC 5 ROW L SEAT 3
APR. 23, 1977
ADMIT ONE ON ABOVE DATE ONLY

UAC PRESENTS
ROBERT ALTMAN
HILL AUDITORIUM
UNIVERSITY OF MICHIGAN
IN ANN ARBOR, MICH.
SATURDAY APR 23 1977 7:30 P.M.

NO REFUND PRICE NO EXCHANGE
$3.50

7:30, sat. march 26, rackham auditorium, $3.50

elliott gould
will discuss cinema and the role of the actor

The star of three Robert Altman films (M*A*S*H, The Long Goodby, and California Split) plus a cameo role in "Nashville". Gould achieved identity as an actor as the burlesque impressario Billy Minsky in "The Night They Raided Minsky's"; he then went on to earn an Academy Award nomination for his role of Ted in "Bob & Carol & Ted & Alice" and was immediately rushed into Altman's "M*A*S*H". Elliot Gould has starred in "Getting Straight", "I Love My Wife", "Little Murders", "Move", "The Touch" and "Harry and Walter Go to New York".

PRESENTED BY THE ROBERT ALTMAN LECTURE SERIES

time, you somehow sensed he got exactly what he wanted from you without having to coach you seriously," he recalled. Though his only prior acting experience had been in school plays, Deming would receive onscreen credit alongside stars like Carol Burnett, Mia Farrow, Howard Duff, Geraldine Chaplin, and Lillian Gish. "Most of the people were very nice. They treated me like a peer more than just some kid from Saginaw who kind of got there by accident." When the film was released in the fall of 1978, his performance made enough of an impression on director Joseph Ruben that he was offered an even larger role in American-International summer camp comedy *Gorp*, where he replaced Eddie Deezen, stuck finishing Steven Spielberg's ill-fated *1941*.

"Between *A Wedding* and *Gorp*, I was able to pay for about three-quarters of my college education out of my pocket," Deming remembered. "I was extraordinarily lucky." But the experience of acting in an Altman film was priceless. "When we were working on *A Wedding*, more than one person said to me, 'It's a shame you've never been in a movie before, so you can't really appreciate how nice it is working with Bob.' That came back to me every once in a while when I was making *Gorp*."

Altman's visit to Ann Arbor had an even greater impact on the director himself. "That was when he fell in love with Michigan," Diane Kirkpatrick recalled. His welcoming first trip to the university would lead to a relationship that lasted for the rest of his life and beyond. In 1982, he returned to direct a U-M sponsored production of Stravinsky's opera *The Rake's Progress*, and then two years later shot an adaptation of a one-man play about Richard Nixon, *Secret Honor*, while co-teaching a film course with Frank Beaver. Awarded an honorary U-M arts degree in 1996, upon his death a decade later his widow Kathryn Altman gave the director's archives, including his honorary Oscar statuette, to the University of Michigan Special Collections Library. Housed with the papers of filmmakers like Orson Welles, Alan Rudolph, John Sayles, Nancy Savoca, and Jonathan Demme, they form a key part of the university's Mavericks and Makers collection, curated by former Ann Arbor Film Cooperative member Philip Hallman.

ABOVE:

Mark Deming on set.

© Mark Deming

CULT MOVIES AND CAMPUS VISITORS

"I NEVER WENT TO A FILM SCHOOL; THEY'RE A WASTE OF TIME."

Documentarian Frederick Wiseman to the *Michigan Daily*

Joan Rivers speaking in Angell Hall Auditorium A, November 18, 1977. Photos by John Knox, *Michigan Daily*

VIP Visits Surge

Though the Altman festival had reportedly gone $19,000 in the red, it was soon followed by a flood of campus visits from other motion picture artists, mostly underwritten by the film societies. In September of 1977 the AAFC sponsored a return to campus by director Sam Fuller, and in November hosted Joan Rivers for a test screening of her sole directorial effort, *Rabbit Test*. A month later the group brought in German filmmaker Werner Herzog, and then in early 1978 Cinema Guild hosted both documentarian Frederick Wiseman and cinematographer Haskell Wexler. Wiseman spoke following an afternoon screening and mingled with faculty and students afterward over cocktails. The *Titicut Follies* filmmaker was less enamored of Ann Arbor than Altman, however, and according to the *Daily* was heard to remark, "I never went to a film school; they're a waste of time." Skipping a planned dinner gathering, he caught an early flight home.

In April of 1978, UAC and several film groups sponsored a visit by German director Wim Wenders. Hugh Cohen was teaching his work that term. "I was taking a psychoanalytical approach to Wenders in my class, and several of the students were very resistant to that. So when Wenders talked that night in Aud. A, one of my students stood up and said, 'Mr. Wenders, we're taking a psychoanalytic approach to your films. Is

200 CINEMA ANN ARBOR

ABOVE:
Cinema Guild poster

LEFT: **Flyer for visit by Elfriede Fischinger, 1978**

there any validity to that approach?' And I said to myself, 'Uh-oh, if he answers one way it'll destroy my class.' And he said, 'Absolutely yes.' So I've always loved Wim Wenders since then, for saving my class." One film society member who met Wenders at the afterparty was Cinema II's John Sloss, who was also taking Cohen's course. Following graduation from U-M Law School he began working with independent filmmakers, and 25 years later reconnected with Wenders as an executive producer of his feature *Land of Plenty*.

Other visitors of 1978 included Elfriede Fischinger, who discussed the abstract animated films of her late husband Oskar; film noir auteur Joseph H. Lewis, who spoke after his 1950 *Gun Crazy* as part of a free festival of his work sponsored by the AAFC; and *Easy Rider* star Dennis Hopper. Speaking at an AAFC-sponsored screening of his 1971 *The Last Movie*, which he had been touring the country with, Hopper performed scenes from the notoriously drug-fueled feature

CULT MOVIES AND CAMPUS VISITORS 201

onstage while claiming that "I'm straight now," per the *Daily*, though Gerry Fialka remembered him sneaking into the back of the room and "drinking a beer out of a can that had a Coca-Cola emblem wrapped around it, so it looks like he's drinking a Coke."

In the fall of 1978, the AAFC also brought to campus Pittsburgh-based director George Romero, who took questions after both *Night of the Living Dead* and his new release, *Martin*.

George Romero speaking, September 14, 1978. Photo by Wayne Cable, *Michigan Daily*

Impressed by his Ann Arbor reception, Romero returned just four months later on January 11, 1979, to run what was reportedly the second-ever rough-cut screening of his US version of *Dawn of the Dead* in Auditorium A (the foreign edit having already been completed by Dario Argento). "It's 380 capacity, and we had probably 500 people," remembered Gerry Fialka. "We were trying to shut the door, and the actual experience of showing the film was like *Night of the Living Dead*. Their arms were coming in the door, and we were like, 'Back, back!'" Romero brought much of his production team, who circulated response forms with questions like, "Did you find the violence offensive? Fun?"

One month after Romero's second visit, Cinema II presented Andy Warhol's three-and-a-half-hour, dual-screen *Chelsea Girls* with another special guest. Shown in town only a handful of times since its 1966 release, the film's most notorious scene featured Robert Olivo, a.k.a. Ondine, shooting heroin onscreen. "We were always looking to do new things and top the other film societies, and we tried to hunt down *Chelsea Girls*," John Sloss recalled. "Our sleuthing led us to Ondine, who owned one of two existing prints. And in order to rent the print, you had to rent him as well. You had to fly him to Ann Arbor and let him speak. So we did." After his appearance, the group took him to the Old Town Tavern, where Sloss was working as a bartender. "He was such an insane alcoholic, he would just drink anything," Sloss remembered. "We had this box of note cards that had obscure drinks. And there was one I could never get anyone to try called the Papoose, which was one shot of 151 rum and one shot of Southern Comfort. And that was it. So I said, 'Hey man, you should try this drink,

it's great, it's called a Papoose.' 'Yeah, I'll do that.' He drank it, and he goes, 'Man, that's great. Give me another!'"

Just a few weeks after Ondine's appearance, the AAFC brought an even more offbeat visitor, cult actor/director Timothy Carey. Known to film buffs for memorable appearances in features like Stanley Kubrick's *Paths of Glory* and Marlon Brando's *One-Eyed Jacks*, Carey had also produced, written, directed, and starred in the obscure 1962 vanity production *The World's Greatest Sinner*. Featuring a score by Frank Zappa that Coop members like Gerry Fialka were keen to hear, the group eventually tracked down the star himself, who had the same requirements as Ondine. "He said, 'Well, you have to rent me, and I have to come with,'" Fialka recalled. Carey agreed to bring several more recent productions to screen as well.

Arriving from LA complete with his family and their German shepherd dog, Carey put himself full-force into promoting the April 12, 1979, event. He paid a visit to Detroit TV–movie host Bill Kennedy's live afternoon show and joined several AAFC members to carry ballyhoo signs around the central campus Diag. With Peter Wilde rigging up a custom system to play the two-track magnetic soundtrack of unfinished short *Tweet's Ladies of Pasadena*, Carey gave dynamic performance-talks before the screenings that included writhing on the Auditorium A stage. "I was only 15 years old," the late actor's son Romeo Carey recalled. "I remember vividly sitting and watching my father speak in one of the Ann Arbor theaters as it filled with Mary Jane."

The film societies kept a steady stream of guests coming through the end of the decade, with Cinema Guild hosting legendary special effects

"THEIR ARMS WERE COMING IN THE DOOR, AND WE WERE LIKE, 'BACK, BACK!'"

Gerry Fialka, on crowds at a *Dawn of the Dead* screening.

TOP: Timothy Carey, in dark coat, and Gerry Fialka, with yellow hat, carrying faux protest signs on the Diag. © Gerry Fialka

BOTTOM: In the Angell Hall "Fishbowl." © Gerry Fialka

CULT MOVIES AND CAMPUS VISITORS

OPPOSITE: Timothy Carey performing at Angell Hall, April 12, 1979. © Gerry Fialka

artist Linwood Dunn; the AAFC sponsoring underground filmmaker Jon Jost; Cinema Guild and the AAFC bringing documentarian Les Blank; and Cinema II hosting critic Molly Haskell, producer Judy Steed, and filmmaker Chick Strand as part of an 18-night women's film festival.

The guests, the film series, the colorful calendars they created, and the interesting, year-round, nearly nightly offerings had by now made the film societies into one of Ann Arbor's signature cultural resources. "It became the topic of all conversation," Cinema Guild's Rob Ziebell remembered. "Everybody would talk about what they saw that week when you went out to dinner, or after beers." As future *Variety* chief film critic Owen Gleiberman wrote in a 1979 *Michigan Daily* essay, "There is so much film here—screenings, classes, and endless, endless discussions—that you almost get shell-shocked."

The Ann Arbor Film Cooperative presents at Aud. A
Thursday, April 12

TIMOTHY CAREY is a legendary character actor who first gained attention for his brilliant performance in Kubrick's *THE KILLING* and *PATHS OF GLORY*. Tonight we are proud to present Timothy Carey **in person** (and he is quite a showman) with **THE WORLD'S GREATEST SINNER** and *TWEET'S LADIES OF PASADENA*. Tim Carey will speak after both shows.

TWEET'S LADIES OF PASADENA
(Timothy Carey, 1974) 6:30 only—AUD. A

Says Carey: "My most satisfying role to date. Tweet-Twig, the main character, is the only male member of a knitting club run by old ladies who teach him to knit without dropping a stitch."

Plus short: TARZANA (Steve DeJarrnet, 1977) A dramatic short starring Tim Carey as Benny Coglin. With EDDIE CONSTANTINE.

THE WORLD'S GREATEST SINNER
(Timothy Carey, 1962) 9:30 only—AUD. A

Carey starts as Clarence Hilliard, an insurance salesman who denies the existence of any supernatural deity and proclaims himself God (Jimmy Jones??). He becomes a rock-and-roll evangelist and enters national politics. This film combines sensationalist elements with an ultramoralistic wrap-up and a genius kinky-kinetic sense of movie-making elan throughout. Music by Frank Zappa. "Carey has the emotional brilliance of an Einstein!"—John Cassavettes.

Tomorrow: THE PINK PANTHER and REVENGE OF THE PINK PANTHER

the ann arbor film cooperative presents

VISITING FILMMAKER
JON JOST

FREE – LECTURE & FILMS

THURSDAY, MAY 15
AUD. A, ANGELL HALL
7:00

JON JOST IS THE MOST IMPORTANT political" (and I use the word advisedly, not in its shrill modern sense, but in its original Greek sense, as a citizenly concern and engagement with one's society) filmmaker presently working in the United States, but that's not all. His films reflect a startling cinematic consciousness: they are visually and structurally revolutionary as well as politically acute. In this sense one can't help feeling that he is the only American filmmaker in Godard's league ... Just speaks for us, not to us - and in a purely American voice." (Michael Goodwin)

Jon Jost. Born 1943, Chicago. Education: expelled from Illinois Institute of Technology; two years in Ohio Reformatory for draft evasion. Jon Jost is one of the few political filmmakers working in America today outside the agitprop documentary, originally in the analytical method developed by Godard, and more recently in an attempt to cross the lines between political/experimental/commercial filmmaking.

Jost's first long film, SPEAKING DIRECTLY: SOME AMERICAN NOTES, "is a feature-length autobiographical essay or, as the title indicates, cinematographic notes giving a personal and political reflection on contemporary American life. In particular, Jost examines the relations between our personal lives, US international politics, the media, modes of discourse, and our relation to our geography, our towns and landscape." (Julia Lesage).

SPEAKING DIRECTLY is an autobiographical film; not in the sense of being a celebration of an individual consciousness, but as an assessment of its *meaning* in contemporary America. The film explores fully the tensions of being a socialist individual within a capitalist collectivity, and as such represents not just a powerful/entertaining/valuable document, but a *useful* one.

Since SPEAKING DIRECTLY, Jon Jost has moved into quasi-commercial film-making: with ANGEL CITY, the potentially deconstructive elements of the voice-over Private Eye movie — direct address, pre-knowledge of events invested in a character within the diegesis — to dissect the forms and the ideological functions of "entertainment" films. LAST CHANTS FOR A SLOW DANCE (Dead End) adopts a less strategic position: though still employing distancing devices (single colour overprints on black-and-white shots/black leader), LAST CHANTS is much more naturalistic than his previous work — a head-on attack on the mythology of the "free individual" expressed in terms of the "road movie" (with an original C&W score performed by Jost himself).

Thursday, May 15
JON JOST FESTIVAL 7:00 Aud A FREE

Visiting filmmaker Jon Jost makes his first Ann Arbor appearance. Jost, a 36 year-old independent, experimental filmmaker, examines political and social issues. His stay in Ann Arbor will be highlighted by screenings of **Speaking Directly** (7:00) and **Last Chants for a Slow Dance** (10:00). He will give a lecture on low budget filmmaking between the two shows. *Speaking Directly* (1973) has been described as a rumination on life in America, Vietnam and the process of filmmaking. *Last Chants for a Slow Dance* is the story of an unemployed trucker who plays at being "King of the Road," while his family struggles for welfare. Don't miss Jost's films and the chance to listen to an independent filmmaker expouse on his art. A workshop is tentatively scheduled for Wednesday afternoon, May 14. Please check the desk or office phone for details.

American Independent: JON JOST

AAFC flyer, 1980

Cinema II festival program, 1979

CHAPTER 12
A LIBERATING EFFECT

AS THE FILM SOCIETIES grew in size and ambition, other parts of the scene were evolving as well, including the Ann Arbor Film Festival. In 1972 George Manupelli's creation had celebrated its 10th anniversary in style, giving out record prize money of $1,875 and expanding its popular Sunday screenings of winners and highlights to six showings in two auditoriums, with three separate programs shuttled between the two sites. Local filmmakers continued to be an important part of the event, with nearly a dozen Ann Arbor productions on the public program, including the festival director's own out-of-competition *Cry Dr. Chicago* and David Greene's AAFC-backed feature *Pamela and Ian*; and shorts by Jay Cassidy and Fred LaBour, Chris Frayne, Tom Berman, Luis Argueta, and Andrew Lugg, both solo and with his wife, Lynne Cohen. Prominent names continued to submit their new work as well, including Ed Emshwiller, Curt McDowell, Richard Myers, and Nam June Paik and Jud Yalkut.

With the campus film societies now freely able to show softcore pornography, there was no longer any need to store prints in a getaway car as had once been necessary. In the same auditorium where just five years earlier Cinema Guild members had been arrested for showing *Flaming Creatures*, the festival could screen Anne Severson's *Near the Big Chakra*, a 15-minute color film featuring nothing but vulvas. "Close-ups of people of all ages, from little tiny kids right on up," attendee Doug Rideout recalled. Rather than exciting prurient interest, the film caused a mass exodus. "Pretty soon there wasn't anybody left except me and a few others who stayed for the end." Filmmaker and future festival manager Woody Sempliner enjoyed the newfound freedom. "That was the whole liberating effect of the medium. The idea that you could get a camera, and you could shoot pictures of anything you wanted. And then the question was like, 'Anything?' And it's like, 'Yeah. Yes!'"

Along with Buster Simpson's lobby piece, "Italian Video," and six performances by Pat Oleszko, the 10th festival included a memorable outdoor installation by Bill Finneran. A junior member of the ONCE Group during his late '60s art school studies as well as a filmmaker, festival juror, and actor in the Dr. Chicago series, he was teaching at NYU when Manupelli asked him to contribute. His piece "Car Surfacing" required five brand-new automobiles. "I just called Ford and said, 'Lookit, I'm an artist, and I'm here in Ann Arbor for the Ann Arbor Film Festival,'" Finneran recalled. "I have this idea to do a temporary sculpture using cars, and I would very much like to use the Grand Torino because it's the Car of the Year.'" His calculated flattery of the recent *Motor Trend* honoree worked. "So, unbelievably, they said, 'Sure, who's your dealer? We'll give them a call. How many do you want?' So they gave me a whole bunch of them."

The piece was realized in stages, as Joe Wehrer remembered. "On the first

"I JUST CALLED FORD AND SAID, 'LOOKIT, I'M AN ARTIST…"

Bill Finneran

OPPOSITE:
Excerpt from 17th 8 mm festival poster, featuring Jeri Hollister, photographed by Rafael Duran. Courtesy Mark Schreier

FOLLOWING SPREAD: George Manupelli's 1972 AAFF flyer

A LIBERATING EFFECT

TENTH ANN ARBOR FILM FESTIVAL, MARCH 14-19, 1972, $25,000.00 in awards and fees

To Italians all over the world, to all those children of a modest little country who have traversed the earth with a spade and pick, casting their seed in new furrows and constructing for themselves on the shores of every sea, at the foot of every mountain, in the lap of every valley, a larger and stronger homeland; to all those of my race who have journeyed at a venture towards the west in search of happiness, and who, remote and forgotten in exile, have not forgotten their name, their language, and their native land; to all those dwellers in the globe-encircling chain of oases of Italianity, to all, great and small, rich and poor, who, by their voice, their affection, and their enthusiasm have sustained our flight, this diary of a pilgrimage across the world is dedicated by its author ANTONIO SCARFOGLIO.

day, one of these cars would appear at the entrance of the auditorium. The next day, a second. They'd pull up and be painted completely black. Flat black. So you had to see the form in a totally new way." After he finished covering a car, Finneran stayed outside. "People were walking by all the time, not only people involved with the film festival, but just regular old civilians," the artist recalled. "So I spent a lot of my time talking to people about what I was doing and art in general." Defacing an expensive, factory-fresh American consumer product seemed deliberately confrontational, but Finneran hoped for a more subtle impact. "This was one of the few sculptural objects that an ordinary person invests a whole heck of a lot of money—and aesthetic interest—in, in our culture," he remembered. "And the people who had that investment were not ordinarily art lovers, but they were people from the general population. And my interest was in finding a way to reach out to people like that and say, 'See, you have an artistic aspect to your way of thinking about things, just as much as art collectors do.'" His friendly encounters with the public, the clear weather, and a paid overnight security guard combined to keep the cars from being bothered, and after the festival Finneran power-washed and returned them to Ford.

Manupelli Steps Back

In his 1972 survey of film on campus prepared for university administrators, Marvin Felheim wrote that the film festival "has brought international fame to the university," but noted: "The art department has only reluctantly granted Manupelli tenure and still keeps him at the associate professor rank; the future of film in this department

TOP: Excerpt from the 10th film festival program
BOTTOM: *Daily* story on Bill Finneran's car piece.
Photo by Jim Judkis, *Michigan Daily*

as I see it is uncertain to say the least." Frustrated about his ongoing lack of support, during that same year George Manupelli took a job at York University in Toronto, while holding on to his role as festival director. "George had pissed everybody off at the art school and he wanted to leave, but he couldn't leave the film festival. He invented it. He created it," his friend Allan Schreiber recalled. "So he thought that he could take this job in Toronto, and he could come to Ann Arbor whenever needed and he would get somebody who would kind of be a placeholder, who would take care of the nitty-gritty details, which George always hated and got other people to do anyway. So George was like the 'Papa,' and then the kids would shovel the snow, if you get my metaphor."

While Manupelli continued to design the graphics and come to Ann Arbor for the event, he turned the administrative work over to Cinema Guild's Jay Cassidy. There was little formal organization, however. "In my year as the first manager of the festival beyond George," Cassidy recalled, "it was conducted out of a shoebox with index cards of the names and addresses of the filmmakers. And John Caldwell and Woody Sempliner, who managed the festival after me, kept the same philosophy." The festival remained dormant from April through December, "just a mailing list" as Sempliner remembered, with a PO box that was checked periodically until year's end, when the gears began to turn again.

While things outwardly were much as before, longtime attendees began noting a gradual change of spirit. In an *Ann Arbor Sun* review of the 1974 festival, its associate director, Ellen Frank, wrote: "*TIME* magazine would say, 'Everyone is getting into movies.' With Everyone doing it, the films are very different than they were a dozen years ago. It is no longer the personalized and subjective beatnik avant-garde, centered in San Francisco, New York, and Ann Arbor. It is virtually everyone—young, old, rich and some poor, Black and white, and finally male and female. The change is obvious—less Art." She concluded, "For the first time the strong films of the festival were documentaries and narratives rather than the once dominant personal 'art' films that I couldn't understand at all when I first saw the festival at the age of 16." Doug Rideout had the same feeling. "When George left, it really took the wind out of the sails," he recalled. "But I think the big change came with the National Film Board." The Canadian government–sponsored agency churned out interesting but decidedly professional films and submitted them regularly. "Those films of course were

George Manupelli at the 1975 festival. © Ken Beckman

A LIBERATING EFFECT

technically excellent. But they weren't the kind of films that the Ann Arbor Film Festival showed as a rule. If anything was in focus even, it was considered slick."

Another change came in the format of prizes, which had always been left up to the jurors to award, with no categories beyond the Dominick's-sponsored Prix De Varti for funniest film. But when local filmmaker Tom Berman was murdered in New York in 1973, his family approached Manupelli to endow a prize for Most Promising Filmmaker. Though the festival director had long avoided establishing categories that had to be fulfilled whether or not an entry met the criteria, he accepted it out of sympathy for Berman's family. As subsequent memorial prizes were added for Marvin Felheim and Chris Frayne, the festival began to slowly become more tied to categories, which in turn began to influence submissions.

Despite the changes, the Ann Arbor Film Festival kept moving forward. Along with the list of films in competition, short political commentaries had begun appearing on the printed program, including a 1974 note soliciting donations to support freedom in Chile following the coup that toppled President Salvador Allende. A film on the subject and a translated version of Allende's final radio broadcast were also played. Each year's festival continued to feature nightly live performances by Pat Oleszko and lobby art displays by locals like Dan Mulholland and Vicki Honeyman, along with new additions like circus/vaudeville/music act the Friends Roadshow. In 1974 Manupelli also brought from Toronto a student noise-rock band called Below the Belt, which featured future Sonic Youth bassist Kim Gordon. Their second-ever live show proved inspirational to U-M art student and Destroy All Monsters member Mike Kelley, who would later meet up with Gordon in LA and become her close friend and collaborator. Networking was an important aspect of the festival for filmmakers as well. Jay Cassidy got to know prominent experimental filmmaker Pat O'Neill when he was in town as a juror and reached out to him after moving to California. "I ended up working on one of his films," Cassidy remembered.

The festival jury continued to mix locals, like Fred LaBour, Allan Schreiber, Al Loving, and activist/photographer/

"IF ANYTHING WAS IN FOCUS EVEN, IT WAS CONSIDERED SLICK."

Festival regular Doug Rideout

Pat Oleszko confers with "Blue" Gene Tyranny at the 1975 festival.
© Ken Beckman

filmmaker Leni Sinclair with invited guests, like O'Neill, Curt McDowell, *Film Comment* editor Gordon Hitchens, and *Near the Big Chakra* director Anne Severson, but the selection committee had largely shifted from Manupelli and his ONCE cohorts to recruits from the film societies. The assignment of watching every minute of several hundred entries required endurance, but had its rewards, as Cinema Guild's Mary Cybulski recalled. "We would watch about six hours of experimental film like five days a week for a month. When I started I really had no idea what I was looking at, but you just see so much of it and it starts to make sense to you. Just seeing what happens when you slap one image up against another, or the sound. Just the really elemental language of it." Though she was taking film classes at the art school, the intense immersion had a profound impact.

"That's when I really got it. And there was no class that I took, there was no book I read, or lecture I heard, or anything that did anything even one hundredth of what that did for me." After producing popular festival entries like *Up There Keweenaw* with classmate and future husband John Tintori (later chair of the graduate film program at NYU), Cybulski pursued a career as script supervisor and set photographer for directors like Michel Gondry and Ang Lee.

Another festival tradition that began during these years was the compilation film. Shot off the screen by the selection committee with a tripod-mounted 16 mm camera, it was intended to catch part of each entry, with the resulting silent film processed in time to play the last night of the festival, accompanied by improvised or found sound. "Maybe two seconds of all different kinds of pieces from the different films," Pat

From left: Fred LaBour, John Caldwell, Anne Severson, Jay Cassidy, and Susan Zeig at the 1973 festival. Courtesy Jay Cassidy

A LIBERATING EFFECT

215

Claywood "Woody" Sempliner had first been introduced to the Ann Arbor Film Festival in 1966 by his then-girlfriend and Cinema Guild chair Ellen Frank, who took the unsuspecting undergrad to see *Up-Tight with Andy Warhol and the Velvet Underground*. "Afterward we went to Joe Wehrer's house for an afterparty," he remembered. "And I was standing there in a conversational circle with Andy Warhol. I thought Ann Arbor was pretty much the center of the universe." He subsequently made a film that was shown at the festival, as well as videotaping some of Pat Oleszko's performances while working for Ann Arbor's early cable TV service. In 1974 he was living in an old house near campus when Frank, serving as associate festival director, asked if he would join the selection committee, in part so they could use his spacious flat. He agreed to help, and a few months later, when manager Jay Cassidy decided to give up the role, George Manupelli asked Sempliner and John Caldwell to jointly take over the job.

While pleased with the assignment, Sempliner had also begun to feel that the festival was losing its way with its guiding light in Toronto. "What I started noticing was that, as devoted as I was to George, most of the local people were getting more and more vague about who he was," he remembered. "And the whole magic of the original festival was kind of fading. So I realized that I needed to get more young people and specifically people who were in the film societies." In addition to co-sponsor Cinema Guild, he and Caldwell reached out to Cinema II and the Ann Arbor Film Cooperative. "Without the film societies in those days, we were dead. We had nothing. We weren't supported by the university at all, except through

TOP: An early 1970s festival party. Co-manager John Caldwell second from left. © Ken Beckman
BOTTOM: Pat Oleszko performing at the 1975 festival. © Ken Beckman

Oleszko recalled. "Like you would see, 'Oh, everybody's taking pictures of the sun through the trees,' or 'I got seven films that are birthing films, from cows to people.'" A creative opportunity for the screeners, it also served as an irreverent finale to the competition before the big Saturday night party.

Woody Sempliner Takes Charge

216

CINEMA ANN ARBOR

"WITHOUT THE FILM SOCIETIES IN THOSE DAYS, WE WERE DEAD. WE HAD NOTHING."

Film festival manager Woody Sempliner

Cinema Guild." He recruited a group of interested volunteers (many of them also filmmakers) that included Mary Cybulski, John Tintori, and John Nelson from Cinema Guild; Ruth Bradley, Alan Blomquist, Kevin Smith, and Bernie Coakley from Cinema II; and the AAFC's Gerry Fialka.

Sempliner also began to seek publicity outside of Ann Arbor, especially in Detroit. "I went on WJR; I was interviewed by J. P. McCarthy," he recalled. "I learned how to write press releases, how to interface with newspapers. We got people from the *Free Press*, from the *News* to come and prescreen films. We would give them press packets, things like that. And we started getting a much bigger audience." The festival continued to get national attention as well, with scouts from independent distributors and museums attending, and *Variety* publishing a detailed report.

Despite some shifts in emphasis, submissions continued to feature a multitude of styles that ranged from abstract experiments and humorous animated shorts to quirky narratives and documentaries. The festival also maintained Manupelli's mixed-genre programming style that exposed audiences to more variety and kept the palate fresh. Sempliner believed this best served the filmmakers. "Our object was to make the films stand out on their own," he remarked. "Like if you were going to be in a talent show, and you're going to do a tap number. Then someone does a tap number before you, someone does a tap number after. That's no good. What you want before you is, like, a solo accordion player and then you do your tap and then someone juggles or something." Screenings were also tightly packed so as many of the submissions as possible could be seen,

The 1974 selection committee. Left to right: Leslie Coutant, Stuart Klein, John Caldwell, Jay Cassidy, Woody Sempliner. Courtesy Jay Cassidy

A LIBERATING EFFECT 217

leaving post-film discussions to the hallway or Dominick's. Other than Pat Oleszko's short pre-show performances and the art displays in the lobby, "It was actually fairly spartan the way it was done," Sempliner remembered. "It was just this darkened room focusing on this one medium, this one type of art. And that was all you needed."

In the latter half of the 1970s the influence of the emerging punk rock scene began to appear, as did some pre-MTV "music videos." One was Chuck Statler's *The Beginning Was the End* starring Devo, whose 1977 festival screening was among the group's earliest exposures outside its home in Akron, Ohio. Other entries were submitted by San Francisco's enigmatic Residents. "They sent us two that were wonderful," Sempliner recalled. "One of them was *The Man in the Dark Sedan*. Fabulous, post-apocalyptic. There were a bunch of 'troll-y'-looking people pulling this car, and in it is the lead singer. It's sort of like *Mad Max*, except there's no gasoline." A gritty documentary on New York's CBGB club, *Punking Out*, won an award at the 1979 festival, and was later brought to campus for several film society showings.

Though Pat Oleszko was beginning to scale back her performance schedule to weekend nights only, George Manupelli continued to return for each spring's festival. He hung out at the home of his now ex-wife Betty Johnson and her second husband Allan Schreiber, just steps away from the Wehrers, who still hosted an end-of-festival brunch. "George would show up the Friday or Thursday before the week of the festival," Woody Sempliner remembered. "And we would type up the whole program, and then we used to put the whole thing on one big sheet of paper. So we'd have everything typed and we'd lay it out on Allan and Betty's dining room table. And George always had some outrageous idea; he would stick things on it. One year George got everyone to use a stamp pad. So we all rubbed our sexual organs on a stamp pad and then made an imprint on the program."

The festival program from 1979 featuring body part imprints at lower right

CINEMA ANN ARBOR

1970s tickets
designed by George
Manupelli

Cinema Guild member Peggy Ann Kusnerz was there. "We were cutting and pasting and trying to put up this big one-page list of what movies were being shown," she recalled. "At some point, after a lot of beer and wine and dope, the men, in particular Manupelli, unzipped their pants, whipped out their penises, put ink on the penises, and then made penis prints on this schedule. I think I was young enough that I was pretty shocked with all this, but then I figured, 'They're artists, that's what they do.'" Imprints of both male and female genitalia can be spotted on several festival programs of the 1970s, while Manupelli also raised eyebrows with provocative brochure designs that featured an autopsy photo of Lee Harvey Oswald (1973) and a nude Pat Oleszko (1977), as well as a ticket featuring a photo of Joe Wehrer holding a dead cat.

Moving to the Michigan

In 1974, the university had relocated the art, architecture, and urban planning schools from the heart of campus to a sterile new building on North Campus that Bill Finneran likened to "a remote CIA installation," leaving their funky former home in a state of limbo. Though the auditorium was still being used by Cinema Guild and the film festival, Rob Ziebell recalled that the university was growing unhappy with both the amount of money being made by the film society and the crowds it drew, as well as the

A LIBERATING EFFECT

BELOW: Linda Pantry (left) and director Ruth Bradley prepare for the 20th festival. © 1982 MLive Media Group. All rights reserved. Used with permission

OPPOSITE: 24th Ann Arbor Film Festival flyer by Rob Ziebell

anything." Along with cleaning up the messy finances, she also added a board of directors for oversight, primarily drawn from the film societies. "It wasn't trying to wrest it off of Cinema Guild so much as it was trying to make it a legitimate organization. I was not going to get popped for tax fraud if I was running it. At the same time, we got the name copywritten. And subsequently some of the people who worked on the festival over the years said to me, 'That was the smartest thing you ever did.'"

The festival's reconfiguration into an independent entity was a gradual process, with its original co-sponsors, Cinema Guild and the Dramatic Arts Center, still credited in the programs for the next several years. The U-M film societies also continued to give money and be the primary source for staff, board, and selection committee members, while Cinema Guild's Rob Ziebell took over the critical job of graphic design for the first several years before passing it to the equally capable Dan Bruell, another Guild member.

Notwithstanding the unhappy end of his leadership role, both George Manupelli and the Ann Arbor Film Festival had made an indelible mark on the world of experimental film, with the event earning recognition as one of the longest-running and most prestigious film festivals in North America. "I think George was the kind of guy who needed to be the boss," Woody Sempliner recalled. "And he didn't interact well with authority. Which was why he was sort of charming in a way, too. Because when you were with him you thought you could kind of get away with anything." He added, "He was extremely eloquent, and he knew how to express himself in really powerful ways. And he was very seductive. I mean, why would Andy Warhol come to the A&D Auditorium? Something about it was just hip enough for him." Pat Oleszko concurred. "You know he drank too much, and he was such a renegade, and he enjoyed being in that place of being the underdog. It was part of his DNA. The idea was that you were going to make art, and that's why you went to art school, to learn how to make art. And that's what you did. You did it with whatever means necessary, however you could."

Jay Cassidy remarked, "He started the festival so he'd have a place to show the movies, his own movies, in a sense. And it grew from there. He always used to say that it was not a festival about experimental films, it

HANDEYE PHOTO: PAUL TASSIE

THE ANN ARBOR FESTIVAL
FILM MARCH 11-16

REMAINING PHOTOS, POSTER DESIGN: ROBERT ZIEBELL

Screenings are held at the Michigan Theatre, located at 603 East Liberty Street in Ann Arbor. Shows Tuesday March 11 through Friday March 14 are 7:00, 9:00 and 11:00 p.m. Saturday March 15 shows are at 1:00, 7:00 and 9:00. Highlights and winners are shown Sunday March 16 at 7:00, 9:00 and 11:00 p.m. Single admission is $3.00; daily series $7.00 (not available Sunday). Advance sales begin at 6:00 p.m. for that day only. $25.00 series passes good for the entire Festival are on sale the opening day of the Festival at 5:30 p.m.

#24

The Ann Arbor Saxophone Choir performing at the 1986 film festival

was a festival where artists who made films would have a place to show them. And that's kind of different from the language that's used to describe the festival in subsequent years. He had a very well-thought-out mandate for what the festival was, and he used to always say, 'If the films come and the audience shows up, there'll be a festival. And if either of those doesn't happen, there won't be.' His orientation was developing a community of artists who made films, and filmmakers who were artists, and that was always his mandate on what the festival was."

After serving as dean of the San Francisco Art Institute, where he made a Clio Award–winning recruitment film starring *Saturday Night Live*'s Don Novello as Fr. Guido Sarducci, George Manupelli would eventually mend fences with the festival, quit drinking, and settle into the role of founder emeritus, helping maintain a connection to its original spirit until his passing in 2014. Woody Sempliner went on to a variety of mostly film-related jobs, including taking a Peter Wilde–pitched gig shooting a never-aired 16 mm documentary about Olivia Newton-John for HBO, as well as working as an actor in New York. Jay Cassidy became an in-demand film editor, receiving multiple Oscar nominations and working on projects ranging from Barack Obama and Joe Biden's Democratic Convention biofilms to *An Inconvenient Truth*, *American Hustle*, and *A Star Is Born*. At the end of her five years as festival director (during which she wrote its history for her dissertation), Ruth Bradley moved to Athens, Ohio, where she served for three decades as director of both the Athens Center for Film and Video at Ohio University and the Athens International Film and Video Festival.

In the years following its separation from Cinema Guild, the Ann Arbor Film Festival carried on as an independent organization dedicated to George Manupelli's mission of presenting the best in experimental filmmaking. It remained true to the 16 mm format through the long tenure of former Cinema Guild president Vicki Honeyman, and, in the early 2000s, expanded under successor Chrisstina Hamilton to include 35 mm film and finally digital video, which became its primary format. Along with prize money from Dominick DeVarti and supporters honoring the memory of Marvin Felheim, Chris Frayne, and Tom Berman, the festival reached out to prominent filmmakers who had attended in its formative years, including Ken Burns, Lawrence Kasdan, and Michael Moore, each of whom funded awards.

The 8 mm Film Festival

As the Ann Arbor Film Festival was

facing challenges in the late 1970s and early '80s, its 8 mm sibling was becoming a force of its own. Launched in February 1971 by the Ann Arbor Film Cooperative as a successor to local showcases presented by Cinema II, Canterbury House, and the film festival itself, according to Danny Plotnick's *Super 8: An Illustrated History*, Ann Arbor's 8 mm film festival was the first event of its kind in North America.

AAFC founder David Greene described the group's mission in a fundraising letter written shortly after it began: "In planning the festival we were aware of the noticeable lack of attention paid to 8 mm as a serious art form, evidenced by the fact that there is as yet no well-known annual 8 mm festival in this country. We hope that now there will be, should we be fortunate enough to be

First Ann Arbor Film Cooperative 8 mm Film Festival advertisement

Third 8 mm Film Festival Flyer

A LIBERATING EFFECT

225

successful in this venture. We hope to borrow on the reputation of our sister festival—the Ann Arbor Film Festival—and become established as the largest regular 8 mm festival in the country."

To attract submissions, the AAFC placed an ad in *Filmmakers Newsletter* and reached out to 500 high schools and colleges, with the entry fee set at just three dollars. Films were accepted in both the original 8 mm format and new cartridge-based Super 8, introduced in 1965, which had slightly better image quality and would several years later be enhanced with a magnetic sound stripe. In its first year, a jury that included Marvin Felheim awarded $450 in prizes, with top honors going to Mt. Vernon, New York–based Larry Miller's *The Pawn*, a silent short that juxtaposed shots of chess pieces advancing across a board with footage from old Hollywood movies. For 1972, educational workshops and a special night of films by women,

Special programming for women filmmakers was offered at the 1972 8 mm Film Festival

"OH NO, NOT ANOTHER GI JOE MOVIE!"

Screener Philip Hallman

co-sponsored by the Ann Arbor Women's Film Collective, were added.

Though they shared the same experimental spirit as their 16 mm compatriots, 8 mm filmmakers were by and large a different breed. "The 8 mm festival was a bastard child, or a rebellious child, of the 16 mm festival," mid-1970s director Gerry Fialka recalled. "The key with the 8 mm festival, it's even less expensive, so anybody can do it. The main medium that we grew up with was our parents shooting Super 8 films to document what's called 'home movies,' so it was a medium that was accessible to kids. Great art is when you tap into your childhood-ness, or the innocence of child naivete. And that's what happened with the 8 mm festival." Later director Michael Frierson concurred, describing much of it as, "very beginning filmmaking. There was a lot of stuff you'd see, 'How not to make a film.' I mean, clichés, and slow openings and all that, and no structure. But when they're good, they're really good." Screener and festival projectionist Dan Gunning enjoyed this lack of pretense. "It was really fun because we got to screen movies from little kids," he recalled. "It was hard to sort things out sometimes, because you'd have some artist doing childlike stuff and you'd have real children doing it." Screener Philip Hallman remembered, "There were a lot of movies with GI Joes and Barbie dolls and that sort of thing, which you'd never get in the Ann Arbor Film Festival. We'd go, 'Oh no, not another GI Joe movie!'" Inspiring local teenagers like the prolific Jimm Juback, in its early years Ann Arbor productions constituted as many as a fifth of the films screened.

Another young filmmaker who participated was David Fair, who grew up in the small Michigan town of Coldwater, where access to 16 mm equipment was nonexistent. "When we were in sixth, seventh grade, all the way through high school, that's what we would spend our money on. We would buy Super 8 film." His friend Mark Donner had a camera, and they started off filming fight scenes or stunts like jumping off the roof into a snow pile. "We just would show them to friends and watch them ourselves. And really there was no plan like 'Let's make a movie and get famous' or something like that. It was really just like what you were doing in your backyard. Like, make a movie and you watch it and your friends watch it. And then you make another one." Post-production was nonexistent, and the pre-loaded Super 8 cartridge determined the

Teen filmmaker David Fair, from his eighth grade yearbook

A LIBERATING EFFECT

227

film's length. "Generally, back in those days we would just edit in the camera and the movies were all three minutes and 20 seconds." Of some 150 films Fair and Donner made, only *Thise Cate & Ting Rink* was entered in the Ann Arbor 8 mm Film Festival. It featured Fair, dressed as Charlie Chaplin, knocking on a door at the top of a staircase when a woman lurches out and tumbles down, only to meet him again at the bottom. "It was all shot in a stop-action animated way, but with real people. Because it was stop and go that way, we were able to make the tumbling very extreme." Though the 1975 entry did not win an award, *Michigan Daily* reviewer James Valk singled it out as "the most original approach to comedy in the festival." David Fair and his younger brother Jad would go on to form the ultra-primitive rock group Half Japanese, itself later the subject of the documentary *The Band That Would Be King*.

While Fair's 8 Fest entry was silent, some films had magnetic sound, and others required special dexterity on the part of the projectionist. "People would send their camera original stuff," Michael Frierson recalled. "And they'd send a cassette. There'd be a little flash to start the cassette. It was always a little bit hairy, because you're working with somebody's original piece of film. Surprisingly, people were willing to do it." Gerry Fialka noted that the projector's location halfway down the center aisle of the education school's Schorling Auditorium, the 8 Fest's primary home, was an integral part of the amateur-derived 8 mm experience. "You go to a big theater and you get lost in the darkness, and you're not aware of the process or the form." But at the 8 mm festival, "We'd have a tech problem, everybody'd see us deal with it. There wasn't, 'There's a guy behind the curtain, pay no attention to it.'"

When *Super-8 Filmmaker* magazine was launched in 1972, it gave the 8 Fest another way to connect with the community. "Anybody who was in that magazine or advertising, we would always look for jurors there, sponsors," Frierson recalled. "Elmo made great projectors, and they would lend us an arc lamp Super 8 projector." The festival's modest entry fee was an important source of startup cash. "We'd get up to 200, 225 entries," Frierson remembered. "So that was a lot of the funding for the festival, which was funded out of the fees. The Film Coop would put up a thousand dollars, or something like that." Other money for operations came from occasional grants from the university, with prize money donated by individuals, local businesses, and the other film societies. Each year the 8 Fest's quality grew, and the submissions came to include short comedies, documentaries, near-feature length dramas, scratch-

film experiments, and animation, both drawn and in ever-popular stop-motion, sometimes using clay. While *Daily* reviewer Chris Kochmanski had complained that the 1976 festival "was notable for the seemingly unanimous efforts of its entries to parody popular films and film genres and to recreate the film mechanics of Stanley Kubrick," in 1980 Dennis Harvey credited it as "perhaps the best to date—some of the entries may have been artistic failures, but none suffered from a lack of imagination or energy. The winners offered plenty of proof that it's possible, even with the most limited equipment and resources, to create film works as sleek and impressive as any commercial projects." By that year the three-night festival's prize fund had grown to over $2,200, awarded by a jury which included Woody Sempliner and John Tintori.

Along with providing a forum for inspired amateurs like David Fair and *Shlamozzle* producers the Ann Arbor Comic Opera Guild, the 8 Fest also attracted more serious filmmakers, including music video director Rocky Schenck, future Oscar winners Alex Gibney (*Taxi to the Dark Side*) and Cinema Guild member John Nelson (*Gladiator*), plus *Far from Heaven* director Todd Haynes, whose short *The Suicide* won $100 in 1979. Another future industry success was Michigan native Sam Raimi, who started out making Super 8 movies with friends in the Detroit suburbs and developed a popular campus sideline screening his films at Michigan State University in East Lansing. With his friend Bruce Campbell he acted in Josh Becker's violent *Stryker's War*, which was submitted to the 8 Fest. "It was clear that this filmmaker was extremely promising, because the quality was better than the average film," screening committee member Philip Hallman recalled. "But it was very divisive, the reaction to the film. Some people gave it a ten, and others gave it a zero." Another entry featured one-time U-M dance student Madonna Ciccone, as Michael Frierson remembered. "It wasn't great, but she was just becoming a thing. So we had to show that, of course."

Gerry Fialka recalled that along with "stupid narratives, and normal films, and kids who were, 'How can I make *Star Wars* or *Jaws* in my back yard?,'" the entries also featured in-your-face

ABOVE: 8 mm Film Festival director Tim Artist reads sound sync instructions for a film while screener/projectionist Dan Gunning looks on © 1981 MLive Media Group. All rights reserved. Used with permission

OPPOSITE: Frames from a 16 mm trailer for the 8 Fest created by AAFC members

A LIBERATING EFFECT 229

experiments like Willard Small's *Disco Dog*. "Five minutes is the eye-splitting sequence in *Un Chien Andalou*," he recalled. Back-to-back repeats of Buñuel's disturbing shot over familiar rock songs then shifted to a loop of a Vietnam War prisoner's execution. "People freaked out," Fialka recalled with admiration. "It was, like, the most radical film I've shown in 45, 50 years of curating." Awarded $115 in 1979, Fialka convinced Small to blow it up to 16 mm and enter it in the Ann Arbor Film Festival, where it got a more muted reaction. "It was emphasizing to me that the 8 mm Film Festival was a little more like, 'You can do anything in the spirit of what the form is, that's experimental film, that's avant-garde film.' We can go a little further."

8 Fest on Top

The 8 mm festival's high-water mark coincided with the restructuring of the Ann Arbor Film Festival after George Manupelli's departure and its switch to the Michigan Theatre. The energetic leadership of Michael Frierson, with his future wife Martha Garrett and her graphic design flair, helped boost its profile significantly. "He was making it as competitive to the Ann Arbor Film Festival as it had ever been," Philip Hallman recalled. "They really did a lot more promotion. And they did these books and these program guides, they did stickers." The 8 Fest's printed materials of the early '80s were now considerably more evolved than those of the struggling larger event, which continued to follow Manupelli's practice of giving attendees only an 11 x 17 sheet listing showtimes and titles.

With attendance grown significantly from the sparser audiences of the mid-1970s, in 1985 the smaller-gauge event was named Ann Arbor's best film festival by *Michigan Daily* critics Byron Bull and Joshua Bilmes, and as locals took to calling Manupelli's creation "the 16 millimeter film festival" to clarify which they were referring to, in February 1986 its attorney sent the 8 Fest a letter. "It appears that your organization has used a descriptive name, 'Ann Arbor 8 mm Film Festival' to attract public attention to your recent festivities. The board of directors of the Ann Arbor Film Festival believes that these advertisements create confusion in the public mind between your organization and their group." Claiming "the sole right to usage of that name," the letter went on to demand that, "Future 8 mm Film Festival advertising should refrain from using the name Ann Arbor in its title and from advertising in such a manner as to confuse and mislead the public into thinking that the two festivals are one and the same." The 8 Fest's new director Mark Schreier, himself a recent U-M Law School graduate, composed a reply. "For the past 17 years our two prestigious festivals have existed side by side within

8 Fest directors Michael Frierson and Martha Garrett, 1985

the Ann Arbor community. Each has helped solidify Ann Arbor's standing as a great town for both festivals and films. I would be glad to appear at your next board of directors meeting to discuss your belief that the public suddenly lost its ability to distinguish between the two festivals." Nothing further was heard from the aggrieved larger organization.

"It was a great period for Super 8," Michael Frierson remembered. "There wasn't so much access for people to shoot all kinds of different video as there is today. So I think the people who were doing it were pretty serious about it. We had a big festival that was pretty well connected, and kind of piggy-backing on the 16 mm festival, so it was well known all over." As with its cross-campus rival, the 8 Fest also reached out to prominent alumni, like Lawrence and Meg Kasdan, who funded an award for best student film.

Having established itself as the oldest and largest festival of its type in the US, and one of the top half-dozen showcases for the 8 mm format in the world, during his tenure Frierson developed strong connections with the international Super 8 community. In addition to inviting foreign filmmakers to town, he took highlights from the local festival abroad. "That was our ticket to go to Portugal or Caracas or whatever," he recalled. "They were happy to have us program our films from our festival. So we would just ask the makers, 'Hey, could we keep your films for another three or four months?' People who had prints didn't have a problem with that. We would take them and show them in Montreal or down in Caracas."

Filmmakers who came for workshops and presentations, and

Martha Garrett artwork

A LIBERATING EFFECT

OPPOSITE: 8 mm festival flyer for Nick Zedd appearance. Courtesy Mark Schreier

sometimes also served as jurors, included future *Nightmare Before Christmas* animator Timothy Hittle, Germany's Christoph Doering, and Venezuelan Carlos Castillo, who at the 1984 event set up an installation piece in the lobby of Angell Hall Auditorium A, where the festival had moved several years earlier. "They were projecting an image of Carlos in a bathtub on top of this bathtub that had shaving cream all over the top of it," Frierson remembered. "When the film ends, Carlos Castillo pops out of the bathtub naked, dripping wet, like a stripper popping out of a cake or something. People just gasped and fell over. It was an amazing thing." The setup had required a bit of last-minute problem solving. "We couldn't get it dark in there; we couldn't find the light switch. So we took a broom and punched the fluorescent lights out. Just broke 'em."

After Frierson left town following the completion of his doctorate in 1985, he went on to teach at the University of North Carolina, write, and make films, including the documentary *FBI KKK* and, with Martha Garrett, clay-animation shorts for Nickelodeon and the Children's Television Workshop. But without their dedication, the 8 mm festival began to stumble. "It all kind of fell apart," Philip Hallman recalled. The 1986 iteration was co-sponsored by the AAFC and local cutting-edge arts presenter Eyemediae, where Mark Schreier kept things going with visits from Australian and Hungarian filmmakers, as well as New Yorkers Beth B and Nick Zedd.

With production of 8 mm films starting to decline due to the introduction of cheap video cameras, the 8 mm festival was fully taken over by Eyemediae in 1987. Along with programs of films from Hong Kong and the Los Angeles punk-rock scene, featured guests included German filmmakers Hannelore Kober and Jonathan Dobele (both later to teach at the university); journalist Laura Flanders, who presented the world premiere of her documentary about women in Northern Ireland, *What's the Difference Between a Country and a House*; *Film Threat* cofounder André Seewood; and downtown New York dancer/filmmaker Diane Torr, who gave a provocative, partly nude live performance.

Dark for a year after Schreier left town, the festival was revived and expanded to two weeks in July 1989. Billed as the 18th Ann Arbor 8 mm Film/Video Festival, it also incorporated video and 16 mm movies, with an outdoor performance stage; screenings at Eyemediae, Lorch Hall, and the Michigan Theatre; and multiple guests, including *Scorpio Rising* filmmaker Kenneth Anger. The 1990 iteration included several outdoor screenings and a live performance by Pat Oleszko, but submissions dropped to less than 100, which consisted equally of 8 mm, 16 mm, and video pieces. Though Danny Plotnick's Super 8 *Steel Belted Romeos* was awarded a prize, and Eyemediae director Michael Clarren proclaimed that, "There is no way 8 mm is dying" to the *Ann Arbor News*, it proved to be the event's final outing.

NICK ZEDD
Presents THE CINEMA OF TRANSGRESSION
11pm Tonight
RESIDENTIAL COLLEGE AUDITORIUM

Films from the New York Underground

Worm Movie	Lung Leg	Thrust In Me	Nick Zedd & Richard Kern
Mutable Fire	Bradley Eros & Aline Mayer	King of Sex	Richard Kern
Bogus Man	Nick Zedd	Right Side of My Brain	Richard Kern
A Suicide	Richard Klemann	Judgment Day	Manuel Delanda
Simonland	Tommy Turner	Ism Ism	Manuel Delanda
Nigger Night	Michael Wolfe	Trust Me	Niles Southern

8mm. 16TH ANNUAL ANN ARBOR FILM FESTIVAL

CHAPTER 13
THE RENEGADES RUNNING THE ASYLUM

BY 1980 the U-M film societies had reached a peak of activity. Recognized as a reliable source of movies that could not be seen anywhere else in Michigan, including Detroit, their screenings were drawing people to both Ann Arbor and the university. Philip Hallman grew up a few miles away in Plymouth. "I went to school at Michigan because of having gone to the film societies for a number of years prior as a high school student. Not even realizing that it wasn't necessarily part of the curriculum. It was just something that was going on outside of classes."

The film groups' efforts were gaining national attention as well. Critic Leonard Maltin called Ann Arbor "one of the most cinematically saturated communities in the country" in his 1983 *Whole Film Sourcebook*, and Cinema Guild's practice of trading schedules with film societies at schools in places like New York, Texas, and Hawaii also revealed how strong their programming was. "We got every kind of film possible here," Hugh Cohen remembered. "We knew that there were very few other places in the country that were exhibiting as many films as we were." While film series were now standard at most colleges, many were simply oriented toward providing cheap entertainment for the greater student body, with minimal focus on art. The independent nature of U-M's student-run groups was a critical factor here, as Ann Arbor Film Cooperative member Philip Hallman noted. "There was enough momentum and enough passion that people were able to create something that was even maybe better than what the university could have taught. We used the university's resources, but it wasn't coming from the sanctioned university. It was just the renegades running the asylum."

The number of films offered each term had now reached an all-time high. In the early 1930s the Art Cinema League had programmed roughly a dozen titles per four-month semester, each for two weekend nights, which successor Cinema Guild doubled in 1953 to 28 different features per term. With

OPPOSITE: Cinema Guild's internal operations manual

LEFT: Night deposit bag for Cinema II

THE RENEGADES RUNNING THE ASYLUM 235

TOP: A Cinema II meeting, 1983. Left to right: Mark Schreier, Michael Kaplan (holding a 16 mm film print), Judy Perry, Marlene Reiss

BOTTOM: A 1981 Cinema II film suggestion list

more groups starting to emerge in the late '60s, the number of feature films shown each semester jumped tenfold to around 300 by the fall of 1973, according to an estimate in the *Daily*. But Ann Arbor filmgoers appeared insatiable, and after Cinema Guild increased its activity to seven days most weeks and more societies entered the fray, by 1983 the average number of features shown per term had reached 500.

Cinema Guild, Cinema II, and the Ann Arbor Film Cooperative had all been started with more or less the same goal of showing good but audience-pleasing movies to make money for a secondary purpose, but as time went on, they were taken over by film lovers who sought to program as many interesting titles as possible. The societies were run differently from most student organizations, as Cinema Guild's Peggy Ann Kusnerz observed: "It wasn't just a bunch of people taking out movies from a library collection on campus and then showing them in your basement for your friends. This was something that was much grander. Operating a movie theater, having to deal with all of the problems of projectionists. Taking the hall and the seats, making sure everything worked physically. The advertisement, all that stuff. It really was a business. Which is very different than a political student group or a social justice student group."

While drawing from the same pool of established money-makers that were used to balance the books, each of the older "Big Three" societies developed its own identity from the personal interests of members: Cinema Guild for classic Hollywood and foreign films; Cinema II for a mix of recent imports and more eclectic fare; and the AAFC for cultish, boundary-breaking work. Prior to the start of each semester, members held a selection meeting. "People would bring food. It was a potluck pretty much all day, and hosted at somebody's

236

CINEMA ANN ARBOR

"WE NEVER SAW THEM AS CINEMA FANS. WE THOUGHT THEY WERE ONLY IN IT REALLY FOR THE MONEY."

Philip Hallman on rivals to the Big Three

house," the AAFC's Philip Hallman remembered. "People had to prepare in advance. They could submit, it was a crazy number, up to 50 titles. But each person then had to kind of sell the movie. And then we voted on it, and the top winners moved on to a next round." Peggy Ann Kusnerz recalled that Cinema Guild's meetings were sometimes tense. "They were always heartfelt, dramatic. Some people would cry for their films. I mean, literally wail and cry. And people could also get snarky and say to someone that they didn't like their ideas, that their ideas were juvenile, unsophisticated. And the worst would be, 'Your movies are boring.'"

Before a schedule could be finalized, a list of top vote-getters was assembled, often including one personal pick per member. After adding the "big grossers" that would theoretically balance out losses on the more esoteric titles, a swap meet was held among the Big Three. "We all negotiated with one another to make sure a film was only shown on campus once that semester," Philip Hallman remembered. The smaller film societies were not part of the initial process, however, and took part in a less conciliatory second round. Hallman characterized the Big Three's attitude: "We never saw them as cinema fans. We thought they were only in it really for the money, to help get their various organizations funded. So there was a lot of tension between us." Alternative Action's Dave DeVarti experienced this from the other side. "The three big film groups were distinctly at odds with what they saw as the interlopers, the smaller film groups, including Alternative Action and Gargoyle and Mediatrics."

In the early 1980s the Big Three began sharing an office, Cinema Guild having exited the Old A&D Building (recently renamed Lorch Hall) when the economics department moved in after an arsonist destroyed its home. The cramped office just off the lobby of the Michigan League was jammed with three desks, multiple filing cabinets, and shelves full of books, posters, catalogs, flyers, and other graphic material. Having worked together on and off over the years, the Big Three

In the summer the film societies played softball and croquet together. Cinema II's Michael Perry lines up a shot, 1983

began to socialize and collaborate even more, putting on risky ventures that one could not take on alone. Co-sponsored presentations included Rainer Werner Fassbinder's *Berlin Alexanderplatz*, a 15-hour miniseries made for German television that was screened in both a marathon single run and in separate parts; Wim Wenders's *Paris, Texas*; and Erich Von Stroheim's rediscovered silent film *Queen Kelly*. For several years the three groups also sold a combined three-way pass which offered discounted admission to their films.

Putting on a Show

Because U-M film society screenings were held in rooms designed as lecture halls, it took a coordinated effort to convert them into something resembling a movie theater. Each group had a print runner who tracked shipments and shuttled films to the booth, where at least an hour before showtime an FPS projectionist arrived to check the film for damage, run tests, and set up the screen, the masking, and sometimes extra audio gear. At about the same time, the film society's designated house manager and ticket sellers gathered at their office to pick up tickets, startup cash, and promotional materials before heading over to the auditorium. Hanging one-sheet posters for upcoming films behind a table in the hallway, they taped down the money box, noted the starting ticket number, and made contact with the projectionist before opening for business. Also present was a lobby supervisor, who had been assigned by the university to non-Lorch screenings since the contentious Friends of Newsreel days. "Older retired men mostly," recalled Philip Hallman, "who helped take the tickets and closed the doors at a certain time." Generally less than thrilled to be there, and with no discernible interest in films of any kind, they usually added an odd, crusty element to the proceedings.

Though the oldest campus film society was not required to have one, Cinema Guild had its own unofficial lobby supervisor in the person of custodian Joseph Tooson Sr. Tooson was "something of a character," according to Harry Todd. "He used to drive around town in his Cadillac—he had more than one—with the windows down, playing Muddy Waters and what have you." Tooson had served in the Korean War, and put on his uniform to stand guard over ticket seller Ed Weber. "He would stand behind the ticket table in his fatigues, he always had these military fatigues. With his hands clasped behind his back, looking impassively forward. He and Ed were a formidable sight," Todd recalled.

Most shows were uneventful, but sometimes the house manager had to make an executive decision. "There were times when the projectionist would come down and sort of say, 'Um, there's a problem,'" remembered Philip Hallman. Once, 20 minutes of *Urban*

The Cinema Guild office ca. 1981. Left to right: Angelica Pozo, Reed Lenz, Brian Wolf, Paula Goldman, Ed Weber.
© Rob Ziebell

Cowboy was skipped. "The whole reel got missed. But somehow no one seemed to notice, nobody complained." Patrons could also be unreasonable. "There was sometimes pandemonium and craziness," he recalled. "I remember some guy came a little bit late, and we had sold out. He was pissed, and pulled the fire alarm. Disrupted the movie because he was angry he couldn't get in."

The ventilation systems varied widely from room to room, with MLB almost always freezing, and the older buildings sometimes too hot and requiring a hands-on intervention. "It was very difficult to get the plant department to leave the air conditioning on in the auditorium," Harry Todd remembered of A&D/Lorch. "But you could, if you knew how to do it, turn the air on. There was a blower which was in a mechanical room above the women's lavatory." One night he noticed it was getting stuffy as the seats filled up for a screening of Hitchcock's *Rear Window*, at a time when part of the building was under construction. "So I went up to the mechanical room and switched it on and it began blowing dust into the auditorium. I panicked because I knew if I didn't shut it off immediately that people were going to start walking out. And it only takes a few people to start an exodus. Even though I think a few people sneezed, it didn't turn out to be the disaster that I was immediately fearful of."

A major advantage of film society membership was free admission to the other campus groups' screenings, and sometimes even to local commercial venues. "We had deals with Briarwood, and the Village Theatre, and Wayside. We had passes for all of them, though they never came to ours. That was a pretty good arrangement," Philip Hallman recalled. Film society members

TOP: Lobby supervisor taking tickets at Auditorium A, 1982. Photo by Deborah Lewis, *Michigan Daily*

INSET: AAFC ticket

THE RENEGADES RUNNING THE ASYLUM

who weren't working a show were often watching it or seeing one of the other societies' films. "That was the big difference between then and now," Hallman remembered. "You hustled to see something. Because you knew, 'I'm not going to get a chance again, perhaps.'" Cinema II's Matthew Smith was one of many film society members who immersed themselves in celluloid. "I went to movies every night, practically," he recalled. "And then the next day, go to see movies in film classes. Then go see more films that night. And then get together and watch something in 16 mm somewhere in someone's house afterward. I spent a few years just watching movies every day and all night and just all the time, on film." Cinema II president Marlene Reiss enjoyed it as well. "Because we got in free, we could really take advantage of it," she remembered. "You learned about 60 years of world cinema by being able to go to the films that we brought. And that doesn't exist anymore."

Those with deeper film knowledge often assumed the role of mentor. Like Ed Weber of Cinema Guild, Cinema II's Michael Kaplan was an expert in classic Hollywood, and insisted skeptics view things they turned their noses up at, such as musicals like *Meet Me in St. Louis*. "It turned out to be one of my favorite movies, which I would have ignored otherwise," Philip Hallman recalled of the film, which Kaplan had implored him to watch. Though many society members also took some film/video courses, relatively few declared it their major. "No offense to my instructors, but I felt like I learned just as much if not more going every week and then talking with people about the movies," Hallman remarked. Cinema Guild's Angelica Pozo agreed. "You learn, you think, people turn each other on to other things, you share. It was a great experience to have been able to get involved on that level." Cinema Guild's John Cantu noted, with a smile, "It truly was like a graduate education.

Membership cards

With one advantage, right? I didn't have to turn in any quizzes or tests."

For a few passionate movie lovers, one film society was not enough. Neal Gabler joined three. "I was on Cinema Guild, I was on Cinema II, and I was a founding member of the Coop. I did all three simultaneously, if memory serves me correctly. Each served a slightly different need and a slightly different constituency, so there was surprisingly little overlap. What three active film societies speak to is how much Ann Arbor was a film hotbed in those days, though other campuses got more attention. In fact, I can't imagine any better place in the nation for those who were film fanatics. The discussions on film were intense. The culture ran deep."

Arbor. One was my risk aversion, being from a family of salesmen, that sent me to law school to learn a skilled trade. And my immersion in the film societies and in film is what awakened me to what my true passion was. And that was film."

A sizable number of other society members also ended up in movie-related careers, ranging from projectionists and grips to producers, directors, screenwriters, editors, professors, critics, and archivists. Along with John Sloss and Neal Gabler, notable Cinema II alumni included *What's Eating Gilbert Grape* producer Alan Blomquist and Athens (Ohio) International Film Festival director Ruth Bradley. The Ann Arbor Film Cooperative saw a number of its members enter the field as well

"MY IMMERSION IN THE FILM SOCIETIES AND IN FILM IS WHAT AWAKENED ME TO WHAT MY TRUE PASSION WAS. AND THAT WAS FILM."

Producer John Sloss

The connection to cinema that the groups fostered led a number of members to careers they might never have pursued otherwise. Recruited as a freshman to join Cinema II by his dorm neighbor Kevin Smith, John Sloss would go on to serve as producer or executive producer on dozens of films by directors like Richard Linklater, John Sayles, Errol Morris, and Todd Haynes. "I just owe so much to that time," he recalled. "My entire career is a perfect combination of the two things that happened in Ann

in addition to Gabler, including award-winning *November/The Celluloid Closet* cinematographer Nancy Schreiber, underground film programmer/PXL This Film Festival founder Gerry Fialka, public television writer/director Jim Watson, U-M Mavericks and Makers collection curator Philip Hallman, author/filmmaker/teacher Michael Frierson, and Pordenone Silent Film Festival artistic director Jay Weissberg.

The longest-lived film society spawned the largest amount of industry

careers, however. Cinema Guild alumni included *Star Wars/Raiders of the Lost Ark* screenwriter and *Big Chill* writer/director Lawrence Kasdan, Oscar-nominated *American Hustle/A Star Is Born* editor Jay Cassidy, Oscar-winning *Gladiator/Blade Runner 2049* visual effects designer John Nelson, *The Fluffer/Quinceañera/Still Alice* co-director Richard Glatzer, Ang Lee/Michel Gondry script supervisor/set photographer Mary Cybulski, NYU graduate film school chair John Tintori, Wong Kar-wai/Yonfan associate Norman Wang, Ann Arbor Film Festival director Vicki Honeyman, *Atomic Café* co-director Jayne Loader, U-M film professor Hugh Cohen, the ubiquitous Neal Gabler, and William Morris agent Joel Jacobson, whose 1976 licensing of Russ Meyer films, like *Faster Pussycat Kill! Kill!*, for direct sale on U-Matic and Betamax tapes is credited as one of the first steps toward the creation of the home video industry.

Even when film was not a primary focus of their career path, many society members put their experience to use when the opportunity arose. The AAFC's Greg Baise programmed experimental films for the U-M graduate library, Cinema Guild's Angelica Pozo judged shorts and designed awards for the Cleveland International Film Festival, Cinema II's Mark Schreier headed the board of Connecticut alternative film/multidisciplinary arts organization Real Art Ways, and Alternative Action's Dave DeVarti served on the board of the Ann Arbor Film Festival, to note only a few examples.

Publicity and Promotion

To get the word out and enhance their events, the film societies relied heavily on printed materials. They created flyers, semester-long schedules, and handouts that prepared audiences for what they were about to watch. In their heyday the groups' central role in Ann Arbor's cultural mix was made clear by their postings' ubiquitous presence on campus bulletin boards, telephone poles, convenience store entranceways, and dorm and apartment walls.

The surviving early print efforts of the Art Cinema League and Cinema Guild were relatively utilitarian, but in the 1950s the latter group began paying an artist to produce attractive, hand-lettered announcement signs for display outside the Architecture Auditorium. Though its published schedules remained little more than a simple typed list whose sole flourish was a distinctive Western-typeface logo, as the group increasingly took on an educational mission it put more effort into the materials it gave out at screenings. "We always wrote a handout for every movie," Rick Ayers recalled. "A weird, single-

spaced handout. We'd do a little research, we'd read about it, we'd type it up, we'd mimeograph it. When we did the *Apu* trilogy by Satyajit Ray, we made a whole booklet. We somehow got it printed."

The appearance of new rivals like Cinema II, the liberating influence of '60s psychedelic poster design, and easier access to duplication services all caused the societies' graphics to evolve. As the number of presenters on campus jumped in the early 1970s, the quantity of flyers and calendars being printed increased as competition to get bodies into seats grew. By the middle of the decade the amount of advertising material generated by student organizations of all types was so great that the university installed concrete kiosks at numerous locations to

TOP: A 1960s Cinema Guild program note. **BOTTOM:** 1967 Cinema Guild series booklet designed by Rick Ayers

THE RENEGADES RUNNING THE ASYLUM

display it, as well as enlarging existing posting areas in buildings.

While some film societies used slickly designed templates from distributors that only needed a date and location to be written in, most flyers had a DIY look that reflected the organization's overall graphic style and/or its members' skill level. The more ambitious favored two ink colors on color paper, which stood out in places where flyers were constantly being added and covered over. Some of these were produced in a printing cooperative run by White Panther Party co-founder (and onetime FBI Ten Most Wanted fugitive) Pun Plamondon, located on the fourth floor of the Michigan Union. Its Gestetner duplicating machine was later also used by Alternative Action founder Rod Hunt to good effect. "He did the greatest color mimeo for Ralph Bakshi's *Wizards*," Dave DeVarti recalled. "He would run stuff through multiple runs to get the basic four colors." Other eye-catching flyers were created by Destroy All Monsters collective member and U-M art student Jim Shaw, who designed an atmospheric hand-drawn series commissioned by Cinema II.

Once the flyers were made, they had to be put up, no matter the weather. "I remember spending two hours on a Wednesday morning just postering everywhere around campus that we could get to, to promote a film for the weekend," Dave DeVarti recalled. Matrix employee Dan Gunning worked on both design and distribution for the off-campus venue. "It was cheaper than putting an ad in a magazine, and it probably reached a lot more people, really. I had a whole route. It was in all the dorms, all these kiosks, and you go into the Michigan Union and all that."

A film society's biggest graphic project was its semester-long calendar, which required a group effort to write film descriptions, create artwork, and paste up the final layout. After it was ready, several members would take it to the printer, often located a half hour or more away in small towns like Mason, Northville, or Tecumseh. "Phil Hallman and I would drive there, drop it off, and then have breakfast a couple blocks away," the AAFC's Nancy Stone recalled. "By the time we were done and lingered after, chatting, we'd go back and it was done, we could take them home." As many as 15,000 copies,

A typical campus kiosk, 1983.
Ensian

folded and wrapped with twine into foot-high bundles, were stuffed in their car and driven back to be dropped off at convenience stores, dorms, the League, the Union, and screenings. Film fans knew to seek out a full set of up to seven groups' schedules at the start of each term, and carefully examined them to highlight not-to-be-missed titles. "They were designed to be displayed in dorm rooms and campus apartments, and give you a little blurb on each of the movies," Stone remembered. "So even if they weren't things that everybody knew about, you'd get exposed to it all the same." Cinema Guild's Peggy Ann Kusnerz recalled that the schedules also conferred a certain cachet. "If you met someone new and you went over to their house, the first thing you did was check their refrigerator. If they didn't have a poster on the refrigerator, you knew they weren't your kind of person."

Calendar styles ranged from the slickly designed glossy paper format used in the late 1970s by the AAFC,

A flyer paste-up ready to photocopy.

THE RENEGADES RUNNING THE ASYLUM

Indochina Peace Campaign in Ann Arbor presents

Nelly Kaplan's

a very curious girl

1970
English subtitles

Bernadette Lafonte

George Genet

Michel Constantin

A woman's most extreme dream

of revenge on male supremacy

A gypsy woman forced into prostitution turns a provincial French town upside down and her petty bourgeois clientele is never the same... a biting and sophisticated satire.

March 4 **Tuesday** 7:15 and 9:30
$1.25 cont. 994-9041

Modern Languages Aud. 3

"THE FIRST THING YOU DID WAS CHECK THEIR REFRIGERATOR. IF THEY DIDN'T HAVE A POSTER ON THE REFRIGERATOR, YOU KNEW THEY WEREN'T YOUR KIND OF PERSON."

Cinema Guild's Peggy Ann Kusnerz

featuring typeset descriptions laid over a bold single-color graphic, to the newsprint schedule Cinema II members sometimes struggled to complete in the early '80s with rubber cement, an X-Acto knife, and ragged press-type letters pulled from an office drawer. Photos of the group might appear as well, posing on a softball field or dressed as 1940s-era actors for the film noir–themed "Big Schedule."

The most memorable surviving film society calendars include the elaborate hand-drawn ones created for Cinema II in the late 1960s and '70s by artists like David Baker and Mark Wagner, and those designed for Cinema Guild a decade later by Rob Ziebell, a photographer and filmmaker who had studied at the U-M School of Art and Design. His newsprint calendars ranged from a tabloid-inspired booklet to huge two-page spreads that included detailed blurbs on each of the 80-plus films the group was showing per semester. Ziebell's work often featured photographs of his housemate and fellow Cinema Guild member Angelica Pozo, who was herself completing a master's degree in art. "Angie became a little bit of a poster child," Ziebell recalled, noting that her then-uncommon dreadlocks made her stand out and become "our kind of walking advertisement all day long when she was going through campus." Pozo cheerfully obliged. "I was the cover girl. He photographed me in different scenes. One was the drive-in between Ann Arbor and Ypsilanti. It was winter, the speakers were out, but it wasn't operating. Another time he had me put curlers on, and he had film canisters in a shopping bag like I was a housewife shopping for film. He had the creative ideas, and I played along. It was a lot of fun." Ziebell recalled that she made a strong contribution. "I can't take credit for it all, because I put it up on the flagpole and she jumped in with both feet forward."

Though smoking was discouraged on campus, it was still sometimes tolerated in classrooms, and in a darkened movie auditorium people were prone to indulge in a variety of substances. So many smokers were present at one late '60s Cinema II film that Angell Hall custodians threatened to shut off the electricity if patrons refused to put out their cigarettes, which inevitably wound up stubbed out on the floor. Seeking to avoid such problems, Cinema Guild created several 16 mm "no smoking" announcements. Mary Cybulski and

OPPOSITE: Flyer for a short-lived political film series, 1976

John Tintori made a memorable sepia-toned short which was also used at the film festival featuring smoke slowly curling backward into Tintori's cigar, while Dan Bruell produced an upbeat animated version that used multiple Muybridge motion studies, as well as a hand-drawn cartoon of a spinning coin that stopped to display the message "Coming Attractions." The other film societies made custom films for use before their screenings as well, with the AAFC shooting 16 mm ads for the 8 mm Film Festival using primitive video animation; Mediatrics producing a slick logo trailer; and the less-ambitious Cinema II managing only a silent, static shot of its MGM-inspired mouse.

Another way the film societies sought to spruce up their presentations was by obtaining theatrical-grade movie posters. Most groups managed to set up accounts with the National Screen Service, which distributed posters, 35 mm trailers, and other promotional materials for current movies at low cost. Though that company's policy was to service only commercial exhibitors, determined members like Cinema II's John Sloss broke down their resistance, giving the groups access to a Kansas City warehouse full of lithographed posters going back to the early 1950s. No matter the vintage, they were all five dollars, and it was hard to resist ordering for personal consumption. "We got a line

Cinema II flyer designed by Jim Shaw, 1976

—HOW TO GET A SCHEDULE DONE—

1. members submit lists / vote on lists / select titles from highest votes (2-3 months in advance of new term)
2. trade-off titles with FILM COOP & CINEMA II (don't forget mediatrics at some point)
3. decide on dates and send letter to MSA and scheduling office with requests
4. while waiting for MSA to call the scheduling meeting at which conflicts for dates are resolved:
5. schedule films and book
6. get started on blurb-writing / editing / typing
7. hopefully MSA will have cleared and requests by now so graphics can be done
8. typeset blurbs – design or have someone design graphics, do layout
9. take to printer
10. get PSA's out prior to schedule's return from printer.

Vicki Honeyman's instructions on schedule-making from the Cinema Guild operations manual

– PRINTING SCHEDULES –

offset 60 lb. heavy & expensive paper at any local printer — Kolossos has been used in the past — 994 5400

John at Kolossos must be phoned in advance to order paper — takes them about one week to print

> 7b,000 spring/summer
> 15,000 fall/winter

– or –

go <u>cheaper</u> even with 2 or more colors with newsprinting (offset on newsprint) at

NEWS PRINTING, INC
560 S. MAIN
NORTHVILLE 48167
349-6130
MR. BRADLEY
MRS. HANEY
"21½ x 13"

this is an incredible savings — take in and get returned (delivered for $30) 2 days later.

ABOVE: Another page from the Cinema Guild operations manual
OPPOSITE: Ann Arbor Film Cooperative schedule, spring 1980

the ann arbor film cooperative
spring-Summer '80

Admission: $1.50 single feature — $2.50 double feature unless otherwise noted

- A & D — Lorch Hall (Old Architecture)
- MLB — Modern Languages Building
- Aud A — Auditorium A, Angell Hall
- MLB 3 — 603 Liberty
- NS — Natural Science Auditorium

The Ann Arbor Film Cooperative has exhibited films in 16mm and 35mm at the University of Michigan since 1970.

For current listings please call 769-7787

MAY

Tuesday, May 6
A CLOCKWORK ORANGE (Stanley Kubrick, 1971) 7 & 9:30
A tale of the ultra-bad and the ultra-violence. This nightmare vision of a not-too-distant future is considered by many to be Kubrick's best work. Winner of the New York Film Critics' Award for the Best Picture and Best Director. "Brilliant, a tour de force of extraordinary images, music, words and feelings... probes the senses and the mind." — N.Y. TIMES. Starring Malcolm McDowell, Patrick Magee. 35mm. Plus THE MAKING OF THE ROSE.

Wednesday, May 7
CARNAL KNOWLEDGE (Mike Nichols, 1971) 7 & 10:20
A compelling film examines two friends from their college days on. In a hilariously humorous screenplay by Jules Feiffer, Sandy (Art Garfunkel) and Jonathan (Jack Nicholson) embark on a sad odyssey from sex-hungry adolescence to sexually bewildered adults. Feiffer's painfully funny study of these two people tell themselves and one another about love. Nicholson's sexiest role with Ann-Margaret.

KING OF MARVIN GARDENS (Bob Rafelson, 1970) 8:40
The brothers seek the elusive American dream. Jack Nicholson as the timid D.J. is content to spin his dream in words: his brother Davis has a big deal going and wants to cut his brother in. They meet in Atlantic City. Nicholson (played and immortalized in the fabled city of MONOPOLY), awful almost lifeless direction. "An irresistibly fascinating film..." With Ellen Burstyn.

Thursday, May 8
INVASION OF THE BODY SNATCHERS (Don Siegel, 1956) 7, 8:45 & Michigan Theatre
Mimetic pods reproduce and replace the residents of a Southern California town, sapping them of their independence and emotions. Chillingly dramatic, this film is the perfect metaphor for the political paranoia of the fifties, one of the few authentic science fiction classics." — Andrew Sarris. 35mm. $2.00.

Friday, May 9
WERNER HERZOG SHORTS 7:00 MLB 3
LAST WINTER (1975). This beautifully photographed film captures the adventure and talent of the world's best ski flier. Great music and shot on location in the Dolomites document Steiner's thrill of victory and agony of defeat. Subtitled film starts 20 meters below his contestants and flies further than anyone, even the Olympic champ. LA SOUFRIERE (1977). The Apocalypse delayed. Herzog and his crew travel to the island of Guadeloupe to film a volcanic eruption. An anticipated disaster never occurs. He is left to marvel at the unpredictability of nature. English narration by Herzog.

ROSZKE (Werner Herzog, 1977) 8:40 MLB 3
In Werner Herzog's most accessible and audience-oriented film to date, Jack tells the lyrical, melancholy, bitterly funny tale of three oddly-matched Berlin misfits who follow the American Dream to Railroad Flats, Wisconsin, a godforsaken truck stop where they find a bleak Eldorado of T.V., pinball, C.B. radio, and mobile homesteading. The little role is played by B.S. Schwartzenberg previously raised by Herzog to play Kaspar Hauser. "An Easy Rider shot in the language of pictorial paranoia." — Vincent Canby, N.Y. TIMES. "Heartbreaking ... a brilliant, poetic film." — Penelope Gilliatt. In West German with English subtitles.

Saturday, May 10
PINOCCHIO (Walt Disney, 1940) 7:00 MLB 3
Winner of two Oscars (Best Original Music Score and Best Song: "When You Wish Upon A Star"), this warm classic combines Disney's gifts in animation, sentiment, and music. The story centers around Geppetto, a puppeteer, and a young boy, Pinocchio, to entertain him. Moving, sensitive and beautiful, this animated classic is a Disney masterpiece not to be missed.

5000 FINGERS OF DR. T. (Roy Rowland, 1953) 8:40 MLB 3
A fantasy concerning a young boy who hates his piano teacher and dreams of being held captive and forced to play the world's largest piano along with 500 other little boys. Surreal sets include the towering castle in which the boys are held, and One of the most bizarre musicals ever made. With Peter Lind Hayes, Mary Healy and Hans Conreid.

Sunday, May 10
SLEEPER (Woody Allen, 1973) 7 & 10:20 MLB 3
Allen's modern slapstick classic. Our Woody wakes up 200 years in the future to find himself on the enemies list of a police state. See Woody in the clutches of Orgasmatron. See McDonald's sell its trillionth hamburger. See Woody as Blanche DuBois. Also stars Diane Keaton as a future poet and as Stanley Kowalski.

TAKE THE MONEY AND RUN (Woody Allen, 1969) 9:00 MLB 3
Allen's directing debut, Allen plays Virgil, product of an unfortunate childhood (a broken glasses, neighborhood bully, bickering parents, acute cello playing and a neurotic tendency to win a girl by playing cellos only. His downfall comes when he misspells "gun" on his holdup note. Stars Allen and Janet Margolin, Louise Lasser.

THE MOTHER AND THE WHORE (Jean Eustache, 1973) MLB 3
A significant film about contemporary male-female relationships, Jean-Pierre Leaud stars as a young cafe denizen caught between his two conceptions of woman — mother and whore. An extremely frank examination of love, sex, language, and cinema that has been judged by many to be "the best film from that country in a long time", this revealing, confusing, egotistical, irritating, often beautiful document" (Molly Haskell, VILLAGE VOICE). French with English subtitles.

Tuesday, May 13
THE DESPERATE HOURS (William Wyler, 1955) 7:00
Humphrey Bogart gives a scorching performance as one of three escaped convicts hiding from the heat in the home of a well respected family. This was Bogie's last gangster role and he played it with the wild intensity that characterized his stellar performance as Duke Mantee in The Petrified Forest. Also stars Frederic March, Ray Collins.

HIGH SIERRA (Raoul Walsh, 1941) 9:00 Aud A
Action-packed gangster film by the director of White Heat. Humphrey Bogart plays Mad Dog Earle, a killer on the run from the police, who is befriended too late by Ida Lupino. The superb cast also features Arthur Kennedy, Joan Leslie & Cornel Wilde.

Wednesday, May 14
CUL-DE-SAC (Roman Polanski, 1967) 7:00 Aud A
One of a side of a half, whimpering asexual whose gorgeous wife loves him longs to dress him in her nighties. Interrupting this strange form of bliss is a gangster needing a hideout. Mean and sadistic or slapstick comedy, depends on how you look at it. One of Polanski's best, it won a golden bear at the Berlin Venice film festivals. Stars Donald Pleasance, Francoise Dorleac, Jack Macgowran, Jacqueline Bisset.

ROSEMARY'S BABY (Roman Polanski, 1968) 9:00 Aud A
The runner of the whole world worship genre, Rosemary's Baby, in the hands of the master of the macabre, Roman Polanski, remains one of the most horrifying documents of justified paranoia ever filmed. Did Mia Farrow really participate at a Satanic orgy or is it a devilish nightmare? In Polanski's cinema of mood, one answer is as frightening as the other. John Cassavetes, Sidney Blackmer.

Thursday, May 15
JON JOST FESTIVAL 7:00 Aud A FREE
Visiting filmmaker Jon Jost makes his first Ann Arbor appearance. Jost, a 36 year-old independent, experimental filmmaker, examines political and social issues. His stay in Ann Arbor will be highlighted by screenings of **Speaking Directly** (7:00) and **Last Chants for a Slow Dance** (10:00). He will give a lecture on low budget filmmaking between the two shows. **Speaking Directly** (1973) has been described as a rumination on the in America, Vietnam and the process of filmmaking. **Last Chants for a Slow Dance** is the story of an unemployed trucker who plays at being "King of the Road," while his family struggles for welfare. Don't miss Jost's films and the chance to listen to an independent filmmaker expound on his art. A workshop is tentatively scheduled for Wednesday afternoon, May 14. Please check the desk or office phone for details.

Friday, May 16
FIVE EASY PIECES (Bob Rafelson, 1970) 7 & 10:20 MLB 3
Jack Nicholson as Bobby Dupea: "an extraordinary person posing as a human", is arguably his best performance. As in Rafelson's other films, King of Marvin Gardens and Stay Hungry, he entertainingly captures the charms and vices of American life. Nicholson is on a tough chicken salad sandwich like Jack Nicholson does. Karen Black, Susan Anspach, Sally Struthers.

DRIVE, HE SAID (Jack Nicholson, 1970) 8:30
Of the rash of college films to come out of the late 60's, this witty, sensitive film was the only honest one. Typically, it was overlooked. This story of a college basketball star who must choose between his sport and political activism, with strike home for many University students. Bruce Dern's excellent performance as the coach won the best supporting actor award from the National Society of Film Critics. William Tepper, Karen Black, Robert Towne.

Saturday, May 17
THE LAST PICTURE SHOW (Peter Bogdanovich, 1971) 7 & 9:15 MLB 3
Life in a small Texas town in the early 50's is captured in a painfully authentic slice of America. Wonderful performances by Jeff Bridges, Timothy Bottoms, Ben Johnson, Ellen Burstyn, Cybill Shepherd, Eileen Brennan, and Cloris Leachman. Nominated for best picture, two of its stars, Leachman and Johnson, deservedly won Academy Awards for their performances.

Tuesday, May 20
TOBACCO ROAD (John Ford, 1941) 7:00 Aud A
John Ford's adaptation of the famous Broadway play about life in rural Georgia. A tragic-comedy about moral depravity and social injustice starring Charlie Grapewin and Marjorie Rambeau.

HOW GREEN WAS MY VALLEY (John Ford, 1941) 8:45 Aud A
Beautiful, moving story of a Welsh coal mining family trying to stay together. This touching story is filled with incidents which evoke emotional responses even from the most indifferent viewers. A "must see" film. Stars Walter Pidgeon, Maureen O'Hara, Donald Crisp, Roddy McDowall. Academy Award Best Picture.

Wednesday, May 21
THAT OBSCURE OBJECT OF DESIRE (Luis Bunuel, 1971) 7 & 10:20 Aud A
Once again the mad Spanish director of The Discreet Charm of the Bourgeoisie and Un Chien Andalou makes ridiculous the morals, attitudes and sexual passions of the European bourgeoisie. Fernando Rey is sexually frustrated and flustered, chasing the elusive and beautiful Conchita. She reneges again and again on her promise to make love to him and drives him to bizarre extremes. "Magisterially, Bunuel rearranges key themes from his own work to come up with a caustic (and brilliantly funny) analysis of terrorism in all its distorted forms. Four stars." — SIGHT AND SOUND. In French with English subtitles.

PHANTOM OF LIBERTY (Luis Bunuel, 1974) 8:40 Aud A
This film is a surrealist trip. Bunuel pushes himself and advances beyond Discreet Charm with an ironic circularity that comes closer to Un Chien Andalou than in recent works. As usual, Bunuel challenges conventional attitudes concerning sex, politics and religion. French with English subtitles.

Thursday, May 22
SUSPICION (Alfred Hitchcock, 1941) 1, 3, 5, 7 & 9 Michigan Theater
A shy, provincial British girl marries an unprincipled charmer whom she discovers gradually to be a wastrel and lying cheat — and, possibly a murderer. Although this is one of Hitchcock's most suspenseful films and long forgotten, it's more worth seeing for the performance of Cary Grant as the shabby bounder who perhaps his greatest performance, giving his character more shading only seen in the work of the finest actors. This is an exciting superior thriller admirably played by a fine cast and directed by Hitchcock in the manner that makes him dean of Cinematic Melodrama." — NEWSWEEK. 35mm. Admission $2.00, matinees $1.50.

Friday, May 23
THE WRONG BOX (Bryan Forbes, 1966) 7 & 10:20 MLB 3
Hilarious British satire based loosely on very loosely — on a Robert Louis Stevenson story about an insurance gambit. Fabulous comic performances by Michael Caine, Peter Cook and Dudley Moore (of Bedazzled and Beyond the Fringe). Ralph Richardson, John Mills, Peter Sellers, and Nanette Newman (as the archetypically uptight Victorian heroine, so sensitive that she fainted at the mention of "eggs disgusting). See the Bournemouth Strangler and the venal Dr. Pratt! The climactic chase involves hearses, a resurrected corpse, the police (naturally), two embezzlers, the Salvation Army, three impolent girls fins, an Englishman who speaks pure Swahili, and a British military band.

TWO-WAY STRETCH (Robert Day, 1961) 8:40 MLB 3
Peter Sellers gives a remarkable performance as a prisoner who plans to break out of jail, pull a robbery, and break back into prison again. Along with Sellers, Lionel Jeffries displays his talent as a brutal guard. A highly amusing film.

Saturday, May 24
WAIT UNTIL DARK (Terence Young, 1967) 7:00 MLB 3
A tense suspense tale that will surely keep you on the edge of your seat. Audrey Hepburn stars as a blind woman who accidentally acquires an antique doll stuffed full of heroin. Alan Arkin is perfect as the sinister fiend who breaks into her house and initiates a terrifying game of cat-and-mouse.

THE 7% SOLUTION (Herbert Ross, 1976) 9:00 MLB 3
Nicole Williamson as Sherlock Holmes, Robert Duvall as Dr. Watson, and Alan Arkin is Sigmund Freud in this hilarious mystery caper. They join forces to solve the baffling disappearance of a popular French actress (Vanessa Redgrave), and Freud rids us of Sherlock Holmes' dreams, drug addiction, and obsessive hatred of Professor Moriarty. "100% entertainment." — Gene Shalit.

Tuesday, May 27
ONIBABA (Kaneto Shindo, 1963) 7 & 10:20 Aud A
One of the most sensuous and terrifying horror stories ever put on film is this grim tale of two women who live in the reed fields and prey on unsuspecting Samurai. A dark and foreboding work that has become a classic in the last few years. Japanese with English subtitles. Chinese subtitles.

THRONE OF BLOOD (Akira Kurosawa, 1957) 8:40 Aud A
Kurosawa's version of Macbeth doesn't use Shakespeare's text. Instead he adapts the plot to Japan during the Middle Ages with Macbeth as a Samurai. Peter Brook calls the result "a great masterpiece, perhaps the only true masterpiece inspired by Shakespeare." Toshiro Mifune.

Wednesday, May 28
ASHES AND DIAMONDS (Andrzej Wajda, 1958) 7 & 10:20 Aud A
On the final day of WWII, a Polish resistance fighter stalks his intended assassination victim — the new Moscow-trained District Secretary. Ironies abound in this intense and complex work. Wajda's masterpiece, this is one of the greatest films to come out of Eastern Europe. Starring the late Zbigniew Cybulski. "Brilliantly conceived and directed." — N.Y. TIMES. Polish with English subtitles.

EVERYTHING FOR SALE (Andrzej Wajda, 1968) 8:40 Aud A
Zbigniew Cybulski was to Poland what James Dean was to America. Wajda's elegy to the legendary actor is a film-within-a-film in which the star, never appears. A highly personal work is also a fascinating exploration of the process of filmmaking. "A classic of self-reflective cinema." — Herb Eagle. Polish with subtitles.

Thursday, May 29
MISTER AND MRS. SMITH (Alfred Hitchcock, 1941) 7 & 10:20 Aud A
Hitchcock delivers a change of pace with this entertaining romantic comedy. A young couple discover that their marriage may not be legitimate, and things take off from there. The film has an excellent cast featuring Carole Lombard and Robert Montgomery.

I CONFESS (Alfred Hitchcock, 1953) 8:40 Aud A
An unjustly neglected work by Hitchcock. Montgomery Clift stars as a dedicated priest caught in a conflict between religious ethics and self preservation. Anne Baxter, Karl Malden.

Friday, May 30
LOVE AND DEATH (Woody Allen, 1975) 7 & 10:20 MLB 3
Woody Allen's satire on Russian novels, Napoleonic Wars, and movie classics from Eisenstein to Bergman, among the one-liners on 100 other subjects. Along with Diane Keaton.

Thursday, May 15
Saturday, May 31
RICHARD PRYOR — FILMED LIVE IN CONCERT (Jeff Margolis, 1979) 7 & 10:20 MLB 3
Funnier than a three Marx Brothers film, than a Mort, more powerful than a Robert Klein, Look! Up on the stage, it's Richard Pryor — Live in Concert. 80 minutes of non-stop hilarity, this film proves Pryor as the funniest stand-up comic to hit the stage in years. "This physical and verbal comic gifts range from expert mimic and pantomimist to wilding raconteur." — L.A. TIMES.

SILVER STREAK (Arthur Hiller, 1976) 8:30 MLB 3
Gene Wilder stars in this comedy thriller about a book editor who witnesses a murder on the L.A.-New York super train and then becomes hunted by the murderers and the cops. The film boasts Richard Pryor in superb comic form and an elegant Patric McGoohan as the suave villain since Basil Rathbone and James Mason. Pryor giving Wilder lessons in how to act black to avoid the cops is a classic scene in American comedy. With Jill Clayburgh.

JUNE

Sunday, June 1
THE KIDS ARE ALRIGHT (Jeff Stein, 1979) 7, 8:45 & 10:30 Old A&D
Bursting on the big screen is this highly entertaining chronicle of a rock 'n roll phenomenon — The Who. An explosive look into the music of Peter Townshend, Roger Daltrey, John Entwistle and the late Keith Moon. "More than alright ... enough to bring back memories of glorious performances by one of the world's greatest rock bands." — N.Y. POST. 35mm Dolby.

Wednesday, June 4
WINTER KILLS (William Richert, 1979) 7 & 9:45 Old A&D
Controversial in its obvious to historical reality, Winter Kills charts the journeys of a millionaire's son, Nick Keegan (Jeff Bridges), as he attempts to piece together the mystery behind the assassination of his brother — president of the United States. Black humor in the Dr. Strangelove tradition, featuring John Huston, Anthony Perkins, Sterling Hayden and a cameo role by Elizabeth Taylor. 35mm. Admission: $2.00, matinees $1.50.

Thursday, June 5
PSYCHO (Alfred Hitchcock, 1960) 1, 3, 5, 7 & 9 Michigan Theater
Often cited as the most frightening film ever made, Psycho is the story of a secretary (Janet Leigh) who absconds with $40,000 and comes upon a lonely motel near a Gothic house inhabited by a strange young man (Anthony Perkins) and his possessive mother. Need we continue? Will you ever shower again? If you've only seen it on TV, you've really never seen it. Chilling music by Bernard Herrmann. With Vera Miles, Martin Balsam. Admission $2.00, matinees $1.50.

Friday, June 6
A BOY AND HIS DOG (L. Q. Jones, 1975) 7 & 10:20 MLB 3
Based on Harlan Ellison's short story, this film takes a kinky look at life in the year 2024. The world has been decimated by a nuclear holocaust, and the roaming survivor-bands battle each other for food and women. A Boy and His Dog is a "science fiction film that is an intelligent example of the genre as it should be, unaccompanied by silken explanations and not diluted for the masses." — CINEFANTASTIQUE. With Jason Robards and Don Johnson. Cinemascope.

THE TIME MACHINE (George Pal, 1960) 8:40 MLB 3
A literate and imaginative adaptation of the H.G. Wells story. Noted special-effects wizard George Pal employed excellent time-lapse photography to capture the essence of time travel. Winner of the 1960 Academy Award for special effects. With Rod Taylor and Yvette Mimieux.

Saturday, June 7
KING OF THE GYPSIES (Frank Pierson, 1978) 7 & 9:15 MLB 3
A compelling and realistic portrayal of life in the gypsy culture. Based on the best-selling non-fiction book by Peter Maas (The Valachi Papers and Serpico). "It is an original and bizarrely fascinating motion picture ... a remarkable introduction to what is probably the most exotic surviving subculture within the American diversity." — Charles Champlin, L.A. TIMES. Stars Sterling Hayden, Shelley Winters, Eric Roberts, Susan Sarandon, Judd Hirsch and Brooke Shields.

Tuesday, June 10
TROUBLE IN PARADISE (Ernst Lubitsch, 1932) 7:00 MLB 3
Two jewel thieves meet and fall in love while doing each other in. The pair moves from Vienna to Paris, where they rob the Peace Conference of "everything but the peace," and then larcenously establish themselves in the household of a stuffy millionairess. "It is superb ... it comes as close to perfection as anything I have ever seen in the movies." — Dwight McDonald.

NINOTCHKA (Ernst Lubitsch, 1939) 9:00 MLB 3
"Garbo Laughs," said the original ads in 1939, but there is by now a wide-spread story that although Garbo could pantomime laughter superbly, no sounds emerged, and these were provided by an anonymous creature in the sound lab. The rest of her performance is her own — and she brings distinction as well as her incredible throaty, sensual abandon to the role of a grim, scientifically-trained Bolshevik envoy who succumbs to Parisian freedom, i.e., champagne... Directed by Ernst Lubitsch, this light, satirical comedy has the nonchalance and sophistication which were his trademark." — Pauline Kael.

Wednesday, June 11
THE GOALIE'S ANXIETY AT THE PENALTY KICK (Wim Wenders, 1973) 9:00 Old A&D
A goalie with a German football team, past his prime, embarks on a series of extraordinary adventures. Wenders' film was one of the most highly acclaimed European movies of 1973, and immediately catapulted Wenders into the front ranks of contemporary directors. "A mystery thriller ... one of the year's ten best films." — SIGHT AND SOUND.

THE AMERICAN FRIEND (Wim Wenders, 1977) 9:00 Old A&D
Wenders' film is a medley of great movie directors — Nicholas Ray, Jean Eustache, Samuel Fuller — with Dennis Hopper as the American friend. Bruno Ganz, Hopper's German friend, gets himself involved in a pretty nasty business with some pretty shady characters. The action combines Paris, Hamburg, and New York in a blur of subways, streets, wharfs, and automobiles. Travel and rock 'n' roll, with a pace that is totally new. In English and German, with subtitles.

Thursday, June 12
PROVIDENCE (Alain Resnais, 1977) 7 & 9 MLB 4
Resnais' film, made in England, offers a dazzling probe into the creative imagination of a dying writer. Extraordinary performances given by John Gielgud and Dirk Bogarde. The film that Milos Forman calls "touching, beautiful and surprising," that Anthony Burgess calls "a great masterpiece," and that Susan Sontag calls "brilliant and unforgettable." With Elaine Stritch, Ellen Burstyn, and David Warner. In French with subtitles.

Friday, June 13
THE LAST TYCOON (Elia Kazan, 1976) 7 & 10:20 MLB 3
Robert DeNiro stars in this faithful adaptation of F. Scott Fitzgerald's unfinished novel. The story is based on the life of the legendary Hollywood mogul Irving Thalberg. Screenplay by Harold Pinter. The star-studded cast includes Jeanne Moreau, Robert Mitchum, Ingrid Boulting, Jack Nicholson.

THE LAST DETAIL (Hal Ashby, 1973) 9:00 MLB 3
A tough film that alternates between the sensitive and the brawling, as two sailors (Jack Nicholson and Otis Young) are detailed to transport a convicted sailor (Randy Quaid) to a military prison. Taking pity on the prisoner, Nicholson turns the two day detail into a five day one. Excellent performances by Nicholson and Quaid.

Saturday, June 14
ANIMAL HOUSE (John Landis, 1978) 7, 8:45 & 10:30 MLB 3
NATIONAL LAMPOON and the esthetique de piggo. Beloved Faber College self-destructs in an orgy of the things that make college worthwhile: food fights, toga parties, frat wars, heavy petting, back-seat sex, voyeurism, adultery, sadism, statutory rape, and the homecoming parade. Bluto, Otter, D-Day, and the gang. Boola Boola John "Na-p-o-o-o!" Belushi.

Tuesday, June 17 (Cont. next col.)
RIDE IN THE WHIRLWIND (Monte Hellman, 1965) 7 & 10:20 MLB 4
In 1965 Jack Nicholson starred in two very offbeat and very original Westerns directed by Monte Hellman. Neither was distributed only a few lucky critics have seen them. Nicholson also wrote the film, a story of innocence and paranoia, and how paranoia can be justified. Cameron Mitchell, Millie Perkins.

Tuesday, June 17 (cont.)
THE SHOOTING (Monte Hellman, 1965) 8:40 MLB 4
One of the most absorbing, bizarre, and existential Westerns ever made. Nicholson plays a cowboy who joins a group of cow persons chasing a mysterious rider. Written by Adrien Joyce, who wrote Five Easy Pieces. Remember, you'll probably never get another chance to see this rare Nicholson film. Jack Nicholson, Warren Oates, Will Hutchins, Millie Perkins.

Wednesday, June 18
DIARY OF A CHAMBERMAID (Jean Renoir, 1946) 7 & 10:20 MLB 4
Jean Renoir was already famous as a French humanist director when he went to Hollywood to make this satiric drama about the bourgeoisie. He was trying to raise his status through romantic affairs with her social superiors. Renoir was able to go beyond a purely political analysis of the characters to reveal their more closely guarded and sometimes violent motivations. "An all of Renoir's work, there's also one film with more freedom of invention and humility." — Andre Bazin.

LOLA MONTES (Max Ophuls, 1955) 8:40 Old A&D
Ophuls' final and finest film depicts through flashbacks the life of a famous courtesan, recounted as part of the lavish circus act. Lola includes her humorous with Franz Liszt, a student and a king, before elevating her to the humiliation of her present life — a paid spectacle for the masses, a bravura masterpiece "... the greatest film of all time. Lola Montes contains the most intoxicating imagery of auteur's feelings I have ever seen on the screen..." — Andrew Sarris. Martine Carol, Peter Ustinov, Oscar Werner. French with English subtitles.

Thursday, June 19
THE SEARCHERS (John Ford, 1956) 1, 3:30, 7 & 9:30 Michigan Theater
Quite frankly, one of the greatest films ever made. Stunning in its imagery, scope and depth of expression, this is a movie in which "the American experience is summed up in one character." "On its simplest level, the story of a man's search for a niece kidnapped by Indians, The Searchers has that clear yet ringing allegorical which characterizes the artist's masterpieces. "How can John Wayne's poetics, yet love him tenderly in The Searchers?" — Jean-Luc Godard. "The dialogue is like poetry ... so subtle, so magnificent! I see it pop or twice a year." — Martin Scorsese. "So many superlatives praise this film — John Wayne's best performance ... a study in dramatic framing and composition. High on my favorite film list." — Steven Spielberg. With Jeffrey Hunter, Vera Miles, Ward Bond. Presented in conjunction with Schoolkids Records. 35mm. Admission: $2.00, Matinees $1.50.

Friday, June 20
THE WILD CHILD (Francois Truffaut, 1970) 7 & 10:20 MLB 3
A boy who lives the first twelve years of his life in a forest is captured, and an eighteenth-century rationalist philosopher (Truffaut, in a splendid performance) tries to introduce him to civilization. A true story of a celebrated crisis in the Enlightenment. One of Truffaut's very best. English narration, some French dialogue with English subtitles.

EVERYMAN FOR HIMSELF AND GOD AGAINST ALL (Werner Herzog) 8:40 MLB 3
A film concerned with madness and alienation, based on the legendary Kaspar Hauser story about a man who mysteriously appears in a German town with no memory or experience of life. Herzog's perspective is darkly mysterious, a vision which dissolves the comforting surfaces of everyday life to reveal the nightmare beneath. The portrayal of Kasper by Bruno S., a psychotic with all manner case history, is amazing, as intense as it is unconventional. The most popular film of the 1975 Cannes Film Festival. "... a stunningly fable full of universals. A superb movie." — N.Y. TIMES. In German with subtitles.

Saturday, June 21
MODERN TIMES (Charles Chaplin, 1936) 7 & 10:40 MLB 3
Chaplin's greatest legacy to us may be this hilarious and poignant vision of industrial America run amok. The film features some of Charlie's greatest bits: the assembly line, the feeding machine, the heroin in the salt shaker, and the phoney Italian song lyrics which were his first cinematically spoken words. "... more timeless than ever ... a masterpiece ..." — SIGHT AND SOUND.

THE GREAT DICTATOR (Charles Chaplin, 1940) 8:30 MLB 3
Great political comedy. Chaplin superbly mimics the mincing mannerisms and overblown oratory of an infamous demagogue, called Hynkel (not Hitler). He's also Hynkel's double, a kind little Jewish barber who takes over for the dictator in the end. See Chaplin's famous ballet scene — a bubble dance with a globe.

Tuesday, June 24
BRINGING UP BABY (Howard Hawks, 1938) 7 & 10:20 MLB 4
Cary Grant in a zany story of a staid paleontologist whose orderly life is derailed by a daffy, beautiful heiress (Katharine Hepburn), a leopard, a wire-haired terrier, and a rare bone. Insanely funny and tenderly touching, the pinnacle of screwball comedy. Missing it would be an act of self-deprivation along the lines of celibacy. "The American movies' closest equivalent to Restoration Comedy. This is Hepburn's best comedy." — Pauline Kael. With Barry Fitzgerald, May Robson, Charles Ruggles, Fritz Feld.

TO CATCH A THIEF (Alfred Hitchcock, 1955) 8:40 Old A&D
A charming and suspenseful Hitchcock film. A suave, smooth, retired jewel thief (Cary Grant — who else?), suspected of new thefts when an imposter copies his methods, falls in love with an ice-cold American girl (Grace Kelly), who has a diamond-encrusted mother in tow and is attracted by the thought that Cary may be the real thief. Hitchcock's funniest film. "... comes off completely as a hit in the old Hitchcock style." — N.Y. TIMES. With Jessie Royce Landis.

Wednesday, June 25
GET OUT YOUR HANDKERCHIEFS (Bertrand Blier, 1978) 7, 8:45 & 10:20 MLB 4
From the same people who brought you Going Places, this is the story of a young man who gives his lethargic wife to another man in an attempt to cheer her up, only to have her leave them both for a 13-year-old boy. Academy Award winner for best foreign film, Get Out Your Handkerchiefs features Oscar-winning performance and music by Mozart.

Thursday, June 26
MARLOWE (Paul Bogart, 1969) 7 & 10:20 MLB 4
This screen version of The Little Sister is Chandler set in contemporary times, four years before Altman tried it with The Long Goodbye. Marlowe stumbles upon a blackmail plot while being beaten in a parking lot and spends the rest of the film attempting to keep breathing. Features Bruce Lee in an early role as a gangster who kicks Marlowe's office to smithereens. "The cast is excellent and appropriate. The lovely women suggest a kind of hunger which better than authenticity to the nostalgia that conditions what we know of Marlowe's world." — Roger Greenspun, N.Y. TIMES. James Garner, Gayle Hunnicut, Carroll O'Connor, Rita Moreno, Bruce Lee.

LAURA (Otto Preminger, 1944) 8:40 MLB 4
Fascinating mystery about a detective who investigates the death of a beautiful woman — and finds himself falling in love with her. Typically lavish Otto Preminger production from the mid-forties, when Hollywood was Hollywood. Starring Dana Andrews, Clifton Webb, Gene Tierney and (in an early, non-camp, non-terror role) Vincent Price. "Laura is the face in the misty light/Footsteps that you hear down the hall..."

Friday, June 27
ESCAPE FROM ALCATRAZ (Don Siegel, 1979) 7 & 10:30 MLB 3
A fascinating and beautifully photographed account of the only successful escape during the 29 year life of the infamous maximum security prison at Alcatraz. Filmed on location, the film has all the power one expects from a Siegel/Eastwood movie with its gritty realism and emotional involvement. A truthful film with strong performances from Eastwood, Patrick McGoohan, Roberts Blossom and Jack Thibeau.

CHARLEY VARRICK (Don Siegel, 1973) 8:45 MLB 3
Walter Matthau turns in the performance of his career as an ex-stunt pilot turned crop-duster who also robs banks — small ones (less risk). He and his partners hit one of these and find that it happens to have $750,000 in laundered Mafia money. From there it is a race to see whether the mob or the FBI gets Varrick first. A thrilling, fast-paced examination of greed and human nature. "Siegel has raised the trifle to a new high, topping his own Dirty Harry." — LONDON TIMES. Joe Don Baker, Andy Robinson, Sheree North.

Saturday, June 28
CHINATOWN (Roman Polanski, 1974) 7 & 9:15 MLB 3
Polanski's evocation of the detective thriller combines a Raymond Chandler plot and a Dashiell Hammett atmosphere, envelops up with an intriguing case of murder and political corruption set in 1930's Los Angeles. A fascinating, complex film, Chinatown is complete with political scandal, romance, and comedy, and violence. Excellent acting, especially John Huston's cameo as the fantastic wealthy patriarch, who molded the secluded California land barons. Jack Nicholson, Faye Dunaway. Cinemascope.

alternative action film series

$2 to get into one showing and $3 for both ends of a double feature*

except for socio-political documentaries on Thursday nights, which are FREE of charge

The Alternative Action Film Series has been in existence since 1977. It is a small non-profit series that chooses movies for thematic message as well as for entertainment value. Any profits are distributed to student groups promoting student activism and experiential learning. The people who help with programming, tickets, announcements, postering and other logistics work as volunteers without monetary reimbursement. They deserve thanks. If you have questions, you may contact us at 662-6599.

*and except for kids, who get in for $1 instead of $2.

SUNDAY, MARCH 7
101 DALMATIONS
1:00, 2:30 & 4:00 Angell Hall, Aud. A
The most flamboyant, outrageous, and hateful of villainesses, Cruella de Vil, dognaps fifteen dalmation puppies to make a new spotted fur coat. If you missed this when you were nine years old because you had the measles, don't miss it now.

THURSDAY, MARCH 11
LOVEJOY'S NUCLEAR WAR (58 min)
8:00 UGLI Multi-purpose Room Free
Sam Lovejoy is the organic gardener who toppled a 500 foot steel weather tower in his attempt to sabotage the utility's plans to go nuclear. Lovejoy's trial is intercut with lively interviews of utility spokespeople, nuclear chemists, townspeople and jury members.

FRIDAY, MARCH 12
THEY DRIVE BY NIGHT (R. Walsh, 1940)
7:00 only MLB 4
Walsh's direction reveals a combination of tousing action, hard-boiled dialogue and broadly but colorfully etched characters that represented Warner Brothers' "workingman film" at its best. Waitress Ann Sheridan's blunt exchanges with the truckers, the drivers' rough loyalty to each other in battles against crooked bosses and loan sharks, the long cross-country hauls—these and other elements are blended expertly. Humphrey Bogart and George Raft are brothers wheeling their rig from job to job.

THE BIG SLEEP (Howard Hawks, 1946)
9:00 only MLB 4
The film's fascination derives from the highly charged atmosphere, crackling with acrid, sharp-edged dialogue and an unfathomable storyline which keeps the viewer interested though baffled. Humphrey Bogart is Phillip Marlowe, Raymond Chandler's cynical detective, plunging into a world of blackmail, deception and stark violence, trying to understand and put a stop to the seemingly senseless behavior around him. Verbal sparring between Bogart and Lauren Bacall.

SATURDAY, MARCH 13
THE CHINA SYNDROME (Bridges, 1978)
7:00 & 9:15 Nat Sci
On a feature assignment, a TV news reporter (Jane Fonda) and a cameraman (Michael Douglas) witness and secretly film a possible accident at a nuke plant, after not believing the operators' explanation that what happened was a "normal and routine occurrence." Chief Engineer (Jack Lemmon) faces the consequences of a nuclear core meltdown, finally admitting that the plant is unsafe and resorting to a takeover of the plant by force to stop a possible "China Syndrome." As topical as this morning's weather report.

THURSDAY, MARCH 18
BETTER ACTIVE TODAY THAN RADIOACTIVE TOMORROW (65 min)
8:00 UGLI Multi-purpose Room Free
Do you think there's nothing you can do to stop the building of more nuclear power stations? This film shows how the people of Wyhl, West Germany mobilized against a local nuclear power plant.

SATURDAY, MARCH 20
MARATHON MAN (J. Schlesinger, 1976)
7:00 & 9:15 MLB 4
Dustin Hoffman stars in this suspense thriller as a grad student with a family history and a research interest that leads him into intrigue with a Nazi war criminal. Though aging, the fugitive Nazi (Sir Laurence Olivier) is still ruthlessly vicious—you might never visit your dentist again. With Marthe Keller.

THURSDAY, MARCH 25
NORTHERN LIGHTS
(John Hanson & Rob Nilsson) (95 min)
8:00 RC Theater/East Quad Free
A visually staggering film set in the winter of 1915 when farmers rose up against the strangle-hold of Eastern Big Business. Their farmers' victory is not without sacrifice.

FRIDAY, MARCH 26
WHITE HEAT (Raoul Walsh, 1949)
7:00 only Nat Sci
James Cagney in one of his great roles, as Cody Jarrett, a ruthless killer jailed on a minor charge to escape a murder rap. Cagney's sobered-up hypnotic portrayal of a killer on the rampage and Walsh's masterful buildup of suspense give White Heat a raw power. Cody Jarrett's death atop an oil tank remains one of the most powerful images on film. With Edmond O'Brien, Virginia Mayo.

PUBLIC ENEMY (William Wellman, 1931)
9:00 only Nat Sci
The film that made Cagney a star is a classic of the genre. Cagney's Tom Powers is a vicious criminal with no socially redeeming characteristics, who derives pleasure from even the most petty of ill-vital limits. With Jean Harlow, Jean Blondell.

SATURDAY, MARCH 27
JOE (John J. Avildsen, 1970)
7:00 only MLB 4
This prophetic film was an instant and controversial hit when released, only a year or so before "hard-hats" took to the streets to demonstrate against hippies and in support of Nixon, the Viet Nam war, and the American Way in general. In what may be the most famous role, Peter Boyle (Young Frankenstein) is the "red-neck" in conflict with the "hippie" lifestyle. Funny and terrifying at the same time, Joe pulls no punches.

EASY RIDER (Dennis Hopper, 1969)
9:00 only MLB 4
Easy Rider chronicles two men's motorcycle journey through the Southwest and the Deep South, a trip that condenses the emotional drama that was the 1960's. Well-acted, with Peter Fonda, Dennis Hopper, and Jack Nicholson in the role that made him a leading man. A great soundtrack, with Hendrix, The Band, Steppenwolf, Buffalo Springfield, and others, rounds out this eloquent film.

SUNDAY, MARCH 28
NO NUKES
(Schlosberg, Goldberg and Potenze, 1980)
7:00 & 9:00 Angell Hall, Aud. A
Springsteen, Crosby, Stills and Nash, Bonnie Raitt, The Doobie Brothers, Carly Simon, Jackson Browne, John Hall and James Taylor shake the floors during five sold-out No Nukes benefit concerts at Madison Square Garden. Gives you a glimpse of what the artists are "really like," as they and prominent anti-nuclear spokespersons comment on the dangers of nuclear power. A fine concert film. "Remember Three Mile Island—Radiation Never Forgets."

THURSDAY, APRIL 1
PEOPLE'S FIREHOUSE (25 min)
8:00 RC Theater/East Quad Free
The New York City government decides to sacrifice whole neighborhoods to arson as part of their plan for the future by moving firehouses out of the Bronx. The People's Firehouse is a chronicle of one community's battle to keep its firehouse. A community organizer's must.

PRAIRIE FIRE
(John Hanson & Rob Nilsson, 1976) (30 min)
A documentary of the Non-Partisan League, the largest and most widespread populist movement from the American midwest.

FRIDAY, APRIL 2
JOHNNY GOT HIS GUN
(Dalton Trumbo, 1971)
7:00 & 9:00 MLB 4
Timothy Bottoms (The Paper Chase) plays a young soldier who barely survives a WWI explosion, leaving him without limbs, sight, or the ability to communicate. An anti-war film and an inspiring tale of peace and life. Trumbo's screen adaptation of his classic novel took three awards at the Cannes Film Festival.

SATURDAY, APRIL 3
ONE FLEW OVER THE CUCKOO'S NEST (Milos Forman, 1975)
7:00 & 9:20 Nat Sci
Based on Ken Kesey's bestselling novel about rebellion in an authoritarian mental hospital, inspired by a spirited, ingenious rogue. Society seen as an insanity ward; Nurse Ratched as The State. Jack Nicholson, Louise Fletcher. It won lots of awards, but still a good film.

SUNDAY, APRIL 4
RAGGEDY ANN & ANDY; THE RED BALLOON; POGO'S BIRTHDAY PARTY
1:00, 2:30 & 4:00 MLB 4
Raggedy Ann & Andy: Every little kid's favorite pair are on their way to the Castle of Names but are separated. A happy ending's in store, though, as Ann & Andy are reunited, their hands sewn together (ouch!), and they live happily ever after. The Red Balloon: The timeless fantasy of a boy and his "pet" balloon. Pogo's Birthday Party: Pogo Possum, Hepzibah La Fleur, and Albert band together to give Porky Pine a birthday party.

THURSDAY, APRIL 8
THE WOBBLIES 8:00 Free
(Stewart Bird & Deborah Shaffer) (89 min)
A joyous chronicle of the Industrial Workers of the World, combines rare newsreel footage, interviews with former members, propaganda cartoons, posters and songs from the period to lovingly evoke the passion, energy and commitment of the Wobblies.

FRIDAY, APRIL 9
HEARTS OF THE WEST (H. Zieff, 1975)
7:00 & 9:00 MLB 4
Jeff Bridges is everything good about naïveté as a Nebraska farmboy seeking adventure in Hollywood. He is a whizbang blond bushwacker, a dishwasher, an un-merchandisable stuntman, and finally a writer of Western novels. You'll come out asking why you never heard of the film before. Truly one of those rare gems that leaves you feeling good with a caring, comedic sweetness. Henry is destined to become a classic. With Blythe Danner, Alan Arkin, Donald Pleasance.

SATURDAY, APRIL 10
FAME (Alan Parker, 1980)
7:00 & 9:30 MLB 3
A realistic film about the talented and ambitious students at New York's High School of Performing Arts. The acting, singing and dancing are superb. Newcomers Irene Cara and Gene Anthony Ray shine brightest in this (rising) star-studded film.

THURSDAY, APRIL 15
SALT OF THE EARTH (90 min)
8:00 RC Theater/East Quad Free
Made by blacklisted writers and directors during the McCarthy era, Salt of the Earth follows the lives of a striker and his wife. The story of a Mexican zinc miners' strike is the setting for this film about the strength of the worker's spirit.

FRIDAY, APRIL 16
YOUNG FRANKENSTEIN (Brooks, 1975)
7:00 & 9:00 Nat Sci
Mel Brooks' maddening, disrespectful parody of the classic Frankenstein monster genre. Complete with zippered necks. Gene Wilder, Madeline Kahn.

SATURDAY, APRIL 17
GALLIPOLI (1981)
7:00 & 9:00 MLB 4
One of the finest recent of a rash of excellent and intelligent films to emerge from the Australian cinema. Two mates are on the road in Australia to large audiences without going stale. A moving portrait of the lives of a group of friends who, for various reasons, abandon their civilian lives to join the Australian forces fighting in Europe during World War I. Our scheduling of Gallipoli is not tentative at time of this printing. Contact the RC Theater office or other local periodicals for more information.

THURSDAY, APRIL 22
WITH BABIES AND BANNERS / UNION MAIDS (48 min)
8:00 RC Theater/East Quad Free
With Babies and Banners: "With Babies and Banners" reveals the history of the 1936 Flint, Michigan sit-down strike led, in part by the women-workers of the Women's Emergency Brigade. Interviews with the members of the Brigade make With Babies and Banners, one of the best films on the industrial union movement. Union Maids: Three union maids, in their 60's, tell of their involvement in the early days of union organizing. With newsreel footage and personal interviews, Union Maids squares the realities of working class struggles of the 1930's.

THURSDAY, APRIL 29
SONG OF THE CANARY (58 min)
8:00 RC Theater/East Quad Free
This film exposes the health hazards that workers must face daily. In Song of the Canary, the risks of pesticide work and brown lung disease do not stop the workers from fighting for safe work places. Don't leave town without seeing this film.

THAT'S ALL, FOLKS!

Alternative Action calendar, winter 1982. OPPOSITE: Cinema II, winter 1984

CINEMA TWO presents THE BIG SCHEDULE

★ *Tunes, Buffoons and Cartoons*
Throughout our schedule, Cinema II is presenting a series of early animation shorts.
These cartoons tend toward the nameless, nonstar, bizarre musicals, renowned for their detail and "off the wall" surrealistic humor that influenced and fascinated the underground comic artists of the late 60s. You can watch them as film history, cultural history, psychology of the unconscious or just plain fun.

Wed., Jan. 4 Aud. A
Little Big Man
(Arthur Penn, 1970)
After surviving Custer's Last Stand, Jack Crabb (Dustin Hoffman) goes on to suffer through numerous permutations in his identity, which include being an adopted Indian, a mule skinner, a town drunk and gunfighter (*The Sodey Pop Kid*). The gusto with which he handles each fated new role is Penn's statement on how to live life. "One of the year's ten best." —Vincent Canby, Judith Crist, Charles Champlin. (147 min.) 6:45 and 9:20

Fri., Jan. 6 Aud. A
Dr. Strangelove, or How I Learned to Stop Worrying and Love the Bomb (Stanley Kubrick, 1964)
A wildly comic nightmare with the President of the U.S. and the Premier of the U.S.S.R. cooperating in a bizarre effort to save the world from total disaster. A wonderful COLD WAR black comedy of sensual insecurity, nuclear deterrence and the holocaust. With Peter Sellers (in multiple roles), George C. Scott, Sterling Hayden, Keenan Wynn and Slim Pickens. Featuring the cartoon "Of Thee I Sting."
(93 min.) 7:00 and 9:00

Sat., Jan. 7 Aud. A
Blade Runner
(Ridley Scott, 1982)
In this futuristic film noir, Harrison Ford plays the city cop whose special duty is to do in replicants, androids who do the dirty work for humans and are calling for revolution. Tired of it all, he runs into trouble when he finds that some replicants come in very attractive packages. Ridley Scott (Alien) directs this eerie and fast-paced film, which connects the present to the year 2019, with its rush hours, and punk-styled crowds. Quickly becoming a cult favorite. 35 mm, Cinemascope. (118 min.) 7:00 and 9:15

Sun., Jan. 8 Aud. A
The Passenger
(Michelangelo Antonioni, 1975)
Jack Nicholson and Maria Schneider (*Last Tango*) star in Antonioni's provocative film about a man who changes his identity we can't escape his destiny. Filmed in North Africa, Spain, Germany and England, *The Passenger* had been aptly called "a profoundly beautiful expression of the time warp into which we all have wandered in the 70s." (Andrew Sarris) Antonioni's most commercial film, this sometimes-thriller shimmers with color and visual bravado.
(119 min.) 7:00 and 9:15

Wed., Jan. 11 MLB 3
Mean Streets
(Martin Scorsese, 1973)
An intense Robert DeNiro plays Johnny Boy the troublemaker; Harvey Keitel is his confused friend who finds it hard to abandon his Catholic upbringing and ascend the mafia throne of New York's Little Italy. One of the most explosive films of the 70s, this is a must-see for Scorsese fans.
(112 min.) 7:00 and 9:00

Fri., Jan. 13
ANN ARBOR PREMIERE
Tales of Ordinary Madness
(Marco Ferreri, 1981)
From the maker of *La Grande Bouffe* comes this off-beat, often hilarious film based on Charles Bukowski's story "The Most Beautiful Woman in Town." Los Angeles is the setting, the city of dreams and desperation where it's uncertain how or where you'll get your next drink. Ben Gazzara gives a captivating performance as the Bukowski character, lashing out with humorous pathos at the misery that encompasses his beloved city. With Ornella Muti and Susan Tyrell. "Has a shocking comic power...a startling movie." —Pauline Kael. Featuring the cartoon "Mad Hatter."
(107 min.) 7:00 and 9:00

Sat., Jan. 14 Aud. A
Missing
(Costa-Gavras, 1982)
Costa-Gavras, director of *Z* and *State of Siege*, examines personal tragedy within the greater scope of political turmoil. In this, his first American release, he does not compromise his critical attitude of abuses of power. Sissy Spacek gives an outstanding performance as the wife of American journalist John Shea, who mysteriously disappears in politically-torn South America. Jack Lemmon received the Cannes Film Festival Award for best performance as Shea's anguished father, and *Missing* was 1982's Grand Prize Winner at Cannes. 35 mm. (122 min.) 7:00 and 9:15

Sun., Jan. 15 Aud. A
That Man from Rio
(Phillippe de Broca, 1964)
Phillippe de Broca's (*King of Hearts*) engaging French spoof of the James Bond films stars Jean Paul Belmondo (*Breathless*). The plot concerns an Amazon Indian statuette stolen from a museum. Belmondo, who is incidentally France's biggest star aside from Gerard Depardieu, trails the thieves and is led by land, sea, and air to Rio de Janeiro, to Brasilia, and into the jungles. De Broca's direction creates the quintessential Belmondo character—naive, but able, bewildered, but never awed. Satirizes every type of cinematic derring-do from *Perils of Pauline* to *Tarzan*. This is a good movie about bad movies. (114 min.) 7:00 only

Hi Mom!
(Brian De Palma, 1970)
This is an early film from De Palma and one in which he both directed and co-authored the script. It stars the then-unknown Robert De Niro. *Hi Mom* stands out for its wit, its ironic good humor, its multi-level sophistication, its technical ingenuity, and its nervousness, not to mention its very special ability to being the sensibility of the suburbs to the sits of the inner city as it displays through its "ironic good humor" the conflicts of blacks and whites against an urban backdrop.
(86 min.) 7:00 only

Wed., Jan. 18 MLB 3
Paths of Glory
(Stanley Kubrick, 1957)
Kirk Douhlas stars as the heroic and human military officer who gets caught in an ethical bind between the decisions from above made by military hierarchy and real-life concerns in the French Army's fighters. This gripping World War I movie is one of Kubrick's earliest and features excellent direction and heavy-hitting dialogue. (86 min.) 7:00 only

Caine Mutiny
(Edward Dmytryck, 1954)
Humphrey Bogart portrays Captain Queeg, the nerve-taught navy veteran, whose crew judges him unfit to command. Acting on this belief, the crew leaders are subsequently court-martialed. It is during the trial that we realize that what seemed to be so clear is not so at all, and we must reconsider Captain Queeg and men like him. A top-grossing film in 1954, it is based on the Herman Wouk novel. With Van Johnson and Jose Ferrer. (125 min.) 8:45 only

Fri., Jan. 20 Aud. A
Beauty and the Beast
(Jean Cocteau, 1946)
A visually stunning rendition of the proverbial story of Beauty taming and eventually loving the beast. Portrayed with Cocteau's unique blend of fantasy and surrealism, this film remains one of the masterpieces of modern cinema. With Jean Marais and Josette Day. "A brilliant example of what cameras can do with a poet in charge..." —Newsweek. (90 min.) 7:00 only

The Golden Coach
(Jean Renoir, 1953)
After being out of distribution for a number of years, *The Golden Coach* is back to mesmerize you with its beauty, humor, and its ability to infuse the screen with the passions and failures of humanity. The story centers around a theatre troupe, with the great Anna Magnini at its core, starring as the actress Camilla. As if she were a painter, Renoir colors the screen with lush and vibrant images to detail the relationship between theatre and reality, ornament and representation.
(100 min.) 8:45 only

Sat., Jan. 21 Lorch
Dial M for Murder in 3-D
(Alfred Hitchcock, 1954)
So even Hitchcock fell prey to the wonders of 3-D technology, using them subtly and effectively; especially in the scissor murder scene. Ray Milland plays a man financially dependent on his wife's (Grace Kelly) fortune who is afraid that she's going to leave him for another man. Robert Cummings, the other man and a mystery writer, must come to the rescue when she is implicated for the murder of a man she claims she's never met. Hitchcock puts the key to it all in the most obvious of places. With 3-D glasses included. 35 mm. (105 min.) 7:00 & 9:00

Sun., Jan. 22 Aud. A
El (This Strange Passion)
(Luis Bunuel, 1952)
A virtually scientific study of a psychopath. One of Bunuel's favorites of all his films, *El* is a black comedy about a man driven insane by obsessive jealousy. Bunuel's irreverence and feminism are in full swing, and Catholicism is casually trashed in this film. (100 min.) 7:00 only

Simon of the Desert
(Luis Bunuel, 1965)
An important and very personal work, this rarely seen philosophical comedy concerns Simon, a prophet who spends his life perched upon a huge column. "...surprising and profound, serious and entertaining, full of gags and of clear surrealist imagination." —Francisco Aranda. (42 min.) 8:45 only

The Criminal Life of Archibaldo de la Cruz
(Luis Bunuel, 1955)
Bunuel's black comedy about murder, impotence, paranoia, and sexual perversion. This film observes the pursuits of Archibaldo de la Cruz, a highly unbalanced man who believes he is a murderer. The film is tragic, funny, and surrealistic at the same time. (91 min.) 8:30 only

Wed., Jan. 25 MLB 3
To Have and Have Not
(Howard Hawks, 1944)
Based on a Hemingway tale and set in the French Caribbean, this patriotic World War II "thrillo-drama" stars Bogie & Bacall. The sentimental value comes from knowing the real-life courtship of B & B. Often overlooked is Walter Brennan's wonderful performance as Eddie, Bogart's endearing alcoholic assistant. Sigh. Songs get written about movies like this!
(100 min.) 7:00 & 9:00

Fri., Jan. 27 Aud. A
The Year of Living Dangerously
(Peter Weir, 1983)
One of the best films of 1983, *The Year of Living Dangerously* confirmed Mel Gibson (*Mad Max*) and Sigourney Weaver (*Alien*) as international stars. Set in the tumultuous Indonesia of 1965, this romantic adventure tells the story of a young Australian journalist out to make a name for himself while covering the chaotic last months of President Sularno's rule. With revolution in the air and people starving in the streets, he moves through this desperate world with the extraordinary assistance of a half-Chinese, half-Australian cameraman whose humanity and intelligence dominate the film and provide its moral conscience. Sigourney Weaver is a British military attache, with whom both of these men are in love. The best film yet from the director of *Gallipoli* and *Picnic at Hanging Rock*. 35 mm. Cinemascope.
(114 min.) 7:00 and 9:15

Sat., Jan. 28 Aud. A
Pixote
(Hector Babenco, 1981)
Pixote, slang for Peewee, is one of some three million abandoned children in Brazil. Homeless, they live on the streets and pick pockets, hustle, and even kill to survive. Winner of the Best Foreign Film Award from both the N.Y. and L.A. Film Critics and named one of the year's ten best by the *N.Y. Times* and the *Village Voice*, *Pixote* takes us into a world where child bandits rule the streets and anguish and despair hang thick in the air. Often compared to Bunuel's *Los Olvidados*, *Pixote* is an unrelenting look at a society that will shock some and outrage others. "*Pixote* is good enough to touch greatness; it restores your excitement about the confusing pleasures that movies can give." —Pauline Kael, *The New Yorker*. With Fernando Ramos da Silva and Marilia Pera. (127 min.) 7:00 and 9:15

Fri., Feb. 3 Aud. A
The Tin Drum
(Volker Schlondorff, 1979)
A masterful cinematic translation of the greatest German novel written since World War II, *The Tin Drum* won the 1980 Academy Award for Best Foreign Film. It is the story of Oskar Matzerath, who has lived through the long Nazi nightmare and who is detained in a mental institution. Willfully stunting his growth at three feet for many years, wielding his tin drum and glass-shattering scream as anarchistic weapons, he provides a profound yet hilarious perspective on both German history and the human condition in the modern world. One of the best post-war German films, *The Tin Drum* is hilarious, bizarre, repulsive, and much more. Not to be missed. 35 mm. (142 min.) 7:00 and 9:30

Sat., Feb. 4 Aud. A
ANN ARBOR PREMIERE
Yol
(Yilmaz Guney, 1981)
Yilmas Guney directed this film (which shared the Grand Prix at Cannes in 1981) while imprisoned in Turkey and waited until the final rushes were smuggled out of Turkey before escaping from prison, fleeing the country to edit the film. The film presents the separate stories of a group of inmates who receive one-week furloughs to visit their families. Through these men, Guney explores the political repression of Kurds and takes an in-depth look at the role of women in traditional Turkish culture. In conjunction with this Ann Arbor premiere, we are presenting a half-hour panel discussion of the film between the 7:00 and 9:45 shows. Turkish with subtitles. Co-sponsored with Cinema Guild.
(111 min.) 7:00 and 9:45

Sun., Feb. 5 Aud. A
The Three Ages
(Buster Keaton and Eddie Cline, 1923)
The second feature of Keaton's career, the first directed by him, an entertaining spoof on D.W. Griffith's *Intolerance*. (Keaton and Wallace Beery vie for the affection of Margaret Leahy) in 3 parallel stories set in the Stone Age, ancient Rome, and prohibition America and intercut like Griffith's epic, featuring fine accompaniment of a piano score, including short *The Paleface* (1921) in which Keaton is a butterfly collector who wanders into an Indian tribal war and ends up adopted by one of the tribes after, of course, enduring much trauma. In one of the best bits he escapes one angry tribe by crossing a bridge made of two parallel wires with only two planks that he places ahead of one another for each step—only to reach the other side as the second and equally hostile tribe arrives.

College
(James W. Horne, 1927) 7:00 only
The showing of the Keaton film features a tainted restored print and live piano accompaniment. Buster Keaton plays "The Boy" who delivers a high school graduation ceremony "Brains vs. Brawn" paean speech. At college he meets "The Girl" who worships athletes. He decides to eye his words and win her by displaying his athletic prowess, but we hilariously watch him fail in one sport after another. When he has completely embarrassed himself as a track meet, he learns that she is being attacked by a masher in her dorm room. He suddenly comes to life and takes off running to her aid, setting track records as he crosses the field leaping over and around obstacles in Keaton's typically amazing finale. (67 min.) With short: Neighbors (1920, 17 min.) Keaton climbs over fences, clothes lines and up telephone poles to reach his girl so they can elope. 9:00 only

Thurs., Feb. 9 Schorling Aud. Education School
WCBN BENEFIT
Rhythm n' Blues Revue (1955) (70 min.)
St. Louis Blues starring Bessie Smith (25 min.)
Jammin' the Blues (20 min.) **7:00 only**

Rock n' Roll Revue (1955) (70 min.)
Cab Calloway's Hi de Ho (20 min.)
Jittering Jitterbugs (20 min.) **9:00 only**

Watch for more information about this special event at our ticket desk and around campus.

Fri., Feb. 10 Eve MLB 3
Risky Business
(Paul Brickman, 1983)
Sometimes you just have to say "what the f...k" and let yourself go. That's what Tom Cruise decides to do when his folks leave town, and such slambanging fun you've never seen. This film is for all who have ever let their imagination run wild as they imitated their favorite rock singer in a mirror. This film was the hottest comedy hit of last summer. Featuring the cartoon, "Lady in Red." (96 min.) 7:00 and 9:00

Sat., Feb. 11 Nat. Sci.
Star Wars
(George Lucas, 1977)
Special effects, limitless action, and a wholesome cast make this phantasmagorical space-opera worth seeing yet another time. R2D2 and C3PO adorn screen for the seventh time; our friend Obi "Ben" Kenobe is as forceful as he's ever going to be. An escapist's treat with enough literary parallels to make even the serious filmgoer happy. Cinemascope.
(123 min.) 7:00 and 9:15

Wed., Feb. 15 MLB 3
X-Man with the X-Ray Eyes
(Roger Gorman, 1963)
Winner of the 1963 Venice Science-Fiction Film Festival, Roy Milland plays a research scientist who develops a drug that enables the human eye to see through things. He tries it on himself and at first enjoys the novelty, until he realizes that the effects are cumulative and will get worse, not wear off. Unable to continue his work, he is forced to earn money at circus side-shows (Don Rickles plays his manager) until he can see the center of the universe and goes mad. The ending embraces the notion that man's scientifically-acquired powers only lead to destruction. (80 min.) 7:00 only

The Illustrated Man
(Jack Smight, 1969)
Based on the Ray Bradbury novel. *The Illustrated Man* is the prototype for science-fiction stories. The setting is a rural campground; a young man meets a wanderer who is tormented by the tatoos that completely cover his body. As the illustrated man falls asleep, each tatoo comes alive and tells its own story. The blend of the real and the bizarre in these stories directly influenced later shows like *The Twilight Zone*. With Rod Steiger, Claire Bloom, and Robert Drivas.
(103 min.) 8:30 only

Thurs., Feb. 16 Nat. Sci.
ANN ARBOR PREMIERE
A Week's Vacation
(Bertrand Tavernier, 1980)
Laurence is a 31-year-old French teacher whose feelings of purposelessness, loneliness, and inadequacy have brought her close to a breakdown. Though her classes seem to go well, she hasn't the strength to face her pupils. A psychiatrist prescribes a week's vacation. For the first time in months she returns to visit her family, only to find her father sinking into senility, and her brother a stranger she encounters by chance outside a cinema. But she finds friendship and strength from the father of one of her troubled students and also the "clockmaker of St. Paul." Starring Nathalie Baye (*The Return of Martin Guerre*) and Philippe Noiret (*Coup de Torchon*), this is a highly-acclaimed film of great sensitivity and understanding. Cinemascope. (105 min.) 7:00 and 9:00

Fri., Feb. 17 Aud. A
Gilda
(Charles Vidor, 1946)
This film noir set in post-World War II Buenos Aires is the story of a love triangle between Gilda (Rita Hayworth), Ballin Mundson (George Macready), and Johnny Farrell (Glenn Ford). Johnny, the newly-hired manager of Mundson's casino, is surprised when Mundson returns from a trip married to Gilda, Johnny's former lover. Mundson discovers this previous love affair and makes Johnny spy on Gilda, who is a less than faithful wife. Gilda resents the actions of both men and one night does a striptease in the casino while singing "Put the blame on Mame." The plot then thickens when Mundson murders a man and flees the country. Rita Hayworth was Hollywood's biggest Sex Goddess at the time of this film (a picture of her was taped to the first atomic bomb) and Gilda is her most legendary performance—the "Mame" striptease is about as wild as Hollywood got in those strictly censored times. (112 min.) 7:00 only

All About Eve
(Joseph L. Mankiewicz, 1950)
Bette Davis plays the role of her life in this Academy Award-winning movie. As Margo Channing, she is the aging Broadway actress whose life has killed a man twenty and then deviously infiltrated by an upstart young actress (Anne Baxter) clawing her way to the top. One of Davis' classics, this movie brings out the best from all its actors—Thelma Ritter, Celeste Holme and George Sanders. And for all you Monroe fans, Marilyn has a small, but choice part which shouldn't be missed.
(138 min.) 9:00 only

Sat., Feb. 18 Aud. A
To Kill a Mockingbird
(Robert Mulligan, 1962)
Seen from the eyes of a child, this is the story of growing up in the South. Based on Harper Lee's novel, we follow a young girl's adventures with her brother and his friend Huck Finn. She is unable to understand why it has such consequences in the adult world. Gregory Peck won an Academy Award for best actor as a lawyer who defends a black man accused of raping a white woman. Robert Duvall gives a gripping performance as the very misunderstood Boo Radley. With Brock Peters.
(129 min.) 7:00 only

Anatomy of a Murder
(Otto Preminger, 1959)
Filmed on location in Michigan's upper peninsula, this film realistically portrays the murder trial of a young Army lieutenant (Ben Gazzara) who has killed a man his wife claims raped her. James Stewart for the defense and George C. Scott for the prosecution are at their best as they argue the case before a sardonic judge, played by Joseph Welch who achieved fame in the 1954 Army-McCarthy hearings. (161 min.) 9:15 only

©by Cinema II 1984

Cinema II is a non-profit organization, providing Ann Arbor with the best of alternative cinema. For program information, call the campus film information line—763-FILM—or try our office—665-4626. All shows $2.00, $1.00 for kids 12 and under, and $3.00 for double features unless otherwise advertised.

Aud. A = Auditorium A, Angell Hall
Lorch Hall = Lorch Hall, formerly Old Architecture Auditorium (below CRISP)
MLB 3 = Modern Language Building, Auditorium 3
MLB 4 = Modern Language Building, Auditorium 4
Nat. Sci. = Natural Science Auditorium

winter 84

CINEMA II

JAN.

SATURDAY, 8
TO HAVE AND HAVE NOT (Howard Hawks, 1944)
From Hemingway's novel, with a script by William Faulkner, the tale of a tough, self-centered run-runner in French Martinique who turns patriot one last time. Humphrey Bogart and Lauren Bacall together for the first time in the film that spawned their famous romance. Also starring Walter Brennan and Hoagy Carmichael. "If you want anything, just whistle . . ." 7:00 & 9:00

SUNDAY, 9
MUTINY ON THE BOUNTY (Frank Lloyd, 1935)
The original film adaptation about a sadistic captain who loses both his ship and crew. A grim and brutal drama starring Charles Laughton as Captain Bligh and Clark Gable as Christian - a film which contains the inspiration for not one, but a dozen adventure films, and certainly one of Gable's great films. 7:00 & 9:15

FRIDAY, 14
LOST HORIZON (Frank Capra, 1937)
A plane crash in the Himalayas. The survivors struggle through the mountains until suddenly they come upon a land untouched by time - the enchanted kingdom of Shangri-la. A classic motion picture, Capra at his best. Ronald Colman, Jane Wyatt. 7:00 & 9:00

SATURDAY, 15
A MAN FOR ALL SEASONS (Fred Zinnemann, 1966)
Against the backdrop of 16th century London, we witness the historic, yet timely battle between King Henry VIII (Robert Shaw) and Sir Thomas Moore (Paul Scofield), with Orson Welles appearing as the poisonous Cardinal Wolsey. A dramatic and beautiful film study of a conflict of wills. The excellent cast includes Susannah York, Vanessa Redgrave, and Collin Blakely. Scofield won an Oscar for his portrayal of the courageous Moore. 7:00 & 9:15

SUNDAY, 16
DESK SET (Walter Lang, 1957)
Vintage Tracy and Hepburn about an efficiency expert (Spencer Tracy) who invades the domain of a professional trivia librarian (Katherine Hepburn). The romance takes off from there. Lots of laughs as well as a sardonic comment on the worth of today's "technological improvement." An unbeatable comedy team in one of their best films. 7:00 & 9:00

FRIDAY & SATURDAY, 21 & 22
SPECIAL SECTION (Costas Gavras, 1976)
The newest, and perhaps most controversial film by the maker of Z and STATE OF SEIGE, this film demonstrates the possibilities of cinema as a personal, powerful form of political expression. ANN ARBOR PREMIERE. 7:00 & 9:15

SUNDAY, 23
JULES ET JIM (Francoise Truffaut, 1961)
A beautiful film about the classic menage a trois, starring Jeanne Moreau as the elusive Catherine, a vehicle for Truffaut's musings on life and love. One of the classic romantic films of commercial cinema. Also starring Oscar Werner. In French, with subtitles. 7:00 & 9:00

FRIDAY, 28
GIMME SHELTER (David and Albert Maysles, 1970)
What might have been just another documentary of a rock tour becomes radically changed by the tragic events at Altamont. A film about the powers and dangers of charisma, as well as about our own pop culture. With Mick Jagger, Charlie Watts, the Rolling Stones, Ike and Tina Turner, and the Hells Angels. 7:00 & 9:00

SATURDAY, 29
A STREETCAR NAMED DESIRE (Elia Kazan, 1951)
Brando's Stanley and Vivian Leigh's Blanche are superb together in this film version of Tennessee Williams' smoldering drama about some very lost, mixed up people. Brando never looked better in a t-shirt, and Vivian Leigh's aging Southern Belle is a heart-rending performance. Fine supporting cast headed by Kim Hunter and Karl Malden. 7:00 & 9:00

SUNDAY, 30
EXPERIMENTAL FILMS 7:00 & 9:00
FIREWORKS - Kenneth Anger
NUDES - Curt McDowell
HOT LEATHERETTE - Robert Nelson
FFFTCM - Will Hindle
ARNULF RAINER - Peter Kubelka (who will appear here on February 11 with his new film, MONUMENT FOR THE OLD WORLD)
THE END - Christopher Maclaine
THIS IS IT - James Broughton

FEB.

FRIDAY, 4
LAWRENCE OF ARABIA (David Lean, 1962)
This on-location extravaganza displays the characteristics of a mammoth western. Peter O'Toole stars in the role of a British soldier-of-fortune who goes off to become a leader of Arab tribesmen during WWI. A vast movie: alive, inspiring, and beautiful. John Ford - eat your heart out. Cast includes Anthony Quinn, Claude Rains, and Omar Sharif. 6:15 & 10:00

SATURDAY, 5
O LUCKY MAN! (Lindsey Anderson, 1973)
Malcolm MacDowell helped originate and stars in this picaresque tale of an ambitious young coffee salesman whose life turns inot a movie before your very eyes. Reminiscent in many ways of Kubrick's A CLOCKWORK ORANGE, but lots more irreverant and fun. Excellent music by Alan Price and his band, who somewhere along the line manage to become active characters in the story. 7:00 & 10:00

SUNDAY, 6
DARLING (John Schlesinger, 1965)
An early Schlesinger film (MIDNIGHT COWBOY, MARATHON MAN) that traces the mis-spent life of an untalented model, Julie Christie, from her juvenile marriage into a series of shabby affairs. The story of a life that ultimately triumphs in love-less marriage. With Dirk Bogarde and Laurence Harvey, and an Oscar-winning performance by Julie Christie. 7:00 & 9:00

FRIDAY, 11
LA SALAMANDRE (Alain Tanner, 1972)
Vaulting its director into the front ranks of European filmmakers, this film presents the story of a free spirited working-class woman, who becomes involved with two different men - who inevitably become enchanted with her inimitable charms. A charming, delightful film about the unfettered and unconventional lifestyle of its courageous heroine. In French, with subtitles. 7:00 & 9:00

FRIDAY, 11
PETER KUBELKA 8:00 Personal Apperance
Natural Science Auditorium. One of the world's great filmmakers, Peter Kubelka, will be here to speak and show his new film, MONUMENT TO THE OLD WORLD. This will be the second showing of this film in America.

SATURDAY, 12
McCABE AND MRS. MILLER (Robert Altman, 1971)
A delicate treatment of a rough man and woman in an equally rough life. The film moves slowly through the last days of John McCabe, a small-time entrepreneur in a Washington mining town. The photography is magnificent, the color is beautiful: the film is a masterpiece. Warren Beaty, Julie Christie. 7:00 & 9:15

SUNDAY, 13
ANIMATION NIGHT
This semester's animated festivity is a kaleidescopic presentation of Hollywood and experimental animation including: Bugs Bunny, Betty Boop, Tweety Pie, Felix the cat, J.S. Meets Barbi Doll, "Oh" by Stan Vanderbeek, and "Snapshots" by Adams. 7:00 & 9:00

FRIDAY, 18
IMAGES (Robert Altman, 1972)
One of Altman's lesser-seen films, IMAGES is the frightening account of a woman's violent and sexual visions. A collection of startling visual images, effectively edited, leave the viewer in a mood both perplexing and foreboding. Susannah York 7:00 & 9:00

SATURDAY, 19
IDI AMIN DADA (1976)
Idi Amin is an intelligent and perceptive documentary which studies the African leader who is a humorous figure of ridicule to us and a symbol of terror for thousands. Rave reviews for this film. ANN ARBOR PREMIERE. 7:00 & 9:00

SUNDAY, 20
STORY OF A LOVE AFFAIR (Michelangelo Antonioni, 1950)
The first feature film by the director of BLOW UP and THE PASSENGER tells the story of Milanese industrialist who hires a private eye to probe into the past of his young wife. The investigation reveals an illicit affair, and a mysterious death. Antonioni's prize winning film noir has been called "one of the most perfectly and completely structured films in the entire history of cinema". Stars Lucia Bose, Massimo Girotti, and Fernando Sarmi. Italian with English subtitles. ANN ARBOR PREMIERE. 7:00 & 9:00

FRIDAY, 25
THE DAMNED (Luchino Visconti, 1970)
The first of the films in our tribute to Visconti, this film explores the lives - and deaths - of an aristocratic family in Nazi Germany. A study in cultural perversion, which perhaps is not so distant from the 1970's. Cited often for its experimental use of color, THE DAMNED is a film whose visual impact parallels its thematic statement. Starring Ingrid Thulin and Dirk Bogarde. 7:00 & 9:30

SATURDAY, 26
THE CONVERSATION PIECE (Luchino Visconti, 1974)
Burt Lancaster stars as a reclusive art history professor living in Rome. From the director of DEATH IN VENICE and THE DAMNED, this moving study of the interaction of the introverted professor and the boisterous family group which invades his insulated world was directed by Visconti from his wheelchair, and as his last film, becomes his testament to life, death, and dying. With support appear Helmut Berger and Silvana Mangano. English version.
ANN ARBOR PREMIERE. 7:00 & 9:00

SUNDAY, 27
GODS OF THE PLAGUE (Rainer Werner Fassbinder, 1969)
Fassbinder is a member of the German "New Wave". GODS OF THE PLAGUE is one of his three major meditations on American gangster mythology, "Fassbinder's gangsters - although they have a style of their own - are a far cry from Bogart and Cagney." A stark film that is a must for any serious filmgoer. 7:00 & 9:00

MARCH

FRIDAY & SATURDAY, 4 & 5
THE STORY OF ADELE H. (Francoise Truffaut, 1975)
Isabelle Adjani as the true romantic, both in spirit and by birth. Adele H. is quite literally the creation of the premier French romantic, M. Victor Hugo. Conceived in the brooding browns and gloomy greens of the watercolors of the period, Truffaut realizes the beauty and sorrow of this tragic and hopeless search for love. French, with English subtitles. 7:00 & 9:00

SUNDAY, 6
TWO WOMEN (Victorio de Sica, 1961)
The story of a lusty, young widowed mother (Sophia Loren) who escapes Rome with her 13 year old daughter after a series of heavy bombardments in 1943. Basically a mellow story, which becomes shattered by a brutal rape scene in a bombed-out church, followed by Loren's attempts to correct the damages done. De Sica's representation of the tragedy of war, and the effects of that tragedy upon the Italian people. Featuring an Oscar-winning performance by Loren. Italian, with subtitles. 7:00 & 9:00

FRIDAY, 18
CAT BALLOU (Elliot Silverstein, 1965)
Jane Fonda stars in the title role, but its Lee Marvin who steals the show, along with his horse, in this comedy western about the misadventures of a group of would-be outlaws who attempt to save "Cat" from the gallows. Marvin's drunken cowboy routine earned him an Oscar, half of which he gave to his horse. 7:00 & 9:00

SATURDAY, 19
THE BIG STORE (Charles Riesner, 1941)
A rarely seen Marx Brothers comedy: Harpo and Chico play a duet, Groucho pinches his way through the ladies wear department, and general bedlam throughout. An hilarious movie, rich in ad-libbing, and vintage Marx Brothers. 7:00 & 8:30

SUNDAY, 20
FILM FESTIVAL WINNERS
Presenting the final winners in the famous ANN ARBOR FILM FESTIVAL - the culmination of a week-long festival of new films by up and coming filmmakers from all over the country. Three different shows at 7:00, 9:00 & 11:00

FRIDAY, 25
THE LONG GOODBYE (Robert Altman, 1973)
Altman's private eye film based on the adventures of Raymond Chandler's Phillip Marlowe. Elliot Gould is, in some ways, an anti-Bogart; bumbling and chasey. But like Bogart, his inherent romanticism and moral code force him to search out the truth. Nina van Pallandt, Sterling Hayden, Jim Bouton, Henry Gibson. 9:15

SATURDAY, 26
SCENES FROM A MARRIAGE (Ingmar Bergman, 1975)
Liv Ullman stars in this painful, yet ultimately healing vision of two people, in and out of love, and in and out of marriage. An important film in the Bergman canon, and in tracing the filmmaker's path and development. 7:00 & 10:00

SUNDAY, 27
AND NOW MY LOVE (Claude Lelouch, 1975)
A love story based on a belief in the predetermination of love. A good guy ex-con filmmaker and a bored rich woman meet on a plane to the U.S. With Marthe Keller and Charles Renier. 7:00 & 9:00

APRIL

FRIDAY, 1
THIEVES LIKE US (Robert Altman, 1974)
A carefully aimed mood piece picturing love and crime in the halycon Coca-Cola days of the 1930's. The original version of this film was the basis of Penn's BONNIE AND CLYDE. "So sensuous and lucid it is as if William Faulkner and the young Jean Renoir had collaborated." Keith Carradine, Shelly Duvall. 7:00 & 9:15

SATURDAY, 2
THE BRIDE WORE BLACK (Francoise Truffaut, 1968)
Truffaut has described this film as an "homage to Hitchcock". In it a bride (Jeanne Moreau) devotes her life to the liquidation of those responsible for killing her husband on their wedding day. A superb study in cinematic terror, and indeed, a worth tribute to the master of cinematic terror. In French, with English subtitles. 7:00 & 9:00

SUNDAY, 3
TWO OR THREE THINGS I KNOW ABOUT HER (Jean-Luc Godard, 1966)
A study of prostitution, both on a personal, industrial, and political level. Oftern exhibiting Godard's own special brand of humor, this film ranges from the adventures of a young French housewife prostitute, to the contemplation of the universe within a coffee cup. Sometimes maddening, but altogether, an important film by one of the world's most intriguing filmmakers. 7:00 & 8:30

FRIDAY, 8
BEAUTY AND THE BEAST (Jean Cocteau, 1946)
A visually stunning rendition of the proverbial story of beauty taming - and eventually loving - the beast. Displayed with Cocteau's unique blend of fantasy and surrealism, this film remains one of the masterpieces of modern cinema. With Jean Marais and Josette Day. In French, with subtitles. 7:00 & 9:00

SATURDAY, 9
THE HARDER THEY COME (Perry Henzell, 1973)
A violent tale of a young innocent who comes to seek his fortune as a pop star and ends up as a desperado. Reggae music by Jimmy Cliff. "THE HARDER THEY COME has more gits, wit, humor and sheer exuberance than most movies you'll see in any one year of movie-going." - Vincent Canby. 7:00 & 9:00

SUNDAY, 10
BEFORE THE REVOLUTION (Bernardo Bertolucci, 1963)
The first feature by the director of LAST TANGO IN PARIS, the brilliant study of a wealthy young Parmanese endeavoring to commit himself to the demands of Communism - and to the emotional needs of his young, beautiful and neurotic aunt - established Bertolucci as an outstanding talent. The critic of the 1964 N.Y. Film Festival called it the "revelation of the festival." Starring Adriana Asti and Francesco Barilli. Italian, with subtitles. 7:00 & 9:00

FRIDAY, 15
THE THIRD MAN (Carol Reed, 1949)
Set in post-war Vienna, this melancholy film is the tale of a western writer (Joseph Cotten) who discovers that his friend (Orson Welles) is a racketeer and has gone literally "underground." The investigation, discovery of fraud, and eventual chase through the sewers of Vienna are heightened by haunting, omnipresent zither music. 7:00 & 9:00

SATURDAY, 16 Double Feature
CALIFORNIA SPLIT
George Segal as a compulsive gambler who matches up with Elliot Gould for one last try at the big one. To be shown in stereophonic sound as originally filmed. AN ANN ARBOR EXCLUSIVE. 7:00

SATURDAY, 16
NASHVILLE
Altman's panoramic view of America. Set in the Country music capital of the world. To be shown in stereophonic sound as it was originally filmed, with Karen Black, Ronee Blakely, Henry Gibson, Keith Carradine, Shelly Duvall and many, many more. 9:15

SUNDAY, 17
FOLLOW THE FLEET (Mark Sandrich, 1935)
Fred Astaire and Ginger Rodgers tap dance their way through another heart-warming musical comedy. All you can do is sit back and marvel at these two dancing - so who cares about plot? Its great fun, and inspiring too. 7:00 & 9:00

FRIDAY, 22
BUFFALO BILL AND THE INDIANS (Robert Altman, 1976)
Paul Newman, in one of the title roles, sizes himself up in the eyes of the past, the public, and the future. A more introspective film than the standard Altman fare. Great supporting performances by Harvey Keitel, and Joel Grey, among others. 7:00 & 9:30

SATURDAY, 23
MURDER MY SWEET (Edward Dmytryk, 1945)
This beautifully successful "film noir" outclasses its later re-make, FAREWELL MY LOVELY by miles. Dick Powell made a convincing transformation from his earlier cream-puff comedy roles to a hard-boiled dick. "Where's Velma?" "Put me down, you big ox." 7:00 & 9:00

SUNDAY, 24
GUYS AND DOLLS (Joseph L. Mankiewicz, 1955)
"When you see a guy reach for stars in the sky" you can guess the guy is Brando, and he's doing it for some doll - Jean Simmons. Based on Damon Runyon stories about the "seamier" side of New York, this musical also stars Frank Sinatra and Stubby Kaye, participants in the oldest-established floating crap-game-in-New York. But its worth everything just to see Brando sing and dance. With music by Frank Loesser. 7:00 & 9:45

* * * * *

IN CONJUNCTION WITH THE
ROBERT ALTMAN FESTIVAL

ANGELL HALL AUDITORIUM A

ABOVE: Angelica Pozo at the University Drive-In for Cinema Guild's winter 1979 calendar
OPPOSITE: Cinema II schedule for winter 1977

CINEMA GUILD
SPRING SUMMER 80
CINEMATIC LINEUP

Located in the old architecture auditorium, tappan & monroe st. (below "crisp"). Admission: $1.50/children: $1.00 - series ticket: ten shows $12.50 Non Profit film showplace/ funded by you

THIS PAGE AND OPPOSITE: Rob Ziebell calendars for Cinema Guild featuring Angelica Pozo

Frames from
Mary Cybulski and
John Tintori's
no smoking film

OPPOSITE, TOP:
trailer can for Dan
Bruell's *No Smoke*

OPPOSITE, BOTTOM:
Images from Dan
Bruell's film

RIGHT: Frames from Cinema II's pre-show trailer

BELOW: A trailer shipment to the AAFC, 1981

on some good movie posters from that," remembered Cinema II's Matthew Smith. "I still have *The Slime People* and *Godzilla vs. the Smog Monster*, and a few others." Another promotional effort was the occasional production of whimsical T-shirts. The AAFC made one for the pornographic satire *Flesh Gordon*, while Cinema II created one for a summer spaghetti western series that depicted Clint Eastwood holding a bag of pasta and a jar of tomato sauce.

Other graphic spinoffs of the film scene on campus were a handful of magazines begun with hopes for quarterly or even biweekly distribution, though most quickly faded away. Probably the first of these was envisioned by Cinema Guild chair Rick Ayers, who in late 1967 circulated a prospectus soliciting writing from film society members and contributors to the *Daily*, which he also wrote for. He hoped that the *Ann Arbor Film Review* would cover everything from film theory to history but, "It came to naught when I ended up leaving Ann Arbor in spring of 1968 ahead of the draft man." Exactly one year later a film magazine with a similar mandate did make it to print. *Cinema Scope*, jointly published by Cinema Guild and Cinema II, was released to coincide with that year's Ann Arbor Film Festival and featured contributions by society members, including Ellen Frank, Elliot Barden, Jay Cassidy, and Bruce Henstell. Only one issue appears to have been completed, however.

In 1972, a similar publication called *Ann Arbor Eye* was published by a Michigan Union–based media production and distribution collective of the same name. Pieces by various film society members and even projectionist Peter Wilde were featured, though the first issue of the *Eye* was the only one

Cover of 1969 magazine published by Cinema Guild and Cinema II

Cinema II T-shirt design for a summer film series

OPPOSITE: Cover of the only issue of *Ann Arbor Eye*, 1972

to reach print. The next attempt took place about a year later when a colorful interview-, review-, and grievance-filled biweekly called *Take Five* was launched by the New World Film Cooperative, which soon was replaced by the equally strident bimonthly *Movie News*. The Ann Arbor Film Cooperative also gave it a shot in 1976 with the 25-cent, ad-supported *Cinegram*. Several issues followed over the next two years and included an appreciation of Robert Altman by Neal Gabler and a two-part interview of early film animator Frank Goldman by Diane Kirkpatrick, but when the magazine attempted to go bimonthly it vanished as well.

A unique promotional effort of the early '80s was a weekly cable access program called *Ann Arbor Screen Scene*. Primarily hosted by Cinema II's Michael Kaplan, it was a joint venture of the Big Three. "We were either guests on the show, or we were the camera people or the floor manager or shooting the graphics," Philip Hallman recalled. "Who knows if it actually helped or not, but it was just kind of one of the fun parts of it." Occasionally featuring special guests like *Atomic Café* co-director Kevin Rafferty, the show's old tapes were used to fill the local cable outlet's programming gaps for years afterward, causing *Screen Scene* to effectively outlive some of the film groups it promoted.

262 CINEMA ANN ARBOR

ann arbor eye

special
festival issue

vol. 1, no. 1

50¢

TAKE FIVE

The Ann Arbor Cinema Bi-weekly 25¢ August 1

University Moves To Stop Film Showings

For the first time in Ann Arbor history the University of Michigan has moved to halt all further film showings on campus. Without prior warning, and for no apparent reason, Vice President Kennedy, at the orders of the Executive Officers, (cont. on p. 4)

GILLO'S PONTECORVO'S *BURN!* (re-evaluated)

BRANDO'S OSCAR SPEECH

FEMALE IMPERSONATORS

007 LIVE AND LET DIE

STATE OF SIEGE

INTERVIEW WITH HASKELL WEXLER

CINEGRAM
"The Magazine of Film and Video"

The Eyes of Irvin Kershner

Women In Hollywood

Video Bootlegging The New Underground

Summer, 1978 $1.50

OPPOSITE: New World Film Coop's *Take Five* magazine from 1974. **ABOVE:** The last known issue of *Cinegram*, 1978
FOLLOWING SPREAD: Waiting for a Cinema II screening in Angell Hall, October 1971. © Rolfe Tessem

CHAPTER 14
BENDING TO THREATS

AS FILM SOCIETY programming was reaching its peak, the commercial theaters within walking distance of campus continued to decline. In 1979 the Fifth Forum was sold to the Goodrich Theater Co. of Grand Rapids, which split it into two screening rooms and began to program more mainstream fare, while Butterfield's State was converted into four sometimes-uncomfortable theaters which still utilized the original 1942 seats. At the same time Ann Arbor's most lavish showplace, the Michigan, was facing either repurposing into retail shops and a food court or outright demolition. But after a group of devoted fans of its still-playable 1928 Barton organ stepped up to create the nonprofit Michigan Community Theater Corporation (later known as the Michigan Theater Foundation) to operate the facility, they convinced the city to buy the building from its owners. Because the transfer agreement with Butterfield did not allow the screening of films which might compete with the State and Campus, programming would be limited to older movies (some booked by the film societies), the Ann Arbor Film Festival, Ann Arbor Symphony concerts, and one-off rentals like an onstage boxing match. Keeping things going was a constant challenge. "We couldn't turn the lights on because we couldn't afford to pay the electric bill till right before the doors opened," projectionist/technical director J. Scott Clarke remembered. "I learned every stairwell by heart."

Sensing an opportunity in Ann Arbor's seemingly limitless appetite for movies, in 1980 several core members of the Ann Arbor Film Cooperative created a for-profit company called Classic Film Theatre (CFT) to take over the Michigan's movie programming. CFT soon began to provide much-needed rental income nearly every night of the week with double features drawn from the film societies' repertoire, some shown on a worn-down Hortsen 16 mm projector acquired from a pornographic theater. Michigan Community Theater Corporation vice president Henry Aldridge was grateful for their efforts. "As far as I'm concerned, CFT saved us," he recalled. "Because for that first year, the theater was operated by volunteers. We didn't know how to do any programming, we just opened the doors and hoped that somebody would show up. CFT did all the films for us, and then the stagehands' union took care of all the live shows."

Though CFT name-checked the Ann Arbor Film Cooperative in its first *Daily* ads, this association was soon dropped, and after relatively recent titles like *Johnny Got His Gun*, *Mean Streets*, and *Performance* were pulled at Butterfield's insistence, the organization settled in with proven older hits like *Psycho*, *Casablanca*, and

OPPOSITE: The State Theatre being "quadded." © 1979 MLive Media Group. All rights reserved. Used with permission

BELOW: Butterfield insisted the evening screenings of this September 1980 booking be canceled

classic film theatre
TONIGHT TONIGHT
Now More Than Ever It Is Important To See
JOHNNY GOT HIS GUN
Directed by Dalton Trumbo from his highly acclaimed 1938 anti-war novel. Starring JASON ROBARDS, TIMOTHY BOTTOMS, DONALD SUTHERLAND, DIANE VARSI.

"My favorite recent American film is Johnny Got His Gun. It took my breath away."—Francois Truffaut

Michigan Theatre
4, 7 & 9 35mm Admissions: $2
 603 E. LIBERTY
the ann arbor film cooperative

BENDING TO THREATS 269

Classic Film Theatre calendar, 1982

AAFC evergreen *The King of Hearts*. But with CFT now programming many of its standard profit-makers, the Coop began to fracture. "There was all this tension between two halves of the group," Philip Hallman recalled. "They knew what the big sellers were, so they started taking this stuff and programming it over at the Michigan, stealing from the bank basically. So we were competing with ourselves, in a sense." Within a few months, CFT's founders quit the Coop to focus on their new business, which also began showing films at the similarly distressed Punch and Judy Theater in Grosse Pointe Farms.

Along with this daunting new competitor, another unexpected challenge appeared in the form of a free, ad-supported publication called the *Michigan CinemaGuide*. Listing all of the films scheduled for a given semester and including an alphabetical index at the back, it was founded by Alternative Action's Dave DeVarti and Tim Kunin, whose company Sport Guides Inc. had been publishing coupon books and programs for U-M football games. "There were at least five film group schedules a semester that you had to paste up on your wall, and a lot of them were two-sided," DeVarti recalled. "So you either had to turn it around when the semester was half over or put two copies up." At a Sport Guides meeting to brainstorm new products, "I said, 'Well, there's all these movie things on campus, we should do a cinema guide to make it easier for people to find their movies.'"

Launched in January 1981, 35,000 copies of the new publication were distributed on campus and to surrounding areas. Filmgoers quickly took to the ease of checking a single source to learn what art and repertory films were showing on a given night.

"WE BOYCOTTED THEM."

Philip Hallman

"The *CinemaGuide* achieved immediate cachet here," DeVarti remembered. "People from all around campus were coming up to me. 'Oh, that's an idea I had!'" At first glance it seemed win-win. "We saw it as a positive, a way to promote films," he remembered. "We were creating an equal playing field. Basically, any film group, including groups that weren't the Big Three, would have an equal opportunity to be publicized in this convenient way."

But the older film societies quickly grew concerned about the publication editing their member-written descriptions to less than 50 words, and spotlighting a few select titles. "We might have a brand-new premiere or something, and they wouldn't even focus on it," remembered the AAFC's Philip Hallman. "They'd pick *Casablanca* and that'd be their little highlight box of the month. And you could see whatever they highlighted would actually draw better. It was so frustrating."

In April 1982 the Big Three decided to withhold release of their printed calendars until the last possible moment, forcing the *CinemaGuide* to wait until upcoming titles appeared at the start of the month in the *Ann Arbor Observer*. "We boycotted them," Hallman recalled. "We didn't provide them with blurbs, and we wouldn't put their guides out. So it got kind of tense there for a while." At first, DeVarti, his staff, and a few freelance writers frantically churned out film descriptions to get the magazine to press in a timely manner, but these dashed-off efforts were sometimes less pleasing to the societies than the edited ones. An uneasy détente was ultimately reached whereby the *CinemaGuide* agreed to give the groups some degree of editorial input.

With many patrons now using the

ABOVE: *CinemaGuide* cover, September-October 1985

RIGHT: Dave DeVarti in the *Ann Arbor News* with various issues of *CinemaGuide*

"THE UNIVERSITY WAS, IN MY OPINION, EFFECTIVELY PUSHING THE FILM GROUPS OUT."

Dave DeVarti

the ann arbor film cooperative
The University of Michigan
1055 Haven Hall
Ann Arbor, MI 48109 • 313/769-7787

INFLATION DOES NOT EXCLUDE FILM!
Why we had to raise our prices...

Due to increases in all of our expenses (auditorium rentals, union projectionist fees, janitorial services, film rentals, security and advertising costs, among others), it would be impossible for us to continue operating at last year's prices. Therefore, we regret that we have to raise our admission for the first time in over four years. If you consider, for example, that our auditorium rates have gone up 50% since last semester then it becomes apparent that our new prices will simply cover our increased expenses. We appreciate your continued support.

AAFC handout about pricing increases, ca. 1982

CinemaGuide as their primary information source, the film societies gradually began to reduce the effort they put into designing and distributing their semester-long calendars. Though this ultimately saved time and money, it came at the cost of diminishing their distinctive curatorial identities, as well as the loss of the critical "share of mind"

visibility that dorm and kitchen wall schedule-posting fostered.

Another headache of the early 1980s was a sizable increase in expenses on several fronts. In 1981, the university raised auditorium rents to more than $120 per night for all the rooms but Lorch, where Cinema Guild had long enjoyed a grandfathered-in lower rate of about half that amount. Ostensibly spurred by drastic funding cuts imposed by the State of Michigan, the new rates appeared to be significantly more than the actual costs of room cleaning and a lobby supervisor. "There are two auditoriums in MLB: 3 and 4," remembered Dave DeVarti. "And they would charge both groups the cost of the one security person that they put on site." While the film societies publicly protested the increase, the university refused to back down. Projection costs were also going up, with FPS boosting its hourly rate to $10, meaning that, with shift minimums of at least six hours for a typical double feature, labor would take another $60 per night.

On top of all this, film rental rates were increasing. A major recent release, which would have been counted on to turn a decent profit, might now have to sell out two shows in a large auditorium just to break even. "One night we showed *Fitzcarraldo* and

Burden of Dreams, the documentary about the making of *Fitzcarraldo*, and the rentals on those movies were $1,000," DeVarti recalled of Werner Herzog's 1982 film. "And then you start adding on all those extra charges that the university was putting on, and I think it just became economically not viable for the film groups to carry on." He added, "The university was, in my opinion, effectively pushing the film groups out. Or making their requirements for operation so expensive and onerous that they were ceasing to operate."

Even CFT began to have financial difficulties, and in the fall of 1984 the Michigan Theatre's 28-year-old manager, Russell Collins, took over booking its films. "I had to kick them out because they weren't paying their bills," Collins recalled. "One day it was CFT's program, the next day we talked to all the film companies and said, 'From this day on we will pay for all of the film programs, and we will continue.' And that's where I started film programming. I had never done any before that." While Collins agreed to meet with the leaders of the U-M film societies, they were disappointed to learn that he had no plans to alter the CFT template of showing their proven money-makers. Philip Hallman remembered having the sinking feeling that, "He was the new sheriff in town, and he was going to run us out."

Soon after Collins took over the film booking, Butterfield sold the State and closed the Campus, freeing him from its restrictions against recent releases. The Michigan's programming gradually evolved into a mix of current arthouse titles and familiar classics, while occasionally reaching back to

The Ann Arbor Film Coop's premiere of *Atomic Café* in MLB. Left to right: lobby supervisor Frank Kelly, Philip Hallman, Merrill Wilk, Geoff Baker, director Kevin Rafferty, Judy Perry of Cinema II, and Deborah Kanter

BENDING TO THREATS

Flyer for 1984 Cinema II Ondine visit

the venue's roots to show silent films with live musical accompaniment. After five decades as an unthreatening presenter of standard Hollywood fare, the Michigan Theatre had become a permanent, and powerful, competitor to the film societies.

The Societies Carry On

Facing a steadily tightening financial squeeze, as the 1980s wore on the U-M film groups began to reduce programming and shift further toward "big grosser" titles. Despite the challenges, members remained committed to the mission of showing worthy imports, neglected Hollywood releases, themed series, and local premieres. One bright spot was new recruits, who could provide both a boost of energy and a fresh perspective. John Cantu, who joined Cinema Guild in 1986, had managed a commercial theater as a teen and been a member of Cinema Texas in Austin before getting his master's degree in philosophy at the University of Illinois, Urbana-Champaign. Though he had already experienced campus cinema at two of the more active college towns in the country, he was immediately impressed with Ann Arbor's offerings, reduced though they might be. "There was so much richness there. I don't see how anybody could have picked up that *CinemaGuide*, looked at the weekend, seen six to seven, maybe even a dozen

"I GOT TO ASK HIM EVERY QUESTION I COULD POSSIBLY ASK ABOUT THE WARHOL ERA…I GOT A LOT OF INSIDE INFORMATION."

Musician Matthew Smith

films, and said, 'I don't like any of these movies.' I mean, the first thing I would do is just take their arm and see if they had a pulse. There had to be something there for everyone."

The number of VIP visits had now fallen from their late-'70s peak, but the societies still brought interesting guests to campus, often in conjunction with screenings of documentaries. In November 1982, Alternative Action presented anti-war protest film *In the King of Prussia* with director Emile de Antonio and subject Molly Rush; and in January 1983, the AAFC hosted one of the three co-directors of the satirical anti-nuke feature *Atomic Café* for its Michigan premiere. Former Cinema Guild member Jayne Loader had originally been scheduled but had to cancel, so the invitation was extended to co-director Pierce Rafferty, who also couldn't make it, before his brother Kevin agreed to come. "Somebody made this cake, and it said, 'Welcome Jayne Loader,'" Philip Hallman recalled. "Crossed out. 'Welcome Pierce.' Then, crossed out. Finally, it was, 'Welcome Kevin.' He got a kick out of it."

Frequent U-M film society patron Michael Moore drove down from Flint to see the movie, and he and the substitute guest hit it off. Rafferty invited Moore to work on a feature he was making about white supremacists, and the filmmaking basics Moore learned on that shoot were put to use in his own documentary about Flint's abandonment by General Motors, which Rafferty helped out on as well. In September 1987, two years before its Telluride premiere, Moore brought a working version of *Roger & Me* to screen at an Ann Arbor Film Festival–sponsored Michigan filmmakers showcase, and he would continue to use Ann Arbor audiences as a sounding board for most of his subsequent films.

Cinema II also brought in special guests. In April 1984, the group hosted both the Ann Arbor premiere of gospel music documentary *Say Amen, Somebody* with a live performance by the local Voices of Bethel choir, and a return engagement by Ondine and *Chelsea Girls*. The Warhol superstar slept over at Mark Schreier's house, where he cooked puttanesca sauce for his housemates. "He kept saying, 'It's the sauce of the whore and the sauce of the whore loves to drink her vodka.' And he just kept pouring vodka in," Schreier remembered, noting that Ondine also took a swig each time. "He was just a gem." Rebuffing several anti-Warhol hecklers at the sold-out screening, Ondine joined the group for dinner afterward at the

BENDING TO THREATS

tony Earle restaurant, where Matthew Smith sat next to him. "I got to ask him every question I could possibly ask about the Warhol era, about Nico, about Lou Reed and John Cale. I got a lot of inside information." A musician himself, Smith went on to front Velvet Underground–influenced bands like Outrageous Cherry, and his alt-country group the Volebeats would later appear in the Steve Martin film *Shopgirl*.

In January 1985, the Art Cinema League's five-decade-earlier local premiere of Joris Ivens's *Spanish Earth* was brought full circle with the Ann Arbor debut of Spanish Civil War documentary *The Good Fight*, jointly presented by Cinema II and the AAFC. A panel of Abraham Lincoln Brigade veterans had been assembled to speak afterward. "That was really special," Marlene Reiss remembered. "The last surviving members of the pro-rebel, fascist-fighting force. A lot of them were leftist and got blackballed. I remember being in awe of those men." With frequent film society co-sponsor the Goethe Institute, in 1986 the AAFC also brought director Margarethe von Trotta to town for the Midwest premiere of her film *Rosa Luxembourg*.

While these events still drew decent crowds, overall campus film attendance was continuing to slip. Seeking a way to turn things around while carrying on the Ann Arbor Film Cooperative's reputation for edgy programming, in early 1986 future spouses Glenn Mensching and Teresa Bungard curated a series of films that had been censored or banned. "Being involved in library school and libraries, we were really into anti-censorship stuff," remembered Mensching. "We came up with the whole concept of the festival to promote the heck out of it." The eleven Banned Film Festival titles ranged from *The Birth of a Nation* to Pier Paolo Pasolini's X-rated *Salò, or the 120 Days of Sodom*, and featured a two-night run of Jean-Luc Godard's controversial new release *Hail Mary* on January 24 and 25, 1986. "Phil Hallman and I pretty much jumped on that one, because we knew it would generate a lot of news," Mensching recalled.

Co-presented with Cinema II, the film was making its Michigan premiere, having then only screened a handful of other places in the US. Godard's modern-day depiction of the Virgin Mary, sometimes nude, had been condemned unseen by Pope John Paul II, and as society members began to sell tickets in Angell Hall, a large group of protesters appeared. "They were marching around outside the building carrying crosses and all sorts of stuff," Mensching recalled. One was a nun, who collapsed from an apparent heart attack. "She was rushed to the hospital," Jay Weissberg remembered. "I

Coverage of the Banned Film Festival in the *Detroit Free Press*

Glenn Mensching, left, and Teresa Bungard, librarians at Eastern Michigan University, find films for the Ann Arbor Film Cooperative's Banned Film Festivals. "I think that people need to be constantly reminded that there needs to be freedom of speech," said Bungard.

276 CINEMA ANN ARBOR

> **Film**
>
> **'Hail Mary' draws protests in Ann Arbor**
>
> *Sunday, Jan. 26, 1986/THE DETROIT NEWS/7A*
>
> **From page 3A**
>
> "WE HAVE received bomb threats before, but this is the first one I can remember that dealt with a movie," said campus security officer Robert L. Davenport.
>
> The 107-minute film retells the story of Mary and the birth of Jesus Christ in modern-day France and contains some nudity and coarse language.
>
> The film is set in a provincial French city where Mary, a high school student, plays basketball and pumps gasoline at her father's gas station. Joseph, her fiance, drives a taxi.
>
> The demonstrators said they were protesting the film based on what they had heard about it in various religious and secular publications.
>
> THEY RECITED the Lord's Prayer and other prayers during the candle light vigil outside the theater. Some carried a statue of the Virgin Mary, while others carried signs denouncing the film as "An Insult to God."
>
> Protest leader Jerry Wuestenburg, a member of St. Alexis parish in Ypsilanti, said the film "has been condemned by the holy father in Rome and is degrading to the Blessed Mother."
>
> The audience was not nearly as moved by the show as the protesters were.
>
> Contributing to this story was News Staff Writer Robert E. Rosch.
>
> NEWS PHOTO/JIM VARON
>
> Protest leader Jerry Westonburg and his sister, Dolores Brzustewicz, both of Belleville, march last night outside the University of Michigan's Angell Hall where the film *Hail Mary* played to sellout crowds.

don't know whether she died or not."

The tension increased further when the film society members were informed that an anonymous caller had reported a bomb was hidden in the theater. Cinema II president Marlene Reiss was the house manager. "The police came out and did a sweep of the auditorium," she remembered. "They recommended that we actually do go ahead with the show. Because if we didn't, this was homegrown terrorism and anti-free speech. They didn't want it to look like we were bending to any kind of threat." She decided to let the screening proceed, and it took place without incident. The protests and bomb threat generated sizable media coverage from area newspapers, Detroit television, and even the recently launched CNN, and the second night's screenings were packed. Most of the other Banned Film Festival screenings also did well, and the AAFC followed it up with a sequel and other themed series designed to draw audiences.

Inspired by the successful monetization of controversy, in July 1987 the oldest campus film group reluctantly dusted off its 16 mm copy of *The Birth of a Nation*, which it had not shown for several years. "Cinema Guild had a very long, heated discussion about whether to show this thing," John Cantu

The AAFC passed out copies of a *Detroit News* story about the 1986 *Hail Mary* protests

BENDING TO THREATS

277

EYEMEDIAE

214 N. FOURTH AVE., ANN ARBOR, MI. 8 pm, $3 (unless otherwise noted) CALL 662 2470

Monday March 23
'The Invisible Cinema': Super Eight from New Zealand and Elsewhere
Martin Rumsby Presents

New Zealand filmmaker Martin Rumsby has been travelling around North America for the past 7 months, showcasing film while at the same time picking up new films for his programs. Tonight he presents a collection of Super 8 works from New Zealand including his own VISTAS, as well as works by John Porter (Toronto), Albert Kitchesty (California), Willie Varela (Texas) and others. Following the screening Mr Rumsby will be present to answer questions.

Tuesday March 24
Three Films By Sidney Peterson

In 1946 Peterson was hired to teach an avant garde filmmaking class at the California School of Fine Arts. From these classes came a number of films in the Dada tradition including THE CAGE (1947), MR. FRENHOFER AND THE MINOTAUR (1948) and THE PETRIFIED DOG (1948). THE CAGE follows the adventures of a deranged artist who, in an act of self-mutilation, removes his eye. The eye then escapes his studio and roams the streets of San Francisco. MR FRENHOFER is based on Balzac's story "Le Chef-d'oeuvre inconnu" while THE PETRIFIED DOG has been compared to Lewis Carroll's "Alice in Wonderland." (total time=69 min)

Monday March 30
A City At Chandigarh (Alain Tanner, 1966)

Tanner's film captures one of the most spectacular feats of modern architecture, Le Corbusier's construction of a city from scratch in the Punjab desert. This imaginative documentary breaks down the barriers between poetry and technology. (54 min) Additional program details to be announced.

Tuesday March 31
Dadascope (Hans Richter, 1961)

Richter collaborated with Jean Arp, Marcel Duchamp, Kurt Schwitters, Tristan Tzara and others in this delightful portrait of the Dada movement with its specific techniques of sound and visual clash, word puns, chess, dice and other games of chance. DADASCOPE is the third of Richter's collaborations with other artists following DREAMS THAT MONEY CAN BUY and 8 X 8. (41 min). Also, video of Eberhard Blum performing Kurt Schwitters' "Die Ursonate." Additional Dadaesque program details to be announced.

April 5 - May 2
Gallery exhibit by Elaine Noyes

(mixed media installations) and Mark Blottner (moveable animation). Reception for the artists April 6th, 6-8 PM.

Monday April 6
Virtual Play: the double direct monkey wrench in Black's machinery (Steve Fagin, 1984)

Fagin's work traces its way around the figure of Lou Andreas-Salome. "Fagin's views range far and wide and join the eloquences of the tableau with the elementary clarity of the comic strip. Two hats bob atop some chair backs and we realize that we are watching and hearing Lou (Andreas-Salome) and Anna Freud recount stories about Freud's pet dogs and a narcissistic cat. We see Lou...engage in an astutely zany bilingual conversational duet with Elizabeth Nietzche...Fagin has concocted a `creative' con-glamourture of psychoanalytic theories, biographical snippets, Syberbergian expositions, and calculated child's play." (80 min)

Tuesday April 7
Oedipus, Mom and Freud Movies

Featuring THE LEAD SHOES (Sidney Peterson, 1949), MOTHER'S DAY (James Broughton, 1948) and ON THE MARRIAGE BROKER JOKE AS CITED BY SIGMUND FREUD IN WIT AND ITS RELATION TO THE UNCONSCIOUS OR CAN THE AVANT-GARDE ARTIST BE WHOLED? (Owen Land, 1978).

Monday April 13
The Prints and the Paper: Our Airlines

Filmmakers Jeff Plansker (Detroit), Tom Ludwig (Detroit) and Owen O' Toole (Boston) will be present to screen a number of their 8mm films, involving one and two projectors. Among the films featured will be Plansker and Ludwig's "Appastapas" which has won awards at various festivals across the country.

Tuesday April 14
Rome 78 (James Nares, 1978)

Lydia Lunch and Eric Mitchell don the togas for this burlesque of "I, Claudius" complete with Roman costumes and New York locations. A must see.

Monday April 20
Music Videos

Recent works by Cabaret Voltaire, The The and Robyn Hitchcock and the Egyptians. Additional details to be announced.

Tuesday April 21
Michigan Film/Video

A tradition of the best and the brightest. And so close to home. Submissions in all formats are welcome. (662-2470)

March 9 - April 4
On Our Own: Five Young Architects

The work of Catherine Wetzel, Eduardo Gascon, Bob Henry, Robert Cole and Ian Taberner. Reception for the artists Monday, March 9th, 6-8 PM.

Monday March 9
The Films of Charles & Ray Eames

Between them, Charles & Ray Eames were architects, furniture designers, filmmakers, graphic artists, urban planners and toy makers. Many consider Charles the creative genius of modern furniture design, while Ray originally was a painter (she studied with Hans Hofmann), who collaborated with Charles for 40 years until his death in 1978. The films tonight provide examples of the Eameses' talents for toy-making (PARADE, 1952), communications technology (A COMMUNICATIONS PRIMER, 1953) and architecture (HOUSE, 1955). Also featuring BLACKTOP (1952) & POWERS OF TEN (second version, 1978). (total program time = 70 min).

Tuesday March 10
Crime Without Passion (Ben Hecht, Charles MacArthur, 1934)

Claude Rains gives a brilliant performance as a lawyer whose entanglement in a web of crime leads him to murder. Or does it? This film features a chilling montage sequence by Slavko Vorkapich, who was a master of special montage effects and a leading theorist on the visual structure of the filmed image. (80 min). Also two short films LIFE AND DEATH OF 9413--A HOLLYWOOD EXTRA (Robert Florey, 1928) with camera work by Gregg Toland (of CITIZEN KANE fame) and art direction by Vorkapich, and MOODS OF THE SEA (FINGAL'S CAVE) (Vorkapich and John Hoffman, 1942) an interpretation of Mendelssohn's work that is a stunning montage of music and imagery.

Monday March 16
3 Films on New York and Its Architecture

SKYSCRAPER (Shirley Clarke, 1959) is an enthusiastic, sometimes comic musical salute to the collaborative effort of the building of a skyscraper. THE CITY (Willard Van Dyke & Ralph Steiner, 1939) explores in a personal style the glory and the squalor of Manhattan. THE WONDER RING (Stan Brakhage, 1955) was financed by artist Joseph Cornell, who wanted a film made about the El before it was torn down. (total program time=67 min)

Tuesday March 17
Riddles of the Sphinx (Laura Mulvey & Peter Wollen, 1977)

Mulvey and Wollen are two British critics and theorists whose films explore new approaches to narrative in cinema. This story centers on Louise, a middle-class mother obsessively involved with her four-year-old daughter to the exclusion of the outside world. Once her husband announces he's leaving her, Louise's oblique and maternalistic stream of consciousness slowly revolves into a twisted delirium. (92 min).

Monday April 27
Video Noir I

The next two Mondays will look at the "noir" genre as it applies to video, investigating the "darker side of life and articulating the primary question What do we fear?" LINES OF FORCE (Bob Snyder, 1979) depicts a modern claustrophobia created by computer technology. In BENEATH THE SKIN (Cecelia Condit, 1981), a "true" murder story is retold numerous times with complications, contradictions and embellishments, revealing the narrator's frightening fascination with the incident. In DOUBLE LUNAR DOGS (Joan Jonas, 1984), Jonas and Spalding Gray play two timeless travellers journeying aimlessly across the universe, having forgotten the purpose of their mission. Influenced by Bunuel, Deren and Cocteau, Wayne Fielding's HUMAN SKELETON (1983) explores the relationship that develops around a woman's delusion of her friend's apparent suicide. (total program time=70 min)

Tuesday April 28
The Asphalt Jungle (John Houston, 1950)

Huston's themes of collective effort and nihilist failure are brilliantly dramatized in this genre-creating caper film. This seldom seen masterpiece depicts a gang of small-time losers who plan the perfect heist only to be done in by human foibles. Featuring an outstanding cast of mostly B-part players including Sterling Hayden, Sam Jaffe, Marc Lawrence, Jean Hagen, Louis Calhern & Marilyn Monroe. Screenplay by Huston and Ben Maddow (112 min).

May Gallery Exhibit
Kathy Kowalski: Photographs with text

Monday May 4
Video Noir II

Tonight's program features two works, NAKED DOOM (Edward Rankus, 1983) and THE COMMISSION (Woody Vasulka, 1983). "Naked Doom" takes us into an intensely dark inner world, populated by the visuals common to both "noir" and science fiction stories. "The Commission" tells the story of a 19th century commission offered to the violinist Niccolo Paganini from wealthy music publisher Hector Berlioz. Vasulka leaves the familiarity of his well-traveled electronic terrain and takes to the high ground of narrative and theatricality." Starring Robert Ashley and Ernest Gusella. (total program time=65 min)

Tuesday May 5
The Suspect (Robert Siodmak, 1944)

From the director of THE KILLERS comes this velvety thriller based on the famous Dr Crippen murder. Charles Laughton stars as a weak man who finds the strength to fulfill his lustful yearnings...at any cost. With Henry Daniell and the mysterious Ella Raines. (85 min)

recalled. "We didn't know if we were going to have protests. We didn't know what was going to happen. But this is one of those cases where, with all honesty, we were in a situation where it was like, 'Look, we need to have a winner here.'" They decided to go ahead. "On one proviso: we asked a professor from the Afroamerican Studies department, who was a film professor, and Ed Weber, to serve as a panel after the screening, and I served as the moderator." The group persuaded *Ann Arbor News* film critic Christopher Potter to give it a front-page writeup, which quoted guest panelist Dr. Ralph Story. "I would recommend it to anyone. I'm very anti-censorship, and I think racism, even in its most virulent forms, at least should be witnessed. It's rooted in American history." A full house Cantu described as "almost 100 percent majority culture" watched the 1915 release in dead silence, a pianist having been dismissed as "corny."

After this coda to the film's campus history that began with the canceled 1950 speech department screening, *The Birth of a Nation* was rarely shown in Ann Arbor again. Though censorship-averse Hugh Cohen recalled that the film program had "no discussion, none at all" about halting its use, its screen time was reduced to a handful of clips shown in class to illustrate key technical advancements. One notable revival came in 2005 when the University Musical Society hosted DJ Spooky, a.k.a. Paul D. Miller, to present his digitally manipulated *Rebirth of a Nation* edit. "It's pretty much a straight-up Ku Klux Klan propaganda film," Miller commented to the *University Record*. "What I'm doing is thinking about terrorism and thinking about multiple interpretations of history."

New Exhibitors Add Variety

Despite the difficult environment of the 1980s, several new off-campus presenters appeared that added excitement to the Ann Arbor film scene. One was Eyemediae, which began showing experimental films and videos in late 1982 at the Performance Network on West Washington Street, while sometimes sponsoring or co-sponsoring events on campus. Started

OPPOSITE AND BELOW: Eyemediae flyers. Courtesy Mark Schreier

BENDING TO THREATS 279

by a group that included Michael Clarren and Bob Hercules, in 1984 it opened the Eyemediae Gallery on Fourth Avenue, which was subsidized by proceeds from for profit video affiliate Access Productions.

"We had visual art, we had film, we had performance, we did poetry," remembered program director Mark Schreier, who took the post after serving as president of Cinema II. "We were doing so many different things. There was a big garage in the back, and we turned the garage into a theater. Put up a big screen and we set up a projection booth. We'd show videos, we'd show 16 mm films." Eyemediae held screenings on Monday and Tuesday nights, and for a time repeated them at Detroit's Trumbull Street Playhouse. The organization's eclectic, sometimes challenging screenings ranged from documentaries and student-made videos to *Film Threat* co-founder Chris Gore's *Cool Teenager from the Planet X* and Nam June Paik's live-via-satellite *Good Morning, Mr. Orwell*. In 1986 Eyemediae also stepped in to co-sponsor the AAFC's struggling 8 mm Film Festival, and in 1987 took it over completely. After an impressive run bringing a wide variety of cutting-edge programming to town, Eyemediae ceased operations in 1990.

Another new organization with a special mission was the Ann Arbor Silent Film Society (AASFS), founded in 1981 by conductor/composer/pianist/filmmaker Arthur Stephan. A veteran of George Patton's Third Army in World War II, Stephan had studied at Columbia, Wayne State, and the State Academy of Music in Vienna. Playing cocktail piano at local hotels like Weber's Inn, he put much of his limited income into collecting 8 and 16 mm film prints of silent movies and held AASFS screenings once or twice a month in hotel conference rooms, which he could get at a discount.

"Two things inspired me to organize my society," Stephan wrote in a 1983 letter to Cinema Guild. "First, out of 100 films per month listed in the *Michigan CinemaGuide*, usually two or three silent films are shown. I thought I should do something about this neglect. In the last 18 months, I have shown 30 features and 82 short subjects to my group. The second reason I felt I

A page from one of Art Stephan's scores, and an AASFS membership card

must show these films is that they are usually shown at the wrong speed and do not have accompanying music." A standard speed for early films had never been mandated, and modern machines typically offered only the 24 frames per second sound-film standard and an arbitrary "silent speed" of 18 FPS. Stephan carefully previewed his films to select the best of these options, and did his utmost to get the music right. Initially using soundtracks that had been added to his film prints or purchased reel-to-reel tapes, he became frustrated when two different recorded scores for *Orchids and Ermine* were pegged to a too-fast 24 FPS. "So I sat down at my little piano and composed a score for the film at 18 FPS," he wrote. "As a teenager in the '30s, I went to the movies three times a week, seeing six features, of course. I was completely fascinated by the movie music of that era, namely Korngold, Steiner, Tiomkin, etc. That was my ambition—to write movie music. Now, many years later, my ambition is coming true!"

The Silent Film Society attracted a loyal following that was a mix of Stephan's friends and curious filmgoers who saw its listings in the *CinemaGuide*. Attendees ranged from Dr. Jack Kevorkian, later famous for his participation in assisted suicides, to a young member of the Ann Arbor Film Cooperative, New York native Jay Weissberg. "There weren't many of us who went from the university," he recalled. "I remember when I discovered that. Just so excited that that existed. And that I was going to have that opportunity to see these films. Because even in New York you didn't see all that much." Weissberg's love for silent film led him to program an ambitious but poorly attended Ernst Lubitsch series for the AAFC, using his own home-taped soundtracks, with a screening of Stephan's rare 16 mm copy of the 1929 *Eternal Love* attracting not a single customer. His passion undiminished, after curating film series and serving as a reviewer for *Variety*, in 2015 Weissberg was named artistic director of Le Giornate del Cinema Muto in Pordenone, Italy, the world's premier

> " **THAT WAS MY AMBITION—TO WRITE MOVIE MUSIC. NOW, MANY YEARS LATER, MY AMBITION IS COMING TRUE!"**
>
> AASFS Founder Arthur Stephan

Art Stephan preparing to start an 8 mm silent film

silent film festival. "I think about that often, the Ann Arbor Silent Film Society," Weissberg remarked. "Because of just how great it was that it existed."

The AASFS persisted for more than 20 years, during which time Art Stephan would regularly correspond with silent star Lillian Gish, assist the Museum of Modern Art's efforts to restore early D. W. Griffith shorts, and compose and play original scores for all the major campus film societies as well as the Michigan Theatre. His collection also came to include the holdings of Connecticut-based distributor Milestone Films, whose owner Hartney Arthur wrote Stephan in the early '90s, "Since you are the only person I know who still shows silent films to an audience, I would like to make you a generous offer of my own complete private collection and whatever is left of Milestone." Stephan passed away from cancer in November 2003, having kept his society active almost until the end. A true lover of film, the late Arthur Stephan made an important and unique contribution to Ann Arbor's cinema offerings.

ABOVE LEFT: Flyer for an AASFS show

ABOVE RIGHT: Jay Weissberg-designed flyer for a 1985 AAFC screening with an Art Stephan score

OPPOSITE: Letter from Lillian Gish to Art Stephan. Courtesy Mars De Ritis

282

CINEMA ANN ARBOR

October 17th, 1981

Dear Arthur Stephan,

 Thank you for your kind birthday wishes and I certainly wish you all well with the Ann Arbor Silent Film Society.

 It has always been my belief, like Mr. Griffith's, that silent film should have married great music.

 The recent success of Abel Gance's "Napoleon" is a perfect example of that. It is an enormous hit all around the world and is playing a return engagement in the huge Radio City Music Hall.

 Am off myself this week to Kentucky as a guest of the Governor for the re-opening of a movie palace in Lexington to appear with "Broken Blossoms." Another good example.

 With every success to you.

 Most earnestly,

 Lillian Gish

Also — "The Wind" and "Scarlet Letter" have stood the test of time!

CHAPTER 15
A DESCENT INTO DISAPPOINTMENT

DESPITE OCCASIONAL successes like the Ann Arbor Film Cooperative's Banned Film Festival, in the latter half of the 1980s film society attendance continued its steady decline. Along with rising print rental costs, the groups were also affected by U-M construction projects that took both Auditorium A and Lorch out of service for extended periods of time, forcing them to scramble for rooms and lose access to their 35 mm equipment. By 1987 ticket prices had risen to $2.50, still about half the premium commercial theater rate, but not enough to keep them from losing money.

The biggest challenge of all had slowly been advancing on the horizon and was now becoming an existential threat. Inexpensive VCRs and video rental stores had begun to provide easy access to content that had once been available only on celluloid, making the film groups' mission suddenly seem less vital. "When the film societies were dying it seemed like the novelty of video stores was king," remembered the AAFC's Jim Pyke. "That was the time when Liberty Street Video was at their peak. They had this amazing collection that had all the crazy underground stuff. Amazing repertory selection. And we couldn't compete with that. Maybe we were going to show something, but they were probably going to get that same thing." Local film fans and even film society members began to frequent Liberty Street Video, laserdisc mecca Video Hut, and other new outlets that had taken note of Ann Arborites' love affair with cinema, some of which even offered home delivery in partnership with nearby restaurants.

Independent and foreign films, as well as deep Hollywood vault titles, were also being shown on cable television channels that had begun to spring up, like Bravo, American Movie Classics, and Turner Network Television. Hardcore film buffs could now stay home and watch an endless stream of obscure gems and tape others overnight on their VCRs. While seeing a film on television was less engaging than watching it in a darkened auditorium, it was much more convenient, and as dormitories and campus apartments added cable, the sudden proliferation of screen entertainment options began to keep many students from venturing out in the evening. As a result, the film groups' audiences dwindled further while skewing toward the older, but still-loyal community members who had always supported their offerings.

The University Belatedly Steps In

For the year ending June 30, 1987, a detailed report was produced on the

> "THAT WAS THE TIME WHEN LIBERTY STREET VIDEO WAS AT THEIR PEAK... AND WE COULDN'T COMPETE WITH THAT."
>
> Jim Pyke, AAFC

ABOVE: Video Hut ad from 1988

OPPOSITE RIGHT: Button worn by IATSE picketers, 1984

A DESCENT INTO DISAPPOINTMENT

finances of the five U-M film societies (excluding the Hillel-supported Hill St. Cinema), which showed they were hemorrhaging money. Total campus ticket sales for the period stood at $181,393, with the AAFC accounting for nearly a third—$58,434—while running $4,988 in the red. Cinema Guild was second in revenues with $48,363, but posted a larger loss of $8,118, while Cinema II sold $31,401 in tickets and lost $7,573, and Alternative Action took in $22,119 and lost $3,529. These groups were made up of a mix of students and more experienced older members, and it was the all-student Mediatrics that posted the worst results, a loss of $10,699 versus total revenues of just $21,076. With the film landscape rapidly changing, it appeared that things were only going to get worse.

The five societies' combined total auditorium rental cost of $51,918 was significantly larger than their aggregate loss of $34,907, and it seemed logical to assume that if auditorium fees were waived, as all the other Big Ten schools but Northwestern reportedly did, the University of Michigan film societies' financial woes would be over. In the fall of 1987, the groups approached the university to ask that it reduce or eliminate auditorium charges, holding meetings with administrators and issuing a jointly created report to make their case. LS&A associate dean Jack Meiland was impressed by their argument. On March 9, 1988, he wrote to associate vice president for academic affairs Mary Ann Swain, "I believe the film societies and their health are extremely important to the university in a number of different ways." Citing his experience interviewing prospective faculty members, he remarked, "Only a month ago a job candidate told me that, in her opinion, Ann Arbor had a much greater variety of films showing than did New York City at the present time, even with the societies' present difficulties! We in this university often have trouble competing against universities on the two coasts for faculty. I am convinced from my personal experience with job candidates that the availability of a wide variety of films here, due in part to the film societies' activities, gives us an important edge over other universities in a significant number of cases. Moreover, I am told that the admissions office mentions this aspect of the cultural opportunities here in recruiting undergraduates."

Meiland then revealed a long-suspected secret about the film societies' early '80s rent increase, which he had learned from the head

Advertisement in the *Michigan Daily*, 1987

> **Liberty St. VIDEO**
>
> ALL FILMS $2.87
> EVERY MON. & WED. 2 for 1 Films
>
> VCR Rental + 1 Free Film
> only $7.99
>
> Big Foreign Film Selection
>
> 663-3121
>
> 120 E. Liberty
> Downtown Ann Arbor
> (IN P-BELL BUILDING)

of U-M's scheduling office. "Al Stuart explained to us at one of our meetings that his office had to raise those fees in order to balance their budget after that budget was cut by the central administration. As I understand the matter, Al agrees that the fees now being charged exceed the cost to the university of operating the auditoriums." Academic affairs VP Mary Ann Swain added an even more damning detail in a September 14, 1988, memo to U-M Provost Robert B. Holbrook and his assistant Ruth G. Hastie. "I talked with RBH [Holbrook]. He confirms that we are 'making money' off the film societies. Al Storey [sic] uses this money to fund a part-time secretary and has done so since the budget reductions in the early '80s." Apparently chagrined by this discovery, Swain proposed that the university "reduce their fees to cost," and concluded: "Films at U-M have been part of our intellectual tradition and contribute to the cultural environment here. Besides, they are used for direct teaching and to supplement a degree sequence."

The administration moved slowly, however, and it was more than a year after the film societies approached the university that it agreed to subsidize up to 20 room rentals per term for Cinema Guild, the Ann Arbor Film Cooperative, Cinema II, and Alternative Action beginning in January 1989. Though it "helped a little bit," according to the AAFC's Philip Hallman, "it really came too late." Long the weakest member of the Big Three, Cinema II had already been forced to temporarily suspend operations in the fall of 1987. After contemplating leaving its unpaid bills to the university, the remaining members decided to abandon all pretense of creative programming and see how much they could recover. Focusing on inexpensive student-appeal titles like Budget Films's $40 program of public domain Warner Brothers cartoons, they managed to recoup roughly half their losses over the next couple of semesters. But attendance continued to decline, and in 1990 Cinema II decided to close up shop for good, with the rest of the former Big Three absorbing a handful of its refugees.

Alternative Action was also on its last legs. As recently as 1981 the organization had made enough in profits to give $1,500 each to PIRGIM, the Ann Arbor Tenant's Union, and Project Community, but those days were long gone, and even with free auditoriums its members could see no path forward.

Mary Ann Swain. Photo by Daniel Stiebel, *Michigan Daily*

A DESCENT INTO DISAPPOINTMENT

1989 Current *masthead*

At the same time that Cinema II was going under, Alternative Action, too, ceased operations. Debt-free in the recollection of Dave DeVarti, the group donated the 16 mm prints it owned of *The War at Home* and John Huston's World War II shellshock documentary *Let There Be Light* to the university.

The Film Coop Falters

As the 1990s began, the Ann Arbor Film Cooperative carried on with a tighter Friday/Saturday-only schedule that mixed proven money-makers with area premieres, like Guy Maddin's *Tales from the Gimli Hospital* and Nancy Savoca's Sundance Grand Jury Prize–winner *True Love*. The group continued to program themed series as well, like a gay/lesbian film festival that was perhaps the first in the state. But the reduced programming only served to further push the Coop, and the other remaining film societies, into the shadows, and articles about their impending demise began to regularly appear in local papers. In a 1991 *Daily* story, the AAFC's Matt Madden summarized the groups' dilemma. "Up until the last five years or so, it wasn't really an issue, since everyone knew who the film societies were. Now, all of a sudden, we find our audience totally gone, and we're unknowns." While the group still printed a full-semester schedule, the primary source for its listings remained a free, ad-supported magazine. But the *CinemaGuide* had also been affected by the societies' dwindling offerings, and in 1988 had changed its name to *Current*, broadening its scope to include live music and other arts events.

Keeping to its longtime mission of seeking out edgy content, the AAFC seized on new cinematic trends like Hong Kong action movies, bringing titles like the area premiere of John Woo's *The Killer* in October 1991. It also continued to court controversy, with its Ann Arbor premiere of Kevin Rafferty's white supremacist documentary *Blood in the Face* picketed by protesters who claimed it was not sufficiently critical of its subjects, and, in December 1992, showing a video which had been pulled from a student-curated Law School exhibit called "Porn'Im'Age'Ry: Picturing Prostitutes." Trying to find material that had not yet made it to home video, in early 1993 the group presented an evening of experimental 16 mm films called Ann Arbor Eye and Ear Control assembled by Greg Baise. "I basically went through the Filmmakers Cooperative catalog, and anything that had an interesting, avant-garde soundtrack was fair game," he remembered. But, "I also learned a lesson that night." He had forgotten to list the auditorium on the flyer, and the AAFC logo showed the office address. "So people were going to the Michigan League looking for it. There were a couple of angry messages. Because it was a rare opportunity, you couldn't see these films any other way."

To save costs, in the early 1980s the film societies had stopped their longtime practice of advertising in the *Daily*, which for many years had also published contributions from group

"NOW, ALL OF A SUDDEN, WE FIND OUR AUDIENCE TOTALLY GONE, AND WE'RE UNKNOWNS."

Matt Madden, AAFC

```
            PICKET BLOOD IN THE FACE!
               SATURDAY, NOV. 9
     7:00pm at the Modern Languages Bldg.

-- Smash the Nazis and KKK!  Smash the Duke campaign!
   No free speech for fascists.
-- Cops off campus!  Build worker/student/community
   defense guards to defend against racist, sexist and
   anti-lesbian/gay attacks.
-- Fight right-wing attacks on workers and the
   oppressed.  Fight the social service and education
   budget cuts.  Defend and expand abortion and
   reproductive rights.  Shut down Cracker Barrel.
-- Build a workers' party based on the unions and
   organizations of the oppressed.
```

[comic strip: "WE MUST GUARANTEE THE RIGHTS..." / "OF FREE SPEECH AND ASSEMBLY..." / "EVEN TO THE FASCISTS, IF WE ARE TO PRESERVE.." / "...DEMOCRACY."]

```
    Sponsored by RYSC (Radical Youth and Student Coalition)
           Meetings: Mondays, 7:30, Michigan Union
                 Check at 1st floor info desk.

     Demands and Demonstration (not text) endorsed by AACDARR
```

Picketers' handout, 1991

A DESCENT INTO DISAPPOINTMENT

AAFC Gay/Lesbian Film Festival flyer, 1989

members like Rick Ayers, Ellen Frank, Andrew Lugg, Neal Gabler, Mark Shaiman, and Mike Kuniavsky. As this practice ended, the campus paper seemed to abandon any semblance of support. First, its entertainment listings ceased mentioning the name of the organization sponsoring a film, and then the once relatively serious blurbs devolved into snarky, uninformed commentary. For Eye and Ear Control, the description had read: "Seven pretentious films by seven pretentious directors. Intended for pretentious people."

By now, when a film society flyer was occasionally spotted on a campus kiosk, it was almost a surprise to see the once-familiar logo of Cinema Guild or the Ann Arbor Film Cooperative. Jim Pyke joined the AAFC in 1992. "From the very beginning of the time when I was a part of it, 'Well, let's just try to do what we can' was the attitude. And then we went from that very low level to, 'How can we keep doing this?' in the space of just a couple years." The rise of the internet, available to college students earlier than in most other places, also had an impact as easy access to once-forbidden content took away yet another reason the film societies existed. "I think the primary actor was just a shift in students' views of what alternative media was," the Michigan Theatre's Russell Collins commented. Until the internet came along, "It was where you could see nudity, it was where you could see alternative political points of view."

With a core group of film fanatics still at the helm, the AAFC continued to plumb the extremes of cinema with 3D

pornographic movies, notorious German shocker *Nekromantik*, pedophile documentary *ChickenHawk*, and an immersive experimental video/live music event called Noise-A-Palooza. To celebrate the film society's 25th anniversary, in February 1995 it brought to campus onetime 8 mm Film Festival entrant Bruce Campbell, who spoke after a screening of Sam Raimi's *Army of Darkness*. That September the Coop also showed *Shakes the Clown* with director/star Bobcat Goldthwait in the recently upgraded Natural Science Auditorium, but there was little optimism remaining. "At the very end we did personal appearance events," Jim Pyke remembered, "and those definitely pulled in a lot of people. But then the print rental cost was so much that we could show only a few movies that had maybe ten people show up for them, and that was the reward." Glenn Mensching observed, "That was our final hope of things we could do. But there wasn't enough interest."

As with the film societies which had already folded, the AAFC's members grew weary of the struggle, unable to even turn a profit on a rogue print of *Debbie Does Dallas* that had fallen into their hands. "It was already well past the point of the rise of video porn," recounted Pyke. "So at a certain point nobody even wanted to come out of their house for that. It was just sort of this slow descent into disappointment."

One month after Bobcat Goldthwait's appearance, on October 12, 1995, the *Daily* highlighted the AAFC's plight by quoting a public plea that began, "MONEY: We have none and we need it. PEOPLE: We have few and need them. PURPOSE: We have one, but it's only leading us to our demise." After screening a handful of additional films, including documentary *Hooked on Comix*, Edmund Merhige's transgressive 1990 horror movie *Begotten*, Mormon Church satire *Plan 10 from Outer Space*, and a third iteration of Noise-A-Palooza in August 1996, the University of Michigan's second-longest-lived, barrier-breaking film society ceased operations.

The AAFC still shared a Michigan

LEFT: Bruce Campbell meets fan Chris Taylor at 1995 AAFC event.
© Chris Taylor

BELOW: *Michigan Daily* cover story about film societies' demise

A DESCENT INTO DISAPPOINTMENT

"WHERE THEY LIVE ON, THEY ARE OFTEN JUST SECOND-RUN MAINSTREAM MOVIE HOUSES..."

Chronicle of Higher Education, March 1995

Ann Arbor Film Cooperative members, early 1990s. Helen Hurwitz (seated), with Zoey Weaver and Dan Glickman

League office with Cinema Guild, which was now on the third floor rather than in the convenient Room 67 just off the lobby. As with the demise of former suitemate Cinema II, little effort was made to save anything for posterity. Pyke recalled the remaining members sorting through "stacks and stacks of promotional materials that different distributors had mailed to us over the years and movie posters that we had saved." They split up what seemed useful and discarded the rest. "It was just disappointing, really, at the end, because none of us felt like there was anything to hold on to anymore," he remembered.

Student film societies everywhere were suffering the same fate. A March 1995 *Chronicle of Higher Education* story cited an estimate from distributor Films Incorporated that the number of US campuses with such groups had dropped by half, to about 600. "Where they live on, they are often just second-run mainstream movie houses, charging students a few dollars to see 16 mm prints of very recent films," the piece reported. "Gone, on all but a few campuses, are the societies that specialize in foreign films, avant-garde work, or American genre movies that came before *Star Wars*."

Mediatrics Hangs On

According to the *Chronicle*, the film societies that appeared most likely to survive in this new climate were either at land-locked schools or subsidized in some way, like the now less-active, Hillel-supported Hill St. Cinema and the UAC-underwritten Mediatrics. In 1991 the latter had changed its name to M-Flicks, which in addition to a much-reduced schedule of popular recent films, in December 1997 launched Film Farm, a festival of U-M student productions from both inside and outside the Film/Video Studies program. The latest iteration of a concept that had been promoted by earlier groups including InFocus Filmworks, Film Farm became a popular semi-annual event and was eventually supplanted by the Film & Video Student

1991 AAFC flyer

WHAT IS THE ANN ARBOR FILM CO-OP?

"ONLY ONE OF MICHIGAN'S LONGEST RUNNING VENUES FOR INDEPENDENT and ALTERNATIVE CINEMA, DUMMY!"

Maybe you've seen our movies listed in **CURRENT Entertainment Monthly Magazine** or the **Ann Arbor Observer** or **AGENDA** or even the **Ann Arbor News**? Perhaps you've seen our flyers occasionally posted about downtown Ann Arbor and the campus of the University of Michigan?

Or maybe you've even **seen** one of our movies but didn't realize that we were responsible? If that's the case, you're already familiar with the types of films we exhibit: **Independent, Foreign, XXX, Psychotronic, Experimental, Cult, Documentary, Obscure, Controversial**, or to use a trendy buzzword- **ALTERNATIVE**. But don't let that last word jade you, we've been around for 25 years doing this sort of thing. Check out our track record (over) and you'll see that **the AAFC has been dedicated to presenting and preserving what the mainstream (including the Michigan Theater) doesn't want to touch.**

And in addition to showing films, we regularly invite filmmakers, video artists, and musicians to inform and perform for our enlightened audiences. **"Noize-A-Palooza"** is our Multi-media performance series that has featured experimental music from around the country accompanied by video, film, and other stimuli. Our recent guest filmmakers/speakers have included local documentarians Gary Glaser (Bombing L.A.) and Carol Jacobson (From One Prison). Past guests have included **George Romero, Robert Altman, Sam Fuller, and Wim Wenders**. We've premiered hundreds of features and shorts that would have otherwise been ignored. To quote film critic and historian Leonard Maltin from his reference volume, *The Whole Film Source Book*, "**Ann Arbor is one of the most cinematically saturated communities in the country; at any given time there are a number of film societies organizations in operation.**"

We are a "NO PROFIT" U of M student organization. That is, we spend any (minimal) revenues on events and films rather than filling any University or corporate pockets. So your money is being put to good use. And if you are interested in joining the AAFC to show films you want shown (the primary objective of every member), you need not be a student and there is no fee so feel free to ask for a membership application or call and leave a message: **(313) 741-9265**.

Your patronage is VERY important to us and to you if this venue is to stay alive. Too many stay home with their VCRs and miss our rare and unique venue which leaves us sliding closer and closer to BANKRUPTCY (no kidding!). So get out of the house and come to our humble (yet cozy) classroom theaters, conveniently mapped below.

2 AUDITORIUMS A,B,C OR D ANGELL HALL Rm. 1035: 435 S. State.
14 MICHIGAN THEATER: 603 E. Liberty.
15 MODERN LANGUAGES BUILDING AUDITORIUMS: 812 E. Washington.
16 NATURAL SCIENCE BUILDING AUDITORIUMS: 830 N. University.
11 LORCH HALL: 909 Monroe.

Association–sponsored Lightworks, an end-of-semester screening of films made in the unit's classes.

Along with recent hits and well-known classics like *Lawrence of Arabia*, M-Flicks sometimes sponsored more adventurous programming, including midnight movies at the State Theatre and a screening of Kenneth Branagh's *Hamlet* at the Michigan in February 2000. Shown on 70 mm film, it appears to have been the only U-M film society presentation ever made in the highest-resolution celluloid format.

But because its membership was limited to students, M-Flicks continued to lack the continuity and institutional memory of the other groups. At one point in the late 1990s it went dormant, before a revival by undergraduates who learned that a film society was one of the available options at a UAC recruitment meeting. The group eventually settled into a low-maintenance pattern of a half-dozen free screenings per semester, many of them studio-sponsored sneak previews. "Our main purpose is to show movies that are entertaining and have a positive message," remarked 2017 co-president Chris Seeman, who, like so many other film society members, had taken Hugh Cohen's long-running Art of Film course.

The Last Days of Cinema Guild

Like the other film societies, by the late 1980s Cinema Guild was also struggling to stay afloat. Seeking to add more titles that it could show repeatedly without paying rent, in 1985 it had undertaken an ambitious new print-buying campaign, investing thousands of dollars to add to a collection that already contained more than 110 features and 70 shorts. While many of these were in the public domain, the new titles were clearly not. Purchases included campus standbys like Ingmar Bergman's *Cries and Whispers*, Woody Allen's *Take the Money and Run*, and Stanley Kubrick's *2001: A Space Odyssey*, the latter two in 35 mm.

When the three large film cans containing *2001* mysteriously vanished in April 1986, it briefly brought university scrutiny to bear on the propriety of owning and screening copyrighted film prints. Though the group initially forswore the effort and sold some of the recent acquisitions, it soon returned to its old ways and even replaced the missing *2001* with a 16 mm copy (of "very poor quality," according to Harry Todd). As rental rates continued to rise and the ranks of nontheatrical distributors thinned to giants like Films, Incorporated and Swank Motion Pictures, showing campus staples royalty-free was rationalized as a way to continue offering the obscure films members wanted to see. "I was always quite paranoid," Todd remembered. "The people I was actually afraid of were Swank. But they never, that I'm aware of, caught us at that. If they had, I think they really would have raised a big objection."

Hard-driving new Cinema Guild president Barry Bergin proposed another, even more audacious attempt to reverse the group's decline, according to Louis Goldberg. "Barry also wanted to buy or rent the Campus Theatre. At the time, Cinema Guild was incorporated as a student association. It wasn't supposed to compete with other businesses. So he said, 'Fine, let's close the doors and just take our organization over there.' We had a vote on it, and we turned it down." The Butterfield chain had sold most of its remaining, increasingly derelict Ann Arbor operations to Illinois-based Kerasotes Theatres in

OPPOSITE:

1995 AAFC flyer

late 1984 (which promptly locked out IATSE projectionists, who began a lengthy picket), and the Campus would be demolished in 1987 to make way for shops and an ill-fated food court.

Even as the film society's schedule was contracting, Cinema Guild maintained a 16-member board, which continued to include Hugh Cohen and Ed Weber. Though the latter's film suggestion lists, composed as always on his typewriter, contained far less than the 70-plus titles of earlier years, they were still full of pungent descriptions, like one for *Elmer Gantry*. "We have so many hypocritical blowhard evangelical ministers in the headlines these days that this acid portrayal of Sinclair Lewis's American Tartuffe should be truly soul-satisfying." Now officially the group's cashier after house manager duties had shifted to younger members, Weber continued to sell tickets for almost every show. The job paid the most, however. "The ticket seller got $13 a night. The house manager got $10, and the usher, when we still had ushers, got $5," Harry Todd recalled.

One of Cinema Guild's most passionate new members was Louis Goldberg, who had started his own film society in high school and joined the group as an undergraduate in 1984. Leveraging the Guild's collection of prints and the late-'80s breakthrough of free auditoriums, he began to seek new ways to bring interesting material to campus. He learned that the French embassy would underwrite cultural programming, and Cinema Guild used this resource to organize a fall 1989 series of films by Jacques Doillon and a January 1990 visit by director Charlotte Silvera. Goldberg also convinced U-M Film/Video Studies to start a free Sunday series that drew on 16 mm features it owned, while offering his programming skills to other organizations, like the Michigan Theatre, Ann Arbor Summer Festival, and Center for Japanese Studies (CJS). Though the latter had co-sponsored films with Cinema Guild beginning in the early '70s, the partnership had gone into hiatus. "A new director came in and I talked with him and he was really into public relations. He saw the value of a series and put money behind it," Goldberg remembered. After several years of partnership with Cinema Guild, CJS took the programming in-house, where it became an enduring part of the Ann Arbor cultural calendar, occasionally featuring guest curators like Roger Ebert.

Like the Ann Arbor Film Cooperative, by the fall of 1991 Cinema Guild was running movies only on Fridays and Saturdays, a significant drop from just five years earlier when there were still some weeks of six-night operation. Its president was now Harry Todd, who had joined the group in the early '80s but had first come to campus as a student two

> **"THEY NEVER, THAT I'M AWARE OF, CAUGHT US... IF THEY HAD, I THINK THEY REALLY WOULD HAVE RAISED A BIG OBJECTION."**
>
> Cinema Guild president Harry Todd

decades before. The lifelong film devotee had gone to see the late screening of *Flaming Creatures* in 1967 and, after learning it was canceled, walked to City Hall for the sit-in. He had also been friendly with Guild members like Rick Ayers, with whom he once "traded opinions of what we would do if we were going to be drafted." In addition to his duties as president, as the group's membership dwindled Todd took on film booking and other tasks. When Cinema Guild abandoned printing its own semester-long calendars, he, Lou Goldberg, and John Cantu also frequently wrote blurbs and longer film profiles for the *CinemaGuide/Current*.

Though the film society still occasionally drew decent crowds for films like the November 1990 Ann Arbor premiere of Andrei Tarkovsky's *Solaris*, attendance was steadily declining, particularly among undergraduates. "It was always an effort to get students to show up," Louis Goldberg recalled. "Less so when I first joined, but more so as time went on." While recent arthouse and mainstream hits had long been staples of film society programming and were dependably profitable when premiering on campus, this was no longer the case. Despite an encouraging *Daily* review by AAFC president Mike Kuniavsky, in September 1991 a two-night/four-screening campus premiere of Luc Besson's *La Femme Nikita* drew a disappointing 297 viewers, leaving more than three-quarters of the seats empty. Four weeks later Cinema Guild's presentation of Peter Greenaway's controversial *The Cook, the Thief, His Wife, & Her Lover*, still fairly fresh from a successful lengthy run at the Michigan, attracted only 124 ticket buyers. The appeal of classic films was diminishing as well, with a double bill of the group's own prints of Chaplin's *The Gold Rush* and *The Great Dictator* selling a total of only 57 tickets that same fall, and an April 1992 double-feature of *Road Warrior* and *2001: A Space Odyssey* hitting a once unimaginable low of just 48 audience members and a gross take of $152 for the night. When movies like these, which were programmed solely to make money, failed to do so, the future began to look increasingly bleak.

Cinema Guild carried on, however, continuing to book auditoriums and films for Hugh Cohen's Film/Video 236 class. Though the U-M Residential

Program for a joint Cinema Guild / Center for Japanese Studies film series, 1988

A DESCENT INTO DISAPPOINTMENT

297

And I had this conflict with Room Scheduling. They sort of knew I was doing that, and they brought it up. And I'm both ashamed of it and happy I did it." Scheduling office head Al Stuart called him out. "He and I had some really tough conversations, and I was even threatening about that. I thought it was sort of ridiculous. I was too casual, I must say that. My loyalties were with Cinema Guild, not with Scheduling."

Sneak Previews

Another way to remain afloat was with advance screenings of new Hollywood movies, as Mediatrics/M-Flicks had begun doing. "We'd reached the point where it was literally famine and famine rather than feast and famine," remembered treasurer John Cantu. "It was just very, very difficult to sustain programming because audiences were starting to dry up. So we did a lot of sneak previews." For several years Cinema Guild tried to offset losses by showing a half-dozen of these per semester, usually a weak studio effort desperately hoping for college student word-of-mouth, which yielded the group a small profit. "We stopped getting what were really prestige films and wound up with things like *One Tough Cop*, which stars one of the Baldwin brothers. It's not Alec. It's not really too great," Harry Todd recalled of one the group co-presented with M-Flicks.

Considerable extra effort was required for sneaks, which included coordinating advertising and calling the distributor afterward. John Cantu drew on his youthful experience managing a Loews theater in Dallas. "Saturday nights at about midnight, I'd be on the phone giving them a detailed breakdown of what was the age of the audience, were there periods in the film where people

Michigan Daily ad for a CG/M-Flicks joint sneak, 1998

College reimbursed the group for the cost of rooms and film rentals, the university was again charging for auditoriums, and his course sometimes became a gray area used to keep Cinema Guild alive. "They got no rent if what they were showing was sponsored by a professor for a class," Cohen recalled. "They couldn't always get that, so I lied and said that it was for my class.

298 CINEMA ANN ARBOR

were with it, did they seem interested, was it a success, failure, that sort of thing." The group sometimes added a second feature in a bid to make more money, which could produce an odd pairing. "You had an entire evening out in the theater to watch a brand-new Hollywood film while you had to suffer through some really pretty worn down 16 mm old-school print of *Key Largo* or some such thing," Cantu remembered.

Shilling for commercial interests had long been anathema to the most-respected film society on campus. In 1970, "Ticket Fred" LaBour had been asked by a friend to pass out promotional cardboard recipe giveaways at a screening. "I went up there with my big box of Minute Rice wheels and made a humorous speech," he remembered. "We got them all passed out, the auditorium was mostly full, and they started throwing them. And you know the end of movies, when everybody throws their caps in the air? It was like that." While it could be amusing when the organization was riding high, because sneaks were usually co-promoted by a marketing agency, Cinema Guild would now be tasked with distributing such swag to stay in business. Louis Goldberg recalled translucent plastic clipboards bearing the logo of the 2001 HBO series *Project Greenlight*. "Do you know how many they sent us?" Goldberg remarked. "Like, 1,000 clipboards, which we were to give out to people. I remember going out on the Diag and handing out these stupid green clipboards. I still have a box myself. This is the kind of thing we did to keep going."

As the group's activities declined to the point where it could no longer program film screenings for his class, Hugh Cohen's involvement fell off. "I slowly distanced myself as Cinema Guild began to fade during the videotape era; I just became less and less involved," he recalled. "I remember going to fewer and fewer meetings and finally just, not washing my hands of it, just not participating in anything having

"WE'D REACHED THE POINT WHERE IT WAS LITERALLY FAMINE AND FAMINE RATHER THAN FEAST AND FAMINE."

John Cantu

"'*Chicken or turkey supreme skillet...*' *The mouth waters.*" — Fred LaBour

A DESCENT INTO DISAPPOINTMENT

Survey card given out at a Cinema Guild sneak preview

The Chamber

YOUR SCHOOL: _____
(please circle the appropriate answers below)
YOUR CLASSIFICATION: FR SO JR SR GR FAC OTH
SEX: M F AGE: _____
HOW WOULD YOU RATE THIS FILM:
(worst) 1 2 3 4 5 6 7 8 9 10 (best)
WHAT DID YOU LIKE OR DISLIKE ABOUT THIS FILM: _____
WOULD YOU RECOMMEND THIS FILM TO A FRIEND? Y N
HOW DID YOU FIND OUT ABOUT THIS SCREENING:
1. School newspaper ad
2. Ad Posters around campus
3. From a friend
4. Announcements at other films
5. Other: _____
WHAT IS YOUR LONG DISTANCE CARRIER? (circle one)
A. AT&T B. MCI C. Sprint D. Other: _____
WHICH OF THE FOLLOWING WERE IMPORTANT IN CHOOSING YOUR LONG DISTANCE CARRIER? (circle those which apply)
A. Service B. Value C. Voice Quality
D. Parents E. Media (Print, Radio, TV)
F. Referred by someone I know
HOW MANY TIMES A MONTH DO YOU CALL COLLECT? (circle one)
A. 1-2 B. 3-5 C. 6-8 D. 9 or more E. Never
ADDITIONAL COMMENTS: _____

©1996 Hogan Communications

to do with Cinema Guild. Faded is probably the best term to describe that." As Ed Weber began to experience health problems, the film society's senior member would drop out as well.

The end was growing near. "Death by a thousand nicks is what it boiled down to, or, more accurately, death by no sales," John Cantu remembered. "We had just reached a point where it was no longer financially feasible to keep the series going. And, to Harry's credit, mostly through his leadership, we just wound down. And that's about the only thing you can say about it." Even with the writing clearly on the wall, it was hard for Cantu to quit. "Toward the end he and I and a couple of others would just simply toss the money in a pot and say, 'Well, I think we've got enough for an auditorium rental and a projectionist tonight, let's show a movie and see if anybody'll show.' That was a little more expensive than just basically buying a ticket to the Michigan Theatre. And after a while it seemed more reasonable to buy the ticket than to try to run the screening. But that's basically what happened." As Cantu and Lou Goldberg both lost interest, president Harry Todd was left to run things more or less on his own.

It took him a while to let go. "My feeling was that having film on campus was something that was really valuable," Todd remarked. "And I've never used this term before, actually, but I was a bit of an apostle for cinema on campus. So I kept things going longer than was really sensible, because it was a matter of great personal satisfaction to present films." His own endpoint came when he discovered that Student Organization Accounts Service (SOAS) had made an error entering the lab fees for Hugh Cohen's class. "I went to SOAS to determine where our account stood, and I got some very disturbing news. We were significantly in the hole," he remembered. "The Residential College would pay us at the end of the term, and we had a balance of like $10,000. I knew that wasn't right. What had transpired actually was the payment from the RC had been entered twice. So instead of having a positive balance, we had a negative balance. And it was a lot of money."

Deciding to pay the deficit from his own pocket, Todd then began preparing

to shut the organization down. He reached out to the group's few remaining members to let them know. "Harry coming to me and saying, 'We're gonna close it,' kind of sent a shudder through me," Louis Goldberg recalled. "I didn't want it to die, because of how much I'd done for Cinema Guild. And I said to myself, 'All right, I will take over.' And the first thing I discovered was we had like $1,200 in debt." After Todd's personal payment, more bills had come in, and SOAS refused to let Cinema Guild resume operations without paying them off. To launch his final quixotic revival of the film society, Goldberg first sold off some of its 16 mm prints.

The group was required to have a certain percentage of student members to keep its office in the Michigan League, but joining a film society no longer resonated with undergraduates, as Harry Todd had discovered several years earlier at the annual student organization recruitment fair. "The whole idea of showing films on campus had become quite alien. They just didn't understand why you would want to do it." This also proved a stumbling block for Goldberg. "One semester I literally got the names of 12, 14, 15 people, and all they wanted to do was put it on their résumé. They never wanted to show up to any meeting. And I had to take them because I needed that many signatures to remain a student organization." Despite his best efforts, "At some point I could not keep the office manned. They insisted that students actually be there so many hours a day, so many hours a week, and I didn't have students. So they said to us, 'You've got to vacate.'" Cinema Guild's remaining film prints, which had first been kept in Hugh Cohen's basement, then an upper-floor storeroom in Lorch Hall, then Harry Todd's home, and finally the League, were hauled to Goldberg's house by hired movers along with its office files.

Despite this setback, Louis Goldberg decided he was still not ready to give up. With help from new recruit John Cameron, he repurposed Cinema Guild into a semi-private film club to show VHS tapes and DVDs in small U-M classrooms or occasionally at an Inter-Cooperative Council house. For the next five years he held weekly screenings that were announced via email and occasionally promoted to the public through *Ann Arbor News* critic Christopher Potter. Though its office was gone, Cinema Guild remained a registered U-M organization by showing a single 16 mm screening in an auditorium each semester

Promotional clipboard distributed by Cinema Guild in 2002

A DESCENT INTO DISAPPOINTMENT

with money from a SOAS grant.

Goldberg presented a slate of obscure, often French films that he felt deserved a wider audience, which John Cantu sometimes attended. "He would show a VHS, and there'd be a little bit of talk afterward. I remember distinctly *A Time to Live and a Time to Die*, and it drew a small group, maybe a half a dozen people. There wasn't too much overhead, projection wasn't too much." In August 2007, Goldberg presented Cinema Guild's final screening, the 1958 Jacques Becker–directed *Montparnasse 19*. "It died with such a whimper," he recalled. "There were no articles, there was nothing. Nobody even knew. In fact, I remember telling Hugh that I was still running Cinema Guild, and he said, 'It's still going? I thought that thing died a long time ago.'" The group's uncelebrated end occurred just over a year after its longest-serving, film-loving, rebellious member, Ed Weber, passed away in April 2006.

"I hated to be the one who closed it, I hated to be the last guy, but I loved showing movies," Goldberg remembered wistfully. For him, it was as much about the communal experience, being in an audience "where there's all sorts of applause and gasps. There's just an energy or a magic or something to it. I don't know how to articulate it." Former president Vicki Honeyman recalled the group's 1970s heyday. "I just remember the beer bottles during Cinema Guild and film festival screenings. People would sneak in beer, which was not allowed because we're on campus, and Peter would be up in the booth and he would start laughing, everybody would. You'd hear a beer bottle fall and start rolling down the floor because it wasn't a carpeted floor, and it was sloped. And everybody would be laughing. And the screenings, people were so verbose and not in any way afraid to react to films out loud and it was this atmosphere of freedom and creative juices and fun. But we were all getting educated. And nobody was telling us that we couldn't do it. Yeah, the beer bottles. God, what a great sound that was."

CINEMA GUILD

Cinema Guild
1310 Michigan Union
Ann Arbor, Michigan
48109

ACKNOWLEDGMENTS

OVER THE YEARS, hundreds of individuals were members of University of Michigan film societies. To keep the narrative moving forward, this book mentions only a few dozen of their names. Though I strove to highlight as many key contributors as possible, there were no doubt many others who could, and should, have been included. I sincerely apologize to anyone whose efforts were not recognized here.

Many people helped me with this project, and without their generous assistance and support the end result would have been far different. A number of folks went above and beyond, and I want to single them out because I truly owe them a special debt of gratitude. I would first like to thank Hugh Cohen, who was there during many of the events the book covers and was one of my main inspirations to write it in the first place. He graciously gave me many hours of his time in person and on the phone, as well as access to his massive scrapbook of *Flaming Creatures* memorabilia. His notes on the text also helped improve it in many ways. Philip Hallman was a steadfast supporter of the project from the beginning, and in addition to his detailed recollections and helpful reading of the text, supplied key graphic materials and contacts. I also received incredibly generous assistance from Pat Oleszko, whose vivid memories, helpful notes on the text, interviewee suggestions, and scanning (three times!) of photos from her personal archives provided a window into the excitement of her live performances. I owe Buster Simpson a deep debt of gratitude as well, for sharing his memories on a variety of topics and his incredible photos of the Velvet Underground, along with passing the ONCE Group and film festival papers of the late Nick Bertoni on to the Bentley Historical Library and the Ann Arbor District Library, where they will be available to researchers. Former Ann Arbor Film Festival manager and Cinema Guild chairman Jay Cassidy also helped me throughout the process, sharing memories, scanning photos and documents, burning DVDs, reading the text, and setting up a screening at the Academy Film Archive of his *Cinema Street* shorts. The Ann Arbor District Library's Amy Cantu was also incredibly helpful in finding images from the *Ann Arbor News* archives and scanning large-format materials. As I closed in on completion, my patient and supportive editors Christopher Porter and Amy Sumerton brought the text across the finish line and the fantastic design work of Amanda V. Szot, Nate Pocsi-Morrison, and Amy Arendts tied it together better than I ever imagined. Finally, Elizabeth Demers, Scott Ham, Haley Winkle, and the University of Michigan Press got behind the project, for which I am extremely grateful.

Others who went far beyond the call of duty with helpful readings of the text and/or generously answering many emails and phone calls, providing photos and documents (sometimes dug out of attics and basements), and screening rare film prints for me include Doug and Betty Rideout, Andrew Lugg, Rick Ayers, David Greene, Gerry Fialka, Mark Schreier, William Hampton IV, Reed Lenz, Glenn and Teresa Mensching, Woody Sempliner, Mark Deming, Diane Kirkpatrick, Louis Goldberg, Danny Plotnick, Ken Beckman, and John Cantu.

Whether by allowing me to interview them, sharing photographs, or pointing me to somebody I wouldn't otherwise have known about, many other people also gave me critical help. I have grouped some by the organizations they were members of (though

a few were involved with more than one, and the people mentioned above also include many film society members).

Cinema Guild: Sue Kaul, Andy Sacks, Neal Gabler, Peggy Ann Kusnerz, Mary Cybulski, Rob Zicbell, Angelica Pozo, Vicki Honeyman, Norman Wang, Dan Bruell, Harry Todd

Cinema II: John Sloss, Kevin Smith, Ruth Bradley, Marlene Reiss, Matthew Smith

The Ann Arbor Film Cooperative: Jim Watson, Nancy Schreiber, Nancy Stone, Michael Frierson, Jay Weissberg, Jim Pyke, Greg Baise

Friends of Newsreel: Laura Wolf

The Matrix Theatre: Dan Gunning

Mediatrics: Mark LoPatin, Chris Seeman

Alternative Action: Dave DeVarti

Hill St. Cinema: Michael Brooks

The Ann Arbor Silent Film Society: Mars De Ritis

The ONCE Group: Joseph Wehrer, Allan Schreiber

The Ann Arbor Film Festival: Betty Johnson, Fred LaBour, Eric Staller, Bill Finneran, Chrisstina Hamilton, Leslie Raymond

Destroy All Monsters: Cary Loren

The Michigan Theatre: Henry Aldridge, Russell Collins, J. Scott Clarke

Film Projection Service and IATSE Local 395: John Briggs, Dan Moray, Bill Abbott, Anne Moray

The University of Michigan Department of Film, Television, and Media: Alan Young, Frank Beaver, Herb Eagle, Dan Herbert, Matthew Solomon

Michigan Daily: Rolfe Tessem, Karen Kasmauski, David Margolick, Jim Judkis, Sara Krulwich

And last, but not least: Donald Sosin, Ken Burns, Luis Argueta, Rich DeVarti, Ann Levenick, Bill Conlin, Bill Kirchen, David Fair, Vicky Henry, Thomas and Patricia Petiet, Michael Gildo, David Swain, Jim Toy, Peter Yates, Dave Eggers, Annie Dills, Emmy Kastner, Conor O'Brien, Devon Thomas, Michael Erlewine,

Chris Taylor, arwulf arwulf, Susan Wineberg, Scott Morgan, Bonnie Dede, Roger Miller, Vince Cerutti, Thomas O'Brien, Peter Andrews, Gregory Fox, Kevin Schmid, Freddy Fortune, Alec Palao, Michael Hurtt, Mike Stax, Miriam Linna, Romeo Carey, Joe Tiboni, Peter Struble, Eric Ahlberg, Josh Guillot, and Howard Brick.

Finally, I want to thank my family for their support and patience—my wife, the amazing Amanda Uhle, my wonderful daughters, Elizabeth and Beatrix, my late mother, Katharine Uhle, and my father, Alvan Uhle, who came to the University of Michigan in 1945 and fondly remembered attending films at the Art Cinema League and the Orpheum Theatre, as well as seeing the world premiere of *Metamorphosis* at Hill Auditorium.

A Note on Sources

Though they wouldn't have existed without the university's facilities and cultured audience, the film societies strove to separate themselves from academia and its footnotes and arcane terminology. I have thus tried to skew this book toward the readable, and hopefully even fun, side, in an effort to bring forth their rebellious spirit.

The story was sourced from a blend of archival research, interviews, and my own experiences as a participant. In March of 1978 I was home on spring break from Kalamazoo College when my brother Raymond spotted a preview of the Ann Arbor Film Festival in the newspaper. We convinced our parents to loan us their car for the 90-mile drive from Coldwater and, once we'd settled into the hard seats of the Architecture Auditorium, were both knocked out by the experimental films and general bohemian atmosphere. A few months later I transferred to the University of Michigan where, after trying and failing to join both Cinema Guild and the Ann Arbor Film Cooperative, I was taken in by the humble but warmly welcoming Cinema II. Following graduation from art school in 1983 I also began working for Film Projection Service, where I showed movies for the film societies, the Ann Arbor Film Festival, and the 8 mm Film Festival, then for the Butterfield-owned University Drive-In and Michigan Theatre, where I eventually became head projectionist. I also joined the Ann Arbor Silent Film Society and served as informal technical advisor to founder Arthur Stephan, occasionally showing films with him in far-flung locales (and, memorably, screening 35 mm reels from 1960s Hollywood features he'd acquired at the drive-in the night after it closed). I also occasionally dabbled in filmmaking, first in high school on Super 8, then in college with a Sony Portapak. Fellow Cinema II member John Sloss and I even made a now-lost experimental short that I intended to enter in the 8 mm Film Festival, in which we taped the camera's trigger button down and played catch with it until the cartridge ran out.

Between 2016 and 2022, I conducted interviews with more than 80 participants in person, on the phone, on Zoom, and via email, and all the quotes come from these, except where credited to the *Michigan Daily*, *Ann Arbor News*, or other cited sources. The voice of the late George Manupelli comes from his March 2009 lecture on the history of the Ann Arbor Film Festival which was sponsored by the University of Michigan's Penny W. Stamps School of Art and Design.

I am also greatly indebted to the Bentley Historical Library and Aprille McKay, Karen Wright, Madeleine Bradford, and everyone on the wonderful staff there. Among the many collections I accessed were the papers of George

Manupelli, Jay Cassidy, James Toy, Gerald H. Hoag, Harlan Henthorne Hatcher, Robben W. Fleming, Wystan Stevens, Susan Wineberg, the Ann Arbor Film Festival, Cinema Guild, the *Michigan Daily*, the Dramatic Arts Center, University Housing, the Department of English Language and Literature, the University of Michigan President's Office, Student Government Council, the Library Clipping File, and Diane Kirkpatrick's oral history interviews with Marvin Felheim.

In addition to his personal recollections and support, Philip Hallman of the Special Collections Library provided me access to the papers of Robert Altman, a large quantity of 1970s film flyers, and a collection of 1960s Cinema Guild newspaper clippings and schedules.

The Labadie Collection and Julie Herrada allowed me to view the papers of the late Edward C. Weber of Cinema Guild and provided several useful scans.

Kathy Ciesinski, general manager of the Office of Student Publications, kindly reviewed and helped me receive permission to use the many photographs and scans from the *Michigan Daily*.

Cathy Pense Garcia and Matthew Quirk of the U-M History of Art Visual Resources Collections diligently searched for images and provided me with a video of Diane Kirkpatrick lecturing in 1974.

The Academy Film Archive in Los Angeles and archivist Mark Toscano facilitated a screening of a 16 mm print of Jay Cassidy's 1971 *Cinema Street* series, as well as providing me access to a digital copy of A. K. Dewdney's *Maltese Cross Movement*.

William Hampton IV kindly loaned me the only existing copy of his father's 16 mm film *Metamorphosis*, which Alan Young produced a digital transfer of.

Doug and Betty Rideout invited me over for a screening of several of the 16 mm films Doug made, including *ONCE Kittyhawk*, which we enjoyed watching with Michigan Theater popcorn in their basement.

A few of many other films produced by Ann Arbor filmmakers were found on Vimeo and/or YouTube, including David Greene's *Pamela and Ian*; Luis Argueta's *El Triciclo*; Pat Oleszko's *Footsi*; Andrew Lugg's *Black Forest Trading Post*, *Gemini Fire Extension*, and *Plow, Skid, Drag*; several short clips from George Manupelli's Dr. Chicago series; *Ozone Burgers (To Go)* by Chris Frayne; and *Summer '70 Ann Arbor* by Warlock Productions Ltd. I highly recommend seeking them out, and hope that more will appear over time. I was also able to view the long out-of-print three-DVD set of the Dr. Chicago films through the efforts of Chrisstina Hamilton, Leslie Raymond, and Jay Cassidy, the latter of whom shared a copy of his own *The Best of May 1968*. Thomas and Patricia Petiet supplied me with a DVD of *The Shlamozzle* (and may still have some available to purchase!).

Two tiny additional notes: The Michigan Theater now renders the last word in its name with an "er" at the end, but for many years it, and the other local commercial film venues, all spelled the word with an "re." I have tried to be consistent with the way the names were spelled at the time they appear in the story, so for the most part the "re" is featured (and the State Theatre's beautifully restored 1942 neon marquee keeps this spelling alive today). Similarly, Cinema Guild's elected leader was originally called the "chairman," but at some point in the 1970s this was changed to "president."

BIBLIOGRAPHY

The *Michigan Daily* covered the film societies in great detail from the days of Amy Loomis and the Art Cinema League. The stories it ran and the groups' paid ads together number in the thousands, far too many to cite here. I have noted particularly useful articles in the bibliography below. The digitized *Michigan Daily* is searchable and accessible here: https://digital.bentley.umich.edu/midaily.

Stories in the *Ann Arbor News*, *Ann Arbor Sun*, and several other defunct local newspapers can be found in the (growing) online clipping library maintained by the dedicated staff of the Ann Arbor District Library. They have also digitized the printed programs of the Ann Arbor Film Festival, numerous film society calendars, and thousands of other photos and documents related to local history: https://aadl.org/localhistory.

Chapter 1: Pioneering Presenters

"Against Brutalizing Exhibition." *The U of M Daily*. October 14, 1897.

"Don't Like the Pictures." *Ann Arbor Argus*. October 15, 1897.

"Crowd Raids Star Theatre." *Michigan Daily*. March 17, 1908.

"League Theatre Inaugurates New Type of Entertainment." *Michigan Daily*. October 22, 1929.

Art Cinema League Board. "Art Cinema's Purpose." *Michigan Daily*. February 26, 1935.

Hoag, G. H. "On Foreign Films." *Michigan Daily*. August 17, 1938.

Wasson, Heidi. *Museum Movies.* Oakland, California: University of California Press, 2005.

Chapter 2: Post-War Evolution

"Art Cinema Fills Foreign Film Demand." *Michigan Daily*. July 14, 1948.

Blumrosen, Al and Phil Dawson. "Gives Reason for Showing 'Racist' Film." *Michigan Daily*. May 14, 1950.

"'Birth of a Nation' Shown to New Film Society Guests." *Michigan Daily*. May 25, 1951.

"Cinema Guild to Show British Film." *Michigan Daily*. October 13, 1950.

"Cocteau's 'Orpheus' to Begin Today." *Michigan Daily*. March 9, 1951.

Chapter 3: Cinema Guild Breaks Out

Forsht, Jim. "Speaking of Movies Locally." *Michigan Daily*. February 28, 1960.

Oppenheim, Judith. "SGC Movie Showing Violates Earlier Ruling." *Michigan Daily*. April 19, 1961.

Blumberg, Gail. "Cinema Guild Ends Public Advertising." *Michigan Daily*. October 31, 1963.

Bruss, Neal. "Cinema Guild: Bargain Prices." *Michigan Daily*. August 24, 1965.

Sawyer, Paul. "The Case for Cinema Guild." *Michigan Daily*. February 19, 1967.

Chapter 4: The Ann Arbor Film Festival

Juliar, Michael. "Markopoulos Calls 'All Arts Dead, Except Film.'" *Michigan Daily*. March 12, 1965.

Knox, David R. "To the Editor." *Huron Valley Ad-Visor*. March 24, 1965.

Mekas, Jonas. "Movie Journal" [Report on the 1965 Ann Arbor Film Festival by Gregory Markopoulos]. *The Village Voice*. March 25, 1965.

Manupelli, George. "Letter From the Ann Arbor Film Festival, April 1, 1965." *Canyon Cinema News*. June/July 1965. (Reprinted in MacDonald, Scott. *Canyon Cinema*. Oakland, California: University of California Press, 2008.)

Chapter 5: Doubtful Movies

Wasserman, Harvey. "Police Seize Cinema Guild Film; Protesters March on City Hall." *Michigan Daily*. January 19, 1967.

Rapoport, Roger. "Arraign Four Cinema Guild Members." *Michigan Daily*. January 21, 1967.

Lugg, Andrew and Larry Kasdan. "Warhol Experiments: Invitation to Critical Analysis." *Michigan Daily*. April 11, 1967.

Crabtree, Jill. "Barkey Pleads Guilty in Movie Obscenity Case." *Michigan Daily*. January 5, 1968.

Chapter 6: Beyond Butterfield

Ayers, Richard. "Vth Forum Theatre Shows Art Films; Contest Slated." *Michigan Daily*. December 3, 1966.

"Theater Ownership Changes." *Ann Arbor News*. December 15, 1967.

Kelley, Ken. "Beatles Burn Argus." *Ann Arbor Argus*. April 14–28, 1969.

Chapter 7: If They're Doing It, Why Can't We?
Fensch, Thomas. *Films on the Campus*. Cranbury, New Jersey: A.S. Barnes, 1970.

Rosen, Stephen. "Why 'Ten For Two' is the John Lennon–Yoko Ono Music Doc You Haven't Seen." *Indiewire.com*. December 11, 2011.

Chapter 8: Revolutionaries and Ripoffs
ARM Collective. "False Advertising: Weapon Against ARM?" *Michigan Daily*. March 16, 1971.

Schwartz, Tony and Karen Tinklenberg. "Film Society Barred from 'U' Showings." *Michigan Daily*. October 28, 1971.

Gabler, Neal. "Film Societies." *Michigan Daily*. September 7, 1972.

Sinclair, John. "Setting the Record Straight." *Ann Arbor Sun*. September 24, 1973.

Schwartz, Tony. "Porno Flick Draws Crowds, Profit at Campus Showings." *Michigan Daily*. February 21, 1974.

Blomquist, David. "Fleming Recommends Soft Policy on Porno." *Michigan Daily*. May 15, 1974.

Blomquist, David. "Newsreel, New Morning Funds Linked." *Michigan Daily*. June 26, 1974.

Blomquist, David. "Distributors May Sue 'U' for Student Film Debts." *Michigan Daily*. October 2, 1974.

Kochmanski, Chris. "Film Co-ops Focus on Fine Flicks." *Michigan Daily*. April 17, 1976.

Chapter 9: New Perspectives
Wacker, Denise and Philip Sutin. "Comment Differs on Problems of Homosexuality." *Michigan Daily*. June 29, 1962.

Levick, Diane. "Gay Males Stop Movie in Protest." *Michigan Daily*. July 27, 1973.

Cohen-Vrignaud, Gerard. "Gay & Proud." *Michigan Daily*. February 12, 1999.

National Alliance Against Racist and Political Oppression. "Of Racism and Responsibility." *Michigan Daily*. January 11, 1979.

Chapter 10: Perfection, Not Projection
Garber, Ken. "Inside the Booth." *Current*. December 1988.

Chapter 11: Cult Movies and Campus Visitors
Sharp, Anne. "Escapist Violence Makes 'Dawn' Fun." *Michigan Daily*. January 14, 1979.

Gleiberman, Owen. "Film Establishments: Fare for Fanatics, Casual Fans." *Michigan Daily*. September 6, 1979.

Chapter 12: A Liberating Effect
Bradley, Ruth. "The Ann Arbor Film Festival, 1963–1982: A History Illustrating the Genres of American Avant-Garde Cinema." Doctoral Dissertation, University of Michigan, 1985.

Frank, Ellen. "A2 Film Festival." *Ann Arbor Sun*. March 22, 1974.

Galbraith, Stuart IV. "Festival Brings 'Reel Hysteria' Around Again." *Ann Arbor News*. July 7, 1990.

Plotnick, Danny. *Super 8: An Illustrated History*. Los Angeles: Rare Bird Books, 2020.

Chapter 13: The Renegades Running the Asylum
Maltin, Leonard. *The Whole Film Sourcebook*. New York: Universe Books, 1983.

Chapter 14: Bending to Threats
Potter, Christopher. "Writing History with Lightning." *Ann Arbor News*. July 10, 1987.

Gazella, Katie. "DJ Takes a New Spin on Old Film with 'Rebirth of a Nation.'" *University Record*. January 10, 2005.

Chapter 15: A Descent into Disappointment
Kuniavsky, Mike. "Keeping the Celluloid Fire Ablaze." *Michigan Daily*. September 5, 1991.

Heller, Scott. "Fade-Out for Film Societies." *Chronicle of Higher Education*. March 10, 1995.

Zilberman, Michael. "Movies with a Motive." *Michigan Daily*. October 12, 1995.

PHOTO CREDITS

To streamline the captions for the reader, full source information from some images was omitted.

Many came from the Bentley Historical Library, which is noted in the captions as BHL. More detailed information about the specific sources for these images is listed below. Unless noted otherwise, all newspaper advertisements were sourced from the digitized *Michigan Daily*, cited in the bibliography.

Chapter 1, photo of Lydia Mendelssohn Theatre: U-M Photographs Vertical File (BL004759, HS11546 (photographer: Daines, Ann Arbor) The Bentley Historical Library, University of Michigan

Chapter 1, photo of Rackham Lecture Hall: U-M Photographs Vertical File (HS12757 (photographer: Ivory Photo)) The Bentley Historical Library, University of Michigan

Chapters 1 and 2, Art Cinema League flyers and handbills: Vertical Files: Art Cinema League. The Bentley Historical Library, University of Michigan

Chapter 4, photo of Dominick's: U-M Law School records (HS43) The Bentley Historical Library, University of Michigan

Chapter 4, photo of George Manupelli and Candy Brown: George Manupelli Papers. The Bentley Historical Library, University of Michigan

Chapter 5, Maynard Goldman letter and Ed Weber film suggestion list: University of Michigan Library, Joseph A. Labadie Collection, Subject Vertical Files: Films, Cinema Guild

Chapter 6, photo of Angell Hall Auditorium A: U-M News and Information Service photographs collection. The Bentley Historical Library, University of Michigan. © Regents of the University of Michigan

Chapter 6, 1968 Cinema II schedule: Wystan Stevens papers, the Bentley Historical Library, University of Michigan

Chapter 6, photo of Canterbury House exterior: Canterbury House records (HS12391) The Bentley Historical Library, University of Michigan

Chapter 7, photo of Soo Locks film and AVEC library: U-M News and Information Service photographs collection. The Bentley Historical Library, University of Michigan. © Regents of the University of Michigan

Chapter 11, photo of Mark Deming on set with Carol Burnett: Robert Altman papers,

PHOTO CREDITS 317

University of Michigan Library Special Collections Research Center

Chapter 13, cover of *Ann Arbor Eye* magazine: Jay Cassidy Ann Arbor Film Festival Collection, the Bentley Historical Library, University of Michigan

Photos credited to Jay Cassidy, *Michigan Daily* come from the Bentley's *Michigan Daily* Alumni Photographers collection and are reproduced under a creative commons license, © Regents of the University of Michigan. Other photographs by Jay Cassidy that were not shot for the *Daily* were supplied from his personal archives as noted.

Most of the photographs scanned from the *Michigan Daily* negatives collection came from: *Michigan Daily* Papers, the Bentley Historical Library, University of Michigan. © Regents of the University of Michigan. The *Daily* photos taken by Andy Sacks are reproduced with his permission, but come from: Andrew Sacks Photographs, the Bentley Historical Library, University of Michigan. The *Daily* photographs shot and © by Rolfe Tessem and David Margolick were supplied from their own files. Photographs credited *Ensian* come from the *Michiganensian* yearbook.

Uncredited materials come from the collection of the author. The papers of Cinema Guild were originally saved by Louis Goldberg, then stored for a decade by Reed Lenz. These and other materials given to me by Glenn and Teresa Mensching will eventually be given to the Bentley Historical Library.

Every effort has been made to accurately credit the source of photos and other images, and any errors or omissions are strictly the fault of the author. Please contact Fifth Avenue Press with any corrections.

For more information, including many film society calendars and flyers not included in the book, visit:

aadl.org/cinemaannarbor
cinemaannarbor.com

INDEX

3D films, 186
8 Fest. *See* 8 mm Film Festival
8 mm film: 8 mm Film Festival, 135, 209, 224–233, 248, 279; Ann Arbor Film Festival, 56, 57; and Cinema II, 93; and filmmaking by students, 117
8 mm Film Festival, 135, 209, 224–233, 248, 280
16 mm film: and 8 mm Film Festival, 232; and Ann Arbor Eye and Ear Control, 288, 290; and AVEC library, 130, 132; conversion of projector by Wilde, 180, 183; and Destroy All Monsters collective, 126; and filmmaking by students, 111, 117, 123; as main festival format, 224; quality of, 19
35 mm film: as festival format, 224; nitrate film, 185; projectors, 163, 180, 182; quality of, 19
70 mm films, 295
2001: A Space Odyssey, 295

A

Abbott, Bill, 159, 179, 183
Abraham Lincoln Brigade, 276
Access Productions, 280
ACLU (American Civil Liberties Union), 23, 83
Adams, Charles, 95
Ager, William F., 87
Aguirre, the Wrath of God premiere, 163–164, 165
Al (custodian), 143
Aldridge, Henry, 220, 269
Alexander, Buzz, 169
Alley Cinema, 137–138
Alloy Orchestra, 191
Allvord, Glen, 152
Alpert, Hollis, 87
Alternative Action: closure of, 287–288; founding of, 165–166; graphics and calendars, 244, 252; money and income, 286, 287; tensions with other societies, 237; visits by directors/actors, 275
Altman, Kathryn, 199
Altman, Robert, x, 194–200, 262
Amblers, 74
American Association of University Women, 7
American Film Institute, 116
American Revolutionary Media (ARM), 135, 137, 139–141, 151–154, 194
American Studies 498, 103–104
Amundsen, Roald, 6
The Analog Computer and Its Application to Ordinary Differential Equations, 56
Andrews, Peter, 137, 138
Angell, James B., 5
Angell Hall Auditorium A: and 8 mm Film Festival, 232; and 35 mm equipment, 163, 180, 182; and Cinema II, 93; and gay stings/arrests, 159; lighting panels, 183
Anger, Kenneth, 57, 232
Ann Arbor 8 mm Film Festival. *See* 8 mm Film Festival
Ann Arbor Argus, 100–101
Ann Arbor Comic Opera Guild, 132
Ann Arbor Eye (distribution co-op), 132
Ann Arbor Eye (magazine), 179, 260–262, 263
Ann Arbor Eye and Ear Control, 288, 290
Ann Arbor Film Cooperative: and Ann Arbor Film Festival, 216–217; Banned Film Festival, 276–277; and Classic Film Theatre, 269–270; closure of, 291–292; and cult movies, 193; Ernst Lubitsch series, 281; and filmmaking, 123–124, 133, 248; film selection, 137–139, 236–237; and film studies, 169, 170; flyers, calendars, and graphics, 170, 190–191, 193, 206, 245, 251, 282, 288, 290, 293–294; founding of, 123–124; Gay/Lesbian Film Festival, 288, 290; and gay rights, 160–161; growth of in 1970s, 135–138, 141; income and costs, 272, 286, 287, 291; logo, 167, 168; magazine, 262; pornography and sexually-explicit films, 148, 288, 291; premieres by, 163–164, 165; robbery of, 156; Robert Altman festival, 195; and silent films, 187; struggles in 1980s, 288–294; ticket prices, 144; and *A Token of His Extreme* screening, 183–185; T-shirts, 260; visits by directors/actors, 200, 201–206, 273, 275, 276, 291. *See also* 8 mm Film Festival
Ann Arbor Film Festival: and 8 mm Film Festival, 230–231; 10th anniversary, 209; in 1960s, 50–77; in 1970s, 208–224; art installations at, 71–73, 209–212, 214, 218;

INDEX 321

and audience interaction, 75; censorship accusations, 59; and Cinema Guild, ix, 53, 56, 61, 216–217, 222; and Cinema II, 93, 216–217, compilation film, 215–216; first, ix, 53–57; graphics, 53–55, 60, 62, 73, 75, 210–211, 213, 218–219, 220, 222, 223, 230; income and finances, 52–57, 221–222; as independent entity, 222; influence of, 67, 117, 120, 217, 222; jurors and jurying, 57–59, 214–215; logistics, 61, 213; and Manupelli, 52–62, 67, 73, 75, 209, 210–213, 214, 216, 218–224; and Markopoulos visit (1965), 57–59; move to Michigan Theatre, 186, 219–221; music events at, 62–67, 74–75, 214, 216, 218, 224; performance art at, 67–71, 209, 214, 216, 218; prizes, 55–56, 214, 224; and projection, 180; and *Roger & Me*, 275; and sexually-explicit films, 58, 59–60, 79, 209; showing of rejected films, 57; tour, 60–61
Ann Arbor Film Review, 260
Ann Arbor Screen Scene, 262
Ann Arbor Silent Film Society, 279–283
Ann Arbor Women's Film Collective, 227
Arcade Theatre, 7
Architecture and Design Open House, 52
Architecture/Architecture & Design Auditorium: and 3D films, 186; and 35 mm equipment, 163, 180, 186; and Ann Arbor Film Festival, 53, 219; and Art Cinema League, 19; and Cinema Guild, 35, 41, 219; heating and cooling of, 239; and Program in Film and Video Studies, 169; rental fees, 41
Argueta, Luis, 124–125, 209
Argus, 100–101
The Ark, 93
ARM. *See* American Revolutionary Media (ARM)
arrests. *See* crime, arrests, and lawsuits
Art1 Cinema, 147
Art Cinema League, viii, ix, 9–17, 19–22, 26, 187, 235
art films. *See* foreign films
Arthur, Hartney, 282
art installations: 8 mm Film Festival, 232; Ann Arbor Film Festival, 71–73, 209–212, 214, 218
Artist, Tim, 229
"The Art of Film" course, 168–169, 170
Asheton, Ron, 133. *See also* The Stooges
Ashley, Mary, 51, 56, 112, 113, 115
Ashley, Robert, 51, 56, 59, 112, 113, 117
Athens Theatre, 3–4. *See also* Whitney Theatre
Audio Film Center, 83
Audio-Visual Education Center (AVEC), 128–132
Ayers, Bill, 164
Ayers, Rick: background, 42–43; and Cinema Guild, 44, 45–46, 47, 242–243; on film studies, 104; and *Flaming Creatures* controversy, 86, 87, 91; on handouts, 242–243; and magazines, 260; and Todd, 297; and Weather Underground, 164–165

B
Baillie, Bruce, 57, 59
Baise, Greg, 242, 288
Baker, David, 96, 247
Baker, Geoff, 273
Banned Film Festival, 276–277
Barden, Elliot, 43, 44, 82, 85, 90, 117, 260
Barkey, Mary, 82, 85, 90, 91
Beatles and *Magical Mystery Tour* screenings, 100–101. *See also* Lennon, John
Beaver, Frank, 106, 132–133, 168, 169, 173, 199
Becker, Josh, 229
The Beginning Was the End, 218
Behind the Green Door, 146–148
Bell & Howell, 61
Below the Belt, 214
Bergin, Barry, 295
Berio, Luciano, 51
Berlin Alexanderplatz, 238
Berman, Tom, 116, 209, 214, 224
Bertoni, Nick, 117
The Best of May 1968, 120
Beth B, 232
Bilmes, Joshua, 230
Biron, Lionel, 160–161
The Birth of a Nation, 22–25, 26, 159, 170–173, 174, 175, 277–279
Black Film Society, 161, 162
Black Liberation Week, 159, 161, 162
Black students: civil rights groups and actions, 159, 161–162; student societies, 161, 162
Blank, Les, 204
Blomquist, Alan, 217, 241
Blomquist, David, 151
Blood in the Face, 288, 289
The Blood of God, 126
Blow Job, 85
Boetticher's Roost, 118
Bonnie and Clyde, 111
Boos, Charles, 83–84
The Bottleman, 51, 111
Boys, Richard, 20
The Boys in the Band, 160–161

Bradish, Elaine, 195
Bradley, Ruth, 163, 217, 221–222, 224, 241
Brakhage, Stan, 52. See also *Flesh in the Morning; Time of Desire*
Brick, Howard, ix
Briggs, John, 100, 120–121, 179, 181, 185
Broadhead, Charles, 29
Brooks, Michael, 166–167
Brown, Candy, 67
Bruell, Dan, 222, 248, 258–259
Bull, Byron, 230
Bullard, Perry, 147
Bungard, Teresa, 276
Burns, Ken, x, 67, 71, 101–102, 224
Burns, Ric, 67
Bushnell, Scott, 197
Butterfield Theaters: and Altman visit, 195; competition with student societies, 21, 41, 94; and Hoag, 14–15; and Michigan Theatre, 14–15, 220, 269; monopoly of, 94, 95; sale and demolition of theaters, 295–296; and sexually-explicit films, 36; struggles in 1970s, 162; ticket prices, 100; UM's stake in, 147–148; Wayside Theatre, 97–98. See also Campus Theatre
Butts, Andre, 124

C

cable television: *Ann Arbor Screen Scene*, 262; rise of, 285
Cacioppo, George, 51
Cahiers du Cinema, 43, 67
Caldwell, John, 124, 213, 215, 216
Cale, John, 62, 63
calendars. See flyers, calendars, and graphics
Cameron, John, 301

Campbell, Bruce, 229, 291
Campus Theatre: foreign films at, 35–36, 43, 94, 95; opening of, 35–36; sale and demolition of, 295–296; and sexually explicit materials, 145; struggles in 1970s, 162
Canterbury House, 93–95, 135, 137
Cantu, John, 240–241, 274–275, 277–279, 297, 298–299, 300, 302
Canyon Cinema, 57
Capra, Frank, 174, 192, 193, 194, 195
Capra, Lucille, 195
Captain Beefheart, 139
Carey, Romeo, 203
Carey, Timothy, 203, 204, 205
The Carrier, 133
"Car Surfacing" installation, 209–212
Casa Dominick's. See Dominick's
Cassidy, Jay: and Ann Arbor Film Festival, 75, 209, 213, 214, 215, 217; on AVEC, 130; and *Cinema Scope*, 260; filmmaking by, 74, 111, 113, 117, 120, 130, 209; and Fuller visit, 105, 107; later career, 224, 242; on Manupelli, 222–224; on Orson Welles Film Society, 135; on *Ten for Two*, 127
Castillo, Carlos, 232
Catholic Adult Education Center, 83
censorship: and Ann Arbor Film Festival, 59, 60; of student societies, ix–x, 39, 79–91, 147–148
Center for Japanese Studies, 296, 297
Cerutti, Vince, 82
Chapayev, 13
Chaplin, Charlie, 42
Chelsea Girls, 97, 202–203, 275

Children of Paradise, 19, 37
Chudacoff, Edward, 32
Cinegram, 262, 265
Cinema Guild: Ann Arbor Film Festival founding and support, ix, 53, 56, 61, 216–217, 222; and *The Birth of a Nation*, 159, 170–173, 174, 175, 277–279; closure of, 300–302; collecting by, 41–42, 57, 295, 301; competition from commercial theaters, 94–98; competition from other student societies, 93–94, 141–142; copyright infractions, 41–42; decline of, 295–298; and *Dr. Chicago* series, 113, 117; education role, x, 103–104, 169; end of monopoly, 93; film selection, 236, 237, 249–250, 297–300; and *Flaming Creatures*, ix, 79–91, 297; flyers, calendars, and graphics, 40, 44, 49, 113, 142, 159, 164, 175, 201, 242–243, 255–257; founding of, 26–27; growth of in 1960s, 35–49; income and finances, 27, 35, 38, 41, 47, 87, 98–100, 286, 295, 297–298, 300–302; and licensing discussions, 151; logo, 167, 168; magazine, 260; and *Metamorphosis*, 32; no smoking announcements, 247–248, 258–259; numbers of films per year, 235–236; premieres by, 163, 164; projection upgrades, 35, 167, 180; as robbery target, 156; and sexually-explicit films, 36–37, 38–39, 40, 79–91; and silent films, 26, 187–188; and sneak previews, 298–299; staff postcard, 143; and *Ten for Two*, 127; ticket prices, 35, 46, 100, 144; visits by

INDEX 323

directors/actors, 104–109, 194, 195, 200, 201, 203–204, 296; and *We'll Remember Michigan,* 27–29, 128
Cinema II: and Ann Arbor Film Festival, 93, 216–217; and author, viii; and Banned Film Festival, 276–277; closure of, 287; competition from other student societies, 141; and cult films, 193; education role, 104, 169; and filmmaking, 93, 248; film selection, 236; and *Flaming Creatures* arrests, 85; flyers, calendars, and graphics, 96, 186, 207, 243, 247, 248, 253–254, 274; founding of, 93; Holding Up Half the Sky festival, 204, 207; income and finances, 286, 287; logo, 167, 168; magazines, 260; and nitrate film, 185; premieres by, 163; and Robert Altman festival, 195; and smoking problems, 247; ticket prices, 144; T-shirts, 260, 262; visits by directors/actors, 202–203, 204, 207, 275–276
Cinema Scope (magazine), 260–261
Cinema Street (shorts), 74
Cinnamon Cinema, 93
civil rights movement, 39, 159, 161–162
Clark, William, 93, 117
Clarke, J. Scott, 180, 181, 186, 269
Clarren, Michael, 232, 280
Classic Film Theatre, 269–270, 273
Coakley, Bernie, 217
Codine, 93
Cohen, Hubert "Hugh": acting by, 133; and Ann Arbor Film Festival, 53, 57; on audiences, 37–38; background, 48;
on *The Birth of a Nation,* 279; and Cinema Guild management, 41, 42, 46, 296, 299; on Felheim, 159, 174; and film selection, 41, 235, 297–298, 299–300; and *Flaming Creatures,* ix, 80–91; later career, 242; and live music for silent films, 188, 191; in ONCE Group documentary, 130; teaching by, 48, 168–169, 170, 200–201, 297–298; and visits by directors/actors, 104–106, 200–201; on Weber, 47–48
Cohen, Lynn, 209
Cohen, Milton, 56, 58
Cohn, Betsy, 63
Collaro, Viera, 114, 116
College of Architecture and Design: and *Flaming Creatures* controversy, 82; Manupelli as faculty at, 51. *See also* Ann Arbor Film Festival; Architecture/Architecture & Design Auditorium; Cinema Guild
Collins, Russ, 273, 290
Commander Cody and His Lost Planet Airmen, 74–75, 120–122, 127
communism, 11
Conklin, Jack, 9
Conlin, Bill, 94–95, 97
Conspiracy, 139–141
Contemporary Films, 83–84
Cook Memorial Films, 167
copyright infractions, 41–42
The Corbett-Fitzsimmons Fight, 3
Coronation, 59
Coutant, Leslie, 217
Couzens Hall screenings, 167
Creative Arts Festival, 105–109
crime, arrests, and lawsuits: and *The Birth of a Nation,* 25; and *Flaming Creatures,* ix, 82–91;
and gay stings, 159–160; and Orson Welles Film Society, 135; riots, 4–5, 44; robberies, 156
Cross, Bonnie, 39
Cruse, Harold, 161–162
Cry Dr. Chicago, 114, 115, 116–117, 209
cult films, 193–194
Cummins, Kelly, 197
Cushway, Phil, 166
Cutler, Richard, 81
Cybulski, Mary, 169–170, 215, 217, 242, 247–248, 258

D
Daane, Roderick, 151
Dascola, Dominic, 23
Dascola Barbers, 23
Davies, Valentine, 22
Davis, Peter, 194–195
Davis, Robert, 103, 119
Dawn of the Dead, 202
Day of Wrath, 22
de Antonio, Emile, 164, 165, 275
Dede, Bonnie, 38
Deep Throat, 147
Deming, Mark, 196–199
Demme, Jonathan, 199
The Demon Lover, 133
Demon Lover Diary, 133
DeMott, Joel, 133
Deneau, William, 161
Densmore, G. E., 25
De Pue, Barbara, 152
De Pue, George, 152, 153, 154
Deren, Maya, 32, 137
Desmond, Dorothy, 46
Desperate Living, 167
Destroy All Monsters, 125–127
Detroit: cinema in, 7, 13; and Eyemediae, 280; film industry in, 111; and publicity for Ann Arbor Film Festival, 217
Detroit Cinema Guild, 13

324 CINEMA ANN ARBOR

Detroit Institute of Arts, 13
DeVarti, Dave, 53, 166, 237, 242, 244, 270–271, 272–273, 288
DeVarti, Dominick, 53, 116, 224
DeVarti, Rich, 116
Devo, 218
Dewdney, Alexander Keewatin, 119–120
digital video, as festival format, 224
DisARM, 135, 137
Disco Dog, 230
Dixboro County Breakdown, 74
Dixon, Dave, 100
DJ Spooky, 279
Dobele, Jonathan, 232
documentaries: and Burns, 67, 102; and Moore, 275; New World Film Cooperative series, 141
Doering, Christoph, 232
Dohrn, Bernardine, 164
Dolby Stereo, 186, 187
Dominick's, 53, 75, 116, 186, 214
Donner, Mark, 227–228
Dramatic Arts Center, 52, 53, 56, 222
Dr. Chicago Goes to Sweden, 117
Dr. Chicago series, 112–117, 133
drive-in theaters, 94, 181
drugs: marijuana, x, 75, 195, 197, 203, 247; psychedelics, 119–120
Dunn, Linwood, 204
Durschlag, Debra, 103

E
Eagle, Herb, 169, 170
Ebert, Roger, 296
Edison, Thomas, 3
Eisler, Michael, 53
Elcar, Dana, 29, 31
Elden, S. J., 86–87
Elliott, Chuck, 29, 31
Elliott, Pete, 23
Ellis, Bette, 29

Elmer Gantry, 296
El Triciclo, 124–125
Emergency Examination of Acute Cranio-Cerebral Trauma, 131
Em Gee Film Library, 83
Emshwiller, Ed, 56, 209
Eternal Love, 281
Excerpt, 117
Exploding Plastic Inevitable (performance), 86
Extensions: An Act for Assembly, 56
Eyemediae, ix, 232, 278, 279–280

F
Fackert, Jim, 181
Fader, Lester, 94
Fahey, John, 139
Fair, David, 227–228
Fair, Jad, 228
Fairbanks, Douglas, Sr., 16
Falstaff (Chimes at Midnight), 94
Felheim, Marvin: and 8 mm Film Festival, 226; and Ann Arbor Film Festival, 53, 58, 212–213, 214, 224; on closing of University venues, 147; death of, 174; and gay stings, 159; and Gothic Society, 21; influence of, 174; on number of student societies, 142; on projection equipment, 179; teaching by, 102–104; and visits by directors/actors, 106, 195; and Women in the Reel World festival, 162
Fensch, Thomas, 119
Fialka, Gerry: and 8 mm Film Festival, 227, 228, 229, 230; and Ann Arbor Film Festival, 217; and film selection, 163–164, 193; later career, 241; on robbery, 156; and visits by directors/authors, 195, 202, 203; and Zappa, 183–185

Fifth Forum, 94–99, 127, 145, 162, 269
Film Farm, 292
Film for Hooded Projector, 111–112
Film-Makers Cooperative, 80
filmmaking in Michigan, 110–133; by American Revolutionary Media, 139; by Ann Arbor Film Cooperative, 123–124, 133, 248; by AVEC, 128–132; by Cinema II, 93, 248; *Cinema Street*, 74; and Davis's speech class, 119; by Destroy All Monsters, 125–127; in Detroit, 111; finances, 118, 123, 130; influence of Ann Arbor Film Festival on, 117, 120; low-budget horror films, 133; by Manupelli, 51, 56, 111–117, 133, 224; *Metamorphosis*, 19, 28, 29–33; rise of in 1960s, 117–119; and state tax incentives, 132; and *Ten for Two*, 127–128
Film Projection Service, viii, 180–181, 182, 272
film studies at UM: and Beaver, 132–133; and *The Birth of a Nation*, 170–173, 174, 279; and Davis, 103, 119; and Felheim, 102–104; free Sunday series, 296; full department status, 174; and Kirkpatrick, 167–168, 169, 181, 194, 195; and Manupelli, 63–67; pressure for, 15, 103; Program in Film and Video Studies, 167–170, 173–174, 181, 194, 195
Film & Video Student Association, 292–295
finances and income: 8 mm Film Festival, 228; Alley Cinema, 138; Alternative Action, 286, 287; Ann Arbor Film Cooperative, 272, 286, 287, 291; Ann Arbor Film Festival,

INDEX 325

56, 221–222; Art Cinema League, 11–12, 20; auditorium fees, 41, 98, 272, 286–287, 298; Cinema Guild, 27, 35, 38, 41, 47, 87, 98, 100, 286, 295, 297–298, 300–302; Cinema II, 286, 287; and co-sponsorship programs, 11–12, 20, 27, 35, 38, 41; cost increases in 1980s, 272–273, 285–287; and filmmaking, 118, 123, 130; Friends of Newsreel, 151–154; hustles, x, 135, 142–143, 148–155; *Magical Mystery Tour* screenings, 100–101; Mediatrics, 144, 286; Newsreel, 142–143; New World Film Cooperative, 155; and pornography, ix, 148; robberies, 156; and state tax incentives, 132. *See also* ticket prices

Finneran, Bill, 117, 209–212, 219
First Congregational Church, 7
First Methodist Church, 7
Fischinger, Elfriede, 201
Flaherty, Frances, 32
Flaherty, Robert, 32
Flaming Creatures, ix, 79–91, 297
Flanders, Laura, 232
Fleming, Robben, 147–148, 149
Flesh Gordon, 260
Flesh in the Morning, 79
Fluxus, 62
flyers, calendars, and graphics: 8 mm Film Festival, 225, 232, 233; Alternative Action, 244, 252; Ann Arbor Film Cooperative, 170, 190–191, 193, 206, 245, 251, 282, 288, 290, 293–294; Ann Arbor Film Festival, 53–55, 60, 62, 73, 75, 210–211, 213, 218–219, 220, 222, 223, 230; Ann Arbor Silent Film Society, 282; Art Cinema League, 14, 17, 20; Cinema Guild, 40, 44, 49, 113, 142, 159, 164, 175, 201, 242–243, 255–257; Cinema II, 96, 186, 207, 243, 247, 248, 253–254, 274; designing and posting overview, 243–245; Destroy All Monsters, 125; and *Dr. Chicago* series, 113, 116; Eyemediae, 279; Fifth Forum, 98; Matrix, 155; Mediatrics, 145; New World Film Cooperative, 142, 150–151

football, 13, 21, 128–129
foreign films: and commercial theaters, 14, 21, 35–36, 94, 95; as difficult to see, 7; interest in post-WWII, 19–21, 35; and language departments, 21
Fortas, Abe, 91
Fox Village, 97
Frank, Ellen: and Ann Arbor Film Festival, 213, 216; and Cinema Guild, 44, 45, 48, 81, 82, 85, 87, 90; and *Cinema Scope,* 260; filmmaking by, 117, 131; and *Flaming Creatures* arrest, 81, 82, 85, 87, 90
Frankel, Ellen, 123
Frayne, Chris, 118, 209, 214, 224
Frayne, George, 74, 121–122
Friends of Newsreel, 141, 142–143, 151–154, 194
Friends Roadshow, 214
Frierson, Michael, 227, 228, 230, 231–232, 241
Fuller, Sam, 105–109, 200

G
Gabler, Neal, x, 123, 139, 168, 194, 241, 242, 262
Gargoyle Film Society, 167
Garrett, Martha, 230, 231, 232
Garrison, Garnet, 22

Gay/Lesbian Film Festival, 288, 290
Gay Liberation Front, 160–161
gay rights, 159–161. *See also* LGBTQ people and film
Gebhardt, Steve, 127
Gemini Fire Extension, 117
Gene the Clown, 156
Gentry, Sandra, 39
Getz, Mike, 61
Getz, Morleen, 119
the Ghoul, 145
Gibney, Alex, 229
Gildo, Michael, 195–196
Ginsberg, Allen, 127
Gish, Lillian, 282, 283
Glass, Murray, 42
Glatzer, Richard, 194, 195, 242
Gleiberman, Owen, 204
Glickman, Dan, 292
Godard, Jean-Luc, 103, 104–105, 194
Goethe Institute, 276
Goldberg, Louis, 295, 296, 297, 299, 300, 301–302
Goldman, Frank, 262
Goldman, Maynard, 79
Goldman, Paula, 238
Goldthwait, Bobcat, 291
The Good Fight, 276
Goodman, William, 90
Gordon, Kim, 127, 214
Gorin, Jean-Pierre, 194
Gorman, William J., 9, 11
Gorp, 199
Gothic Film Society, 21, 25, 26, 29–33, 39
Gould, Elliott, 195
graphics. *See* flyers, calendars, and graphics
Greene, David, 123, 136, 137, 138–139, 209, 225–226
Grimshaw, Gary, 138
Gunning, Dan, 155, 166, 195, 227, 229, 244

H

Haber, Alan, 83
Hail Mary, 276–277
HAILStorm, viii
Hale Auditorium, 167
Half Japanese, 228
Hall, Donald, 194
Hallman, Philip: and 8 mm Film Festival, 227, 229, 230, 232; and *Ann Arbor Screen Scene,* 262; as archivist, x, 199; and *Atomic Café* premiere, 273, 275; and Banned Film Festival, 276; on *The Birth of a Nation,* 173; and calendars, 244; and Classic Film Theatre, 270; later career, 241; on *Michigan CinemaGuide,* 271; and robbery of AAFC, 156; on student societies' management, 235, 237, 238–239, 240
Hamilton, Chrisstina, 224
Hamlet, 295
Hampton, William, III, 29, 31, 32
Hampton, William, IV, 32, 81
Hansen, Gunnar, 133
Harris, Rosemary, 37
Harris, Roy, 12
Harvey, Dennis, 229
Haskell, Molly, 195, 204
Hatcher, Harlan, 59, 82–83
Hayden, Tom, 39
Haynes, Todd, 229
Henry, Vicky, 70
Henstell, Bruce, 105, 117, 260
Hercules, Bob, 280
Herzog, Werner, 200
Heusel, Ted, 29
Hill Auditorium: and Art Cinema League, 20; and Cinema Guild, 26, 35; early films at, 6, 7; *Metamorphosis* premiere, 32
Hillel Foundation, 166–167, 292
Hill's Opera House. *See* Athens Theatre
Hill St. Cinema, 166–167, 292
Hitchens, Gordon, 215
Hittle, Timothy, 232
Hoag, Gerald, 14–15, 23, 36, 41, 195
Holbrook, Robert B., 287
Holding Up Half the Sky festival, 204, 207
Hold Me While I'm Naked, 91
Holland, Hugh Henry "Jeep," 42, 46, 48, 87
Honeyman, Vicki, 155, 169, 214, 224, 242, 249, 302
Hopper, Dennis, 201–202
The Horror of Beatnik Beach, 126
The House, 56
House Un-American Activities Committee, 39
Human Sexuality Office, 159
Hunt, Rod, 166, 244
Hurwitz, Helen, 292
hustles, x, 135, 142–143, 148–155
Hutchins, Harry, 3
Hutchins Hall, 167

I

I, a Woman, 95
I Am Curious (Yellow), 145, 146, 147
IATSE, 285, 296
The Image in Time, 51
Inco Graphics, 153
Inevitably, 119
Innergalactic Twist Queens, 75
internet, 290
Inter-Racial Association, 23
It Happens Every Spring, 22
Ivens, Joris, viii, 13

J

Jackson, Donald G., 133
Jacobson, Joel, 39, 242
Jam Handy Organization, 111
Jerovi, 58, 59
Jeter, Ida, 119
John Sinclair Freedom Rally, 127
Johnson, Betty, 51, 58, 59, 61, 67, 70, 117
Johnson, Val, 23
Jones, Terry, 119
Joseph A. Labadie Collection, 46
Jost, Jon, 204, 206
Juback, Jimm, 227
Jurist, Edward C., 15

K

Kael, Pauline, 57
Kameradschaft, 12
Kamrowski, Gerome, 53, 72
Kanter, Deborah, 273
Kaplan, Michael, 236, 240, 262
Kaplan, Wilfred, 52, 56
Kasdan, Lawrence, x, 86, 224, 231, 242
Kasdan, Meg, 231
Kaul, Don, 48
Kaul, Sue, 35, 48
Kelley, Ken, 100–101
Kelley, Mike, 125–127, 214
Kelly, Frank, 273
Kennedy, Bill, 203
Kenny, Dallas, 141, 151
Kerasotes Theatres, 295
Kevorkian, Harry, 161
Kevorkian, Jack, 281
The Killers, 27
King of Hearts, 193
Kipnis, Claude, 114, 116
Kirby, Doug, 39
Kirchen, Bill, 74–75, 122
Kirkpatrick, Diane: and *Cinegram,* 262; on Felheim, 103, 104; and Program in Film and Video Studies, 167–168, 169, 181, 194, 195; and visits by directors/authors, 194, 195, 196, 197, 199; on Wilde, 159–160
Klein, Stuart, 217
Knox, David R., 59
Kober, Hannelore, 232

Kochmanski, Chris, 229
Krasny, Walter, 84, 91
Krassner, Paul, 85
Kraus, Richard, 26, 27, 29
Kreines, Jeff, 133
Kuniavsky, Mike, 297
Kunin, Tim, 270–271
Kurosawa, Akira, 44
Kusnerz, Peggy Ann, 46–47, 219, 236, 237, 245

L
Labadie Collection, 46
LaBour, Fred "Ticket Fred," 74, 91, 179, 209, 214, 215, 299
La Grande Bouffe, 193, 194
Lanchester, Elsa, 194
Lane Hall, 7
language departments, 21, 38. *See also* Modern Languages Building
The Last Movie, 201–202
Lavastida, Aubert, 29, 128, 129, 130
League. *See* Michigan League
Lemler, Ford, 25
Lennon, John, 101, 127–128
Lenz, Reed, ix, 238
Lester, Harold, 22
Levenick, Ann, 121, 122
Lewis, Joseph H., 201
Lewis, Mike, 39
LGBTQ people and film: arrests and stings, 159–160; Gay/Lesbian Film Festival, 288, 290; gay rights, 159–161; student societies as haven for, x, 43
Liberty Street Video, 285
libraries, University of Michigan: donations to by student societies, 15, 20, 288; Joseph A. Labadie Collection, 46; Mavericks and Makers collection, 199
Liddell, Cynthia, 117

Lightworks, 295
Lisemer, L. J., 3–4
Little Cinemas, 11
Little Theatre (Detroit), 7
Lloyd, Harold, 104, 105
Loader, Jayne, 242, 275
lobby supervisors, 238
The Locks of Sault Ste. Marie, 128
Lohmann, Paul, 29
Loomis, Amy, 8–9, 22, 187
LoPatin, Mark, 142–145, 174
Loren, Cary, 125–127
Loving, Al, 72, 214
Lucas, George, 67
Lucier, Alvin, 112–113, 115
Lugg, Andrew: Ayers on, 43; equipment proposal, 122; filmmaking by, 117, 118, 120, 129–130, 209; and *Flaming Creatures* controversy, 82, 83; and ONCE Group documentary, 130; reviews by, 86, 95; and visits by directors/authors, 104
Lydia Mendelssohn Theatre, 8–9, 11, 15, 16, 19, 20

M
Macgowan, Kenneth, 22
Machrowicz, Thaddeus, 87
MacRae, Meredith, 162, 163
Madden, Matt, 288, 289
Madonna, 229
magazines by student societies, 260–266
Magical Mystery Tour, 100–101
Majestic Theatre, 7, 15
Malanga, 119
Malanga, Gerard, 62, 63, 74
The Mallese Cross Movement, 119–120
Maltin, Leonard, 235
The Man in the Dark Sedan, 218
Manupelli, George: acting by, 128; and Ann Arbor Film Festival, 52–62, 67, 73, 75, 209, 210, 213, 214, 216, 218–224; background, 51; filmmaking by, 51, 56, 111–117, 133, 224; and graphics, 53, 54–55, 73, 75, 113, 210, 213, 218–219, 220; influence and impact of, 222–224; and Malanga, 63; and Markopoulos, 58, 59; marriage, 51, 67; move to Toronto, 169, 213; teaching by, 51, 63–67; and *Ten for Two*, 127
marijuana, x, 75, 195, 197, 203, 247
Markens Grode (Growth of the Soil), 8–9
Markopoulos, Gregory, 57–59
Mark's Coffee House, 93, 155
Mass, 57
Matrix Theatre, 155, 156, 244
MC5, 87, 135
McDowell, Curt, 209, 215
McGovern, George, 120
McLean, Jock, 100
Meagher, Paul, 31, 32
Mediatrics, 142–145, 248, 286, 292–295
Meiland, Jack, 286–287
Mekas, Jonas, 52, 57, 59, 80, 86
Mensching, Glenn, 276–277, 291
Metamorphosis, 19, 28, 29–33, 103
Metropolis Film Society, 167
M-Flicks, 292–295, 298
Michigan CinemaGuide, 270–272, 288, 297
Michigan Community Theater Corporation, 220, 269
Michigan Daily: as resource, ix; on student societies, 288–289, 291
Michigan League: construction of, 8. *See also* Lydia Mendelssohn Theatre
Michigan Theater Foundation, 269
Michigan Theatre: and Altman visit, 195; Ann Arbor Film

328 CINEMA ANN ARBOR

Festival move to, 186, 219–221; and Classic Film Theatre, 269–270; and Collins, 273; evolution in 1980s, 273–274; and Hoag, 14–15; projection equipment, 186; reopening of, 186; struggles in 1970s, 162
Michigan Union, 8, 21
Midwest Film Festival (Chicago), 53, 56
Milan Prison, 139
Milestone Films, 282
Miller, Paul, 279
Miller, Roger Clark, 191
Modern Languages Building: and ARM, 141, 151; auditorium fees, 272; and Metropolis Film Society, 167; and New World Film Cooperative, 141; ventilation system, 239
Modern Times, 42
Montalvo, Alfredo, 170
Moore, Michael, x, 224, 275
Moore, Thurston, 127
Moray, Anne, 148, 179, 182
Moray, Dan, 148–149, 183, 193
Moray, Liz, 179, 183
Morrison, Sterling, 62
Movie News, 262
Mr. Hayashi, 57
Mulholland, Dan, 214
Mumma, Gordon, 51, 56
Museum of Modern Art, 13, 16, 21, 25, 32, 282
music: and Ann Arbor Film Festival, 62–67, 74–75, 214, 216, 218, 224; Beatles and *Magical Mystery Tour* screenings, 100–101; benefit concert for *Flaming Creatures* controversy, 87; and Conspiracy, 139; and Fifth Forum, 95, 98–99; music videos, 218; silent films and live musical accompaniment, 9, 16, 26–27, 187–191, 280–281, 282; *Ten for Two*, 127–128; The Velvet Underground, 62–67, 74, 85–86, 216
Myers, Richard, 209

N
NAACP (National Association for the Advancement of Colored People), 23, 25
Nate (custodian), 143
National Alliance Against Racist and Political Repression, 170–173
National Film Board of Canada, 53, 213–214
National General Corporation, 97
National Recovery Administration, 13
National Student League, 11, 13
Natural Science Auditorium: and ARM, 135, 137; construction of, 6; and *Magical Mystery Tour* screenings, 100–101; and Mediatrics, 144
Near the Big Chakra, 209
Neff, Fred, 39
Nelson, John, 129, 217, 229, 242
Nemperor Artists, 100–101
Neptune [society], 25
Newman, David, 111
New Morning bookstore/collective, 151–154. *See also* Friends of Newsreel
New Morning Media Cooperative, 152
Newsreel. *See* Friends of Newsreel
newsreels, 16
New World Film Cooperative, 141–142, 146–148, 154–155, 262, 265
New World Media Project, Inc., 154–155
New Yorker Films, 163–164
Niagara, 125–127
nickelodeons, 4
Nico, 62, 63, 64, 89. *See also* The Velvet Underground
Niehuss, Marvin, 159
nitrate film, 185
Noise-A-Palooza, 291
(No) Peace in the Valley, 63
Nosei, Annina, 58

O
O'Brien, Thomas, 38
Observatory, University of Michigan, 6
Ochs, Phil, 127
Oleszko, Pat: and 8 mm Film Festival, 232; and Ann Arbor Film Festival, 67–71, 75, 209, 214, 215–216, 218, 219, 221; in *Cry Dr. Chicago*, 117; films by, 118; on Manupelli, 222; performance art by, 67–71, 209, 214, 216, 218
Oliveros, Pauline, 116
Olivo, Robert. *See* Ondine
ONCE Group, 51–52, 56, 68, 112–117, 130–132
ONCE Kittyhawk, 130–132
Onder, Jan, 119
Ondine, 202–203, 274, 275–276
O'Neill, Pat, 214
Ono, Yoko, 62, 63, 101, 127, 128
The Opening of Misty Beethoven, 167
Operation Abolition, 39
Ophuls, Marcel, 195
Orentlicher, John, 117
Orpheum Theatre, 7, 21, 35
Orpheus, 27
Orson Welles Film Society, 135, 151
Osterberg, James. *See* Pop, Iggy

P
Paik, Nam June, 209
Pamela and Ian, 123–124, 209

INDEX 329

Pantry, Linda, 222
Paris, Texas, 238
The Pawn, 226
Paxton, Steve, 113, 115
People's Ballroom, 141
Peoples' Bicentennial Commission, 166
Performance Network, 279–280
Perry, Judy, 236, 273
Perry, Michael, 237
Petiet, Tom, 132
Plamondon, Genie, 121–122
Plamondon, Pun, 244
Plotnick, Danny, 232
police: gay stings and arrests, 159–160; and sexually-explicit materials, 81–82, 84, 90, 91; and students as unwanted audience, 4–5
Pop, Iggy, 63, 98–99. *See also* The Stooges
"Porn'Im'Age'Ry: Picturing Prostitutes," 288
pornography, ix, 145–150, 155, 288, 291. *See also* sexually-explicit films
posters, film, 248, 260
Potter, Christopher, 279, 301
Pozo, Angelica, 238, 240, 242, 247, 255, 257
previews, sneak, 295, 298–299, 300
Price, Hereward T., 19
prices. *See* ticket prices
Priebe, Michael, 123
Prime Movers, 63, 74
Prix De Varti, 214
Program in Film and Video Studies, 167–170, 173–174, 181, 194, 195
Project Greenlight, 299, 301
projection and projectionists, 178–187; and 3D films, 186; and 8 mm Film Festival, 228; and 35 mm equipment, 163, 180, 182; and Ann Arbor Film Festival, 180; Cinema Guild upgrades, 35, 167, 180; costs of, 98–100, 272; and drive-in theaters, 181; and Film Projection Service, viii, 180–181, 182, 272; first female, 179; IATSE strike, 285, 296; and nitrate film, 185; and pornography, 148; portable projectors, 94; tinkering by Wilde, viii, 179–182, 186; video projection, 183–185. *See also* Wilde, Peter
protests: and Alternative Action, 166; anti-war protests, 44; and *The Birth of a Nation*, 22–26, 170–173, 174; and *Blood in the Face*, 288, 289; and *The Boys in the Band*, 160–161; and Commander Cody concert, 120–122; and *Flaming Creatures*, 82, 83, 297; and *Hail Mary*, 276–277; and Inter-Racial Association, 23; by National Student League, 13; by Women's Law Student Association, 167
psychedelics, 119–120
Psychedelic Stooges. *See* The Stooges
Punch and Judy Theater, 270
Punking Out, 218
Pyke, Jim, 285, 290, 291, 292

Q
Queen Kelly, 238

R
racism: and civil rights movement, 159, 161–162; and *Song of the South*, 23. *See also The Birth of a Nation*
Rackham: and Art Cinema League, 16; and Gothic Film Society, 21, 32; and HAILStorm event, viii; lecture hall, 3, 16
Radical Film Series, 135
Radner, Gilda, 44, 45
Rae Theatre, 7
Rafferty, Kevin, 262, 273, 275, 288
Rafferty, Pierce, 275
Raimi, Sam, 229
Rainbow People's Party, 127
Rankin, Ruth, 123
Rappaport, Norman, 19, 26
Rationals, 87
Rattner, Richard, 119
Rebirth of a Nation, 279
Reed, Lou, 62. *See also* The Velvet Underground
Reichl, Ruth, 117
Reifman, Katie, 123
Reiss, Marlene, 236, 240, 276, 277
religious organizations and film screenings, 7, 21, 166–167
Residents, 218
Reynolds, Albert, 4–5
Reynolds, Roger, 51
Rice, Warner G., 159
The Rice Cycle of San Sai Thailand, 129
Rickenbacker, Eddie, 6
Ride Dr. Chicago Ride, 114, 116
Rideout, Betty, 75
Rideout, Doug: and Ann Arbor Film Festival, 56, 58–59, 63, 75, 213–214; filmmaking by, 56, 128–132; on Manupelli films, 111–112; on *Near the Big Chakra*, 209; work with AVEC, 128–129
Ringing, 187, 191
Rivers, Joan, 200
Road to Life, 14
Robert Altman festival, 194–200
Robinson, David, 124–125
Robinson, Kenneth, 94
Robinson, Roger, 94
Roddenberry, Gene, 144, 145
Roger & Me, 275
Romero, George, 202

Rosa Luxembourg, 276
Rosen, Marjorie, 162
Rosenthal, Caroline, 16
Rossner, Ruth, 35
Rubin, Jerry, 100, 127
Rudolph, Alan, 195, 199
Rumpf Truck Company, 120–122
Rush, Molly, 275
Ruthven, Alexander, 13

S
Sacks, Andy, 81, 91, 188, 191
Sandburg, Carl, viii, 12
Sarris, Andrew, 195
Savoca, Nancy, 199
Say Amen, Somebody, 275
Sayles, John, x, 199
Scavarda, Donald, 51, 56
Schenck, Rocky, 229
Schlimmer, Jacob, 4
Schneider, Richard, 129
Schorling Auditorium, 228
Schreiber, Allan, 67, 117, 213, 214
Schreiber, Nancy, 137, 241
Schreier, Mark, 230–231, 232, 236, 242, 275, 280
Schultz, Ken, 124
Scio drive-in theater, 94, 181
Scissors, 119
Scorpio Rising, 57, 79
Scotch Tape, 91
Seale, Bobby, 127
Seamon, Pam, 123
Seeman, Chris, 295
Seewood, André, 232
Seidel, Philip, 11
Sempliner, Woody, 181, 209, 213, 216–221, 222, 224, 229
Seventh Seal, 74
Severson, Anne, 209, 215
sexually-explicit films: and Ann Arbor Film Cooperative, 148, 288, 291; and Ann Arbor Film Festival, 58, 59–60, 79, 209; and Butterfield theaters, 36; and Cinema Guild, 36–37, 38–39, 40, 79–91; and Fifth Forum, 95, 145; and Gargoyle Film Society, 167; and internet, 290; and New World Film Cooperative, 146–148; pornography, ix, 145–150, 155, 288, 291; shipping of, 80
Shapiro, Donald, 95
Shapiro, Paula, 119
Shaw, Jim, 125–127, 244, 248
Shaye, Robert, 67
Shea, Thomas, 81, 85
Sheff, Robert. *See* Tyranny, 'Blue' Gene
Shevitz, Henry, 39
The Shlamozzle, 132, 133
silent films: and Ann Arbor Film Cooperative, 187; and Ann Arbor Film Festival, 56; and Ann Arbor Silent Film Society, 279–283; and Art Cinema League, 11–12, 16, 187; and Cinema Guild, 26, 187–188; filmmaking in Ann Arbor, 132; live musical accompaniment for, 9, 16, 26–27, 187–191, 280–281, 282; and Lydia Mendelssohn Theatre, 9, 187
Silver, Alan, 26
Silvera, Charlotte, 296
Simpson, Lewis "Buster," 62–63, 72, 73–74, 116, 117, 118–119, 122, 209. *See also Rumpf Truck Company*
Sinclair, John, 127–128, 135, 153
Sinclair, Leni, 215
Sklar, Robert, 86, 103
Sloss, John, x, 201, 202–203, 241
Small, Willard, 230
Smith, Jack, 125. *See also Flaming Creatures*
Smith, Kevin, 185, 217, 241
Smith, Matthew, 240, 260, 276
sneak previews, 295, 298–299, 300
Song of the South, 23
Sontag, Susan, 86, 87
Sosin, Donald, 147, 187–188
speech department, 22–25, 103, 106, 119, 128
Speer, Anne, 53
Staller, Eric, 72–73
Star Theatre, 4–5
Star Trek, 144–145
State Theatre, 23, 145, 162, 269
Staudenmaier, Eugene, 81–82, 84, 90, 91
Steed, Judy, 204
Steel Belted Romeos, 232
Stein, Andy, 74–75
Stephan, Arthur, 132, 279–283
Stevens, Geoff, 123
Stone, Nancy, 148, 244, 245
The Stooges, 63, 95, 98–99
Story, Ralph, 279
Strand, Chick, 204
Street Stuff, 133
Strick, Joseph, 105
Struss, Karl, 185, 194
Stryker's War, 229
Stuart, Al, 287, 298
student films. *See* filmmaking in Michigan
student government: and *The Birth of a Nation,* 25; and end of Cinema Guild monopoly, 93; and *Flaming Creatures* arrests, 83; and *Flesh in the Morning,* 79; and *Operation Abolition,* 39; and Orson Welles Film Society, 135
Student Government Council, 35, 39, 79, 83, 93, 135
Student Legislature, 25, 27. *See also* Cinema Guild
Student Legislature Cinema Guild. *See* Cinema Guild
Student Organizations Board, 151
Students for a Democratic

Society, 39, 43. *See also* Weather Underground

student societies: author's interest in, viii–ix; censorship of, ix x, 39, 79–91, 147–148; competition from video rentals, 285; competition with commercial theaters, 14, 41, 94–98; coordination between, 237–238, 239–240; copyright infractions, 41–42; and corporate promotions, 299, 301; cost increases in 1980s, 272–273, 285–287; and Dolby Stereo, 186, 187; first in US, viii, 11, 12; influence of, x, 235, 241–242; magazines and publications, 260–266, 270–272, 288, 297; management in 1980s, 235–267; no smoking announcements, 247–248, 258–259; numbers of, 142; numbers of films per year, 235–236; publicity and promotion, 242–265; restrictions on advertising, 41; rise of, 11; robberies of, 156; selection meetings and logistics, 236–239; sneak previews, 295, 298–299, 300; support for Ann Arbor Film Festival, 215, 216–217, 222; and visits by directors/actors, 104–109, 194–207, 273, 275–276, 291, 296. *See also* Alternative Action; American Revolutionary Media (ARM); Ann Arbor Film Cooperative; Art Cinema League; Black Film Society; Cinema Guild; Cinema II; filmmaking in Michigan; finances and income; flyers, calendars, and graphics; Friends of Newsreel; Gargoyle Film Society; Gothic Film Society; Mediatrics; M-Flicks; New World Film Cooperative; Orson Welles Film Society; University of Michigan Film Society

Students United for Porn, 148–149, 151
Studio (chain), 94
Stulberg, Ian, 123, 124
SunDance magazine, 101
Super 8: and 8 mm Film Festival, 226, 227–228, 231, 232; and Destroy All Monsters collective, 126; as format, 227–228, 231
Superstar, Ingrid, 62
Surowitz, "Mad Marvin," 95
"Survey of the Film in America" (MOMA), 13
Swain, David, 101
Swain, Mary Ann, 287
Sweet, Freddy, 123–124

T

Take Five (magazine), 262, 264
talkies, 8, 12
Taxi Driver, 163
Taylor, Chris, 291
Ten Days That Shook the World, 11
Ten for Two, 127–128
Terrell, James, 23
Tewkesbury, Joan, 195
Thise Cate & Ting Rink, 228
Thompson, Tommy, 195
THX 1138 4EB, 67
Thyme, 87
Tichy, John, 74
ticket prices: in 1970s, 165; in 1980s, 285, 286; Ann Arbor Film Cooperative, 144; Art Cinema League, 11, 12; Butterfield theaters, 100; Cinema Guild, 35, 46, 100, 144; Cinema II, 144; Detroit Cinema Guild, 13; Gothic Film Society, 21; Mediatrics, 144; Newsreel, 144

Time of Desire, 36–37
Tintori, John, 215, 217, 229, 242, 240, 258
Todd, Harry, 46, 238, 239, 295, 296–297, 298, 300–301
A Token of His Extreme, 183–185

Too Slim. *See* LaBour, Fred "Ticket Fred"
Tooson, Joseph, Sr., 238
Torr, Diane, 232
Toy, Jim, 159, 160
Trans-Love Energies, 135
Triton Film Society, 25
Triumph of the Will, 173
Tropic of Cancer, 105
Trumbull Street Playhouse (Detroit), 280
Tsaltas, Mary. *See* Ashley, Mary
T-shirts, 260, 262
Tucker, Maureen, 62
Tweet's Ladies of Pasadena, 203
2001: A Space Odyssey, 295
Tyrrany, 'Blue' Gene (Robert Sheff), 70, 117, 188, 214

U

UAW (United Auto Workers), 25
Uhle, Alvan, ix, 19, 20, 21, 23
Ulysses (Strick film), 95
Un Chant d'Amour, 80
Underground, 164–165
United Artists theater, 163
University Activities Center: Creative Arts Festival, 105–109; and director visits, 200–201; and Robert Altman festival, 195, 196. *See also* Mediatrics; M-Flicks
University drive-in theater, 181
University Famine Drive, 22
University of Michigan: bicentennial, viii; and

Butterfield Theaters, 147–148; Film Projection Service, viii, 180–181, 182, 272; hustles and costs to, x; libraries and archives, x, 15, 20, 46, 199, 288; support for gay students, 159; use of film in research and instruction, 5–7. *See also* film studies at UM; student government; student societies; University Activities Center; *specific buildings*

University of Michigan Film Society, 135

Up-Tight with Andy Warhol and the Velvet Underground, 62–67, 216

V

Valk, James, 228

Van Allsburg, Chris, 72

Van Cleef, Ed, 119

Vanderbeek, Stan, 105

Van Dyke, Willard, 87

Vaudette, 4

The Velvet Underground, 62–67, 74, 85–86, 216

Veriscope Company, 3

Vernier, Doug, 119

video: digital video as festival format, 224; first licensing to, 242; music videos, 218; video projection, 183–185; video rentals as competition, 285

Video Hut, 285

Vidor, King, 12

Vietnam War, 39, 43–44, 120, 164–165

Vitascope, 3

Voices of Bethel choir, 275

von Trotta, Margarethe, 276

Vth Forum. *See* Fifth Forum

W

Wagner, Mark, 247

Walda, Ralph, 81, 82

Wang, Norman, 242

Ward, Willis, 13

Warhol, Andy, 62–63, 67, 85–86, 97, 216

Warren, Austin, 21

Washtenaw County Film Library, 94

Watson, Jim, 123, 124, 125, 137–138

Wayside Theatre, 97–98

Weather Underground, 164–165

Weaver, Zoey, 292

Weber, Ed: background, 46; and *The Birth of a Nation*, 279; and Cinema Guild management, 46–48, 143, 238, 296; death of, 302; and *Flaming Creatures*, 79–80, 82, 91; and *Flesh in the Morning*, 79; and gay stings, 159; health of, 300; on importance of film, 42; and Labadie collection, 46–47

A Wedding, 197, 199

Weeks, Robert, 90

Wehrer, Anne, 52, 63, 117, 118, 124

Wehrer, Joe: and Ann Arbor Film Festival, 52, 56, 63, 72–73, 209–212, 219; on classes by Manupelli, 67; and films with Manupelli, 114, 116, 117; and ONCE Group, 51; and *Ten for Two*, 127, 128

Wehrer, Stephen, 73

Weil, Norris, 39

Weill, Claudia, 194

Weinstein, Faith, 36–37

Weissberg, Jay, 241, 276–277, 281–282

Welles, Orson, x, 199

We'll Remember Michigan, 27–29, 128

The Well-Wrought Ern, 29

Wenders, Wim, 200–201

Wendigo, 133

Wexler, Haskell, 200

White, Nathan, 133

White Panther Party, 135, 153, 154

Whitney Theatre, 7, 14, 23

Who Cares about the Huron River, 130

Wickham, Donna, 35

Wiegand, Bill, 29

Wilde, Peter: and 3D films, 186; and 35 mm equipment, 163, 182; acting by, 124; and *Ann Arbor Eye*, 260; and Ann Arbor Film Festival, 63, 100; arrest, 159–160, 186; background, 179; in *Cinema Street*, 74; and Commander Cody concert, 120–121; engineering and tinkering by, viii, 179–182, 186; and equipment upgrades, 167; and Film Projection Service, viii, 180–181, 182; on Friends of Newsreel, 141; and nitrate film, 185; and Oleszko, 70; on projection, 179–180; teaching by, 181; touring work, 181–182, 186; and video projection, 183–185; work with student societies, viii, 100, 143, 167, 203

Wildwood Flower, 120

Wilk, Merrill, 273

Willow drive-in theater, 94

Wiseman, Frederick, 200, 201

Wolf, Brian, 238

Wolf, Laura, 152–154

women in cinema: and 8 mm Film Festival, 226–227; Holding Up Half the Sky festival, 204, 207; Women in the Reel World festival, 159, 162, 163

Women in the Reel World festival, 159, 162, 163

Women's Law Student Association, 167

INDEX 333

Women's League. *See* Michigan League
Wonder, Stevie, 127
The World's Greatest Sinner, 203
W. S. Butterfield Theaters. *See* Butterfield Theaters
Wuerth Theatre, 7, 35

Y
Yalkut, Jud, 209
Young, Alan, 111
Ypsi-Ann drive-in theater, 94, 181

Z
Zanoff, Harold, 39
Zappa, Frank, 183, 203
Zedd, Nick, 232, 233
Zeig, Susan, 215
Ziebell, Rob, 167, 168–169, 204, 219, 222, 247, 257